Special Visions

For John, Kaj, Thane, and Guido

SPECIAL VISIONS

Profiles of Fifteen Women Artists from the Renaissance to the Present Day

by Olga S. Opfell

McFarland & Company, Inc., Publishers
Jefferson, North Carolina, and London

British Library Cataloguing-in-Publication data are available

Library of Congress Cataloguing-in-Publication Data

Opfell, Olga S.
 Special visions : profiles of fifteen women artists from the
Renaissance to the present day / by Olga S. Opfell.
 p. cm.
 Included bibliographical references (p. 209) and index. ∞
 ISBN 0-89950-603-8 (lib. bdg. : 50# alk. paper)
 1. Women artists—Biography. 2. Art, Renaissance. 3. Art,
Modern. I. Title.
N43.06 1991
709'.2'2—dc20
 [B] 90-53603
 CIP

Manufactured in the United States of America

McFarland & Company, Inc., Publishers
 Box 611, Jefferson, North Carolina 28640

Author's Note

This is very much a book for the general reader. It is not for art scholars or specialists or feminist historians. The aim is to present an overview of a variety of women artists from the Renaissance to the twentieth century, to outline the main events that shaped their artistic impulses, and to relate their work to their lives. These profiles do not pretend to be original studies, but, as a result of careful research, they do correct certain factual errors that sometimes have been carried from book to book.

The choice of which women to include was purely arbitrary, apart from the criterion that each woman covered had finished her output of works. I selected women who produced distinctive *oeuvres,* who were memorable personalities, and who led interesting if sometimes unconventional lives.

Each chapter identifies the locations of the paintings mentioned. Several of these pictures hang in private collections or belong to the estate of the artist, but from time to time can be seen in special museum or gallery exhibits. Reproductions in fine art books abound. I have tried to include works from every period of each artist's career, but a reader may miss mention of a personal favorite.

Italian, German, French, Dutch, and Spanish titles (alternative titles are bracketed) are given in English with the exception of Frida Kahlo's *Viva la Vida,* words which in a sense sum up her story.

The bibliography is restricted to books. For Judith Leyster, however, it seemed appropriate to mention the Dutch periodical articles that led to her rediscovery as a major artist.

My first thanks go to my husband, John B. Opfell, for much practical and editorial help, and to Ruth Loring for her invaluable suggestions. I also wish to express my gratitude to M. J. Tilton for her comma-ready pencil and to Pinkney Near and Maureen Reeder for making special material available.

<div style="text-align: right">

Olga S. Opfell
Torrance, California

</div>

Contents

Author's Note v

 I. Artemisia Gentileschi (1593–1652?) 1
 II. Judith Leyster (1609–1660) 13
 III. Angelica Kauffmann (1741–1807) 25
 IV. Elizabeth Vigée–Le Brun (1755–1842) 39
 V. Rosa Bonheur (1822–1899) 53
 VI. Berthe Morisot (1841–1895) 66
VII. Mary Cassatt (1844–1926) 83
VIII. Suzanne Valadon (1865–1937) 96
 IX. Käthe Kollwitz (1867–1945) 109
 X. Paula Modersohn-Becker (1876–1907) 122
 XI. Gabriele Münter (1877–1962) 135
XII. Vanessa Bell (1879–1961) 148
XIII. Sonia Delaunay (1885–1979) 165
XIV. Georgia O'Keeffe (1887–1986) 180
XV. Frida Kahlo (1907–1954) 196

Select Bibliography 209
Index 217

I

Artemisia Gentileschi

(1593–1652?)

At the beginning of her career, her life took a tragic turn. But rape, a sensational trial, and floods of innuendo and rumors spread by malicious tongues actually strengthened Artemisia Gentileschi's determination to become a successful painter. Though she gained the recognition she wanted, after her death art historians through several centuries mentioned her chiefly in connection with her notoriety. Only in modern times has she been given her due as the first significant woman painter in Western art.

Art surrounded her from the first. When she was born in Rome on July 8, 1593, her father, Orazio Gentileschi, aged 30, was already a well-known painter, acclaimed for his elegance and grace. The family lived in the artists' quarter between the Piazza di Spagna and Santa Maria del Popolo; Orazio was prominent among those who kept busy decorating palaces and the new churches that had sprung up all over the city.

He counted as his friend the young painter Michelangelo Merisi da Caravaggio, whose revolutionary naturalism prepared the way for the Baroque era. As a child Artemisia must have seen him whenever he burst into the Gentileschi house to borrow props from Orazio's studio. All Rome talked about this stormy genius, who raised the ordinary to the level of art, casting plain people as saints and Biblical characters. Placing his models in semidarkness or in strong, hard shadows, he then illuminated them with intense, clear light, usually from an unknown source. He had a great many followers, who proudly called themselves *Caravaggisti*. Orazio, too, absorbed his style, combining it with Florentine mannerism.

Artemisia's mother, Prudentia Ottaviano Montone, had been a girl of 18 when she bore Artemisia, her first child. She went on to bear four sons; the first, Giovanni Battista, born one year after Artemisia, died at age six. Prudentia herself died at the age of 30 in 1605, and at 12, Artemisia took

1

over many of her mother's duties. As was the custom with adolescent girls in Roman families, she was usually kept in domestic seclusion, venturing out only with her father or a chaperone to see the rich artistic monuments Orazio encouraged her to study. She must have spent hours twisting her neck in the Sistine Chapel to drink in the power of Michelangelo's heroic figures on the ceiling frescos. About this time, Orazio had begun to train her as an artist, emphasizing Caravaggio's style. Orazio would be her only teacher. Simultaneously he taught his eight-year-old son, Francesco, who was much less talented than his sister.

The next year, the violent-tempered Caravaggio, whose name had often appeared in Roman police records, killed a man during a brawl following a ball game and fled Rome for good. After several misadventures in Malta and Tuscany, he died of a fever in 1610 at the age of 37. But his influence lived on in Rome.

Artemisia's first dated painting, *Susanna and the Elders* (1610), is based on the Apocrypha story from the time of the Judean exile in Babylon. Two elders attempt to seduce Susanna, a beautiful young matron bathing in her garden. They threaten to accuse her of an adulterous relationship with a young man if she does not submit to them. Susanna resists, the men spread the rumor, and she is brought to trial. In the end the elders are accused of false testimony and killed. The foiled enticement had long been a favorite scene for painters. Artemisia's version shows a surprised and distressed Susanna slumped against a stone seat while the two men, one much younger than the other, loom over her.

Some scholars, finding the picture too good to be the work of a 17-year-old girl, have argued that Orazio Gentileschi gave his daughter a big helping hand; others insist that he did not. Lending credence to the case for Artemisia's originality is the almost complete nudity of Susanna, whose white, well-fleshed figure contrasts with the dark shapes of the lascivious men. As a woman, Artemisia had easier access to nude female models than her father; male artists depended on nude male models, forbidden to women artists. As Susanna, Artemisia may have posed a servant, or she may have observed her own body in a mirror. The design, however, reflects some of Orazio's earlier paintings, and it is possible that he advised her on arranging the compositional elements. Artemisia was also influenced by the treatment Annibale and Agostino Caracci gave the Susanna tale in various engravings and paintings. Still, she departed from the customary emphasis on temptation and erotic impulse and portrayed her heroine in a state of anguish. Soon certain elements of the story would be repeated in her personal life.

In 1611 Orazio became well acquainted with dashing, blackbearded Agostino Tassi, a skilled landscape and marine painter, as they worked together at the Palazzo Quirinale. Accompanied by friends, Artemisia ar-

rived by carriage one day to watch them, and Tassi was immediately attracted to his colleague's full-lipped, nubile daughter.

According to Artemisia's later testimony, Tassi came frequently to the Gentileschi house, where he made friends with Donna Tuzia Medaglia, Orazio's tenant and Artemisia's chaperone. (According to Tassi's deposition, at her father's request he came once or twice to give the girl lessons in perspective.) Donna Tuzia kept urging her charge to be more friendly to Tassi, and when Artemisia agreed to speak with him, he warned her that a servant was spreading scandal about her.

One rainy day when workmen had left the door open, Tassi strode into the house and ordered Donna Tuzia out of the room. Artemisia had been painting one of the children, who departed with his mother. Throwing Artemisia's easel and brush aside, Tassi pushed her into a bedroom, locked the door, and raped her. After freeing herself, Artemisia attacked him with a knife, wounding him only slightly on the chest. To calm her, Tassi promised to marry her.

Considering herself engaged, Artemisia gave herself freely to him for some months, Donna Tuzia happily admitting him whenever Orazio was out. But time rolled on without any indication of a wedding. There is no record of when Orazio learned of the affair, presumably from Artemisia's confession. Early in 1612 he brought suit against Tassi, charging him with rape of his daughter, and Tassi was imprisoned.

The defendant's witnesses told the judges that among his roistering companions Artemisia was regarded as a whore and that a gang rape, led by his friend, Cosimo Quorli, a papal orderly, had been attempted and had failed. While Artemisia was being questioned by Tassi, she voluntarily submitted to a seventeenth century lie detector, the *sibille*, consisting of cords gradually tightened around her fingers.

Tassi consistently denied he had raped her or had carnal relations with her. Only one of his friends, Giovanni Battista Stiattesi, with whom Tassi had been intimate, defended Artemisia as a "poor girl, badly treated." He named Quorli as procurer rather than Donna Tuzia. During the trial it was revealed that Tassi had been sued by his sister for adultery and "incest" with his sister-in-law and had been clamped in prison for a couple of days. More shockingly, it was divulged that he had paid to have his wife, Maria, killed in Florence during the previous year.

There is no record of the outcome of the trial. Though the judges were skeptical about much of Tassi's testimony, presumably he was not sentenced and was soon let out of jail. But the exaggerated stories and lies he and his cronies had told about Artemisia would follow her ever afterwards. In order to give her some respectability, Orazio arranged for her speedy marriage to a Florentine painter, Pietro Antonio di Vincenzo Stiattesi, who may have been related to Giovanni Battista.

From 1610 to 1614, a period that included the rape and the trial, Artemisia worked on a subject particularly relevant to her personal life, the story of Judith from the Apocrypha. To save her Israelite town from the besieging Assyrian general Holofernes, a beautiful young widow named Judith goes with her maid, Abra, to the enemy camp and pretends she has come to offer help. They are taken to the commander's tent, where Judith charms Holofernes. One night, after she plies him with wine until he is sodden, she decapitates him with his own sword and puts his head in a basket. Then the women steal home with their prize. The next morning when Holofernes' soldiers see his head dangling from the town wall, they flee in terror.

From about 1610 to 1612 Artemisia copied her father's *Judith and Her Maidservant with the Head of Holofernes,* ostensibly while he worked on it since the two paintings bear the same dates. Orazio shows Judith with a sword on her knee, looking contemplative. Only Abra seems wary. In contrast to customary representations of the maid as an old woman, Orazio made her young and comely. Indeed, Artemisia may have served as his model. On all her Judith pictures, Artemisia followed his lead in rejuvenating Abra. For her highly dramatic *Judith Slaying Holofernes* (1612–13), she chose the slaying scene itself. As Abra holds Holofernes down, a powerfully built Judith plunges the sword into his throat while he writhes in pain, and the blood sprays and drips over the velvet coverlet on the bed. If Artemisia's intent was to shock, she did so mightily. Caravaggio had also used the Judith theme, and she adopted his full-blown realism with mysteriously lit figures against a shadowy background. Heroic Judith is nevertheless womanly; part of her breast is bared, perhaps to indicate the wiles she had used on the general. Artemisia's picture outdid all other versions of the Judith story in sheer horror; it has been suggested that the decapitation represents the punishment she wished on Tassi.

By the close of 1614 the Stiattesis had settled in Florence, and Artemisia set about learning to read and write. In Rome in 1613 she had begun a new Judith picture, finished a year later, perhaps in Florence. *Judith and Her Maidservant* depicts the two women with the general's head in a basket. Abra half covers Judith, but her profile is shadowy in contrast to Judith's illumined face. The lighting and the intensity of the models are distinctly Caravaggesque. Orazio painted a similar scene, but without as much force, probably after he visited Florence in 1616 and saw his daughter's picture. If so, the onetime apprentice had begun to influence her teacher.

Artemisia and her husband used the facilities of the Accademia de Designo, and in 1616 she became an official member. Possibly her admission was due to the support of the Medici court, whose theatrical

spectacles were then inspiring the etchings of the French artist Jacques Callot. Artemisia must have seen many of the lavish entertainments, perhaps even participated in them. As well, she enjoyed the personal patronage of Grand Duke Cosimo II and his wife, Grand Duchess Maddalena of Austria. Cosimo had recently offered sanctuary to Galileo Galilei, fleeing the wrath of the Inquisition for his advocating Copernicus' heretical view that the sun is the center of the universe. The famous astronomer and Artemisia became friends enough to stay in touch through the years. Their later correspondence indicates that the unschooled girl had become quite literate.

She also had the backing of Michelangelo Buonarotti the Younger, the great artist's grandnephew, who busied himself with turning his newly purchased residence, the Casa Buonarotti, into a museum. Artemisia, who had quickly engaged his attention, was among the first artists commissioned to provide painted decorations for him. During 1615–16 she painted on the ceiling of the entry salon a nude, called *Allegory of Inclination,* "of most beautiful, very lively, and proud aspect." The woman holds a compass, and a star shines above her.

Little is known about Artemisia's family life or about her husband at this stage or afterward other than that in 1618 she gave birth to a daughter, Prudentia. Presumably the marriage remained one of convenience.

The Penitent Magdalen (c. 1617–20) treats another Biblical subject, Mary Magdalene, the prostitute who became Christ's devoted follower. It is notable for the golden yellow ("Artemisia gold") silk gown of the generously proportioned woman who, like all Artemisia's heroines, has overly large hands. To some critics her gesture seems theatrical, even insincere. On the chair is the signature Artemisia Lomi, the paternal name Orazio had discarded in favor of his mother's name. This signature, which Artemisia used frequently during her Florentine residence, has led to speculation that she and Orazio had become estranged after the trial. A more credible reason for her use of this name may be that she wanted the Florentine mind to associate her with Orazio's Tuscan family, namely his brother Aurelio, a respected painter.

About 1620 Artemisia made a new version of her 1612–13 *Judith Slaying Holofernes.* Again she created the scene with stunning immediacy. The earlier picture had featured a red and blue palette; its replication showed what was to become a characteristic warm, rich color triad: burgundy, dark blue, and green, together with dark gold. The 1620 *Judith Slaying Holofernes* was stronger, the Caravaggist style more pronounced in the tenebrist shadows punctured by dramatic light.

Artemisia may have finished this painting in Rome, for in 1620 she asked permission to leave the Florentine academy and return to her native city. Her letter to Grand Duke Cosimo recounts several illnesses, family

problems, and a desire to see friends. Once she was back in her old neighborhood, she watched Dutch and Flemish painters absorbing Caravaggio's techniques.

Only a year after her homecoming, she accompanied her father to Genoa, where he had commissions, and to Venice. In Genoa she painted *Lucretia*, a study of the semimythic Roman matron who committed suicide rather than face the shame of her rape by Tarquin, the king's son. Artemisia's *Lucretia* is unlike the conventional beauty, evoking erotic sensibilities, who had been favored by many artists. She is lumpy and awkward, with enormous thighs. Most significantly, rather than being shown with the dagger at her breast, she is seen troubled and debating whether she should commit the act.

Next Artemisia Gentileschi fastened on another suicide. It was her first study of a completely reclining nude. The figure in *Cleopatra* (1621–22) is also ungainly, but she is determined. Artemisia shows her grasping the poisonous snake with full control.

Portrait of a Condottieri [*Portrait of a Gonfaloniere*] dates from 1622, the subject a short man in military costume standing with a plumed helmet beside him. Textures are elegantly defined, and the soldier has an extraordinarily lifelike quality. In doing a commissioned portrait, an artist felt obligated to provide a telling likeness.

During the same year Artemisia worked on *Joseph and Potiphar's Wife* and *Esther before Ahasuerus*, both probably begun in 1622 and finished in 1623. The first painting tells the Genesis story of the wife of the captain of the guard, who unsuccessfully attempts to seduce her husband's overseer. The woman, tousled amid her rumpled sheets, grasps the coat of the understandably resistant Joseph.

The second painting, its scene suggested by the Old Testament book of Esther, portrays the young Jewish wife of the Persian king Ahasuerus, who pleads with him to prevent his prime minister Haman's planned extermination of the Jews. The swooning Esther is in a gold gown, its color even more dazzling against a vivid burgundy curtain.

In 1623, at the height of the Catholic revival, Cardinal Maffeo Barberini was named Pope Urban VIII. An avid collector as prince, as pontiff he dipped deeply into the Vatican treasury, not only to purchase a magnificent selection of ecclesiastical art, but also to build a more beautiful city. His chief protégé was the young sculptor Gianlorenzo Bernini. In 1624, all Rome rushed to see Bernini's electrifying *Apollo and Daphne*, with leaves sprouting from the nymph's fingers and bark springing up around her body as, resisting the sun god's clutches, she is transformed into a laurel tree.

Meanwhile Artemisia's personal life was changing. The Rome census of 1624 lists her as head of household with two servants and a six-year-old

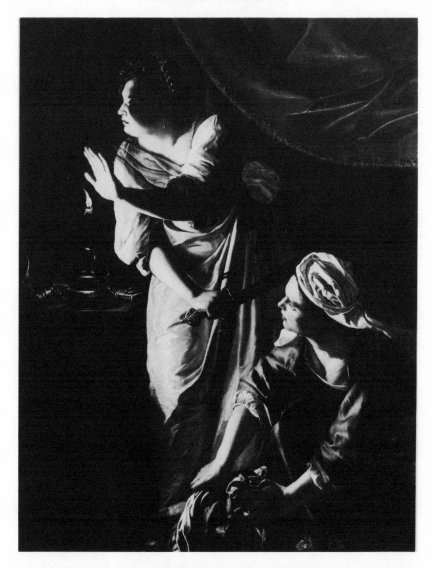

Artemisia Gentileschi, *Judith and Her Maidservant with the Head of Holofernes* (c. 1625), oil on canvas, 72½ × 55¾ in., ©The Detroit Institute of Arts, gift of Mr. Leslie H. Green (52.253).

daughter. In this and a subsequent listing the daughter Prudentia is called Palmira. Clearly Artemisia had separated from her husband. But there is no date for his departure or the birth of a second daughter whose marriage to a knight of the order of St. James she mentions in a 1649 letter. In an earlier letter she refers to "una mia figliuola" (one of my daughters) and

in still another to Prudentia-Palmira's marriage in 1637. Both girls are said
to have become painters.

Once more about 1625, Artemisia picked up the Judith theme, using
her now awesome skill to create a nearly life-size portrait of an imposing
heroine in a Caravaggesque setting. In *Judith and Her Maidservant with
the Head of Holofernes*, however, the violence is spent. Artemisia had
channeled her passion and boldness away from the sensational. Judith and
Abra stand in the aftermath of the slaying; quiet strain and suspense,
albeit with an air of courage, replace intensity. The light source is a candle
flame. In its glow, purple, burgundy, and orange-gold are splendidly har-
monious.

From the Barberini entourage surrounding the pope, Artemisia
gained new patrons: his nephews, Cardinals Francesco and Antonio
Barberini, and more importantly, Cassiano dal Pozzo, whose interest was
unstinting. For him in 1630 she painted *Self-Portrait as the Allegory of
Painting*. But, plumpish and rosy in her lustrous green gown, she does not
look like a conventional, detached muse. Her black locks straggle; she
seems wholly absorbed in her task at the easel. Still Artemisia has followed
the imagery prescribed by Cesare Ripa in his sixteenth century *Iconologia*,
a study of artistic symbolism. Especially noteworthy is the mask of a
human face suspended from a golden chain around her neck.

Some time before, Artemisia had moved to Spanish-ruled Naples,
where prestigious, lucrative commissions existed outside the papal circle.
But Naples, the largest city in Italy, had its drawbacks. In a letter she men-
tions "the fighting...the hard life, and the high cost of living." Soon she
longed for Rome and Florence.

Her first church commission came from San Giorgio de Genovese,
the Genoese church in Naples, for an altar painting. In *The Annunciation*
(1630), a subject also explored by her father, she shows the Virgin Mary
looking properly subdued; the angel Gabriel, depicted as a woman, seems
volatile.

Next for Artemisia a commission arrived from the Count of Monte-
rey, the Spanish viceroy of Naples, to contribute to Massimo Stanzione's
series about John the Baptist for Philip IV's new palace, the Buen Retiro
in Madrid. Artemisia's *Birth of St. John the Baptist* (1631–33) pictured four
women bathing the baby and was remarkably compatible with Stanzione's
canvases.

Often called *Fame*, a 1632 painting more likely is a representation of
Clio, the muse of history, and may be a tribute to a deceased patron. Again
for some of the details Artemisia depended on Ripa's *Iconologia*.

Before long she was one of several artists who received painting com-
missions for the choir of the *duomo* or cathedral at Pozzuoli, a Neapolitan
suburb. Two of her Pozzuoli pictures represent the beginning of col-

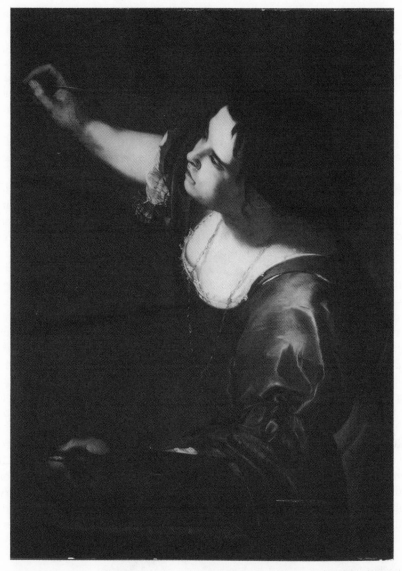

Artemisia Gentileschi, *Self-Portrait as the Allegory of Painting* (1630), oil on canvas, 38 × 29 in., The Royal Collection, Kensington Palace, London. Rodney Todd-White & Son, photographers. Copyright HM Queen Elizabeth II.

laborative activity. Other artists supplied architectural backgrounds for her *SS Proculus and Nicea* and *The Martyrdom of St. Januarius in the Amphitheater at Pozzuoli*, both from 1636–37. Only *The Adoration of the Magi* (also 1636–37), with a shadowy landscape, came from her hand entirely.

By this time Caravaggism had fallen out of favor, and Artemisia's style became gentler and more classical, thereby losing some of its power. Though kept busy in Naples (many of her paintings have disappeared), she sought patrons outside the city and in Rome. One whose court she unsuccessfully tried to enter was Francesco I d'Este, Duke of Modena.

She had not seen her father in more than a decade. In 1626 Orazio had been called to the court of Charles I in London (where Anthony van Dyck would soon lead the pack of painters). Orazio's son Francesco accompanied him and acted as his envoy in delivering canvases. Sometimes father and son made buying trips abroad for the king, an art connoisseur, who was rapidly collecting masterpieces.

In 1639 Artemisia joined her father in London. Orazio, 75 years old and ailing, had felt it necessary to ask for his daughter's assistance in finishing a project. He was decorating the entry hall of the Queen's House (designed by James I's court architect, Inigo Jones), which was being readied for use by Charles's French wife, Henrietta Maria. The paintings, nine in number, were intended to be set in the ceiling. Orazio died early in 1639 before *An Allegory of Peace and the Arts under the English Crown* was complete, and Artemisia worked by herself, perhaps helped by her second daughter. On finishing, she returned to Naples before the end of the year. Francesco Gentileschi had been acting as her business manager since 1635 when he came to Naples. She herself had a sharp head for handling financial matters and never cut any prices she had set. From the beginning of her career, Artemisia had had a healthy appreciation of what could be done with money, and she liked to live in style.

She now welcomed a new patron, the wealthy, aristocratic collector Don Antonio Ruffo from Messina, Sicily. (In 1652 he would commission Rembrandt's famous *Aristotle Contemplating the Bust of Homer.*) To Ruffo she wrote, "You will find the spirit of Caesar in the soul of a woman!" Often she dictated her letters while standing at her easel. For him and other patrons she made at least six versions of the Biblical story of Bathsheba, who so attracted King David that he ordered her husband, his general, to be put in the front line to be easily killed. For her finest version, *David and Bathsheba*, from the early 1640s, Artemisia enlisted the help of colleagues who painted either the architectural backgrounds or the landscapes.

A second *Lucretia* (1642–43), recently attributed to Artemisia Gentileschi, is sophisticated and grandly expressive, albeit lacking the intensity and originality of the *Lucretia* from 20 years before. But the heroine still debates whether to take her life.

Stiattesi had completely disappeared. Artemisia's last mention of him had occurred in a 1637 letter to Cassiano, asking him to send her news as to whether her husband was alive or dead. In the 1640s, her income

dwindled. After her second daughter's marriage she asked Ruffo by letter for small sums to meet some of the expenses she had incurred in arranging the wedding. At various intervals she referred to fatigue and ill health.

Nothing is known about her death. It probably occurred in 1652 or 1653, the dates of two scurrilous epitaphs, published in Venice, which describe her cuckolding her husband. The notoriety that had begun with the trial in 1612 had followed her to the grave. There exists no documentation for the many love affairs she was reputed to have had.

Twentieth century historians, especially those of the feminist persuasion, have fortunately given her the measure of appreciation she deserves. As Mary D. Garrard writes: "In Gentileschi's paintings, women are convincing protagonists and courageous heroes perhaps for the first time in art."

Artemisia Gentileschi : Works Mentioned

Susanna and the Elders (1610), Schloss Weissenstein, Pommersfelden, Germany
Judith and Her Maidservant with the Head of Holofernes (after Orazio Gentileschi) (1610–12) Pinacoteca, Vatican*
Judith Slaying Holofernes (1612–13), Museo di Capodimonte, Naples
Judith and Her Maidservant (c. 1613–14), Palazzo Pitti, Florence
Allegory of Inclination (1615–16), Casa Buonarotti, Florence
The Penitent Magdalene (c. 1617–20), Palazzo Pitti, Florence
Judith Slaying Holofernes (c. 1620), Uffizi, Florence
Lucretia (c. 1621), Palazzo Cattaneo-Adorno, Genoa
Cleopatra (1621–22), Amedeo Morandotti, Milan
Portrait of a Condottieri [Portrait of a Gonfaliere] (1622), Pinacoteca, Bologna
Esther before Ahasuerus (c. 1622–23), Metropolitan Museum of Art, New York
Joseph and Potiphar's Wife (c. 1622–23), Fogg Art Museum, Cambridge, Massachusetts*
Judith and Her Maidservant with the Head of Holofernes (c. 1625), Detroit Institute of Arts
Self-Portrait as the Allegory of Painting (1630), Royal Collection, Kensington Palace, London
The Annunciation (1630), Museo di Capodimonte, Naples
Birth of St. John the Baptist (1631–33), Prado, Madrid
Clio [Fame] (1632), Private Collection
SS Proculus and Nicea (1636–37), Laboratorio di Conservazione di Capodimonte, Naples
The Martyrdom of St. Januarius in the Amphitheater at Pozzuoli (1636–37), Laboratorio di Conservazione di Capodimonte, Naples
The Adoration of the Magi (1636–37), Laboratorio di Conservazione di Capodimonte, Naples

*attributed by Mary D. Garrard

An Allegory of Peace and the Arts under the English Crown (with Orazio Gentileschi) (1638–39), Marlborough House, London

David and Bathsheba (early 1640s), Museum of Art, Columbus, Ohio

Lucretia (1642–43), Museo di Capodimonte, Naples*

II

Judith Leyster

(1609–1660)

For more than three centuries after her death Judith Leyster was forgotten in the Netherlands and the rest of the world. Then in 1892 renewed interest in the Haarlem painter Frans Hals resulted in an English lawsuit over the attribution to him of a painting titled *Carousing Couple*. Leyster's distinctive monogram had been recognized even though the defendant in the case claimed that it represented Hals's name. The dealer who was the plaintiff agreed to buy the picture for a lower price, a tacit acknowledgment that Hals had not painted it. But Judith Leyster still did not receive credit.

The next year, however, Cornelis Hofstede de Groot published an article in *Jahrbuch der Königlich Preussischen Kunstsammlungen*, attributing *Carousing Couple* as well as six other pictures to Leyster. Five of them bore her monogram but had been assigned to Hals or to Leyster's contemporaries, in some cases even labeled "anonymous." So began the slow revival of Leyster's reputation. Several articles by other scholars revealed facts about her and credited her with a few more pictures.

In 1926 at the University of Frankfurt, Juliette Harms wrote a doctoral dissertation on Judith Leyster, uncovering still more paintings. But after the study was serialized in several issues of the magazine *Oud-Holland* (1927), scholars and critics challenged various attributions.

Finally, surveys of Dutch art began to include Leyster. In the 1970s, the women's movement ushered in further reappraisal. The first catalogue raisonné by Frima Fox Hofrichter in 1990 assigned 48 paintings to Leyster.

In Dutch, Leyster means lode star or pole star, and Judith's characteristic monogram consists of intertwined letters, J and L, linked to a star. But Leyster was not the name to which she was born. The brewery in Haarlem owned by her father, Jan Willemzoon, was called Leyster.

After he declared bankruptcy in 1625, Leyster was adopted as a family name.

On July 28, 1609, Jan and his wife, Trijn Jaspers, brought their eighth child, Judith, to be baptized at the Reformed Church in Haarlem. Because of the high infant mortality rate, early baptism was customary; presumably, then, Judith was but a few days old. Her birth date can only be guessed. There would be nine children in all, six of whom would survive to adulthood.

Jan and Trijn had grown up amid the sights and sounds of war. But in the year of Judith's birth, a truce between the United Provinces and Spain was finally worked out, to last for 12 years. War had begun more than 40 years earlier. In 1566, suffering from religious persecution and heavy taxation, Dutch Protestants in the Low Countries rose against their Spanish oppressors, led by the Catholic Philip II. The war was long and hard fought. Trijn was a native of Haarlem, where the Spanish came on a route of destruction in 1572. Attacked from land and sea, the walled city held back for several months until famine forced its surrender. When the conquerors entered, they tossed more than 300 of Haarlem's defenders into the water to drown.

Under William I, Prince of Orange (William the Silent), the seven northern provinces declared independence in 1582 and formed the United Provinces, which Spain refused to recognize. To the south, Antwerp, Jan Willemzoon's hometown, capitulated in 1585 after a long siege, then—as the southern provinces reconciled with the Spanish throne— became a center for financing and provisioning the Spanish troops who fought along the frontier between north and south. Though temporarily dispirited by the assassination of William the Silent in 1584, the Dutch proceeded to drive the Spanish out of the north. Their victory at the Battle of Nieuwpoort in 1600 proved decisive.

The boundaries of the Twelve-Year Truce persisted in spite of naval battles, a rare Dutch surrender at Breda (promptly celebrated by the Spanish court painter Diego Velásquez) and some weak Dutch attempts to retake Brabant and Flanders. Twelve years before Judith Leyster died, the boundaries were formalized in the Treaty of Münster (1648), which finally recognized Dutch independence and which was duly celebrated with bonfires and fireworks.

With the formation of the loose federation known as the Republic of the United Netherlands (United Provinces) in 1582, traditional aristocratic and Catholic church patronage of the arts had begun to dry up, and ordinary citizens became the purchasers. In the new century a moneyed middle class, pushing Holland on to greatness through banking and trade, created a mass market for pictures. More than religious or mythical pictures or recreations of their historical struggle for freedom, Dutch

burghers wanted realistic portraits, recognizable landscapes, still lifes, and genre paintings of men, women, and children in everyday life. They wanted, in short, a mirror of their place and time.

During Judith Leyster's childhood, Haarlem was a lively town of about 40,000. The breweries were among the mainstays of its prosperity. Beer flowed not only at the taverns: It was the principal beverage of the well-to-do merchant's family. Local brewers filtered their water through sand, thereby enhancing the beer's flavor and its reputation. But for some reason Jan Willemzoon's business failed.

It is possible that her father's bankruptcy in 1625 fixed Judith's mind on earning money as a painter. Haarlem was filled with many talented artists; standing head and shoulders above them all was the convivial Frans Hals, whose speedy brushwork made his canvases sparkle and glow. Judith may first have entered the studio of Frans Pieterz. de Grebber. A poem by Samuel Ampzing from 1628 mentions her in connection with the de Grebber family, which included a painter daughter, Maria. Judith is lauded: "Here is somebody else painting with good and bold sense."

Or she may have begun as an apprentice in Hals's studio. Her earliest known painting, *The Jester* (c. 1625), is a copy of Hals's *The Lute Player*. The slanting upward glance of the music maker would become a hallmark of her portraits. Still, since records have disappeared, there is no clear proof of how she first trained.

Judith's parents moved to Vreeland in 1628. It lay seven miles from Utrecht, the home of a school of painters, the Utrecht Caravaggisti. Thus whether she moved with her parents or just visited them in Vreeland, Judith Leyster had an opportunity to go to Utrecht to learn from this group, who were influenced by the example of Michaelangelo Merisi da Caravaggio during study years in Italy and had exploited his treatment of light and shadow in their own ways. Hendrick Terbrugghen (who died in 1629), Gerard van Honthorst, and Dirck van Baburen (who had died in 1624) chose to screen the principal light source, usually a candle, by a figure in the foreground. Deep shadows contrasted with background figures, who were lighted directly or by reflection.

By 1629 Judith's parents had settled in Zaandam, and she came to Hals's studio, possibly for the second time. There, like other apprentices of the time, she probably did considerable manual work: grinding and mixing colors, readying the canvases, cleaning the master's brushes and palette.

Even before she dropped her apprentice title, Judith Leyster was painting some impressive works. She began with genre pictures. Broadly speaking, there were two Dutch types: those concentrating on crowded taverns or smoke shops or other manifestations of rowdy fellowship, and those confined to a single figure, or at most three figures, in comfortable

domestic interiors. In the raw tavern settings men and women fought, flirted, and drank to excess. Home pursuits were quiet and individual, inviting an artist's meticulous attention to light and surface texture.

Judith Leyster's genre paintings featured a wide variety of types: card and backgammon players, lute players, flautists, violinists, drunken revelers, seducers, children playing with cats, mothers devoting themselves to their children or to simple domestic tasks like sewing—but always in small groups. Three was a favorite number. The same types could be seen in the canvases of other painters, but Leyster put her own stamp on them. She liked to include tables whenever possible, to employ diagonals freely, to tilt the heads, to feature only bare walls behind them. Usually she told a story; often she moralized; always she was descriptive and reportorial. With equal facility she painted daylight and nighttime settings.

Early on, the night interiors were influenced by the Utrecht Caravaggisti. *Laughing Youth with a Wineglass* (c. 1628), once attributed to Honthorst, and *Serenade* (1629) get their effect from hidden candlelight. In the first picture, the red wine echoes the color of the doublet sleeves; in the much smaller *Serenade,* on panel, the cheerful young fellow in fur cap who picks out a tune on his lute has the engaging upward glance Leyster had first used in *The Jester.* By contrast, *Merry Company* (c. 1629-31) is a daylight picture. Three grinning fellows in loose theatrical costumes of vivid orange, gray, and brown stand equipped with two jugs of wine, radiating good humor and showing more than a bit of intoxication. In *The Last Drop* (c. 1629-31), an orange-garbed fellow dangles an inverted tankard, and a seated drinker, silhouetted by the light of a leaning candle, drains a jug. In this picture's early stages Leyster had suggested the perils of overindulgence, for she included a life-size skeleton holding skull, hour glass, and candle; this she later replaced with a table.

Another painting from 1629, *Jolly Toper,* was clearly inspired by Hals's *Jolly Drinker.* But whereas Hals dispensed with setting, Leyster has painted a table that extends diagonally into the picture and unites other diagonals and contrasting curves.

Carousing Couple (1630), which would inspire the 1892 lawsuit, gains an air of animation from the oblique angle at which the half-length figures are set. A catalogue from the eighteenth century, when the picture was not yet attributed to Leyster, described the work as "a Dutch Courtezan ogling and offering a drink to a young man playing on a violin." More than anything else the woman looks healthy and mischievous.

Besides canvas, Judith Leyster often used small wooden panels. Her next signed and dated painting, *The Proposition,* (1631), is such a panel and is based on a familiar seventeenth century theme: a man offers money for a woman's favors. But Leyster gave the story a different twist. Customarily in such paintings the woman is eager to accept the offer. The decorous

woman in *The Proposition* bends over her embroidery by candlelight, totally unresponsive to the bearded man who leans over her with coins in his hand. The muted hues built around her soft green skirt contribute to the air of tranquility. In totally different mood, *A Game of Tric-Trac* (c. 1631) features a scarlet-sleeved young woman who gazes attentively at the young cavalier gesturing suggestively across the table.

The Proposition heralded a group of several small nocturnal pictures on wood panels, all from 1633, which many critics consider Leyster's most original contribution to Dutch painting. The circular, quietly intimate *Mother Sewing with Children by Lamplight and Fire, Woman Sewing by Lamplight,* and *Lute Player by Lamplight* depart from the Utrecht Caravaggisti because the source of light (candle flame or fire) is seen directly in each case.

All told, Leyster would paint almost 20 music makers, only one a woman, *Young Woman with a Lute* (c. 1631). Her *Violinist with a Skull* (c. 1633) sounds the *vanitas* theme of many Dutch still lifes. In *Concert* (c. 1631–33), the good-looking violinist in broad-brimmed hat is said to be Jan Miense Molenaer, Leyster's future husband. He was a well-known Haarlem painter who probably had worked in Hals's studio. The good-humored face of the lute player is identical to that of the music maker in *Carousing Couple.* The woman, in black dress with white ruff and starched diadem cap, may be Leyster herself. She bears a distinct resemblance to the *Self-Portrait,* which dates from the same period.

To many, the latter is one of the most engaging self-portraits in the history of art. It vibrates with life. Round-faced, plain-featured, but confident and cheerful, Judith Leyster in her voluminous dress looks purely Dutch with her high hairline, white cap, and stiff round collar edged in lace. Her mouth partially open, she seems to be speaking to the viewer as she turns away from her easel painting of a fiddler (identical, except in color, to the fiddler in *Merry Company*). She holds a brush in her right hand; the thumb of her left hand thrusts through the palette hole while her fingers grasp more than a dozen brushes, as if to indicate her industry. The painting is a study in angles.

Also about 1633 came *Soldier's Family.* The man in limpid blue coat and white leggings sits, either tired or dejected, with his feet to the fire, his back to his wife, who tightly holds a sturdy child in her lap. She does not seem anxious or unhappy, though the helmet and baggage on the floor may point to an imminent leavetaking.

One reason for Leyster's high output in 1633 may be that, after six or seven years of apprenticeship, she had qualified as a master painter and been accepted into Haarlem's Guild of St. Luke, the artists' and artisans' union, which monitored their rights and duties. She was its first woman member. *Self-Portrait* may have been her presentation picture.

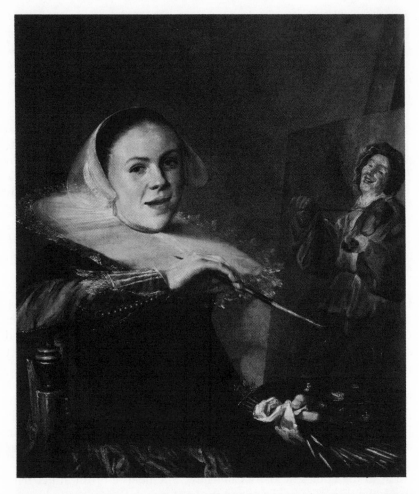

Judith Leyster, *Self-Portrait* (c. 1633), oil on canvas, 29⅜ × 25⅝ in., National Gallery of Art, Washington, D.C., gift of Mr. and Mrs. Robert Woods Bliss.

By 1635 she had three male students, one of whom caused a dispute with Hals which Leyster brought before the Guild of St. Luke. Willem Woutersz. had been working in her studio for only three or four days when he abruptly left to go over to Hals's studio. Without asking permission from the guild, Hals accepted him. An angry Leyster demanded that Willem's mother pay her eight guilders, about one-fourth of his annual tuition. The guild decided that Leyster was due no more than four guilders, that Hals would have to pay a fine of three guilders, and that Willem must leave Hals and never return to him. The affair blown over, Leyster and Hals seem to have remained on good terms.

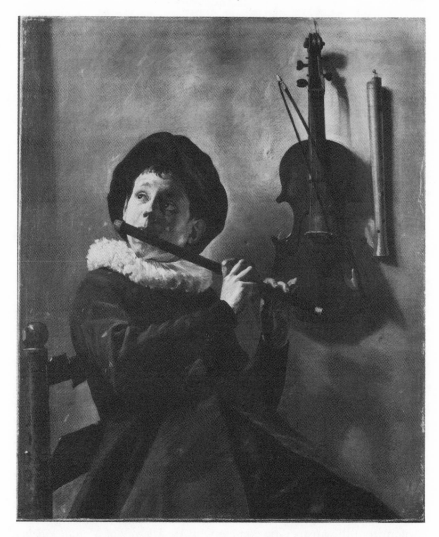

Judith Leyster, *Young Flute Player* (c. 1635), oil on canvas, 29¼ × 24¾ in., Statens Konstmuseer, Stockholm.

From this period comes *Girl with a Straw Hat* (c. 1633–35), another painting long attributed to Hals. With tilted head, the child brims with charm. But the most striking brushwork is reserved for the hat, set back over a cascade of golden curls that match the girl's dress.

With *Fingernail Test* (c. 1633–35) Leyster returned to the theme of intemperance. There is not enough beer left in the boy's tankard to cover a fingernail.

Following that work, *Young Flute Player* (c. 1635), often considered Leyster's masterpiece, portrays a young boy in maroon beret and brown suit with white starched ruff, looking upward with that hallmark glance. Iconographers have puzzled over some strange details, which may be hidden allegory. The top slat of the chair in which the boy sits is broken. The light picks out nail holes in the wall. A large violin with slanting bow and a wooden recorder hang from nails at his left but seem to be dangling in space. What is their purpose?

Also long attributed to Hals was *Portrait of a Woman* (1635), which boasts much quick, even impressionistic brushwork. The good Dutch *huisvrouw* holds a small Bible as if to declare her faith. Her well-scrubbed, intelligent face, rising from a huge, freshly laundered and starched ruff, is softened by a dimple.

No record exists of when Molenaer's courtship of Judith Leyster began. At the age of 25 he was already heavily in debt. Because there were so many Dutch artists of at least second rank, they were less well paid than their counterparts abroad. Wealthy patrons were relatively rare, and paintings were routinely hawked at country fairs. (One English visitor to Amsterdam in 1632 boasted of buying 10 pictures for 64 guilders.) Nevertheless, by age 26 Judith was ready and willing to marry Molenaer. The wedding was set for June 1, 1636, in Heemstede, where Judith's parents now lived.

Almost at once Molenaer was involved in a lawsuit. He had assured his creditors that his wife's dowry would meet his debts. But once married, he forgot about that promise. While she should have been enjoying her new life, Judith Leyster Molenaer saw her husband's property confiscated.

He was an able enough painter. Tradition holds that his *Lady with Two Children at a Harpsichord* (1635) is a richly gowned Judith. *The Tooth Extraction* from 1629 shows Molenaer's lively sense of humor. The "oral surgeon" displays an especially penetrating eye, the patient grimaces, and the patient's wife appears to relish the operation. Easily Molenaer could switch from the aristocratic company of *An Allegory of Marital Fidelity* (1633) to the common folk of *Dance in a Village Street* (1635). He painted portraits, landscapes, and religious themes, and his close connections with the theater resulted in several melodramatic scenes. Later he would concentrate on tavern life and easy debauch.

Within a year of their marriage, the couple left Haarlem for Amsterdam. (The court appearances, however, were lessons lost on Molenaer, who continued to let his bills go unpaid.) Amsterdam, the leading seaport and chief banking center of northern Europe, seemed so preoccupied with commerce that the French philosopher René Descartes complained: "Everyone is so engrossed in furthering his interests that I could spend the

whole of my life there without being noticed by a soul." But he also praised Holland's freedom and tolerance: "In no other country could one enjoy such full freedom."

If philosophers did not command attention, artists did. Indeed the city offered a bigger market for paintings than Haarlem. Painters often worked together, and Judith may have painted a figure or two on her husband's canvases. But soon motherhood beckoned. In November, 1637, a son, Joannes, was born. Thirteen months later a second boy, Jacobus, was held to the font in Nieuwe Kerk. But two weeks after this baptism, Jan Molenaer paid four guilders for the burial of "a child." The record does not state which one.

Within a couple of months of this tragedy, the Molenaers had some good news. Judith received part of a great-uncle's estate, her share being approximately 725 guilders. Immediately, Molenaer claimed power of attorney over the inheritance.

Money worries, child care, and household tasks reflecting the national preoccupation with cleanliness kept Leyster away from her easel much of the time. Nevertheless, about 1640 she was working on *Children with a Cat and a Slow-Worm*, which was said to be modeled on a lost Hals painting.

Still life painting, which lent itself admirably to home display, was at the height of its popularity. One of its best practitioners, Willem Claes Heda, lived and worked his entire long life in Haarlem, and it is possible that Leyster knew him. Her sparklingly fresh *Still Life with a Basket of Fruit* (1635–40) represents a rich variety of colors, shapes, and surface textures. But unlike Heda's purposeful disarray, blue, purple, and green grapes are artfully arranged with quinces and apples. A glass partially filled with liquid reflects and refracts the light, and a tankard partially reflects Leyster's easel.

Rembrandt, three years older than Judith, was living in Amsterdam at the same time as the Molenaers. It is doubtful that they knew him, though his old colleague Jan Lievens lived with them for a time in 1644. One fanciful writer later concocted an astonishing scenario which presents Judith as Rembrandt's mistress.

Like Molenaer and Rembrandt, Judith's old mentor, Hals, was also in constant financial difficulty. Bakers' bills especially beset all three families.

Because the pure chalky sand in its immediate vicinity was ideal for growing bulbs imported from Turkey and southern Europe in the previous century, Haarlem had become a flower town in Judith's childhood. Breeders gambling on public excitement over variations made fortunes on variegated and striped types. (In 1634, one enthusiastic collector paid one thousand pounds of cheese, twelve sheep, eight pigs, four oxen, a bed, and

a suit of clothes for one particular bulb called the Viceroy.) But in 1637 the bottom fell out of the market, and the entire national economy felt the jolt. Still the Dutch wanted to buy tulips. In 1643 Judith Leyster contributed two sheets in silverpoint and watercolor to a *Tulip Book,* no doubt a sales catalog.

She may have been pregnant when she undertook the tulips commission. A daughter, Helena, was baptized in March 1643. A second daughter, Eva, was born in late 1646, but apparently did not survive infancy.

When Lievens lived with the Molenaers, he may have kindled Judith's interest in etching. As with the still life, there is only one example from her hand, *Boy with a Jug* (1644–45), which is sometimes attributed to Lievens. But the feathered beret and uplifted arm follow the Leyster style.

Some recognition came Leyster's way in 1648, when T. Schrevel wrote in a book on Haarlem: "There have been many experienced women in the field of painting who are still renowned in our time, and who could compete with men. Among them, one excels exceptionally, Judith Leyster, called 'the leading star' in art." The same book terms Molenaer a "renowned painter."

But the accolades did nothing to solve their money problems. Constantly beset by debts, the Molenaers moved frequently. In 1648 Jan bought a farmhouse, called The Lamb, in Heemstede, paying for it with paintings. The last child, Constantijn, was baptized in March 1650. He was especially welcome because meantime the other boy had died.

In 1655 the family returned to Amsterdam for a year. In spite of their disastrous credit record, by 1656 the Molenaers owned houses in Heemstede and Amsterdam and a house and tavern in Haarlem. Rents now provided most of their income. But even in her last years, Leyster's life was complicated by new lawsuits. On behalf of her husband she made her last appearance in court in 1657.

Both in declining health, dunned by creditors, pained and weary, she and Molenaer made out their wills in November 1659. Within three months she was dead. She was buried at The Lamb on February 10, 1660. Mourners had been specifically directed "to enter the mortuary dressed in a long cloak."

A household inventory at the time of Molenaer's death in 1668 was so complete that it included the rubbish left in summerhouse, courtyard, and garret. Along with numerous tables, Spanish chairs, cupboards, cabinets, beds, mirrors, pieces of porcelain and cooking pots, there were more than 200 paintings, framed and unframed. They were scattered in the *voorhuijs* (front room), *zijkamer* (side room), *gangh* (corridor), *kamer* (main room), *eetsaeltje* (dining room), *cleer solder* (loft), *boven voorkamer*

(second story front room or attic), and near the *schilder kamer* (studio). Many were by Molenaer; some were by Dutch artists. Those by Judith Leyster included a "round piece"; one picture of a peasant kitchen with a woman cleaning fish and one of a lute player; three small pictures of doves, a turkey, a cock; and a small flower piece. Several prepared and unprepared canvases and panels indicated planned work.

With Molenaer's death the name of Judith Leyster began its slide into obscurity. Hofrichter gives several reasons: a small oeuvre, no major commissions, frequent use of a monogram instead of a signature, omission of her name from inventories and sales catalogs, the artist's own effacement, the easy attribution of her paintings to Hals and others.

Now almost a century after Hofstede de Groot, like Prince Charming, awoke a sleeping princess, scholarly research continues. Writes Hofrichter: "We are still in the process of forming an understanding of a fascinating and unjustly neglected painter. Leyster's work awaits its rightful integration into the canon of Dutch art."

Judith Leyster : *Works Mentioned*

The Jester (c. 1625), Rijksmuseum, Amsterdam

Laughing Youth with a Wine Glass (c. 1628), Staatliche Kunsthalle, Karlsruhe, Germany

Serenade (1629), Rijksmuseum, Amsterdam

Merry Company (c. 1629–31), Collection Noortman, London and Maastricht

The Last Drop (c. 1629–31), John G. Johnson Collection, Philadelphia

Jolly Toper (1629), Rijksmuseum, Amsterdam (on long-term loan to Frans Halsmuseum, Haarlem)

Carousing Couple (1630), Louvre, Paris

The Proposition (1631), Mauritshuis, The Hague

A Game of Tric-Trac (c. 1631), Worcester Art Museum, Worcester, Massachusetts

Young Woman with a Lute (c. 1631), Private Collection

Concert (c. 1631–33), Wallace and Wilhelmina Holladay Collection, Washington, D.C.

Mother Sewing with Children by Lamplight and Fire (c. 1633), National Gallery of Ireland, Dublin

Woman Sewing by Lamplight (c. 1633), location unknown

Lute Player by Lamplight (c. 1633), Louvre, Paris

Violinist with a Skull (c. 1633), City Art Gallery, Bristol, England

Self-Portrait (c. 1633), National Gallery of Art, Washington D.C.

Soldier's Family (c. 1633), Kunsthandel K. & V. Waterman, Amsterdam

Girl with a Straw Hat (c. 1633–35), Fondation Rau, Marseilles

Fingernail Test (c. 1633–35), Metropolitan Museum of Art, New York

Young Flute Player (c. 1635), Statens Konstmuseer, Stockholm

Portrait of a Woman (1635), Frans Halsmuseum, Haarlem

Still Life with a Basket of Fruit (1635–40), Collection of Mrs. Barbara Johnson, Princeton, New Jersey

Children with a Cat and a Slow-Worm (c. 1640), National Gallery, London
Tulip, silverpoint and watercolor on vellum (1643), Frans Halsmuseum, Tulip Book Folio
Boy with a Jug, etching (1644–45), Rijksmuseum, Amsterdam

III

Angelica Kauffmann

(1741–1807)

She never underestimated herself. In her enormously long last will and testament, Angelica Kauffmann proudly wrote: "As all I possess has been attained by my work and industry, having from earliest childhood devoted myself to the study of painting, so now I can dispose of the fruits of my industry, as I wish." Some credit for her development, however, certainly belonged to her devoted father.

An only child, Maria Anne Angelica Catherine Kauffmann was born on October 30, 1741, in the prosperous Swiss town of Chur in the Grison Mountains, to Cleofe Lucia, second wife of Johann Joseph Kauffmann, portraitist and painter of church murals. A year later the family moved to Morbegno in Lombardy, where Kauffmann carried out several church commissions.

Often his little daughter bounced into his studio to use his colored chalks and pencils and to absorb the old prints he so eagerly showed her. Seeing that he had a prodigy on his hands, Joseph encouraged and disciplined her, giving her plaster casts and drawings to copy. At nine she began helping him with his work. Meanwhile she learned German, Italian, and some French from her mother. On her own she later would become fluent in English.

In 1752 the family settled in Como, where Angelica painted such a successful portrait of the bishop of Como that sitters came flocking to her. Now, too, she began showing musical talent, and her parents arranged for singing and harpsichord lessons. After two years in Como, Kauffmann brought his wife and daughter to Milan so the girl could copy Renaissance and baroque paintings in the palace of Rinaldo d'Este, duke of Modena and governor of the city. Not incidentally she could also earn some money with her copies. The duke was so impressed with Angelica's skill that he asked her to paint a portrait of his duchess.

Cleofe Kauffmann died in Milan in 1757, and her grieving widower and daughter fled to his native Schwarzenburg, an Austrian village in the Bregenz Forest of Vorarlberg, where Kauffmann had received a commission to paint the ceiling of the parish church. He put Angelica to work on wall frescoes depicting the twelve apostles, based on a popular Italian engraving. They stayed at the home of Joseph Kauffmann's brother; years later Angelica described her disgust at having to eat with one of her cousins, who came in unwashed and smelling from the goat shed.

The cardinal bishop and his friends requested other works too. Then, after Angelica had painted the various members of the family of the Count di Montfort, her father decided she should study and draw copies of Italian masterpieces.

When they came back to Milan, Angelica found herself at a crossroads. She knew herself talented as a singer and as a painter, but she realized she could not continue to be both. Unable to make up their minds about which skill to develop, father and daughter sought out a priest, who warned of the sexual dangers to any lovely young woman who set out on a musical career. From then on Angelica dropped all dreams of appearing on the stage, but long continued to perform at private parties. Years later (1794) she would paint an exceptionally fine *Self-Portrait Hesitating Between Painting and Music,* which subtly indicates her slight preference. A contemporary admirer would note, "All is feeling, energy, and grace."

After stopping in Parma, so that Angelica could study the works of Correggio, and then in Bologna, the Kauffmanns arrived in Florence in the summer of 1762. Not without some opposition, Angelica received permission, rare for a woman, to copy at the Palazzo Pitti and at what is now the Uffizi Gallery. Almost at once the young woman widened her circle, attracting the attention of Benjamin West, the expatriate American painter, and Councillor Johann Friedrich Reiffenstein from Weimar, a friend of Johann Joseph Winckelmann, the art historian. Angelica longed to meet Winckelmann, formulator of neoclassic theories that were to strongly influence the art and literature of the rest of the century.

At the beginning of 1763 Joseph Kauffmann took his daughter to Rome, where Abbé Winckelmann had just become curator of antiquities. His stress on high-mindedness and the aesthetic simplicity and "quiet grandeur" of the Greeks would permanently alter her style. Quickly Raphael Mengs, chief propagator of Winckelmann's ideas and the most influential painter at work in the city, went out of his way to encourage the young Swiss painter, so clearly awed by the eloquent ruins all about her.

After Angelica received a commission to make copies of pictures in the Museo di Capodimonte in Naples, she and her father stayed there six months, then returned to Rome in the spring of 1764. Soon, probably

through Mengs, she met her idol Winckelmann, and a portrait was arranged. After sitting for Angelica, Winckelmann wrote a friend: "My portrait has been painted by a remarkable lady, a German artist. . . . She speaks Italian as well as German. She is also fluent in French and English and therefore paints portraits of the English visitors. She can claim to be beautiful and sings to rival the best virtuosi." The portrait of Winckelmann proved to be one of Angelica's best. Angelica, however, still considered herself a student and began classes in classical sculpture and perspective, possibly with the artist-engraver Giovanni Piranesi. Further inspired by Winckelmann, she studied mythology too.

With high hopes and enthusiasm, also emboldened by her new knowledge of perspective and her election in 1765 to the prestigious Accademia di San Luca, she now tried her hand at history painting, the large scale treatment of historical events or heroic feats from ancient Athens and Rome. It was a courageous step since history painters were customarily trained to draw from the nude model, a training social convention denied women. But her determination paid off, for reviewers cheered her *Penelope* and *Bacchus and Ariadne*.

At this period the English painter Nathaniel Dance became infatuated with Angelica. Leaving him disappointed, she and her father stopped briefly in Bologna and Parma for more study of the old masters, then headed for Venice and a chilly, damp residence along the Grand Canal. The city was magnificent and sensual, but Angelica remained studious, refusing to flit from party to party, choosing rather to carry her portfolio and pencils to copy drawings and etchings of Titian, Jan Vermeer, and Tintoretto. There in Venice she found a patron in Lady Wentworth, wife of John Murray, the English ambassador. When Lady Wentworth carried Angelica off to London in 1766, simple-hearted old Kauffmann returned to Schwarzenburg, promising to follow soon.

In London a popular young king, George III, stood ready to embark on a colonial policy that would lead to the American Revolution. Politics aside, he had the good sense, unlike the first two Georges, to patronize the arts. In architecture, it was the age of Robert Adam; in literature, of Dr. Samuel Johnson, Lawrence Sterne, and Oliver Goldsmith; in painting, of Joshua Reynolds. Before long Reynolds, who in his notebook referred to Angelica as "Miss Angel," painted her portrait, and she in turn portrayed him. The two enjoyed a fine rapport. He also had studied in Italy, where he came to believe he could rise to greatness by duplicating the grand manner of the past. He and Angelica were rumored to have fallen in love, but he was 20 years her senior, a confirmed bachelor "not deeply read in petticoats." Together with the Reynolds likeness, Angelica's portrait of the famous actor David Garrick, which she had painted while he was on a visit to Italy, went on display.

As Lady Wentworth had predicted, London's rigidly aristocratic houses threw open their doors, especially after Angelica painted a portrait of George III's elder sister, Augusta, duchess of Brunswick, with her infant son, and her mother, the dowager princess of Wales, came to the studio to view it. Because of her patroness's failing health, however, Angelica moved from the great house in Mayfair to her own apartment. Her volume of business soon made her prosperous enough to take an imposing house in Golden Square, Bloomsbury. A contemporary writer told of her wearing "hoops of extra magnitude, toupees of abundant floweriness, shoe heels of vividest scarlet, and china monsters of superlative ugliness."

She had almost too many suitors; Dance also turned up again. But when she seemed disinterested in them all, they spun racy stories about her coquetting character and flamboyant life style. Johann Heinrich Fuseli, a Swiss painter of grotesque fantasies, was another who fell deeply in love and went so far as to propose.

Angelica refused him, but let herself be carried away by the peculiar charm of a gentle Swedish nobleman, Count Frederick de Horn, who gave every indication of being rich and intellectual. Then the infatuation took on the trappings of melodrama. One day Horn arrived at her house in a highly agitated state, warning that he stood in danger of being extradited to Sweden because rumor had implicated him in a conspiracy to kill the Swedish king, Adolphus Frederick. Having persuaded her that only by marrying him immediately could she save him, he arranged a speedy and secret wedding. Not long after the ceremony, Horn, wanting to arrange her affairs, told her father about it.

After hearing that another Count de Horn had showed up in London, some of Angelica's friends began to investigate. The first Horn turned on his father-in-law and forbade his wife to see him. When she refused to obey, the same friends challenged the supposed count to defend himself, but he stormed out of Angelica's house only to dispatch a lawyer who demanded that she join her husband at once. If she refused, she must agree to a formal separation and give him £500.

Father and daughter dismissed the ultimatum and set about obtaining records from abroad. At one point Horn hatched a plot to have two ruffians kidnap his wife; they almost succeeded. Just in time letters arrived from Prussia declaring him an imposter. He may have been the illegitimate son of the late Count de Horn, brought up in the aristocratic household as a servant or the count's valet who had accompanied him on his travels.

More shocking was the news that while parading as a colonel in the service of Frederick the Great, he had introduced a German woman as his wife. The abandoned one declared herself willing to come to England

to prove bigamy if given travel expenses. Angelica, however, could not bring herself to send money. "If his offense is proved in court," she said, "I would be the cause of his death." At the beginning of 1768, still dazed and unhappy, she signed a deed of separation and paid her husband 300 guineas on his agreement never again to approach her. He signed under the name of Brandt.

Rid of her rogue, Kauffmann plunged into her most successful year. On the occasion of the visit of George III's dissolute Danish brother-in-law to London in the spring of 1768, she painted Christian VII's portrait, and his prime minister, Count Bernsdorff, wrote warmly: "She has a peculiar and most womanly dignity. . . . She is by no means a beauty, but extremely attractive . . . the features are noble, the expression sweet . . . and there are moments when she is absolutely beautiful; thus, when she is seated at her harmonia, singing Pergolesi's *Stabat Mater*, she is a living Saint Cecilia."

Still greatly admired by London society though gossip did buzz about her because of the Horn episode, she was among the signers to a petition to King George asking him to establish a Royal Academy of Arts. He complied, and the Instrument of Foundation declared him patron, protector, and supporter. Only painters, sculptors, and architects of high moral character and eminence in their profession, their number not to exceed 40, could be named Royal Academicians. Among 36 founding members who included Benjamin West and Thomas Gainsborough, two were women, Angelica Kauffmann and her friend Mary Moser, a painter of flower pieces.

The new academy elected Reynolds, snobbish and somewhat pompous, as president. To its first exhibit, Kauffmann and West sent history pictures, a bold step since few Englishmen knew the genre, and the London market was extremely limited. Of her four decorously presented stories from the *Iliad* and the *Odyssey*, two — *Interview of Hector and Andromache* and *Venus Showing Aeneas and Achates the Way to Carthage* — won most praise.

From 1769, when Reynolds was knighted, to 1782, Angelica regularly contributed to the annual academy exhibitions. In 1770 with *Vortigern and Rowena* and in 1771 with *Interview of Edgar and Elfrida After Her Marriage to Athelwold*, she became the first artist to depict a scene from English medieval history. Also in 1770 she had offered *Cleopatra at the Tomb of Marc Antony*, a somber study which won critical applause and inspired several neoclassic painters, including West, to pursue the Cleopatra legend.

Her popularity soared still higher when the ill-fated William Ryland, eventually to be hanged for forgery, made excellent color prints of her works. His evident admiration of her person as well fueled more gossip

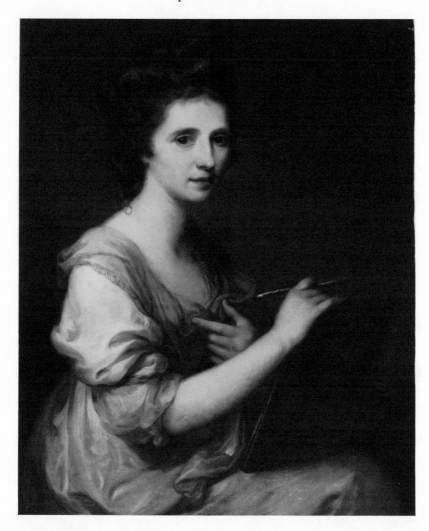

Angelica Kauffmann, *Self-Portrait* (1778), oil on canvas, 29 × 24 in., National Portrait Gallery, London.

after news leaked out that he was married to a woman he had kept in the shadows. Ryland was in partnership with the master engraver of the day, Bartolozzi, who also made plates from Angelica's paintings.

Though London's licentious society was well aware that women were barred from academic training which used live male models, new rumors arose that Angelica employed some for her history paintings. To underscore the academic restriction and perhaps to counter the stories about Kauffmann, Johann Zoffany painted *The Academicians Studying the*

Naked Model (1772), presenting her and Moser in small oval portraits on the wall. Asked directly, Kauffmann replied that her father always stayed with her in her studio and that her models were draped from head to foot.

A six months' sojourn in Ireland in 1771—1772, first prompted by her painting the lord lieutenant, George, fourth viscount Townshend, kept her extremely busy with Irish aristocrats clamoring for sittings. Back in England, she would have liked to concentrate once more on grand themes from history, but she realized such pictures had little market value in London. On the other hand, portraits were commissioned handsomely. Whenever possible, however, she showed her sitters—she had most success with women—in backgrounds full of allegorical allusions. Thus in *Marchioness Townshend and Her Son* she presented the boy as Cupid; in the tableau-like *Family of the Earl of Gower* (1772) the earl and countess and their six children appeared in antique costumes and classical poses with such accouterments as a lyre, a flower garland, and a bust. Still there were times Kauffmann agreed with Gainsborough, who frequently exploded, "I'm sick of portraits." Nevertheless she had not neglected to paint her own. From the age of 13, she had painted several self-portraits; in the 1770s (as also in the next decade) she showed herself years younger than her actual age.

The Royal Academy in 1773 appointed Kauffmann, Reynolds, West and others to decorate St. Paul's Cathedral, but the project proved short-lived because of the bishop of London's objections. A more rewarding opportunity came from Robert Adam, who asked her to paint panels for the cool, neoclassic interiors of the houses he and his brothers designed for the aristocracy and the wealthy. Adam frequently employed the Venetian painter Antonio Zucchi, brother of his good friend, Guiseppe Zucchi, and a special crony of Joseph Kauffmann. Since Angelica left few records of her work for Adam, it is difficult to know on what stately houses she may have worked. Her most famous decorations proved to be the four allegorical ovals *Color, Design, Composition,* and *Genius,* which she painted in 1778 for the lecture hall ceiling of Somerset House, the new residence of the Royal Academy.

Meanwhile the simmering hostility between the American colonies and the mother country erupted into a long war of independence, but it had little impact on Angelica Kauffmann's life. Business soared for her, and she was also taken up with relieving an old friend's distress.

Some years earlier in Florence, she had become acquainted with a Mrs. Hadfield and her daughter Maria, who like the young Angelica was musical and artistic. After her father died penniless, Maria, who had studied with several painters and been made a member of the Accademia della Belle Arte, wanted to enter a convent. In great alarm Mrs. Hadfield

wrote to Angelica Kauffmann for help. And so in the late 1770s the busy artist prepared for the two Hadfields' arrival in London. The exquisite Maria, soon popular in social circles, married the foppish miniaturist, Richard Cosway, and became a miniaturist herself. As Maria Cosway, she would engage the romantic attentions of Thomas Jefferson during his so-journ in France some years later.

Also in 1781 Angelica Kauffmann married again. A devoted Catholic, she had refused to do so while Brandt was still alive. But with his death in 1780, she felt free to accept Zucchi's offer. She was 39, he 54. His steady qualities were attractive, and she saw in him a supportive helpmate. She insisted, however, on a prenuptial settlement keeping him from making any claims on her substantial income. While courting her, Zucchi had often brought along his friend, the Swiss-born Jean Paul Marat, the future fiery pamphleteer of the French Revolution, who later unconvincingly boasted to fellow rebels that he had seduced her.

Soon after the wedding, old Kauffmann, in feeble health, said he wished to die in Italy. Since Zucchi was eager to return to Venice, the move was quickly decided. Rosa Florini, a relative who had lived with the Kauffmanns for several years, had married Joseph Bonomi, an architect, and borne children; for two of them Angelica had served as godmother. With the Bonomis, who decided to settle in Italy, the Zucchis and Angelica's father set out from London toward the close of the year. During the long journey they stopped in Schwarzenburg, where Joseph Kauffmann found few pleasures — all his friends were gone.

With the old man's death in Venice in January 1782, Zucchi took over his father-in-law's longtime functions of buying materials, acting as business manager, shipping canvases, and entertaining visitors to Angelica's studio. Grand Duke Paul of Russia (later Paul I) and other noblemen usually finished off their calls by giving her commissions. Then suddenly the Bonomis changed their minds about living in Italy and returned to London.

Much as Angelica was in demand in Venice, the Zucchis decided to live elsewhere. After staying briefly in Rome, they went on to Naples, where Angelica Kauffmann studied and copied pictures at the Capo-dimonte Museum and gracefully declined the position of royal painter to King Ferdinand and his imperious Austrian-born queen, Maria Caro-lina. But she did answer a summons to appear at the palace to begin paint-ing a full-length, life-size group portrait of the royal family. She chose to show them as the king returned from a boar hunt, his favorite pastime. The huge picture would occupy her for a couple of years. Sir William Hamilton, the British envoy extraordinary to Naples, also commissioned a picture about Ulysses' faithful wife, Penelope. For Prince Orano Caetoni in 1783-84 she painted *Telemachus and the Nymphs of Calypso.*

The Telemachus story was a popular theme, and three more times in the 1780s she did variations on it.

Feeling most comfortable in Rome, the Zucchis found a house near the newly constructed Spanish Steps. They called it the Casa Zucchi. Some years later, to escape the city's stifling summer heat and obtain some rest, they acquired a house at Castel Gandolfo. As usual, business flowed into Kauffmann's studio, and she never failed to please her clients with her smooth, severe handling of portraits and history paintings. Maria Carolina's brother, the Holy Roman Emperor Joseph II, hearing that she had been born in the Grisons at a time when they were under Austrian control, claimed her as a subject and began giving her commissions.

During another visit to Naples in 1784 to deliver her finished picture of the royal family, Kauffmann agreed to teach drawing to the king and queen's daughters. But soon, feeling strapped for time, she asked for her release. Before leaving in 1785, she began portraits of the Russian Countess Skavronsky, by many accounted the loveliest woman in Europe, and another beauty, Lady Elizabeth Foster, mistress and future second wife of the fifth duke of Devonshire. Lady Elizabeth looked beguilingly romantic in transparent gauze gown and stylish Gainsborough hat.

One of Kauffmann's warmest admirers was the wealthy collector George Bowles of the Grove, Wamstead, Essex, England. Zucchi shipped to him in 1785 three of Angelica's richly colored and meticulous Roman history pictures, *Cornelia Pointing to Her Children as Her Treasures* (the well-known story about the mother of the Gracchi); *Pliny and His Mother at Misenum, 79 A. D.;* and *Virgil Writing His Own Epitaph at Brundisium.* That same year she painted another version of the Cornelia legend for Queen Maria Carolina. Still another for Prince Poniatowski of Poland came from her studio in 1788.

New visitors turned up: the Italian sculptor Antonio Canova, the French painter Jacques Louis David, and the English sculptor John Flaxman, who worked for the potter Josiah Wedgwood, eagerly dropped in on her. Kauffmann inspired the austere classical motifs and models of both Wedgwood ware and Meissen china.

On his famous Italian journey in 1786, the multitalented German writer Johann Wolfgang von Goethe particularly wanted to meet Angelica Kauffmann. Once introduced, the two established a warm friendship (he called her "Die Gute"), sharing a devotion to Winckelmann's memory. Goethe reveled in the role of art student as the Zucchis taught him to look with a trained eye and to understand the technical side of painting. He extolled Kauffmann: ". . . she is keenly appreciative of all that is beautiful, true, and delicate."

But when he was back in Weimar, he pinpointed the strength and weakness of her art: "All that is bright, light, and pleasing in form, color,

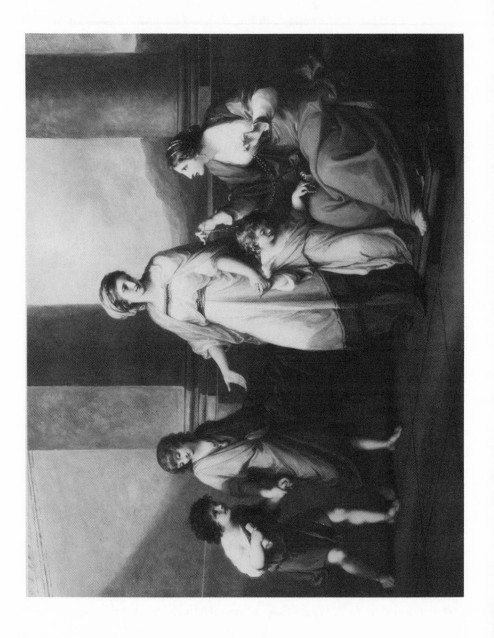

composition and treatment characterizes the many works of our Paint-
ress. No living painter has excelled her either in the charms of what she
represents or the taste and skill with which she handles her brush. On the
other hand, her drawing is weak and uncertain, her figures have little
variety of attitude or feature, and her picturing of emotions has no
strength." Later critics have echoed him.

For her part Angelica gave Goethe literary criticism and advice.
Proudly she arranged for him to read aloud his play, *Iphigenie auf Tavris*,
for her, Zucchi, and their friend, Councillor Reiffenstein, in her elegant
drawing room. But in all their camaraderie Goethe noticed that "she is not
as happy as she deserves to be." He believed she had tired of commissions.
"But her husband thinks it wonderful that so much money should roll in
for what is often easy work. She would like to paint to please herself and
have more leisure to study and take pains...."

After Goethe left Rome, he and Angelica corresponded affection-
ately for some months; then his letters ceased. Angelica, who had fallen
at least half in love, found comfort in the company of his friend, the
philosopher Gottfried von Herder, who described her as "a Madonna, a
little dove." With him, Reiffenstein, Grand Duchess Anne Amalia of Saxe-
Weimar, and other friends, the Zucchis made a special outing to the Villa
d'Este at Tivoli, a happy day caught in J. G. Schutz's well-known painting
The Visit to the Villa d'Este. The grand duchess, the wife of Goethe's
employer, made an extended stay in Rome and became Angelica's close
friend.

A special honor came in 1788 when an engraver named Boydell, also
an alderman of the city of London, asked Kauffmann, Reynolds, West,
Fuseli, and George Romney to contribute to the Shakespeare Gallery he
had designed to assemble paintings by the best-known artists of characters
from Shakespeare's plays. To London, Kauffmann sent *Diomed and Cres-
sida* (from *Troilus and Cressida*) and *Valentine, Proteus, Sylvia, and Julia
in the Forest* (from *Two Gentlemen of Verona*).

Her career had been contemporary with that of the dazzlingly suc-
cessful French painter Elizabeth Vigée–Le Brun, but the two did not
meet until Vigée–Le Brun, fleeing the Revolution in 1789, arrived in
Rome and spent two evenings with the Zucchis. Perhaps with a modicum
of professional jealousy, the Frenchwoman wrote a friend that Mme. Zuc-
chi seemed pleasant and "prodigiously well-informed," but had no enthu-
siasm. The two soon vied in painting the beautiful Emma, mistress of
Sir William Hamilton. Toward the end of 1791, Kauffmann received a

Opposite: Angelica Kauffmann, *Cornelia Pointing to Her Children as Her
Treasures* (1785), oil on canvas, 40 × 50 in., The Virginia Museum of Fine Arts,
Richmond, the Williams Fund.

commission to paint Emma, newly married to Sir William, as the muse of comedy. It became Lady Hamilton's favorite portrait of herself.

Kauffmann was turning out pictures for solid, durable patrons— Russian, Polish, German, and English noblemen and men of wealth. But as the years passed, some of her paintings seemed repetitive and uninspired. A graceful mythology, *Cupid's Wound*, dating from 1793, varied little from her *Bacchus and Ariadne* of 29 years earlier. But also in 1793 her portrait of a Rome resident, the impoverished, genteel Cornelia Knight, an English bluestocking and writer, moved Cornelia's mother, Lady Knight, to write: "...this is said to be the very best portrait [Kauffmann] ever painted and pleases everybody." One of Angelica's most interesting sitters, who became a special friend, was Lady Elizabeth Foster's father, Frederick Hervey, the highly eccentric earl of Bristol and bishop of Cloyne and Derby, much given to rich living.

Zucchi's death in 1795, after two strokes, ushered in a difficult period. To counteract her melancholy Kauffmann launched an even more energetic schedule, driving herself finally to exhaustion. By 1800 her doctors found it necessary to prescribe a holiday from painting as well as an immediate change of air. A young cousin, Johann Anton (Giovanni Antonio) Kauffmann, who had come from the Vorarlberg to live with the Zucchis and who after Antonio's death had managed Angelica's affairs, accompanied her to Como with its memories of her youth. Soon she felt so much better she urged Johann Anton to go off and visit his family. While she waited for him, she may have indulged in a brief autumnal love affair, for in a letter to a friend she wrote mysteriously: "Walking one day with pleasant companions, I saw Cupid sleeping in a shady wood. He woke and greeted me." One biographer has speculated that the love was one-sided and her lines referred to a young Englishman, Capt. Robert Dalrymple, whose portrait she had painted a few years earlier. He arrived in Como to see her, but only as a friend and admirer of her skill.

Returning to Rome, Kauffmann started painting again. But the Napoleonic wars, making travel impossible, sharply curtailed the foreign visitors who in the past had offered so many commissions, and she often felt lonely. Still she tried to entertain on her customary generous scale and was feted by Roman society.

On November 5, 1807, battling ill health and depression, she asked Johann Anton to read aloud for her some verses for the sick. When he mistakenly began the ode for the dying, she directed him to the page she wanted. But before he could read a line of text, she fell asleep, never to awaken. She left her books and paintings to him and generous provisions to those who had been attending her.

To express the devotion and esteem Angelica Kauffmann had won in her lifetime, Canova directed her elaborate funeral on November 7 in

the style that had once honored Raphael. As crowds lined the streets, the dignified signore of the Accademia di San Luca in solemn procession carried two of her rare religious pictures to her tomb, beside that of Zucchi in San Andrea della Fratte.

Years later her friend Flaxman summed up her career: "She was of the time, and the time was made for her." In the context of its taste she should be judged.

Angelica Kauffmann : Works Mentioned

Self-Portrait (1762–63), Galleria dell' Accademia di San Luca, Rome
Johann Winckelmann (1764), Kunsthaus, Zurich
Penelope (1764), Hove Museum of Art Gallery, Hove, England
Bacchus and Ariadne (1764), Amt der Landeshauptstadt, Rathaus, Bregenz, Austria
David Garrick (1766), Burghley House, Stamford, England
Joshua Reynolds (1767), Saltram House, Plymouth, England
Interview of Hector and Andromache (1769), Saltram House, Plymouth, England
Venus Showing Aeneas and Achates the Way to Carthage (1769), Voralberger Handelskammer, Feldkirch, Austria
Vortigern and Rowena (1770), Saltram House, Plymouth, England
Cleopatra at the Tomb of Marc Antony (1770), Burghley House, Stamford, England
Interview of Edgar and Elfrida after Her Marriage to Aethelwold (1771), Saltram House, Plymouth, England
Marchioness Townshend and Her Son (1772), Burghley House, Stamford, England
The Family of the Earl of Gower (1772), National Museum of Women in the Arts, Washington, D.C.
Self-Portrait (1778), National Portrait Gallery, London
Color, Design, Composition, and *Genius* (1778), Burlington House, London
The Family of King Ferdinand IV and Queen Maria Carolina (1784), Museo di Capodimonte, Naples
Telemachus and the Nymphs of Calypso (1784), Metropolitan Museum of Art, New York
Cornelia Pointing to Her Children as Her Treasures (1785), Virginia Museum of Fine Arts, Richmond
Pliny the Younger and His Mother at Misenum, 79 A.D. (1785), Princeton University Art Museum
Virgil Writing His Own Epitaph at Brundisium (1785), Collection of Peter and Margaret Walch, Albuquerque, New Mexico
Lady Elizabeth Foster (1785–86), Ickworth (House), Suffolk, England
Johann Wolfgang von Goethe (1787), Die Nationale Forschungs- und Gedenkenstatten die klassischen deutsche Literatur, Weimar, Germany
Self-Portrait (1788), Uffizi, Florence
Diomed and Cressida (1788), Petworth House, Sussex, England
Valentine, Proteus, Sylvia, and Julia in the Forest (1788), Private Collection
Frederick Henry, Earl of Bristol and Bishop of Cloyne (1790), Ickworth (House), Suffolk, England

Cornelia Knight (1793), City of Manchester Gallery, England
Cupid's Wound (1793), Attingham Park, Shrewsbury, England
Self-Portrait Hesitating between Painting and Music (1794), Nostell Priory,
 Yorkshire

IV

Elizabeth Vigée–Le Brun

(1755–1842)

Elizabeth Vigée–Le Brun's graceful talents flourished in Paris until she fled from the French Revolution. But years as an émigrée did not end her enormously successful career as the most fashionable of portrait painters. Her pictures remain an extraordinary gallery, a virtual *Who's Who* of late eighteenth and early nineteenth century European aristocrats.

Born in Paris on April 16, 1755, she was named Elizabeth Louise and called Lisette. She was the daughter of Louis Vigée, teacher and pastel portraitist, and the beautiful Jeanne Maissin, a hairdresser. When three months old, she was sent to a farm near Chartres, where for five years a peasant woman cared for her. During her daughter's absence, Mme. Vigée gave birth to a son, Étienne, in 1758.

Disappointingly plain-looking when she came back to Paris, Lisette entered a convent school, where she amused herself and annoyed the nuns by drawing heads on walls and in copy books. On visits home to recuperate from frequent illnesses, she busied herself with her father's crayons and pencils. Many evenings poets, painters, and philosophers dropped in on the hospitable Vigées; Lisette often sat in an adjoining room, listening to the animated talk.

After her first communion in 1767, she left school and began attending her father's drawing classes. But he died that year, leaving the family finances at low ebb. Lisette now took drawing lessons from Mme. Blaise Bocquet in her home and from Gabriel Briard at his studio in the old Louvre Palace. In the royal picture collections at the Louvre and the Luxembourg Palace, she studied Raphael, Rembrandt, and Anthony van Dyck. Peter Paul Rubens' cycle *Life of Marie de' Medici* impressed her most.

By the time Lisette reached adolescence, she emerged as a beauty,

with an arresting combination of blond, curly hair, delicate features, and tall, slim figure. Her skill had grown and now she painted in oils. The renowned landscape and marine artist Claude Joseph Vernet pronounced her work outstanding, became her friend and counselor, and introduced her to several patrons. Jean Baptiste Greuze, whose paintings she had also studied at the Louvre, became another admirer; from him, however, she picked up a tendency to sentimentalize. Though her clients rewarded her handsomely, she kept little of her money. Within six months of her husband's death, Mme. Vigée had married a goldsmith, Jacques François Le Sèvre, who demanded whatever his stepdaughter earned. She called him "detestable." She received no money, of course, for her excellent portrait of her brother Étienne in 1773.

At 19 she was licensed by the Académie de Saint Luc as a master painter, even though she had no formal training as an apprentice. Intense and single-minded, she already moved in elegant circles, meeting the famous hostess Mme. Geoffrin; the Duc de Choiseul, a former prime minister; and various nobles. Warmly approving of her work, one of her sitters, the suave Count Ivan Shuvalov, founder of Moscow University and the Moscow Academy of Fine Arts, steered even more influential clients her way. Many had entrée to the new court at Versailles. Leaving France nearly bankrupt, Louis XV had died in 1774 and been succeeded by his grandson, Louis XVI, husband of a sparkling but intellectually dull Austrian archduchess, Marie Antoinette. Disgusted with the erotic atmosphere of his predecessor's court, the well-meaning but clumsy Louis introduced a note of virtue, inspired in part by Johann Joseph Winckelmann's neoclassic theories that were sweeping through art and literature. Idealism ran side by side with the cult of sensibility, best described in La Nouvelle Héloise (1762) by Jean Jacques Rousseau, who saw sentimentality as part of a larger process to help make civilization more human and humane.

When Lisette was 21, her mother pushed her to marry Jean Baptiste Pierre Le Brun, an art dealer who occupied the Hôtel de Lubert, where Lisette's family rented an apartment. For six months he had obligingly allowed her to copy his paintings in stock and then proposed. In the Almanack des Peintres he had already praised her pictures: "They are composed with care and are full of feeling; the clothes are beautifully done and the color is strong." Lisette went quite unwillingly to the altar. Long afterward she wrote: "So small, however, was my enthusiasm to give up my freedom that on the way to church I kept saying to myself, 'Shall I say yes? Shall I say no?' Alas, I said 'yes' and changed my old troubles for new ones." Too soon she learned that her husband gambled passionately and irresponsibly. Her unhappiness increased when he demanded that she earn still more money by taking in pupils. Reluctantly she did so. For the rest

of their married life he leaned on her to keep him out of his creditors' grasp. But she herself liked living well. The Le Bruns bought the Hôtel de Lubert in 1778.

Meanwhile she spun closer toward the highly artificial world of Versailles, painting the fleshy "Monsieur," the king's brother, in 1776 and making copies of portraits of the queen by other artists. Then in 1778 came a commission to do Marie Antoinette's portrait as a gift for her brother, the Hapsburg emperor Joseph II, in Vienna. Praise greeted the formal regal figure in a heavily swagged white satin gown. Artist and model had met informally a few months earlier when Vigée–Le Brun and her mother strolled in the baroque park of the Château de Marly, the favorite summer retreat of Louis XIV. Suddenly they saw the stately young queen and two ladies-in-waiting, all dressed in white, gliding toward them. As the two commoners retreated hastily, Marie Antoinette called after them to walk where they pleased.

Vigée–Le Brun did not allow pregnancy to interfere with her busy studio schedule. One February morning in 1780 she remained at her easel even as her labor pains began. Finally a friend insisted she go to bed. Jeanne Julie Louise, her only child, was born a few hours afterward. The *Self-Portrait* of 1781, however, is hardly that of a new mother; she looks very young and innocent.

During the spring of 1781 the Le Bruns visited Holland and Belgium, and the artist saw Rubens' *Portrait of Helene Fourment,* which inspired her *Self-Portrait in a Straw Hat* (1782). After viewing it, Vernet proposed her membership in the Académie Royale, the official society of fine arts. In 1770, the number of women admitted had been limited to four. Since her husband was an art dealer, however, her admittance seemed unlikely until Marie Antoinette asked Louis to intervene. Adélaîde Guiard-Labille, another successful portraitist, who had been elected by a majority vote, entered with Vigée–Le Brun the same day. Wanting to be admitted as a history painter (Angelica Kauffman had paved the way for women), a more prestigious title than portraitist, Vigée–Le Brun offered as her reception entry *Peace Brings Abundance* in neoclassical, allegorical style. Dark-haired Peace holds an olive branch. Blond Abundance, equally lovely and floating in space, has flowers in her hair, fruits in her lap, and bares one breast.

Vigée–Le Brun always dressed herself in white muslin gowns and turbans and in the interest of simpler fashion often draped shawls over the flounces and hooped gowns of the women who posed for her. Since she did not like powder in the hair, she asked her brittle aristocratic models to appear without it. To the women she invariably gave large, dark, liquid eyes that matched her own. Society demanded flattery, and in her old age she wrote that she had always told her sitters they were beautiful to put

them in a good mood and then with her brush had further improved their looks. Such flattery considerably lessened the possibility of psychological depth, and her critics accused her of creating many vacuous portraits. Often she repeated postures and poses she found most satisfying.

She herself fitted the description Abigail Adams gave of the French ladies she met when she went abroad with her husband, John: "Easy in their manner, eloquent in their speech, their voices soft and musical, and their attitude pleasing. . .they must possess the power of persuasion and instruction beyond any other females." A tough, cool spirit, however, lay behind Vigée-Le Brun's beauty and celebrated smile. She had never been in love.

Portraits remained the artist's bread and butter. In 1783 a new portrait of the queen created a furor. With mounting reports of her extravagance and aimless elegance, Marie Antoinette had become a constant victim of slander, widely known as "Madame Deficit." Perhaps to offset this image, Rose Bertin, her highly influential dressmaker, had begun to encourage simple, loose gowns. The public reacted with more than disgust when Vigée-Le Brun showed Marie Antoinette in a plain Creole smock known as a *gaulle*, very much in fashion at the Rustic Village of the Petit Trianon, where the queen cultivated an artificial rural life that included beribboned cows. Critics raged that by dressing like a chambermaid, the queen favored her brother Joseph's Flemish weavers in the Austrian Netherlands at the expense of the silk merchants and weavers in Lyons. Ultimately the picture caused such a scandal that it had to be removed from the Academy Salon.

Another unpopular subject that year was the delicate Yolande, Duchesse de Polignac, the queen's intriguing favorite and governess to the royal children. She inspired a ravishing portrait, her half-open mouth and ingenuous expression indicating an interrupted singing lesson. More overtly sexual was the likeness of beautiful, languorous Madame Grand, a notorious "kept woman."

The duchesse's lover, the Comte de Vaudreuil—grand falconer, freespending clotheshorse, and court favorite—became Vigée-Le Brun's chief patron. Gossip linked them romantically. To him she owed some of her growing prominence at Versailles; through him Pierre Le Brun gained new clients; and Étienne Vigée was named secretary to one of the king's sisters-in-law. He also achieved success as a poet and playwright.

Vigée-Le Brun painted Vaudreuil in 1784 and also Charles Alexandre de Calonne, the unpopular controller general. Looking handsome and polished in a taffeta coat with lace cuffs, he sits in a gilded chair at a gilded desk on which, amid ornate inkwells, is placed the famous "Sinking Fund," planned to reduce the huge national debt. Calonne and Vigée-Le Brun were also rumored to have had a relationship. Later she claimed the gossip

had originated with the Comtesse de Cérès, Calonne's jealous mistress, who is believed to have been the model for the thoroughly charming *Lady Folding a Letter* (1784).

Vigée–Le Brun went on painting the queen, using her talent for small talk to relax her model. From the first Marie Antoinette, her exact contemporary, had warmed toward her. Indeed they became such good friends that they often broke the tedious sittings to sing duets.

The facile brush would understate a drooping Hapsburg lip and bulging forehead and emphasize instead a delicate complexion. Many years later Vigée–Le Brun described her royal model:

> Marie Antoinette was tall, beautifully made, rather plump, but not too much so. Her arms were superb, her head small and perfectly shaped, her feet charming. She walked better than any woman in France, holding her head high with a majesty which made one recognize the sovereign among all her courtiers. Her features were not regular. She had inherited from her family the long, narrow oval peculiar to the Austrians. But what was most admired in her face was the radiance of her complexion. I have never seen any so brilliant, and brilliant is the word, for her skin was so transparent that it held no shadows. For this reason I could never reproduce it as I wished.

A part of Vigée–Le Brun's fame eventually rested on the glowing complexion she gave to many of her heavily made-up sitters.

In 1784 Vigée–Le Brun again tried not to let pregnancy interfere with her work. But one morning she felt so sick she missed an appointment with the queen at Versailles. Rushing out there the next day to apologize, she arrived in the marble courtyard just as Marie Antoinette was stepping into her carriage. Seeing the artist, the queen promptly stepped down again, having decided to proceed with the sitting at once. Flustered, the young artist dropped her paint box. As she bent down to pick up her brushes and pencils, the queen protested that she was in no condition to stoop and gathered them up herself. The pregnancy resulted in a miscarriage.

When the Diamond Necklace scandal began to unravel in 1785, unjustly implicating the queen in a swindle, Vigée–Le Brun pictured her in satin toque and lace-trimmed gown, seated with a book. Reading was not a favorite royal pastime, but the pose gave an unmistakable air of dignity. By way of contrast, in *Bacchante,* also from 1785, the smiling model (identity unknown) reveals one rosy breast.

That year, enjoying his wife's success, Pierre Le Brun was eager to have larger quarters. He ordered construction to begin on a luxurious townhouse, the Hôtel Le Brun, close to the Hôtel de Lubert.

A new portrait of the queen (1787) showed her in a red velour gown,

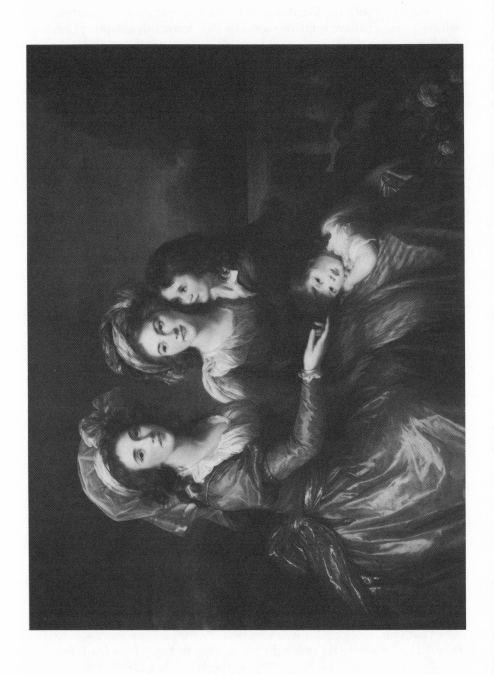

Above: Elizabeth Vigée–Le Brun, *Self-Portrait with Her Daughter* (1789), oil on wood, 51⅛ × 37 in., Louvre, Cliché des Musées Nationaux, Paris. *Opposite:* Elizabeth Vigée–Le Brun, *The Marquise de Peze and the Marquise de Rouget with Her Two Children* (1787), oil on canvas, 48⅝ × 61⅜ in., National Gallery of Art, Washington, D.C., gift of the Bay Foundation in memory of Josephine Bay Paul and Ambassador Charles Ulrick Bay.

posed in a distinctly maternal attitude with her two sons and daughter and the empty cradle of the Princess Sophia, who had recently died. Vigée–Le Brun had spent nearly two years on it and hoped to exhibit it at the Salon in the Louvre. But because of mounting antipathy toward the royal couple, the academy hesitated to accept it, finally, however, changing its mind. The king told the blushing artist, "I don't know much about painting, but you have made me love it." After the death of the dauphin, however, neither Louis nor Marie Antoinette could bear to look at the portrait.

That same year Vigée–Le Brun painted *The Marquise de Peze and the Marquise de Rouget with Her Two Children*, which charmingly combines intimate friendship and maternal love. She further completed her *Self-Portrait with Her Daughter*, carried out in the cool neoclassical style of Jacques Louis David, even binding her hair with a Sapphic fillet. This time she swathed herself in expensive material. Two years later she would pose with Julie in one more tender evocation of motherhood. The theater also fascinated her; no portrait she painted was quite as stunning as that of Mme. Molé-Raymond (1785), who holds a huge fur muff.

In spite of her exhausting schedule, Vigée–Le Brun delighted in keeping a salon for well-born guests, offering them conversation and refreshments restricted to fish, fowl, and salad. Sometimes there were concerts and masquerades. Unlike other well-known hostesses, Vigée–Le Brun never allowed politics to be discussed at her soirees. The American painter John Trumbull began coming to them in 1786; he later declared that she had had a lasting influence on his style.

Unfailingly quick-witted and tactful, she prided herself on being an innovative hostess. Once, after seeing a neighbor's Etruscan vases, she borrowed them for her table at a hastily arranged Greek supper of honey cakes, Corinth raisins, and Cypriot wine, then improvised draperies for herself and her guests. For this party she is reputed to have wiped the powder from her husband's head, undone his side curls, and crowned him with a laurel wreath. The supper became the talk of Paris; though it was actually an inexpensive affair, gossip described it as extravagant beyond bounds.

That year, 1788, she painted what is perhaps the most regal of her more than 25 portraits of Marie Antoinette. Sitting alone amid emblems of royalty, the queen again has a book as a prop, doubtless never read.

By the famine year of 1789, France had gone bankrupt. Louis XVI tried vainly to make repairs, calling first a council of nobles, then summoning the Estates-General, which had not met since 1614. Immediately the Third Estate—the commoners—formed their own National Assembly. Against this unsettled background Vigée–Le Brun went on capturing the easy grace and elegance of the rococo as she completed 39 portraits,

among them a remarkable image of the Comtesse de la Châtre (later the Marquise de Jaucourt), notable for its sweeping diagonals and fine composition. The artist herself believed that her best portraits were those of friends like the painter Hubert Robert, whose favorite subject was overgrown ruins (1786).

In July after the king planned to dismiss the National Assembly, which had vowed to produce a constitution, the people of Paris stormed the old fortress-prison, the Bastille. Though only seven persons were inside, the raid symbolized a revolution. In August the city reverberated with the idealism of the landmark Declaration of the Rights of Man, accepted by the Assembly. October brought a mob of ragged women, howling for bread, pouring out of Paris, and marching on Versailles. The next morning they escorted the royal family to the Tuileries Palace in Paris.

The queen's favorite painter faced a dangerous situation. At once Vigée-Le Brun packed up daughter Julie and her governess and crossed the Alps to Italy. Pierre Le Brun, who for 13 years had borrowed freely from his wife and never paid her back, stayed behind. Many artists of the *ancien régime* were destined to live out their lives in poverty, but not one whose fame had already spread abroad.

Vigée-Le Brun settled first in Florence, where the library asked her to add to its gallery of self-portraits by contemporary artists. To compliment her patron, the grand duke of Tuscany, Marie Antoinette's brother, she showed herself, palette in hand, standing before a canvas with the figure of the queen outlined in white chalk. Whether from vanity or nostalgia, she herself looked as she had in her twenties.

Rome gave her a warm welcome; she gloried in her popularity and the promise of endless commissions. There she spent two evenings with Angelica Kauffmann. Six months later she arrived in Naples, where Marie Antoinette's sister, Maria Carolina, the queen of the Two Sicilies, asked her to paint portraits of the royal children. Vigée-Le Brun was more than willing to do so and rented a villa with a view of Capri.

Then the elderly British ambassador, Sir William Hamilton, asked her to paint his blooming mistress and prospective bride, Emma Hart. He received a portrait of the voluptuous Emma as Ariadne lying on a tiger skin ("bacchante couchée"). Admiring Emma's great quantity of chestnut hair, Vigée-Le Brun again showed it to advantage when she presented her as a bacchante in scarlet draperies, tambourine in hand, dancing in front of Vesuvius. By the time she was painted as a sybil, Miss Hart had become Lady Hamilton, eventually to gain fame as the mistress of England's greatest naval hero, Lord Nelson. Of the three poses, Vigée-Le Brun felt most satisfied with the portrait which had been commissioned by the Duc de Brissac. After his murder, she took the original with her to prove her talent wherever she went. Meanwhile she had basked in Sir William's

company. Years later in a house she visited in England, she unhappily discovered two charcoal figures she had drawn as a gift for a door panel for the Hamilton villa at Portici; she was appalled to learn that Sir William had sold them for a considerable sum.

Mother, daughter, and governess were scarcely settled back in Rome than Maria Carolina, who wanted drawing lessons for the princesses, recalled them to Naples. When not busy at the court, Vigée–Le Brun paid careful attention to the education of "the little brunette," her own remarkably pretty daughter. Lessons for the princesses proved boring for the teacher, and soon she begged to be relieved of her duties, well aware that Angelica Kauffmann had declined the position of royal painter a few years before. Her travels continued in northern Italy. Wherever she stayed—Florence again, Venice, Milan—admirers of her graceful and elegant style plied her with commissions and called her "the female Rubens." Special honors came her way: membership in the Rome, Parma, and Bologna academies.

Her brother Étienne had married Suzanne Rivière in 1785. Vigée–Le Brun had become close to her sister-in-law's family. In Turin, Suzanne's brother Auguste, a painter, joined her and for the next nine years would faithfully accompany her, painting miniatures of many of her portraits.

Word came to her that in Paris her name had been added to the list of émigrés, depriving her of all her rights as a French citizen. Unsuccessfully Pierre Le Brun petitioned the legislative assembly to have his wife's name removed. While she was in Milan, the Austrian ambassador persuaded her to settle in Vienna, where French royalists were popular. At the end of 1792, she rented a house in the suburbs for herself and Julie.

When she heard of Marie Antoinette's execution (the king had preceded her in death by the guillotine), Vigée–Le Brun refused to look at the newspapers. But her genuine grief could not dampen her flair for public relations, and on all her travels she carried with her a portrait of the queen, decorated with a black ribbon. Meanwhile slander circulated in Paris that she roamed about Europe on immoral earnings from aristocratic lovers. Le Brun wrote a long defense of his wife, declaring that mounting debts and their few possessions proved the falsity of the charges against her.

Always practicing her superb self-promotion, Vigée–Le Brun continued to move in the highest circles. Among Austrian and Polish aristocrats she captivated Prince Kaunitz, Marie Theresa's famous minister of state, and noblewomen like the Princesses Lichtenstein and Esterhazy. In Italy she had drawn numerous landscape sketches; in Austria, thrilled by the mountains, waterfalls, and greenery, she began to incorporate romantic settings into her portraits, such as that of the

Comtesse de Bucquoi. But in general her style showed no dramatic changes.

Paris was shaking under the Reign of Terror, hearing the daily thud of the guillotine. Fearing for his life and property, Le Brun sued for divorce, charging desertion, and a decree was granted.

After Vigée–Le Brun had been in Vienna for two years, the Russian ambassador and various of her countrymen there urged her to go to St. Petersburg, assuring her of a cordial reception by Catherine II. But when presented to the empress, she felt so overwhelmed she forgot to kiss the royal hand. Generously Catherine overlooked her gaffe and arranged for portraits of her granddaughters.

One of Vigée–Le Brun's early sitters in Russia was Princess Youssoupov, who inspired a lyrical portrait (1797). Others were her old friend Count Shuvalov and Countess Golovin (1797–1800). Notable are the dramatic diagonal shafts of light and the almost erotic way in which the attractive aristocrat clutches one end of her vivid red cloak. A portrait "in motion" (like that of Mme. Molé-Raymond) is also dated 1797; its model has not been identified but may have been Countess Vorontzov.

Vigée–Le Brun had sharp eyes for the failings of Catherine's successor, her homely and uncouth son, Paul; yet she found this reputed tyrant kind and even charming. To her immense satisfaction he approved of the way she painted his wife, the empress Maria Fedorovna, his daughter-in-law, the grand duchess Elizabeth Alexeivna, and son Alexander. In young Varvara Ivanovna Ladomirsky (later Narishkine), she found dazzling beauty to portray; in Stanislas Poniatowski, the exiled king of Poland, an authority that no longer existed in fact.

Celebrity served Vigée–Le Brun well, for she went everywhere in the great St. Petersburg palaces, enjoying dinners and supper parties, feeling flattered but overburdened with too many commissions. Still she took time to fill notebooks with portrait drawings of women and children at the Russian court. In 1800 she became a member of the Russian Academy of Fine Arts, and her work was considered an important influence on the Russian portrait school.

But along with brilliant success, Russia brought bitter disappointment. Julie became infatuated with Gaétan Bernard Nigris, secretary to the director of the Imperial Theater, and to her mother's dismay married him. Vigée–Le Brun returned to Paris by way of Berlin, where the lovely Queen Louise, soon to be Napoleon's bitter enemy, invited her to Potsdam to paint the royal family. She was now assured of a welcome in Paris. Already in 1799, 255 artists and savants had signed a petition to the Directoire, the government then in place, urging her homecoming.

Once in Paris, in spite of the divorce, she took up residence in the Hôtel Le Brun. With her brother Étienne her relations were somewhat

strained since the former avowed monarchist had become part of a bureaucracy that had confiscated emigrés' properties.

No matter the welcome, she felt uncomfortable in the new political landscape, now dominated by the first consul, Napoleon Bonaparte, and she determined to try her luck in England, where she remained for three years. She arrived in London not knowing a word of English, but soon she was acquainted with important people like the astronomer John Herschel and the actress Sarah Siddons. Among others, the portly prince of Wales (in Hussar uniform) and a very young Lord Byron sat for her.

When a book by an English painter appeared, belittling French art in general and Vigée–Le Brun in particular, she rose to the defense in a letter to him:

> I do not suppose that any artist imagines he has attained perfection, and, far from any presumption on my part, I have never yet been quite satisfied with any work of mine.... It seems that my lace shocks you, although I have painted none in fifteen years. I vastly prefer scarfs, which, you, sir, would do well to employ. Scarfs, you may believe me, are a boon to painters, and had you used them, you would have acquired good taste in drapery, in which you are deficient. As for those stuffs, those elegant cushions, those blinds to be seen in my shop, it is my opinion that one should pay as much attention as possible to such accessories. On that point I have Raphael as an authority.... And now, sir, allow me to remark that the word shop, which term you apply to my studio, is scarcely worthy of the artist. I show my pictures without having money asked at the door.

On hearing that her daughter and son-in-law had arrived in Paris, she returned home in 1805. Three years later Nigris left for St. Petersburg alone. The separation was permanent. Julie, who had become a painter, remained in Paris, but the mother-daughter relationship had grown complicated. "Her beauty and her talents made her most seductive," Vigée–Le Brun wrote long after, "and though I could not induce her to live with me, seeing that she persisted in seeing people whom I would not receive, I saw her every day, which was a great joy for me."

She continued to feel uneasy about Napoleon, who had crowned himself emperor. Yet she approved of his taste in severe, sedate interiors inspired by imperial Rome and of the flowing garb and bacchante hairstyles of such beauties as Mme. Récamier. (Vigée–Le Brun had favored such a mode more than a generation before.) One of her most vexing models, however, was Napoleon's flighty sister, Caroline Murat, who kept missing her appointments and in the intervals between regularly changed her hair arrangement.

Again in 1808 the artist decided on a change of pace. For a year she stayed in Switzerland painting and drawing more landscapes; at Coppet

she met and painted Mme. de Staël as the heroine of her famous novel *Corinne.*

On her return to Paris, Vigée–Le Brun bought a country house at Louviciennes. All France was talking about Napoleon's brilliant military campaigns. Then in 1813 the Allied armies defeated him at the Battle of Leipzig, and his power crumbled. That year Le Brun's death released his former wife from a heavy financial burden.

In 1814 she fled Louviciennes during the Allied advance on Paris when Prussian soldiers went on pillage. Napoleon had been taken to Elba, and Louis XVI's brother, the Comte de Provence, soon rushed out of exile to claim the throne as Louis XVIII. Vigée–Le Brun had painted him 40 years before, and as she mingled with the crowds to see him on his way to mass, he recognized her and stopped his carriage to hold her hand.

Within 11 months Napoleon reappeared from Elba and chased out the king. Then after the Battle of Waterloo and Napoleon's imprisonment at Elba, Louis XVIII returned to the throne. Vigée–Le Brun's *Portrait of a Young Boy* (1817) has an unusual prop, a long gun, perhaps a reminder of the turbulent times. Yet the wide-eyed child looks totally innocent.

Julie died in 1819, followed the next year by Étienne Vigée, whose daughter Caroline took care of her aunt. Vigée–Le Brun's energy had begun to fail, but she sent pictures to the Salon until 1824. Wise investments had given her financial security. Many years earlier her horoscope had predicted that she would become a "lovable old woman," a prophecy which, in a somewhat irascible old age, she found had not come true.

In 1835–37, helped by Caroline and another niece, Eugénie Le Brun Le Franc, Vigée–Le Brun wrote her memoirs, called *Souvenirs,* taking pains to show that she had known "the most distinguished and charming characters in Europe, both men and women." It was an enormous exercise in name dropping and light anecdotage. She reported that she had painted 877 pictures, among them 622 portraits.

Caroline had married her mother's youngest brother, Jean Nicolas Louis Rivière. Together with their children, the Rivières lived with Vigée–Le Brun in her last years. In 1841 she suffered a debilitating stroke and died on March 30, 1842, in Paris, having stipulated in her will that she be buried at Louviciennes. Her genius for presenting herself favorably continued to the end. She asked that a relief carving of a palette and brush be placed upon her grave.

Elizabeth Vigée–Le Brun : Works Mentioned

Étienne Vigée (1773), St. Louis Art Museum
Marie Antoinette (1778), Kunsthistorisches Museum, Vienna

Self-Portrait (1781), Kimbell Art Museum, Ft. Worth, Texas
Self-Portrait in a Straw Hat (1782), Private Collection
Peace Brings Abundance (1783), Louvre, Paris
Marie Antoinette in a Gaulle (1782), Princess von Hessen und bei Rhein, Darmstadt, Germany
Duchesse de Polignac (1783), Waddesdon Manor, Aylesbury, England
Madame Grand (1783), Metropolitan Museum of Art, New York
Comte de Vaudreuil (1784), Virginia Museum of Fine Arts, Richmond
Charles-Alexandre de Calonne (1784), the Royal Collection, Windsor Castle, England
Lady Folding a Letter (1784), Toledo Museum of Art, Ohio
Marie Antoinette (1785), Private Collection
Bacchante (1785), Sterling and Francine Clark Art Institute, Williamstown, Massachusetts
Mme. Molé-Raymond (1785), Louvre, Paris
Marie Antoinette and Her Children (1787), Musée National du Château de Versailles
The Marquise de Peze and the Marquise de Rouget with Her Two Children (1787), National Gallery of Art, Washington, D.C.
Self-Portrait with Her Daughter (1787), Louvre, Paris
Marie Antoinette (1788), Private Collection
Hubert Robert (1788), Louvre, Paris
Self-Portrait with Her Daughter (1789), Louvre, Paris
Comtesse de la Châtre (1789), Metropolitan Museum of Art, New York
Self-Portrait (1789), Uffizi, Florence
Emma Hart, the Future Lady Hamilton, as Ariadne (Bacchante-couchée) (1790), Private Collection
Lady Hamilton as a Dancing Bacchante (1791), Lady Lever Collection, Port Sunlight, England
Lady Hamilton as a Sybil (after 1792), Private Collection
Comtesse de Bucquoi (1793), Minneapolis Institute of Arts
Count Shuvalov (1795–97), North Carolina Museum of Art, Raleigh
Stanislas Poniatowski (1797), Musée National du Chateau de Versailles
Portrait of a Woman (Countess Vorontzov) (c. 1797), Museum of Fine Arts, Boston
Countess Golovin (1797–1800), Barber Institute of Fine Arts, University of Birmingham, England
Varvara Ivanovna Ladomirsky (Narishkine) (1800), Columbus Gallery of Fine Arts, Ohio
Mme. de Staël as Corinne (1808), Musée d' Art et d'Histoire, Geneva, Switzerland
Portrait of a Young Boy (1817), National Museum of Women in the Arts, Washington, D.C.

V

Rosa Bonheur

(1822–1899)

Public fascination with Rosa Bonheur's unorthodox lifestyle continued for almost half a century. Together with a vast bourgeois appetite for her works, that fascination contributed to her tremendous popularity and success. Within a few years of her death, however, her reputation began to suffer from changes of taste. Today she is once more admired for her art as well as her outspoken independence.

Her beginnings were inauspicious. She was born on March 16, 1822, in Bordeaux, France, the first child of Raimond Oscar-Marie Bonheur, impoverished drawing master and teacher, and his wife Sophie Marquis, a talented amateur musician. She was given the name of Marie-Rosalie. Two brothers, Auguste and Isidore, followed in 1824 and 1827. Hints that their mother was of noble though illegitimate birth always intrigued the children.

In 1828 some Spanish friends in Bordeaux moved to Paris and engaged Raimond to teach at their new boarding school there. The next year he sent for his family, and Sophie, the three children, and Raimond's mother made an exhausting two-and-a-half-day journey by carriage to join him in a shabby apartment. The same building housed a boys' school, and Raimond Bonheur, who favored equality of the sexes, enrolled Rosalie with her brothers. Of this experience she later wrote: "It emancipated me before I knew what emancipation meant and left me free to develop naturally and untrammeled."

Sophie Bonheur bore a second daughter, Juliette, just a few days before the 72-hour July Revolution of 1830, which ousted the autocratic Charles X and replaced him with Louis Philippe, the "Citizen King," who quickly betrayed the ideals of his liberal supporters.

Raimond Bonheur had already embraced the radical social theories of the recently deceased Comte Raymond de Saint-Simon, who ad-

vocated public ownership of the means of production and a government of scientists and engineers. Saint-Simon's chief disciple was the charismatic Barthélmy Prosper Enfantin, who enlarged the master's doctrines and searched diligently for a woman messiah. In 1831 Raimond attached himself to the Menilmontant estate, where Enfantin had set up a kind of monastery. For a time Raimond and Sophie served as missionaries. Then Enfantin declared a closed society with 40 of his most ardent disciples. Raimond, who designed their uniforms, was among them.

Dreamy and idealistic, Raimond became an apostle and gardener at Menilmontant, where his family paid him Sunday visits, Rosalie wearing a Saint-Simonian cap with a red tassel over her dark curls. Soon, however, the authorities recognized the workings of a revolutionary spirit and clapped Enfantin in jail. On his release he would find his movement tottering and would go abroad; by 1837 the Menilmontant estate would be permanently closed.

Meanwhile Raimond had joined the old sect of the Templiers and had had Rosalie baptized under drawn swords by Knights of the Temple, who after the ceremony gave the young girl a wooden sword. Raimond also turned to the writings of the Abbé Lammenais, a former conservative priest, who advocated universal brotherhood and suffrage. Rosalie, at her father's bidding, read Lammenais' controversial books and believed he had defined everything she had ever searched for.

The family rejoiced when the Salon, the annual exhibit planned by the all-powerful Académie des Beaux-Arts, accepted one of Raimond's paintings, but the honor did little to improve their poverty. Struggling to keep her family afloat, Sophie Bonheur gave piano lessons whenever possible. After nursing Rosalie through a bout of scarlet fever, Sophie died in 1833, completely worn out. Her eldest child never quite got over the loss.

From an early age, Rosalie had experimented with her father's drawing pencils, sketching animals. As she grew older she continued to draw and drew well, but it was necessary to learn some vocation. Raimond took her out of the boys' school and apprenticed her to a seamstress, but she stubbornly refused to work with the woman. For the time being, she would instead earn pocket money in the studio of some of Raimond's friends, who colored fashion engravings, heraldic insignia, and kaleidoscopic views.

Then, when Raimond grew worried about her lack of a proper education, he enrolled her in the boarding school where he taught. Tomboyish and rebellious, Rosalie one day ordered a cavalry charge in the garden. Brandishing her Templier sword, she helped destroy a prized rose bed. When she was dismissed in disgrace, her father decided to train her as a painter after all. He held Vigée–Le Brun up to her as a model, but also

wanted her pictures to embody lofty Saint-Simonian beliefs including universal equality. In 1836 she took out her permit to copy at the Louvre, where—legend has it—she sported a boy's costume and looked so conspicuously different from the other young girls that the guards gave her the nickname of "the little Hussar." She paid most attention to the landscape and animal painters—Nicholas Poussin, Salvator Rosa, and Paulus Porter. The copies she made sold well.

That same year Raimond Bonheur received a commission to paint a portrait of 12-year-old Nathalie Micas, whom Rosalie had first met six years earlier when they played in the gardens of the Place Royale. As the sickly Nathalie turned up regularly at Raimond's studio, she and Rosalie became fast friends. About this time, Raimond became the head of the state-supported School of Drawing for Young Girls and encouraged Rosalie to do on-the-spot sketches, supporting her wish to make animals her favorite subject. As a Saint-Simonian, he placed science above all else, but he did not object to his daughter's reading Sir Walter Scott and Ossian and responding to their romantic imagination.

All the Bonheurs loved animals and filled their apartment with them. When Rosalie acquired a goat, her brothers obligingly carried it down six flights of stairs for its airings. The pets served as models, but to sharpen her observation even more, Rosalie frequented the botanical garden, the veterinary school at Alfort, and farms and stalls in Villiers, a neighboring village. Recognition first came in 1841 when the Salon accepted the 19-year-old artist's *Rabbits Nibbling Carrots*, a small oil, and *Goats and Sheep*, a drawing.

The next year Raymond Bonheur, who now spelled his name with a y, married a young widow, Marguerite Pecord Peyrol, who won her stepchildren's instant approval. Two years later Rosalie officially changed her first name, dropping the last three letters. As Rosa Bonheur she exhibited six pictures at the Salon of 1845, among them *Ram, Ewes, and Lamb* and *Head of a Ram*, and won a third-class medal.

Since Sophie Bonheur's death in 1833, Juliette had been boarding in Bordeaux with family friends. In 1845 Rosa went to Bordeaux and brought her sister to the home the family had bought on the outskirts of Paris. During her brief Bordeaux stay, Rosa had spent hours out in the country sketching shepherds and their flocks.

Marguerite Bonheur came from the Auvergne and took Rosa back there in 1846 on a family visit; the craggy, forested uplands and the simple peasants in the fields made a lasting impact on the young artist. Home again, she felt convinced of her sister's and her brothers' talents and persuaded their father to join her in giving them lessons. During the evening drawing sessions, family members took turns reading aloud. Auguste and Isidore, also interested in animal painting, showed such progress that

together with Rosa and their father they exhibited at the 1848 Salon, a remarkable family achievement, as friends noted. The distinguished jury included Eugène Delacroix, Jules Messonier, Camille Corot, and Jean Auguste Dominique Ingres. Rosa, who showed eight works, walked off with a gold medal for *Red Oxen of Cantal,* based on her trip to the Auvergne with her stepmother. Auguste submitted a pensive portrait of his sister Rosa.

That 1848 Salon opened amid a highly volatile atmosphere. While enriching the middle class, the Industrial Revolution had created an urban proletariat that seethed with resentment over its poverty. In February mob rioting had overthrown the unpopular Louis Philippe and ushered in a provisional government that covered the city with red flags. Elections in April resulted in a Second Republic. Its president, Prince Louis Napoleon Bonaparte, nephew of the great Napoleon, was backed by banking interests, but had a genuine feeling for the workers. Universal male suffrage was proclaimed for the first time in French history.

Just after Rosa's Salon success, she and Nathalie Micas, increasingly devoted to each other, traveled to the Nivernais, where Rosa sketched cattle. Back in Paris, she welcomed the birth of her half-brother Germain but, needing more room, determined to rent a studio. There she began work on the huge *Ploughing in the Nivernais,* commissioned by the government; its depiction of weary peasants and oxen had wide appeal for critics and the public.

Raymond Bonheur died in 1849, and Rosa, with Juliette as assistant, succeeded him as director of the drawing school. Actually, Juliette was more in command, for Rosa was engrossed in her painting. Raymond had long ago deeply engrained in his older daughter his enthusiasm for natural landscape. Unfortunately he died just before Rosa's 1849 success with *Ploughing in the Nivernais,* which brought an offer of 3000 francs from the Luxembourg Palace. A year later, helped by Auguste, she made a second version, which she sold for 4000 francs, sharing the sum with him. Meanwhile she had sat for a rather pretty-faced portrait by Édouard Louis Dubufe. Since she painted cows so frequently, one was included in the picture. Characteristically, Bonheur insisted on painting the animal herself.

Following her father's death, she made two important decisions. To the consternation of her relatives she moved in with the Micas family and also began a long association with the Tedesco brothers, art dealers. Nathalie's health often broke down, and Rosa gladly accompanied her to various spas and to the Pyrenees, where they spent four months.

Opposite: **Rosa Bonheur, *Ploughing in the Nivernais* (1849), oil on canvas 68¾ × 104 in., Musée d'Orsay, Cliché des Musées Nationaux, Paris.**

Again the winds of political change were blowing strongly. Louis Napoleon Bonaparte staged a coup d'état in 1851; a year later he proclaimed himself Emperor Napoleon III.

Determined to be anatomically accurate, Bonheur by now had steeled herself to enter slaughterhouses and to buy for study animal parts not ordinarily sold by the local butcher. Moreover, she frequented horse fairs and cattle markets and claimed to find masculine attire most suitable for such outings. Ultimately she would admit to having been influenced by the writer George Sand, who wore trousers and jackets with great flair. Sand affected Bonheur in other ways too, especially with her credo, "Art for art's sake is a vain word. But art for truth, art for the beautiful, and the good, that is a religion that I see."

In her own studio, the small, boyish-looking Rosa preferred trousers, worn under a Breton smock. To avoid any public harassment she obtained a special permit to dress like a man when on her sketching trips. Her costume dictated cropping her hair, and it probably encouraged her enthusiasm for cigarettes. Such a lifestyle made her the target of barbs and jibes, which her good humor allowed her to take in stride. She well understood that her trousers contrasted sharply with the voluminous crinolines and flounces made fashionable by the beautiful young Empress Eugénie.

By now she had permanently settled in with the Micases. She always claimed that on his deathbed M. Micas had asked that she and his daughter stay together. The arrangement, freeing her from housekeeping and financial management, was fortunate. Rumors to the contrary, her relationship with Nathalie remained platonic. In her old age Bonheur remarked that had she been a man, she would have asked her friend to marry her.

She still associated with old Saint-Simonians, friends of her father, some of whom the new emperor heeded seriously. On the whole, the Second Empire suited Rosa Bonheur, and its tastes helped her prosper. She attended the theater regularly and freely participated in social life, but always relished her reputation as an original personality, who rode her horse astride through city streets and who, at parties, refused to retire with the women after dinner, tarrying with the men to puff her cigarettes.

For the 1853 Salon, Bonheur submitted a huge canvas and earned a gold medal. *The Horse Fair,* with its superb modeling of percherons viewed from many angles, is generally regarded as her most impressive work. Beyond doubt it is her most famous. While working on it, she had hung on her walls copies of Theodore Géricault's horse studies, which inspired her to paint in a broad manner.

Ernest Gambart, a leading European art dealer, paid 40,000 francs for

the picture in 1855 and put it on exhibit in Great Britain, charging one shilling per viewer. With typical French practicality—"I mean to earn a good deal of the 'filthy lucre,' for it is only with that that you can do what you like"—Bonheur hurried to paint a quarter-size version which, after being engraved by Thomas Landseer, was sold to an English collector for 75,000 francs.

Gambart and Bonheur had first done business together in 1851 when he had staged a large foreign exhibit in London and included her *Charcoal Burners in Auvergne Crossing a Moor*. The pre–Raphaelite painter and poet Dante Gabriel Rossetti praised it as the "best work in the place."

Savoring her success, Rosa traveled with Nathalie again to the Pyrenees, this time meeting some locally well-known smugglers. After their homecoming they rented a larger studio for Rosa in the rue d'Assis with accommodations for a growing menagerie.

Ploughing Scene (1854) seemed similar to *Ploughing in the Nivernais* except that instead of several laborers there is only one. For her poetic *Haymaking in the Auvergne*, based on sketches made nine years earlier and shown at the Exposition Universelle in Paris in 1855, Bonheur received a gold medal and had the satisfaction of seeing the picture hung as a pendant piece to *Ploughing in the Nivernais* at the Luxembourg. *Gathering for the Hunt*, the next year, displayed her continuing interest in peasant life. Then, after having submitted more than 50 works to the Salon, she grew bored and decided not to exhibit regularly any more. Meanwhile, in teaching the "science of drawing," she, like her father, advocated direct observation and analytic study; more, she constantly reminded her young pupils of the possibility of new roles for women in an industrial society.

Well aware of the warm reception of *The Horse Fair* and the popularity of landscapes and animal studies in Victorian England, the astute Gambart now arranged a tour of England and Scotland for himself, Rosa, and Nathalie in 1856. It was not lost on the art establishment that Thomas Landseer's engraving of *The Horse Fair* had been dedicated to Queen Victoria, and such luminaries as Sir Edwin Landseer, John Ruskin, William Morris, and Sir Charles Eastlake, president of the Royal Academy, proved eager to meet the vivacious if eccentric Frenchwoman. Landseer, dean of English animal painters, sat to her for his portrait, but Ruskin announced he did not care for her work. The diminutive queen, who admired Bonheur's anatomical accuracy and empathy for animals, granted her an audience. An English genre painter, Frederick Goodall, who showed her painting cattle, denied that she was masculine. He told how she had put out her little foot and begged him to take notice of its size. "Her face was not strictly beautiful, or fine, or handsome, but her expression was so vivacious and intelligent that I thought her charming."

The Scottish part of the tour especially excited Bonheur, who exclaimed over the lochs, mists, oxen, and sheep she constantly sketched. It pleased her immensely to visit the places connected with Sir Walter Scott, who had remained one of her literary heroes.

Within two years of Bonheur's wildly enthusiastic British reception, Gambart talked an American entrepreneur into buying the original *Horse Fair* and touring it from Boston to New Orleans. Soon she had new admirers in the United States.

With a constant round of visitors, the Paris studio had become too hectic and noisy, and in 1860 Bonheur and Nathalie bought the stately Château de By near the northern edge of the vast forest of Fontainebleau and moved there with Mme. Micas. Once remote and mysterious, the forest was now easily available by railroad. With the manor came acres of pasture and woodland. Speedily Bonheur ordered the construction of a special brick addition to contain studio, carriage house, and coachman's quarters. With this move, she resigned the directorship of the drawing school.

Once she had established herself at By, the emperor Napoleon began granting her special favors. At his command, his master of the hunt gave her permission to shoot in the Fontainebleau forest, for in spite of her love for animals, Bonheur liked to hunt small game with a rifle. In the forest she enjoyed chatting with the charcoal burners, woodcutters, and quarrymen. (She apparently did not associate with the landscape artists who had settled in the village of Barbizon.)

In 1864 Napoleon and Eugénie invited her to a luncheon at the Château de Fontainebleau. Conscious of her ignorance about court protocol, she felt somewhat anxious, but acquitted herself well enough. A year later Eugénie, temporarily acting as regent, came by and surprised Bonheur in her studio with the cross of Chevalier of the Legion of Honor. "Genius has no sex," said the empress, well aware that Bonheur was the first woman to receive this honor. Shortly afterward, the ill-fated emperor Maximilian and his wife, Carlota, awarded Bonheur the Cross of San Carlos of Mexico. Almost simultaneously she received another distinction when her smaller version of *The Horse Fair* became the first painting by a living artist to be exhibited at the National Gallery in London.

Through the 1860s she churned out for Gambart countless portraits of dogs, horses, reindeer, and deer. Sheep she painted over and over in careful studies. Two versions of *Sheep by the Sea* (1865 and 1869) would place them in an unusual setting.

For 12 years her work had not been seen at the official Salon. Finally in 1867 she sent ten pieces, nine belonging to English collectors and one to Empress Eugénie, to the Salon of the Exposition Universelle. That year also, with great familial loyalty, she intervened with the authorities so that

her brother Auguste could receive the cross of Chevalier of the Legion of Honor.

In spite of her socialist upbringing, Bonheur remained well-disposed toward Napoleon III, reminding herself that he seemed interested in many a Saint-Simonian scheme for an industrialized society. And she knew well that under the Second Empire she had become a financial success.

Therefore she reacted with acute dismay to the brief Franco-Prussian War of 1870. At By she responded initially by drilling with her male neighbors. Then, fearful of famine caused by the invading Prussians, she started painting those animals she thought she and Nathalie might have to eat as a last resort. Her worries intensified as news reached her of the bloody days during the Paris Commune the next year. Meanwhile Crown Prince Friedrich sent her a safe-conduct document, but she refused to leave. Eventually some Prussian officers were billeted in her château; stonily she forbade them to enter her studio.

Once the Third Republic was established, Bonheur followed in Eugène Delacroix's footsteps by painting for a number of years "les grandes fauves"—lions, tigers, and panthers. *Royalty at Home* (1885) shows male and female lions relaxed if vigilant; *King of the Desert* portrays a fierce lion.

She seemed happy to be removed from the Parisian art world. Partly because of her growing renown in Great Britain and the United States, her reputation in France had declined. Further, she resented gossip about her and Nathalie's supposed lesbianism. Nonetheless she carried on a teasing correspondence with a young artist, Paul Chardin, and went out of her way, whenever possible, to encourage young women artists, whom she called "colleagues of the palette."

The waxen-faced Nathalie, who liked to dress flamboyantly in scarlet dresses and feathered hats, sometimes stood at an easel beside Rosa, but could never match her companion's talent. Usually she acted as a studio assistant, putting on underpaintings or tracing designs on canvas. Bonheur was invariably a vigilant technician, taking great care of her palettes and brushes and seeing that the underpaintings dried thoroughly even if the procedure took two years.

She firmly believed that her companion had a talent in another direction. When Nathalie devised a special express train brake, Bonheur built a miniature railway for her at By. Though a test proved that the brake worked properly, Nathalie never could sell her idea. Loyally Bonheur insisted the reason was that "the prospect had emerged from the feminine brain." Some years later an Englishman made some slight changes in the Micas design and sold it to the railroads.

Because of Nathalie's poor health, the two women had spent most

winters in Nice after 1875. Though decidedly plump by now, Rosa continued to wear trousers for her sketching trips and was only amused when people said she looked like a little old man. At first she and Nathalie stayed at Gambart's villa. Later they bought their own house, the Villa Bornala, and built an adjacent studio. To the By menagerie Gambart sent two lions, whose advent seemed more exciting than the honorary crosses Bonheur received from the kings of Spain and Belgium. The lions died, but were succeeded by others like little Fathma, who became a favorite model.

Assiduously Gambart staged exhibitions that always included Bonheur's canvases and with the Tedesco brothers sought commissions which kept her cranking out animal studies.

As she grew older, she identified more and more with animals, establishing an ever closer relationship with her pets. Of them all she claimed she preferred horses.

Nathalie Micas died in June 1889. As a friend said, she had "made herself small ungrudgingly so that Rosa might become celebrated." Three months later a special visitor provided distraction for the distraught Bonheur.

William S. Cody ("Buffalo Bill"), on tour with his Wild West show, came to Paris, and Bonheur, always an Americanophile, asked his advice about two untamable mustangs shipped to her several months earlier by John Arbuckle, a New York coffee merchant. Buffalo Bill immediately sent to By two of his cowboys, who lassoed the mustangs and took them off to join the Wild West show. The show, which included an Indian encampment, remained in Paris for seven months, and for a period Bonheur came daily to sketch bison, horses, and Indians. She also painted Cody on his prancing white horse.

Within a few weeks of Buffalo Bill's departure, a new distraction turned up. Arbuckle arrived at By, accompanied by Anna Klumpke, a young American artist living in Paris, who acted as his interpreter. From childhood Anna had admired Bonheur's work; she had even owned a Rosa Bonheur doll.

The artist sensed in her a possible successor to Nathalie though Anna was only in her early 30s. Better still, Rosa thought the young woman resembled the long-dead Sophie Bonheur.

Rosa had once described her work as being in a "matter-of-fact-in-everything American style." Not surprisingly she gained new American admirers who bought four of her paintings, *The King of the Forest, The Stampede, Sheep,* and *The Pastoral,* which were shown at the Columbian Exposition in Chicago in 1893.

Meanwhile her sister Juliette, who under Bonheur's guidance had become a competent animal painter, died in 1891. An unhappy Bonheur

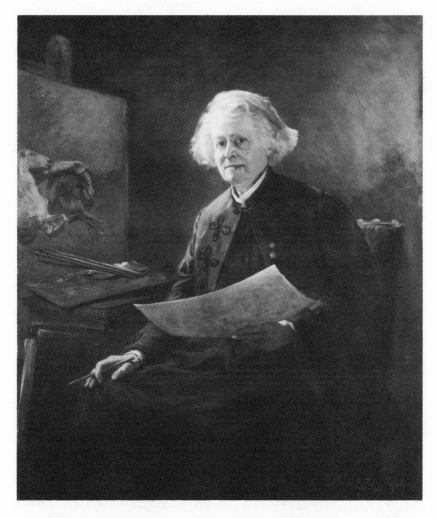

Anna Elizabeth Klumpke, *Rosa Bonheur*, (1898), oil on canvas, 46⅛ × 38⅝ in., The Metropolitan Museum of Art, New York, gift of the artist in memory of Rosa Bonheur, 1922 (22.222).

was cheered by a second visit from Anna Klumpke, who left shortly for the United States to complete some portrait commissions.

Already dripping medals, Bonheur in 1894 was named an officer of the Legion of Honor, the first woman of such rank, just as she had been the first woman chevalier. Within a year her brother Isidore, a sculptor, became the third member of the Bonheur family to receive the Legion's cross. That year too brought Anna Klumpke back for several visits to By. Bonheur, completing a series of paintings on the American West, asked

her to get a sample of prairie grass so that she could paint more realistically.

After much correspondence Klumpke came to By in 1898 to paint Rosa's portrait. A couple of months later Bonheur invited her to stay on indefinitely and to work on a biography that Nathalie had never been able to start. By late fall Bonheur named Anna as her sole heiress. Early in 1899 the two companions built a new studio, where Klumpke helped Bonheur finish *Wheat Threshing in the Camargue*, which she had begun 35 years before.

The aging but still vigorous artist often thought nostalgically of the Second Empire and its deposed emperor and empress. Napoleon had died, but once again to Bonheur's great pleasure she met with Eugénie, who invited her to lunch at Cap Martin. The empress had recently lost her son, an only child, on military duty in Zululand; her grief unleashed Rosa's tears for the mother she had never ceased to mourn.

In May 1899, Rosa Bonheur fell ill and died of a pulmonary infection on the 25th. Not long before the end she had told Anna, "I think Art. It is my husband, my world, my life dream, the life I breathe. I know nothing else, feel nothing else, think nothing else."

But she had thought a lot about her two special friends. She was buried in the famous Père Lachaise cemetery in Paris next to Nathalie. Forty-six years later, Anna's ashes would be placed next to hers. Fittingly Rosa Bonheur's tombstone was inscribed, "L'amitié c'est l'affection divine."

Rosa Bonheur : Works Mentioned

Rabbits Nibbling Carrots (1840), Musée des Beaux Arts, Bordeaux
Head of a Ram (1845), Musée des Beaux Arts, Bordeaux
Ploughing in the Nivernais (1849), Musée d'Orsay, Paris
The Horse Fair (1853), Metropolitan Museum of Art, New York
Ploughing Scene (1854), Walters Art Gallery, Baltimore
Haymaking in the Auvergne (1855), Musée National du Château de Fontainebleau, France
Gathering for the Hunt (1856), The Pioneer Museum and Haggin Galleries, Stockton, California
Sheep by the Sea (1865), Norton Simon Museum of Art, Pasadena, California
Sheep by the Sea (1869), National Museum of Women in the Arts, Washington, D.C.
Royalty at Home (1885), Minneapolis Institute of Art
The King of the Desert (n.d.), The Forbes Magazine Collection, New York
Col. William F. "Buffalo Bill" Cody (1889), Whitney Gallery of Western Art, Cody, Wyoming

The King of the Forest, Warner Collection, Gulf States Paper Corporation, Tuscaloosa, Alabama

Wheat Threshing in the Camargue (1864–99), Musée National du Château de Fontainbleau, France

The Rosa Bonheur Galleries at the Musée National du Château de Fontainebleau (collection, including several unfinished canvases, donated by Anna Klumpke) are closed to the general public.

VI

Berthe Morisot

(1841–1895)

For Berthe Morisot, art offered the best way to reflect and interpret the fugitive notes of her personal experience. But though that vision was rooted in a secure, protected position, she often felt a shattering sense of failure, which posterity has disproved.

As a civil servant who moved frequently from post to post, her father, Edme Tiburce Morisot, owed much of his career to the influential family of his wife, Marie Cornélie Thomas. She also gave him three daughters, Yves (1836), Edma (1839), and then Berthe Marie Pauline, born at Bourges on January 14, 1841. A son, Tiburce, would arrive seven years later. Soon after Berthe's birth, the family settled in Limoges, the porcelain capital, where her father served as prefect of the Haute-Vienne. Over the next few years he held similar posts in Caen and Rennes.

About the time Napoleon III proclaimed his gaudy Second Empire, Morisot *père* took a new position in the national accounting office, and the family settled in Passy, a wealthy western suburb of Paris. The Morisot girls attended a private school and took piano lessons. Sometimes they modeled objects in mud or clay.

When Berthe was 16, Mme. Morisot hit upon the idea of presenting to her husband on his name day a special gift: three drawings by his daughters. Accordingly she brought the girls to a drawing master, Geoffrey Alphonse Chocarne, against whose dullness they all rebelled. Soon, indeed, Yves abandoned art altogether. The next master, Joseph Guichard, who had studied with Jean Auguste Dominique Ingres and Eugène Delacroix, found such talent in Edma and Berthe that later he wrote their mother: With his teaching and their skill they were apt to become true painters! As their brother Tiburce later quoted him: "In the upper-class milieu to which you belong, this will be revolutionary, I might also say catastrophic." The official academy, the École des Beaux-Arts, still

refused to admit women; hence their best alternative was copying old masters at the Louvre. Under Guichard's supervision, Edma and Berthe began working there in the spring of 1858, and Berthe's ability to replicate Paolo Veronese's technique on her canvas soon attracted attention. There at the Grande Gallerie, swarming with eager painters, Guichard introduced his pupils to the engraver Félix Braquemond and his friend young Henri Fantin-Latour, always filled with infectious enthusiasm: "The Louvre! the Louvre! There is only the Louvre! You can never make too many copies."

As the two sisters widened their artistic circle, they also met through Guichard the patriarchal landscape painter Camille Corot. Berthe and Edma, already favorably inclined toward *plein-air* painting, found his lyrical style highly appealing. So they persuaded their parents to spend the summer of 1861 near his house at Ville d'Avray, eight miles from Paris, where they could be taught in an informal way as they set their easels close to his on the banks of the Oise River between Pontoise and Auvers. They even charmed the customarily shy and reclusive Corot into attending Cornélie Morisot's soirées during the winter. Corot preferred Edma's more docile work, but in Berthe he found unusual grace and talent combined with quiet melancholy. The following summer Berthe and Edma rode through the Pyrenees on mule and horseback.

In 1863, before leaving on one of his rare journeys, Corot asked his pupil Achille François Oudinot to teach the Morisot sisters. Oudinot advised their parents to rent a house at Chou on the banks of the Oise, where members of the Barbizon School worked "on location." Once the family had found a place, he introduced the sisters to Honoré Daumier and Charles Daubigny, who usually painted in his studio boat.

A remarkable event had just set Paris on its ear. After the intelligentsia had loudly decried the rejection of many entries by young French painters, Napoleon III offered exhibition space in the Palais de l'Industrie; it was quickly dubbed the Salon des Refusés. There Édouard Manet's *Luncheon on the Grass* provoked instant outrage. The public judged it too extreme, with its rapid brushwork and flattened silhouettes and perspective; too daring, with its subjects, a naked woman picnicking with two men in contemporary dress. Berthe, however, felt especially attracted to the startling break with traditional style. Just at this time Edma tellingly portrayed her younger sister, dark hair falling around her shoulders as she stood before her easel in intense, introspective mood. That winter Berthe studied sculpture for six months with Aimé Millet and posed for one of his artistic medallions.

Not impressed by the Salon des Refusés, Oudinot advised his talented pupils to submit their Corot-influenced landscapes to the 1864 Salon. Both young women were accepted, but only one of Edma's

viewscapes has survived. Meanwhile Tiburce Morisot senior had gained a higher post at the national accounting office and moved his family to a larger house in Passy where, though only a tenant, he built a studio for his daughters in the garden.

By this time the sisters had become so enthusiastic about painting outdoors that for their summer holiday they easily persuaded their parents to rent the painter Léon Riesener's country house, a former mill, at Beuzeval on the fashionable Normandy coast. In a letter, their brother Tiburce described how Berthe with pointed stick and sketching supplies in her knapsack spent entire days on the cliffs. She had hoped that Corot would come to Beuzeval, but he gracefully declined her invitation, encouraging her to work "hard and perseveringly," and not to think too much about Papa Corot. "Nature is the best of counselors," he wrote.

One evening at Beuzeval, Berthe began talking with a peasant she found full of common sense. After several conversations she learned that he was a former convict from the Toulon prison. Unperturbed, she remarked that now she understood why he had repeatedly expressed his dislike for the south of France.

Probably through Riesener's daughter she met a promising young Swiss sculptor, Marcello (Adélaïde d'Affry, the Duchess Castiglione Colonne), to whom Berthe felt especially close. A bit of a snob, Marcello was not equally warm.

In 1865, Berthe and Edma again showed pictures at the Salon. That was the year Manet caused another uproar when he submitted *Olympia*, a simple, blunt presentation of a young *demimondaine* resting naked on a bed while her black maid stands ready to hand her a bouquet. At the Salon, Mme. Morisot complained that she had a hard time locating her daughters' pictures. Finally she found Berthe's *Étude*, her first exhibited figure painting, "well lighted," and another picture by Edma "on the line" (at eye level).

The Morisots summered at the little family resort of Les-Petites-Dalles on the Normandy coast. There Berthe painted *Thatched Cottage in Normandy*, which shows her very personal reaction to the radiance of light and which to modern eyes presages the Impressionist style.

Yves had married Théodore Gobillard, a tax collector, in 1866, and in 1867 Berthe and Edma made their last joint painting trip to Brittany, visiting the Gobillards at Quimper and painting from a boat on the Pont-Aven River.

The next year Berthe met Édouard Manet. After seeing one of her pictures, he had spoken admiringly about her to Fantin-Latour, who had remarked that in addition to having much talent, Berthe was one of the most beautiful girls he had seen in years. Unfortunately, he had added, she seemed dead set against marriage. One day as Berthe and Edma stood

copying a Rubens at the Louvre, Fantin introduced them to his friend Manet, who later wrote flippantly to him: "I agree with you, the demoiselles Morisot are charming. Too bad they are not men. However, as women they can further the cause of painting by each marrying an academician and by starting trouble in the company of those senile fellows. But that would be asking of them great self-sacrifices indeed."

Before Manet, Berthe had met some of the spirited and rebellious young *plein-air* artists, who over beer, coffee, and cigarettes debated endlessly at the Café Guerbois in the Batignolles quarter. When Émile Zola wrote a review of the 1868 Salon, he included Berthe with several of the Batignolles regulars—Manet, Claude Monet, Camille Pissarro, and Frédéric Bazille—in a group of artists for whom he felt the greatest sympathy. Auguste Renoir, Alfred Sisley, Armand Guillaumin, and Edgar Degas also were café faithfuls. That year, too, Berthe became acquainted with Pierre Puvis de Chavannes, grown wealthy from his decorative paintings. Puvis was one of the distinguished bachelors who attended the Morisots' Tuesday evening soirées; he admired both the artist and her art.

Finding her mournful yet fiery eyes particularly appropriate for the Spanish theme he contemplated, Manet urged Berthe to be one of his models for *The Balcony*. (Actually her eyes were green, but he would show them black.) On the grounds of social propriety, Mme. Morisot accompanied her tall, slender daughter to his studio. While Berthe, a rather seductive figure in bluish white crinoline, sat with a fan, the other two models, landscape painter Antoine Guillemet and violinist Fanny Claes, declared themselves worn out with standing. Commenting on the sulphur green Manet used so liberally, Berthe said that his painting "gave the impression of wild or even slightly green fruit."

Though the 1869 Salon accepted *The Balcony*, Manet worried acutely about its reception. Meeting him in one of the Salon rooms, Berthe discovered him "looking dazed." As she wrote: "He begged me to go see his painting because he did not dare move a step. He laughed somewhat nervously, all the while assuring me that his picture was very bad and adding in the same breath that it would be a great success." Berthe herself thought that she looked "more strange than ugly," but acknowledged that the expression "femme fatale" had been making the rounds. About this time, highly critical of her own work, she destroyed much of what she painted before her thirtieth birthday.

In 1869 Berthe lost her almost constant working companion when Edma became the bride of Adolphe Pontillon, a naval officer, and soon stopped painting altogether. During a visit to Adolphe's naval base in Brittany, Berthe painted *The Harbor at Lorient*, with Edma, parasol in hand, sitting on a parapet and gazing at the water, its colors are reflected with

broad strokes in her white dress. Manet liked the painting so much that Berthe gave it to him. Also completed at Lorient was *Young Woman at a Window* [The Artist's Sister at a Window], catching Edma, in a long, white ruffled dress, seated by French doors open to the street, her attention fixed only on her fan.

Morisot, perhaps half in love with Édouard Manet, became jealous when he took the buxom Eva Gonzalès, eight years her junior, as his declared pupil. Berthe complained to Edma that Manet lectured her too much and held up as an example "that everlasting Mlle. Gonzalès"; he was starting her portrait for the twentieth time. Mme. Morisot thought much better of Eva and even had designs of catching her as a bride for her son Tiburce: "She is ravishing in every respect and very intelligent, and such good manners."

Once more Manet asked Berthe to go through the ordeal of sitting for him. He caught her refined poise in an 1869 watercolor and in *Resting*, an oil probably painted in 1870, in which, arms outflung, she relaxes gracefully on a divan. The picture was not shown, however, until 1873, when a newspaper review carped that "this slut, flopping on a couch, might be sleeping off her wine."

At the 1870 Salon, along with the graceful and calm painting of Edma at the window from the year before, Berthe showed *Mme. Morisot and Her Daughter Mme. Pontillon* [The Mother and Sister of the Artist], which she had finished a week before the birth of Edma's first daughter in Passy. When she appeared confused and hesitant about submitting it to the Salon, Manet offered to look at it and advise her. As she remembered later, he started to change her painting with great gusto. "He went from the skirt to the bodice, the bodice to the head, and then he began on the background. He was joking wildly, handing me my palette, taking it back again until. . .we had the most appalling mess." The mess, however, had managed to survive the Salon jury.

National tragedy lay just ahead. In the summer of 1870, Prince Otto von Bismarck, prime minister of Prussia, goaded Napoleon III into declaring war, and in early autumn the Prussians cut down the French army at Sedan, capturing and imprisoning the emperor. To continue French resistance, Leon Gambetta formed a government, but, as the enemy occupied province after province, Paris fell under siege with a nightly Prussian bombardment.

The younger Tiburce Morisot went to the front and achieved the rank of lieutenant. Like Degas, Manet enlisted in the civilian militia, and Berthe jested that he spent most of his time changing his pretty uniforms. Bravely she and her parents refused his entreaties to leave the city. Aerial balloons carried out letters; writing to Edma, Berthe declared that she was becoming accustomed to the thunder of cannon: "I am now absolutely

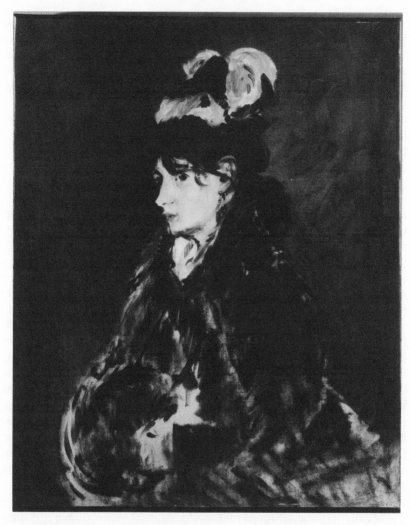

Édouard Manet, *Portrait of Berthe Morisot* (c. 1869), oil on canvas, 29 × 23⅝ in., The Cleveland Museum of Art, bequest of Leonard C. Hanna, Jr. (58.34).

inured to war and capable of enduring anything." Mme. Morisot, however, informed Edma of their small family's loneliness and Berthe's fragile health, broken by the lack of fuel and food during the siege. From then on, Berthe, slimmer and more delicate-looking than ever, frequently suffered from digestive upsets.

The city capitulated at the end of January 1871. Berthe meanwhile wrote to Edma that everybody disgusted her, even her best friends: "Selfishness, indifference, prejudice." Then, dissatisfied with surrender

terms, Parisians drove the government leaders to Versailles and established a communal regime. Promptly the Versailles group raised an army, and Paris again lay under siege while the Prussian victors stayed neutral. Within a couple of months after the streets had run with the blood of 17,000 Communards and their sympathizers, government troops crushed the Commune. The Morisots, however, escaped the horrors of this second siege, having taken Puvis de Chavanne's advice to remove themselves to the western suburb of St. Germain-en-Laye, where they still could hear the cannonades.

Soon Berthe left for Cherbourg to stay with Edma. There she spent most of her time working in watercolors. *At the Edge of the Forest* and *Woman and Child in a Meadow,* both with a hint of melancholy, portray Edma and her tiny daughter Jeanne. (A mother seated in the grass would become one of Berthe's favorite motifs.) Again she showed her sister in her first pastel, an elegant portrait.

By October she returned to Passy to find that Parisians had staged a swift recovery. Mme. Morisot, who often had deplored her youngest daughter's lack of the kind of talent "that has commercial value or wins public recognition," now expressed anxiety over Berthe's impending spinsterhood, though several candidates crossed the horizon. Of them all, Berthe felt most drawn to Manet's 38-year-old brother, Eugène, a charming, cultured man-about-town, well enough off from family land holdings to live without any profession.

Again Morisot sat in Manet's studio and worked with him. Though he did not consider her his student, under his influence she moved away from the Barbizon School, experimented more, brightened her low-keyed harmonies, and freed her brushstrokes. She also continued to spend time in other artistic company. Edma envied her: "Your life sounds fascinating at the moment; to spend the afternoon chatting with Degas as he works, to laugh with Manet and philosophize with Puvis seems enchanting to me now that I am so far away."

Again, too, she sat for Manet. *Berthe Morisot with a Bunch of Violets* is considered one of his finest portraits; faintly melancholy eyes dominate her pale, fine-featured face framed by wisps of chestnut hair and black bonnet strings.

To the Salon of 1872, Morisot sent her now famous *The Cradle,* showing Edma and her second daughter, Blanche. The mother's black dress contrasts artfully with the blue-white curtains and the gauzy muslin covering for the sleeping child. Charles Stuckey has pointed out that it is "a picture about looking," a subject Morisot preferred for several years.

Convinced by this time that landscape with figures was the highest type of painting, she finished a fresh and lively *View of Paris from the*

Trocadéro. From the same period came *On the Balcony,* with Yves Gobillard and her daughter Paule (Bichette) gazing over an iron railing at the Parisian skyline. Morisot felt especially pleased with this picture and made a small watercolor copy. Also that year, a visit to Madrid acquainted her with the works of Diego Velásquez and Francisco Goya, who had so clearly inspired Manet. She had lost her studio, for the Morisots had moved again, and she painted in her room.

During the next summer she stayed with Edma in Maurecourt, close to the area where she had worked on her first landscapes ten years earlier. *Hide and Seek,* finished there, became one of her most successful outdoor scenes.

Returning to Paris, Morisot saw more and more of the avant-garde Batignolles painters. As a well-bred young woman, she could not properly attend their boisterous gatherings, but she met them frequently in Manet's home, where his Dutch-born wife, Suzanne, a pianist, held Thursday musical soirées. Manet enjoyed the young men's company and enthusiasm; he in turn, together with the poet Charles Baudelaire, inspired them by emphasizing modernity. Largely encouraged by Morisot, Manet too tried his hand at painting outdoors. But, still hungering for acceptance by the establishment and having had his fill of artistic scandal, he refused to be considered a bona fide member of a group widely regarded as radical. He gave as his excuse his reluctance to roam the fields like Monet and Pissarro. Nonetheless, he loyally supported them against their detractors.

Morisot, on the other hand, warmly responded to the Batignolles group's determination to translate direct visual stimulation with as little change as possible. Their quivering light and dissolution of forms in a soft shimmer, their accidental poses and sparkling spontaneity delighted her. As she once wrote in her diary, "To catch the fleeting moment — anything, however small, a smile, a flower, a fruit is an ambition still unfulfilled." Under their influence, she no longer hid her brush strokes — at times some of them became a tangle.

The Salon juries had begun rejecting the innovators' paintings, and poverty plagued them even more when the postwar depression threw Paul Durand-Ruel, the art dealer who had befriended them, into severe financial difficulties. So, forming a joint stock corporation called Anonymous Cooperative Society of Artists, Sculptors, Engravers, etc., they planned their own exhibit without juries or awards. Against Manet's advice Morisot joined Monet, Bazille, Pissarro, Degas, Renoir, and Sisley in an independent exhibit. With that courageous step she became one of the first women to defy the art establishment openly. She further vowed never again to show any pictures at the Salon, which had accepted her work for ten years.

For the show, thirty artists contributed 165 pieces, hung by Renoir on the reddish-brown walls of an upstairs suite, formerly home to the photographer Nadar. The exhibit opened on April 15, 1874, for a month, and more than three thousand talkative visitors attended. Berthe showed four oils, three watercolors, and two pastels, among them *The Harbor at Lorient, Hide and Seek, The Cradle*, and *Reading*, another delicate portrait of Edma enjoying a book outdoors, painted the year before.

Of ten important reviews, six were favorable, but the four negative ones attracted more notice. Louis Leroy penned the most scathing, which appeared first. Jeering at the title of Monet's *Impression: Sunrise*, he coined the term "Impressionists." The painting itself he called "less finished than the crudest wallpaper." Viciously he also snapped at Morisot's *Cradle*: "The young lady is not interested in reproducing trifling details. When she has a hand to paint, she paints exactly as many brushstrokes lengthwise as there are fingers, and the business is done."

Worrying over Leroy's review and three other sarcastic articles, the newly widowed Mme. Morisot asked Berthe's old teacher Guichard to attend the exhibit and report back to her. He peremptorily dismissed it: "I became anguished on seeing the works of your daughter in these pernicious surroundings. I said to myself, 'One doesn't live with madmen!' Manet was right in opposing participation.... One finds here and there some excellent fragments, but they all have more or less a cross-eyed look."

During the exhibit Morisot stayed again at Maurecourt, where she painted *The Lilacs at Maurecourt*, notable for its subtle touch. After Renoir had finally taken down the exhibit paintings in Paris, she and her mother left for a summer holiday in Fécamp. The Manets vacationed nearby, and now Eugène began wooing her assiduously. One day while he and Berthe sketched a boat-building yard, he proposed marriage, and she accepted him.

In the autumn, Édouard Manet made two portraits of his future sister-in-law. The first, a striking oil, showed her as "the capable, archetypical, intellectual modern woman." The second, *Berthe Morisot with a Fan*, became his wedding gift. Degas, for his part, presented the couple with a portrait of Eugène seated on the grass. Meanwhile Morisot painted a portrait of Mme. Marie Hubbard, its sensuous overtones enriching the recumbent figure of a young woman with a fan, a recurring symbol.

About this time Berthe met the poet Stéphane Mallarmé, who eventually would become her best friend. Her father had died in January 1874. Because the year of mourning had not yet passed, the Morisot-Manet wedding, three days before Christmas, took place, Berthe noted, "with the least pomp and without guests." The bride wore a simple street dress. Though she wrote her brother Tiburce that she had "entered the positive

stage of life," she was not prepared to sink into domesticity or an uneventful life of comfort. The year before, she had written Edma: "Men are inclined to believe that they fill all of one's life, but as for me, I think that no matter how much affection a woman has for her husband, it is not easy for her to break with a life of work." Fortunately for her, Eugène did not want her to stop painting.

Since the 1874 exhibit had failed to realize a profit, the Anonymous Cooperative Society dissolved at the end of the year. In March 1875, the financially pressed Renoir, Monet, and Sisley decided to hold an auction, though it was considered scandalous for artists themselves to do so. Morisot did not need the money as much as her friends did, but sympathetically she joined them; her pictures brought better prices than theirs.

That spring, when she and Eugène stayed at Gennevilliers, where the Manet family owned property, Berthe painted *In the Cornfield,* which her brother-in-law much admired. During a summer holiday on the Isle of Wight, she stood by the window of a rented boat to record her scenes, using a bold new shorthand of dashes, wobbly lines, scratches, and scumbles. Reluctantly her husband posed for her; *Eugène Manet on the Isle of Wight* shows him straddling a chair as he looks out at the garden and boats. From Cowes the couple went on to London, where Berthe wrote Edma that Eugène "would gladly spend his day on the Thames thinking of nothing." He had sought diplomatic posts in various foreign capitals, but had no luck. The river charmed Berthe too; she made frequent sketching and painting trips along its banks.

In 1876 the Independents — who had happily accepted Leroy's derogatory name of Impressionists — held another exhibit, and Morisot showed 14 oils, three watercolors, and three pastels. The critic Albert Wolff referred in *Le Figaro* to the second show as "a farce organized by five or six lunatics, one of whom is a woman. . . . In her case a feminine grace is maintained amid the outpourings of a delirious mind." Friends had to restrain Eugène Manet, at all times his wife's staunchest champion, from challenging Wolff to a duel. At the end of that year Morisot mourned the death of her mother, who had always been alternately supportive and demanding.

With the third Impressionist exhibit in 1877, an approving critic finally emerged, writing: ". . . Berthe Morisot has captured on her canvas the most fugitive notes with a delicacy of skill and a technique which earns her a place in the forefront of the Impressionist group." He particularly liked *In a Villa by the Seaside,* a "charming little landscape full of greenery and sunshine."

Between 1875 and 1879 Morisot made several variations on a dressing room theme, notably in *Young Woman Powdering Herself* and *Woman at*

Her Toilette. The same period produced more formally dressed figures: *Young Woman at a Ball, The Black Bodice,* a full length *Figure of a Woman* [Before the Theater], the throbbingly fresh *Summer* [Young Girl by the Window], and its companion portrait, *Winter,* whose models she had delicately integrated into their backgrounds.

With some difficulty, Berthe gave birth to her only child, Julie (Bibi), in November 1878. Though reluctant to be engulfed in settled domesticity, she took enthusiastically to motherhood and began painting Julie as a baby. In her soft innocence, the girl remained her mother's favorite model, sometimes posing with others.

Busy with maternal duties in the spring of 1879, Morisot missed the Impressionist show. But, choosing a less time-consuming medium, she did paint several watercolors. For the next four shows, she was joined by another woman, the American Mary Cassatt, who lived in Paris; Degas had first invited her to exhibit in 1879, the year Morisot was absent. Cassatt became a friend who sometimes, after a ride in the Bois de Boulogne, tethered her horse in Eugène Manet's garden. Always a shrewd bidder, at the auction of a bankrupt collector's holdings she obtained Berthe's *Woman at Her Toilette* for 95 francs.

In 1880 Morisot contributed the highly unusual—almost disembodied—*Julie and Her Wet Nurse,* showing the "second nurse" in the act of breastfeeding the artist's baby. Like their background, nurse and nursling were reduced almost to caricature.

For the summer of 1881, Berthe and Eugène rented a country house at Bougival, not far from Versailles, where an ailing Édouard Manet had taken a villa. Doctors had told him he had locomotor ataxia, a disorder of the nervous system. Here Morisot turned to garden pictures, using Eugène, Julie, and their maid Paisie as models.

Meanwhile in Paris, construction had begun on a large house on the rue de Villejust, where Eugène planned to realize extra income by renting out the top floors. Later that year the Manets stayed at Nice, then in early 1882 started on an Italian journey, which unexpectedly ended in Florence when Julie fell ill with bronchitis.

The little family hurried back to Nice, where Berthe and her daughter remained while Eugène returned to Paris to ready his wife's pictures for an Impressionist show. It was remarkable for bringing back Monet, Renoir, and Sisley, who had struck out on divergent paths and defected in 1880. Degas, miffed because many of the artists he had recruited were not included, refused to participate, and Cassatt followed his lead.

Another Bougival summer made Morisot increasingly aware of her brother-in-law's precarious health. Édouard was now at nearby Rueil. All along she had maintained a close artistic and personal relationship with

him, and it was as painful for her as it was for Eugène to watch him hobble around or sit listlessly in his armchair. In April 1883, gangrene set in and necessitated the amputation of one leg. After his death at the end of the month Berthe wrote to Edma: "His was a fearful death, and you will understand that this experience, combined with sadness at losing an old friend, and watching a whole world passing away beneath my eyes, has upset me terribly."

Even though Morisot had never been fond of Eva Gonzalès, who had achieved some success with her Salon pictures, she grieved over her death, which quickly followed that of Manet. Gonzalès had risen early from childbed to make a memorial wreath for her teacher and had been stricken with an embolism and heart attack.

The next year Berthe and Eugène organized a successful retrospective exhibition honoring his brother. That summer, at Bougival, she painted *The Garden*, the largest canvas she ever attempted. The house on the rue de Villejust was now finished. The little family moved into the ground floor apartment and according to plan rented out the other floors. Morisot organized her huge living room as a combined museum, studio, and salon, quietly whisking her painting materials to a closet when guests arrived.

Eugène's brother Gustave died at the close of 1884, and within a month, their mother also passed away. The self-portraits Morisot began in oils and pastels showed her face haggard with grief. She felt in a better mood by late summer of 1885 when she and Eugène and Julie visited art museums in Belgium and Holland, Morisot enthusiastically declaring, "Rubens certainly knew how to paint the sky of Flanders."

The sixth and last Impressionist exhibit, for which she, Degas, Cassatt, and another backer helped underwrite the expenses in exchange for any profits, took place in 1886. A young model, Isabelle Lambert, appeared in such studies as *The Bath* [Girl Arranging Her Hair] and *Getting out of Bed*. Feathery but complex, in its many-angled refraction of light, *In the Dining Room* [The Little Servant] depicts a domestic standing in the rue de Villejust house.

Helping prepare the exhibit, Eugène had argued strenuously against the inclusion of Georges Seurat, whose pointillist *Sunday Afternoon on the Island of Grand Jatte* stole the thunder. But Berthe's picture brought special praise from one critic: "She eliminates cumbersome epithets and heavy verbs in her terse sentences. Everything is subject and verb. She has a kind of telegraphic style."

A family vacation on the island of Jersey in the English Channel in June inspired some watercolors. Probably the finest was *Interior at Jersey*, showing Julie standing by the window, with dazzling interplay of whites — her dress, a draped sheet, dishes, tablecloth.

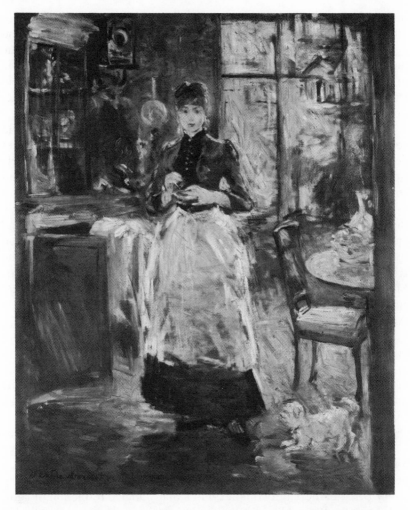

Berthe Morisot, *In the Dining Room* (1886), oil on canvas, 24⅛ × 19¾ in., National Gallery of Art, Washington, D.C., Chester Dale Collection.

After their return, Eugène fell ill. To divert him during his long convalescence, Morisot inaugurated Thursday dinners that attracted a regular coterie of notables: Cassatt, Degas, Mallarmé, Monet, Renoir, James Whistler, the composer Emmanuel Chabrier, and critics and politicians. Often she noted in her journal the sparkling conversation around her table. Of all her guests, Morisot felt most in tune with Mallarmé, whose elusive lines often seemed a perfect text for her silvery, delicate pictures. Denis Rouart, Julie's son, would one day write of his grandmother, "She endowed all things with poetry in her painting."

On Eugène's recovery, the Manets paid a visit to Mallarmé in his country house at Le Plâtreries, in the summer of 1887, then toured the Loire Valley; Morisot recorded in her diary her vivid impressions of the famous châteaux. Back home she made fragile drawings with red, yellow, and blue pencils and frequently posed Isabelle and another model, Carmen Gaudin, in the nude. The Thursday dinners continued.

After Édouard Manet's death, Morisot came increasingly under the influence of the good-natured Renoir, who had passed from loose to more rigid composition. When he encouraged her to pay greater attention to her drawing, she made more careful preparatory sketches, something Manet had once advised her not to do.

For years she and Eugène had dreamed of wintering near Nice, and in November 1888, they rented a large villa at nearby Cimiez, where the artist produced two charming oils of Julie, *Under the Orange Tree* and *The Mandolin*, both greatly admired by Renoir. On returning to Paris in the late spring, Morisot occupied herself with boating scenes from the lake in the Bois de Boulogne. With Julie as a model for *Girl in a Boat with Geese*, Morisot used short, curving brush strokes and blurred the difference between figure and background. Proudly she had watched Eugène write a novel, *Victims!*, which was privately printed in 1889. Ever an anti-Bonapartist, he based his story on a real episode involving opponents of Napoleon III. Despite his productivity, however, Eugène continued to have spells of poor health.

At Mézy, where the family spent the summer of 1890, Morisot painted *View from the Terrace at Mézy*. This stay she interrupted to accept Cassatt's invitation to attend the École des Beaux-Arts exhibit of Japanese art. Like Cassatt, she admired the distinctive woodcuts, but unlike her she was not profoundly influenced by them.

With Eugène and Julie she returned to Mézy for another summer in 1891, there becoming interested in a nearby seventeenth century château, Le Mesnil, and starting negotiations to buy it. It would belong to them by October. And there Morisot painted. *The Cherry Tree*, rich in luminous tones and echoing Renoir, shows Julie standing by a ladder while her cousin Jeanne Pontillon holds a basket. In preparation Morisot made more studies than ever before.

After recovering from a serious illness that year, Berthe had written Edma:

> I am well now but I have not yet got over the mortal shock; I felt the embrace of death, and I am still terrified as to the idea of all that might happen after I go, particularly to Julie. I am approaching the end of my life, and yet I am still a mere beginner. I feel myself to be of little account, and this is not an encouraging thought.

Still, unsparing of herself, she kept at her easel — stubbornly, passionately, fiercely as ever.

Through the years Morisot had exhibited frequently at Durand-Ruel's Gallery. In 1892, at the Boussod and Valadon Gallery, she had her first one-woman show. Sadly, Eugène missed her triumph, for he had died in early spring after months of precarious health, and Morisot could not bring herself to attend her own exhibit. The depth of her grief is evident in *Girl with a Greyhound, Julie with Laërte* (the dog was given to her by Mallarmé), which shows an empty chair almost dissolved into nothingness.

With widowhood, Morisot moved herself and her daughter to smaller quarters on the rue Weber. Proudly she watched Bibi develop as a painter and violinist. As Renoir and Mallarmé took them to the theater and other entertainments, as Renoir painted Julie, and as Mallarmé dined with her or corresponded weekly, Berthe began to think of the painter and the poet as future guardians for her daughter, though she knew that she could rely on Edma.

Morisot had a fresh model in Jeanne Fourmanoir, whom she painted with a new voluptuous style in *On the Lake, Sleeping Girl*, and *Young Girl with a Cat*, but Julie continued as her favorite. In the spring of 1894, after visits to Monet, Mallarmé, and Sisley, mother and daughter traveled together to Brussels, where four pictures by Morisot had been hung at an exhibit of modern art.

With Eugène gone, Morisot had lost interest in living at Le Mesnil, though she saw the château as a future home for Julie. After spending three weeks supervising the most necessary repairs, she rented out the place for three years. That summer Jeanne Pontillon and Paule Gobillard joined their white-haired Tante Berthe and cousin Julie for a holiday in Pontrieux, Brittany, on the Channel coast, where Morisot painted a series of marinescapes.

One of her lifelong dreams had been to have one of her pictures placed in the Luxembourg Palace, since 1818 a museum reserved for living artists. (Ten years after their death their pictures were sent to the Louvre or to provincial galleries.) That year of 1894 Mallarmé interceded with a friend, the director of the École des Beaux-Arts, to buy for the Luxembourg Morisot's *Young Woman at a Ball*, first seen in the Impressionist exhibit of 1880.

Like the fans in many of her portraits, swans on the Bois de Boulogne lake became favorite symbols, sketched in a few deft strokes. The swans appear, half in mist, in her last picture, the haunting *Forest Interior in Autumn*.

On March 2, 1895, after having nursed Julie through the flu, Berthe Morisot lay gravely ill of pneumonia. But she forced herself to leave a

letter for her daughter: "My dear little Julie, I love you as I live and will love you even more when I am dead: I beg you not to cry; this parting was inevitable.... Work and be proud as you always have been." The end came the next day.

That same year Mallarmé, seeking help from Monet, Degas, and other artists, arranged for an official exhibition. It could not, of course, cover her entire oeuvre. She had created more than 400 oil paintings, nearly 200 watercolors, almost 200 pastels, perhaps 300 drawings, eight engravings, and one portrait sculpture of Julie. In the catalogue preface Mallarmé called Morisot "the magician, whose finished work, according to the opinion of several great original artists, who counted her as a comrade in the battle, stands comparison with that of anyone, and links itself, exquisitely, to the history of painting."

The poet Paul Valéry, who later married one of her nieces, would write of Tante Berthe: "Her peculiarity was to live her painting and to paint her life.... Her sketches and paintings kept closely in step with her development as a girl, wife, and mother. Her work as a whole is like the diary of a woman who uses color and line for her expression. She had...no exact routine, and as subject matter the people and familiar subjects around her."

Yet to those familiar subjects and settings she had brought a fresh and enriched composition, always subtle and sensitive, unfailingly refined and elegant.

Berthe Morisot : Works Mentioned

Thatched Cottage in Normandy (1865), Private Collection
The Harbor at Lorient (1869), National Gallery of Art, Washington, D.C.
Young Woman at a Window [The Artist's Sister at a Window] (1869), National Gallery of Art, Washington, D.C.
Mme. Morisot and Her Daughter, Mme. Pontillon [The Mother and Sister of the Artist] (1869–70), National Gallery of Art, Washington, D.C.
At the Edge of the Forest (1871), Private Collection
Woman and Child in a Meadow (1871), Galerie Hopkins and Thomas, Paris
Mme. Pontillon (1871), Private Collection
View of Paris from the Trocadéro (1871–72), Santa Barbara Museum of Art, California
On the Balcony (1871–72), Private Collection
The Cradle (1872), Musée d'Orsay, Paris
Reading (1873), Private Collection
Hide and Seek (1873), Private Collection
The Lilacs at Maurecourt (1874), Private Collection
Mme. Marie Hubbard (1874), Ordrupgaard Collection, Copenhagen
In the Cornfield (1875), Private Collection

Eugène Manet on the Isle of Wight (1875), Private Collection
Figure of a Woman [Before the Theater] (1875-76), Galerie Schröder und Leisewitz, Kunsthandel, Bremen
The Black Bodice (1876), National Gallery of Ireland, Dublin
In a Villa by the Seaside (1877) Private Collection
Young Woman Powdering Herself (1877), Musée d'Orsay, Paris
Summer [Young Girl by the Window] (1878), Musée Fabre, Montpellier, France
Woman at a Ball (1879), Musée d'Orsay, Paris
Woman at Her Toilette (c. 1879), Art Institute of Chicago
Julie and Her Wet Nurse (1879), Private Collection
Winter (1879-80), Dallas Museum of Art, Dallas, Texas
The Garden (1882-83), Sara Lee Corporation, Chicago
The Bath [Girl Arranging Her Hair] (1885-86), Sterling and Francine Clark Art Institute, Williamstown, Massachusetts
Getting Out of Bed (1886), Collection Durand-Ruel, Paris
In the Dining Room [The Little Servant] (1885-86), National Gallery of Art, Washington, D.C.
Interior at Jersey (1886), Private Collection
Under the Orange Tree (1889), Private Collection
The Mandolin (1889), Private Collection
Girl in a Boat with Geese (1889), National Gallery of Art, Washington, D.C.
View from the Terrace at Mézy (1890), Private Collection
The Cherry Tree (1891-92), Private Collection
Girl with a Greyhound, Julie and Laërte (1893), Musée Marmottan, Paris

VII

Mary Cassatt

(1844–1926)

Convinced of the mediocrity of art training in the United States, Mary Stevenson Cassatt went to Paris to study and remained there for long, productive years. But, starchily independent, she never gave up her American ways or loyalties.

She was born into a prosperous and well-connected family on May 22, 1844, in Allegheny City, Pennsylvania, across the river from Pittsburgh. Her parents already had a daughter, Lydia, and two sons, Alexander and Robert. Of French-Huguenot stock, Robert Cassatt was an investment broker and real estate speculator who shared with his Scotch-Irish wife, Katherine Kelso Johnson, a deep interest in French culture. He served briefly as mayor, then brought his family to his home city of Pittsburgh. Soon, however, he bought a country home, Hardwick, near Lancaster. After the birth of the last child, Gardner, in 1849, the family moved to Philadelphia.

A year later the Cassatts went abroad, settling first in Paris just as the Second Empire began. When Aleck showed unusual technical aptitude, they left for Heidelberg so that he could study at a special school. The next step for him was an even more prestigious school in Darmstadt, where the family settled down. But twelve-year-old Robbie died in Darmstadt, in 1855, and the tragedy dictated a return home. To help allay their grief, the Cassatts stopped in Paris to see the Exposition Universelle. Back in Pennsylvania, they lived for a time in the countryside near Lancaster, then at a country home in West Chester until Robert Cassatt bought a four-story house in Philadelphia. Family records from this period deal mostly with Aleck's progress, ignoring Mame, as Mary was known.

At 16, aware of her drawing talent, Mary Cassatt decided to become a painter. In the fall of 1860, the first to register, she enrolled at the Pennsylvania Academy of the Fine Arts in Philadelphia, where the curriculum

of drawing plaster casts and copying third-rate paintings from the academy's dusty collection left no room for originality and soon bored her. After attending classes regularly for two years, she arranged to do some self-study, still keeping up contacts with the academy. Her family now stayed mostly at Cheney, for Robert Cassatt, who had built a stone farmhouse there, showed more interest in fruits and vegetables than in his brokerage business. But Mary could not always concentrate on her art when Civil War battles raged so close by. For the Union soldiers she and Lydia and their mother rolled bandages and knitted countless mufflers.

After graduating from the academy in 1865, Mary longed to go to Paris for further training. Even though women were not admitted to the most prestigious school, the École des Beaux-Arts, she believed that studying the great collections and copying from them would benefit her tremendously. To her way of thinking, there were no adequate American art schools or museums. When she broached her plans, she was not prepared for her father's reaction. As she told her biographer, Achille Segard, many years later, Robert Cassatt exploded that he did not wish to see his daughter become a professional artist: "I would rather see you dead." Almost 50 years later, Mary wrote a friend: "I think sometimes a girl's first duty is to be handsome, and parents feel it when she isn't. I'm sure my father did; it wasn't my fault though."

Reluctantly, he at last gave in to her pleading but insisted that the family accompany her to France and settle her properly on the same genteel scale. She had hoped to study independently, but to keep peace with her father, agreed to take lessons from some established artists. First came Charles Jordan Chaplin and then Jean Léon Gerôme; in each case she stayed only briefly. She wanted to do things her own way, absorbing paintings in the public collection, copying at the Louvre and the Paris Salon. During the Exposition Universelle of 1867, she visited with mounting excitement the private pavilions set up by Gustave Courbet and Édouard Manet, exponents of the new Realism and highly unpopular with the Establishment. Next she took lessons in genre painting from Édouard Frére and Paul Soyer at Ecouen and from Thomas Couture at Villiers-le-Bal, but quickly left, though she would return periodically to Couture. She preferred setting out with other students to sample art colonies around Paris. Independence paid off, for the 1868 Salon accepted her painting, A *Mandolin Player.*

Just after Mary's visit to Rome in the summer of 1870, the Franco-Prussian War broke out, and in urgent telegrams her parents summoned her home. The work she had placed at a New York gallery did not sell well, and in the company of two cousins she took it to Chicago. When the Great Fire erupted soon after their arrival, they had time only to pack a couple of suitcases; all Mary's paintings burned.

Philosophical about her loss, she sailed, before the year was out, for Italy with a traveling companion, Emily Sartrain, a young engraver who wanted to study painting. This time Mary picked Parma so that she could see the works of Parmagianino and Correggio, whose variations on the madonna-and-child theme would later be reflected in her work. There she painted *Two Women Throwing Flowers During Carnival,* which would be accepted by the 1872 Paris Salon. She also learned printmaking under Carlo Raimondi at the Parma Academy.

Spain beckoned her in the fall of 1872, first Madrid, with the Prado and the works of Diego Velásquez and Francisco Goya, and then Seville. The dozens of pictures she produced eventually made their way to French and American exhibits.

Mary Cassatt returned to Paris in April 1873, just in time to see hung at the Salon her *Torero and Young Girl* and *On the Balcony,* representing two women and a man in Spanish costumes observing carnival festivities. That summer her mother came from Philadelphia to join her in Antwerp and to enjoy the work of Peter Paul Rubens; then they crossed the Dutch border to Haarlem, where Mary copied Frans Hals paintings. After Mrs. Cassatt left for home, Mary went on to Rome and made genre pictures until she decided to settle down in Paris.

At the 1874 Salon her *Ida* (Mme. Cortier), a portrait of a cheerful, middle-aged woman, caught the eye of Edgar Degas, who reportedly exclaimed, "There is someone who feels as I do." But Cassatt did not discover him for a year.

After spending the summer of 1875 in Philadelphia with her family, she resolved to continue her career in Paris. One autumn day she saw some Degas pastels in a gallery on the Boulevard Hausmann. Years later she wrote of her experience: "I used to go and flatten my nose against that window, and absorb all I could get of his art. It changed my life. I saw art then as I wanted to see it." In her excitement she encouraged a new American friend, young Louisine Elder, then attending boarding school in Paris, to buy one of the Degas pastels.

She did not meet her hero until 1877, when she and Degas, now burdened with some of his family's debts, were introduced by a mutual friend, the painter Joseph Tourny. Opinionated and fiercely independent, each saw in the other a kindred spirit. It would, however, prove a stormy friendship through the years. Sometimes the misanthropic bachelor and the prim spinster quarreled bitterly and would not speak for months. But more than any other artist, the irreverent Degas influenced her even though she complained, "Degas is a pessimist and dissolves one so that you feel after being with him, 'Oh, why try, since nothing can be done?'" Each time she sat for him he pictured her as crisp, angular, yet always elegantly dressed, never flattering her. From him she learned to use

asymmetrical arrangements and contrasting areas of pattern and to let her borders crop the design.

She had met some of the young Batignolles artists, popularly called Impressionists, after their first exhibit in 1874, and their techniques influenced her. Above all else she had been impressed by Degas' concentration on subjects he knew well, and when Mr. and Mrs. Cassatt and Lydia settled permanently in Paris the same year she met Degas, Mary began to consider them and her friends as models.

In 1878 Degas began actively advising her about her work, and while painting the child of one of his friends, she called on his help for the background. He also worked on other portions of this portrait of a dark-haired little girl in a languid pose. Therefore Cassatt was especially indignant when the American section of the Exposition Universelle turned down her *Little Girl in a Blue Armchair*. But one of her finest portraits would soon sit on her easel. To show how comfortable her mother was in Paris, Cassatt painted *Reading Le Figaro* in which Mrs. Cassatt, composed and intellectual-looking, appears engrossed in the newspaper. Still another outstanding picture that year, *At the Opera,* seemed reminiscent of Manet with rich velvet blacks and bravura brushwork.

Increasingly influenced by the Impressionists, she lightened her palette and used more visible and vigorous brushstrokes. Also, she liked the group's stand against the jury system. In 1878 she grew huffy when the Salon insisted she retouch a picture of Lydia. So it was natural for Degas to invite her to exhibit with them. But she waited to do so until 1879. Like Berthe Morisot, she took a courageous step by affiliating with the group. From now on, she realized, she would have to renounce official recognition, and she would also open herself to much critical derision. But, as she told Segard long after, "I hated conventional art. I began to live."

To the 1879 Impressionist show she sent 11 works, of which the richly colored *Lydia in a Loge,* showing her beautifully gowned sister in front of a mirror at the opera, attracted most attention. Cassatt, who had never forgotten her father's initial opposition to her studying art in Paris, relished the sight of Robert Cassatt clipping art notices to send to his sons.

Following the 1879 exhibit, Degas and Camille Pissarro invited Cassatt to join them and some other friends in the production of a journal, *Le Jour et La Nuit,* featuring original etchings and commentary. Owing to some foot-dragging on Degas' part, the journal was never published, but at least its dream led him and Cassatt to produce several fine etchings.

In the exhibit of 1880, she showed a pastel, *Lydia Leaning on Her Arms, Seated in a Loge,* again with mirror reflection. She had used pastels before, but under Impressionist influence she now drew in a light, soft, more glowing style. The young woman is bursting with health that Lydia in real life did not enjoy. It has been conjectured that for both portraits

of her sister Cassatt used a model who resembled Lydia in coloring. On the other hand, she may have been picturing what she would have liked to see. Since Morisot had not appeared at the 1879 exhibit, the 1880 show marked the first time the only two women Impressionists were seen together. Comparing them, Paul Gauguin noted, "Mary Cassatt has charm, but she also has force."

The theater and opera scenes seemed distinctly French and Impressionist, especially the one titled *The Loge*, an oil, with one woman holding a bouquet and the other an enormous fan. More British (even Philadelphian) in tone were pictures centered around afternoon tea and shown at the 1881 Impressionist exhibit. *Five O'Clock Tea* (1880) pictured Lydia and a friend in the Cassatts' drawing room; here the artist freely used pattern, as taught by Degas. *The Cup of Tea* again featured Lydia, fashionably dressed and wearing long white gloves, her bonneted head blending with a table of flowers. Mary gave no indication that her sister was incurably ill of Bright's Disease.

Meanwhile, again taking her cue from the Impressionists, Cassatt tried a new theme. In *Mother About to Wash Her Sleepy Child* she also used a standard Impressionist motif, a porcelain bowl. The child's pose was reminiscent of the Correggios she had studied in Parma. At this time, though she did only a few such pictures, the influential critic J. K. Huysmans found her children "enchanting."

Alexander Cassatt, rising to prominence with the Pennsylvania Railroad, brought his wife and children to Paris for an extended stay in the summer of 1880, and nieces and nephews became Mary's models. She did not care to paint her sister-in-law Lois, the niece of former president James Buchanan.

Her loyalty to Degas kept her from the 1882 exhibit. Angry when one of his friends was not invited to participate, he withdrew, and Cassatt followed him. It was a sad year, for Lydia died; Mary could not paint for months. Gardner, however, had married and given Mame a sister-in-law, Jenny, whom she could truly enjoy.

A frequent visitor to the Cassatts' apartment had been a cousin, Mrs. Robert Moore Riddle, who once gave them a fine antique porcelain tea and coffee service, which the artist chose to include in her portrait of Mrs. Riddle (1883–85). Unfortunately neither Mrs. Riddle nor her daughter liked the picture, later called *Lady at the Tea Table*, complaining that Cassatt had made the nose too large. Her dander up, Cassatt kept the painting in her studio for almost 40 years, finally donating it to the Metropolitan Museum of Art in 1923.

Now Mrs. Cassatt began to suffer from heart trouble and rheumatism. To improve her mother's health, Mary wintered with her in Spain in 1883–84. From this time on she lost innumerable hours from her

easel in long searches for winter and summer residences suitable for her mother, who could not climb stairs. The Cassatts moved frequently, but finally in 1887 they found an apartment (with studio) at 10 rue Marignan off the Champs Élysées that Mary kept for the rest of her life.

Differences among the Impressionists were smoothed over for the 1886 exhibit, the last they held. It needed financing, and Cassatt joined Degas, Morisot, and another patron in helping to pay for it. As Mary told Segard, one of her entries, *Girl Arranging Her Hair*, resulted from Degas' caustic remark that women should not attempt to be critics, for they knew nothing about style. She wanted to prove to him that she could achieve style through careful composition, even with an ungainly model. Degas was so impressed he asked her to exchange this picture for one of his pastels of a woman bathing. Cassatt had lent money to Paul Durand-Ruel, the art dealer now spreading the fame of the Impressionists, and he included her in his London and New York exhibits.

In the late 1880s she returned with new zeal to printmaking. Then came another interruption. From childhood she had ridden horses expertly, and riding remained her favorite form of exercise in France. But one day in 1888 she fell from her mount, breaking her leg and dislocating her shoulder. Deeply humiliated, she resolved never to sit on a horse again.

Parisian gossip called her wealthy. Since she lived with her family, to whom Aleck gave a generous allowance to supplement Robert Cassatt's fixed income, she had no living expenses, but paid for her studio and her invariably well-tailored clothes.

Soon after getting back to her graphics, she drew fresh inspiration from the huge 1890 exhibit of Japanese Ukiyo-e woodblock prints and illustrated books, sponsored by the École des Beaux-Arts. She attended first with Degas and then again with Morisot. The possibilities offered by Japanese perspective and composition (bold outlines and flattened, patterned areas of color) seemed limitless, and she immersed herself in graphics. Like Degas, she bought her own etching press, setting it up at the rented Château de Bachivillers on the Oise River, and she hired a printer to help her. Wanting every print to be unique, she hand-inked each plate, sometimes changing the colors.

Yet she did not adopt the Japanese woodcut technique. Instead she experimented with new methods of soft-ground etching and drypoint with aquatint. Her most impressive and original production was a suite of ten color prints with beautiful quality of line: *The Bath, The Lamp, In the Omnibus, The Letter, The Fitting, Woman Bathing, Mother's Kiss, Maternal Caress, Afternoon Tea Party*, and *The Coiffure*, each in an edition of 25. The following year, affronted at having been excluded from an important print show solely because she was not French-born, she and Pissarro,

who had been turned away because of his West Indian birth, arranged print exhibits at the Galerie Durand-Ruel next-door to the society that had snubbed them. Cassatt used the opporunity to also display four of her early mother-and-child oils and pastels. A few months later her father died.

With *Emmie and Her Child* [Mother and Child] (1889), she had continued a popular subject. *Baby's First Caress* (1891) emphasized an emotional relationship. *The Bath* (1892), considered one of her finest paintings of the 90s, used a striking purple and acid green combination she would often repeat.

In spite of her long absence abroad, Mary Cassatt never lost her American accent, her air of independence, and her love for her native land. "I am American...clearly and frankly American," she once told Segard. Whenever possible, as had long been her custom, she sent pictures to the National Academy of Design in New York and other American galleries. But France appreciated her much more. If she did not return home often, she had good reason; she grew violently seasick each time she crossed the ocean.

In late 1892 Mrs. Potter Palmer, reigning queen of Chicago society, took very seriously her duties as president of the Board of Lady Managers for the Columbian Exposition, scheduled for the next year. She came to Paris to ask two American women artists to paint murals for the Hall of Honor of the Women's Building. Having applauded Cassatt's work, she bought one mother-and-child pastel and offered her a commission for Chicago. Cassatt's theme was "Modern Woman." Mrs. Palmer assigned "Primitive Woman" to the other artist, Mary Fairchild MacMonnies.

For this commission Cassatt worked again at Château de Bachivillers. To accommodate her huge painting, 11 by 58 feet, she built a special glass-roofed studio. Then, like Claude Monet preparing for his *Women in the Garden* years before, she ordered a large trench dug so that she could lower her canvas and not depend on ladders to reach the top portion.

Her central scene she called *Young Woman Plucking the Fruits of Knowledge or Science*. To its left was *Young Girl Pursuing Fame,* and to the right, *Arts, Music, Dancing.* Installed in Chicago, the mural was well applauded. What eventually became of it remains a mystery, but Cassatt worked her preparatory sketches into oils, pastels, and prints that have survived. Most often she repeated a subject she had first tried in 1892 with *Young Woman Plucking Fruit*; it had won Degas' special praise.

That same year of 1892 she became financially secure enough to buy a seventeenth century hunting lodge, Beaufresne, at Mesnil-Théribus, about 50 miles northwest of Paris. The château, surrounded by gardens and a large pond (45 acres of land in all), had a nineteenth century addition, a glassed-in gallery which served as an informal living room.

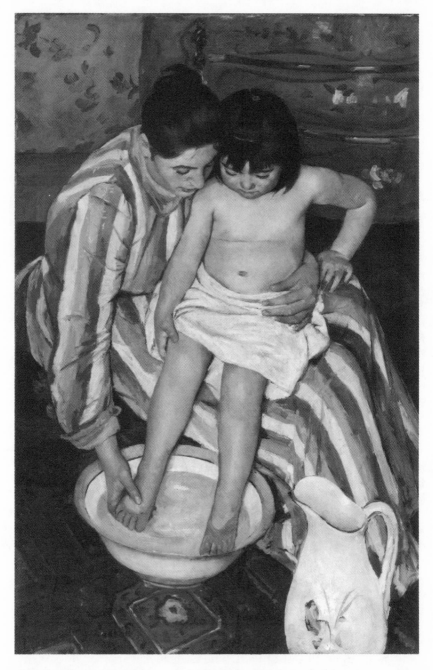

Mary Cassatt, *The Bath* (1891), oil on canvas, 39½ × 26 in., ©The Art Institute of Chicago, Robert A. Waller Fund (1910.2). All rights reserved.

Vacationing at Antibes, she next painted *The Boating Party* (1892–94). Its complex composition of strong curves and tight modeling owed much to the conventions of the Japanese prints she had seen in 1890.

She and Degas had quarreled, reconciled, and quarreled again, over and over. Their most serious falling-out occurred over the Dreyfus Affair, which began in 1894. Cassatt stoutly supported Capt. Alfred Dreyfus, the only Jewish officer on the French General Staff, who was accused of selling military secrets to Germany. Degas championed the government's case against him. Dreyfus was sentenced to life imprisonment on Devil's Island, but after Émile Zola published his thundering "J'Accuse" letter to the president of France, asserting the captain's innocence and naming the real traitor, a new trial finally exonerated the prisoner in 1906.

Following Mrs. Cassatt's death in 1895, Gardner Cassatt, a wealthy banker, came to Paris with his family for an extended stay so that they could comfort his grieving sister. In 1896 Cassatt painted a solemn portrait of her tiny niece Ellen Mary, who was to become her special favorite. Still-life elements continued to be important parts of her mother-and-child portraits. The tender pastel *Breakfast in Bed* (1897) expressed love through two pairs of eyes.

In 1898 Cassatt decided to endure seasickness for the sake of another homecoming. She stayed with Gardner and his wife since she still did not get on well with Aleck's Lois. A Philadelphia newspaper barely noticed her arrival: "Mary Cassatt, sister of Alexander Cassatt, president of the Pennsylvania Railroad, returned from Europe yesterday. She has been studying painting in France and has the smallest Pekingese dog in the world." (The reporter was far from accurate. Mary had left to study in Paris more than a generation before. Aleck did not become railroad president till the next year. As for dogs, Mary was devoted to only one breed, the Brussels griffon, and had one with her.) Once home, she did not really vacation, immediately becoming involved in doing pastels of Gardner's children and accepting commissions from some wealthy families who wanted similar portraits of their young sons and daughters.

Returning to Paris in 1899, Cassatt painted *Mme. A. K. Aude and Her Daughters*, a strong portrait of Durand-Ruel's daughter and grandchildren; turned out a great many children's portraits; and also went back to the mother-and-child theme. As models she preferred the young country women who lived near her château. She said they knew how to hold a baby more naturally than any professional model. She also liked their strong, plain faces. But she liked to dress the country women in gowns from Parisian shops, often in white or with touches of white. One time she wrote a friend: "So you find my models coarse, unworthy of new clothes. . . . Would you could hear them talk. . . . Their philosophy would astound you." A 17-year-old girl posed for an especially popular picture,

Reine Lefevre Holding a Nude Baby (1902). As in most of Cassatt's mother-and-child portraits, the two models were not blood-related. *Young Mother Sewing* (1902) featured an appealing toddler. Critics, however, began to complain that her pictures were deteriorating into mere formula, that her little girl portraits were bland, without personality.

Her longtime friend Louisine Elder had married the sugar magnate Henry O. Havemeyer in 1882 and had become a more ardent collector than ever. In 1901 Cassatt joined the Havemeyers in Genoa for an extended art-buying trip through Italy and Spain, helped by a full-time agent she had hired. She championed the then unpopular El Greco, and with her encouragement the Havemeyers began a long series of negotiations to acquire *View of Toledo* and *Portrait of Cardinal Guevara*. But *Assumption of the Virgin*, which the Havemeyers also bought, was too large to hang in their home. The Metropolitan Museum of Art did not want it, and the Havemeyers sold it to Durand-Ruel. Eventually Cassatt would arrange for its purchase by the Art Institute of Chicago. She hoped that any private collection she helped to build up would eventually be bequeathed to museums. She had never forgotten that the chief reason she had decided to study and work in Paris was the dearth of old masters in the United States. Under Cassatt's direction, the Havemeyers, who owned twenty of her pictures, proceeded to purchase a large collection of paintings by Courbet, Monet, and Manet. Since the 1880s, Mary had also encouraged her brother Aleck to buy Impressionist paintings and to become an important collector.

On her return from her trip with the Havemeyers, she was named a chevalier of the Legion of Honor. But true to the Impressionist renunciation of juries and prizes, she graciously declined the Prize of the Pennsylvania Academy of the Fine Arts, her alma mater, and the Norman Wait Harris Prize of the University of Chicago.

Aleck died in 1906, and Gardner became even more devoted to his sister. In the summer of the following year he invited her to join him and his children on an automobile tour through Scotland, England, Holland, and Belgium. At the close of 1910 she met him again in Paris for a trip to Egypt and Constantinople. Egypt excited but exhausted her. Gardner also became ill on the trip, and shortly after they returned to Paris, he died. Completely overwhelmed, Mary suffered a severe nervous breakdown and could not work again for almost two years.

She had long had a close friend in James Stillman, a retired American banker, who was an ardent admirer and collector of her work and a grateful recipient of her advice on building a collection for his Paris mansion. As soon as Cassatt was able to travel, he brought her to Cannes to recuperate. The winter in the south so benefited her health (she also suffered from diabetes) that, toward the close of 1912, she rented a villa

Mary Cassatt, Grasse (1914), photographer unknown, The Frederick Arnold Sweet Papers, Archives of American Art, Smithsonian Institution, Washington, D.C.

in Grasse in the hills above Cannes, and here she would regularly stay each winter until 1924.

Her eyesight began to deteriorate in 1913, and she gave up printmaking altogether. Pastels, as Degas had found out for himself, were all an artist with poor eyesight could manage.

Ever since she had bought Beaufresne, Cassatt had played the gracious hostess. Artists and writers and celebrated politicians like Georges Clemenceau came to the château, where Cassatt, more than ever the grande dame, stiffly erect and immaculately groomed, conversed brilliantly with them all. Her devoted housekeeper from the Paris days, the Alsatian-born Mathilde Vallet, remained with her. She also kept a cook, a couple of maids, three gardeners, and a chauffeur (her former coachman) for the Renault motorcar Mrs. Havemeyer had given her in 1906. Testy Brussels griffons snapped at her visitors; Mary spent long hours in her rose garden; even when almost blind she declared that nobody but herself could cut the flowers from two particular immense bushes.

During World War I, she had to flee the château, located in the war zone, and seek refuge in Grasse and her Paris apartment. Mathilde was deported as a German alien but was sent to Italy, where Cassatt sometimes visited her just across the border.

She and Louisine Havemeyer had become enthusiastic suffragettes. As a 1915 benefit for the cause of woman suffrage, Mrs. Havemeyer arranged a New York exhibit of old masters and works by Degas and Cassatt. Hoping she would not be considered presumptuous in such company, Mary agreed to participate because of her ardor for the women's movement. Meanwhile, she had undergone unsuccessful cataract surgery.

The exacting Degas died in 1917. They had long been apart, but she wrote a friend: "He was my oldest friend here and the last great artist of the nineteenth century. I see no one to replace him."

Mathilde Vallet returned to Beaufresne after the Armistice and unwittingly contributed to the breakup of a long and devoted friendship. One day she brought to her mistress some old drypoint plates she had discovered. Cassatt was sure they had never been printed and proceeded to have them pulled. But with her failing eyesight, which several surgeries had failed to improve, she could not detect their poor quality. When Mrs. Havemeyer begged her not to show them, Cassatt bristled and broke off an intimacy that had lasted more than 50 years. It turned out that the plates had been printed long before.

Cassatt devoted her last years to seeing that her works were bought for those collections she deemed appropriate. She was happiest when they went to the United States. Several times she said that she regretted only one thing in her life, that she had not reared children. She died at Beaufresne on June 14, 1926, embittered by blindness and loneliness but

proud of her American loyalties and the accolade she had earned from Degas: "She had infinite talent."

Mary Cassatt : Works Mentioned

A Mandolin Player (1868), Private Collection
Two Women Throwing Flowers During Carnival (1872), Private Collection
Torero and Young Girl (1873), Sterling and Francine Clark Art Institute, Williamstown, Massachusetts
On the Balcony (1873), Philadelphia Museum of Art
Little Girl in a Blue Armchair (1878), National Gallery of Art, Washington, D.C.
Reading Le Figaro (1878), Private Collection
At the Opera (1878), Museum of Fine Arts, Boston
Lydia in a Loge (1879), Private Collection
Lydia Leaning on Her Arms, Seated in a Loge (1879), Nelson-Atkins Museum of Art, Kansas City, Missouri
The Loge (1880), National Gallery of Art, Washington, D.C.
Five O'Clock Tea (1880), Museum of Fine Arts, Boston
The Cup of Tea (1880), Metropolitan Museum of Art, New York
Mother About to Wash Her Sleepy Child (1880), Los Angeles County Museum of Art, Los Angeles
Lady at the Tea Table (1883–85), Metropolitan Museum of Art, New York
Girl Arranging Her Hair (1886), National Gallery of Art, Washington, D.C.
Emmie and Her Child [Mother and Child] (1889), Wichita Art Museum, Kansas
Baby's First Caress (1891), New Britain Museum of American Art, Connecticut
Color Print Suite: The Bath, The Lamp, In the Omnibus, The Letter, The Fitting, Woman Bathing, Mother's Kiss, Maternal Caress, Afternoon Tea Party, The Coiffure (1891), Metropolitan Museum of Art, New York; Worcester Art Museum, Massachusetts
The Bath (1892), Art Institute of Chicago
Young Woman Plucking Fruit (1892), Carnegie Art Institute, Pittsburgh
The Boating Party (1894), National Gallery of Art, Washington, D.C.
Ellen Mary Cassatt in a White Coat (1896), Museum of Fine Arts, Boston
Breakfast in Bed (1897), The Huntington, San Marino, California
Mme. A. K. Aude and Her Daughters (1899), Collection Durand-Ruel, Paris
Reine Lefevre Holding a Nude Baby (1902), Worcester Art Museum, Massachusetts
Young Mother Sewing (1902), Metropolitan Museum of Art, New York

VIII

Suzanne Valadon

(1865–1937)

The unfortunate circumstances of her birth helped shape Suzanne Valadon's tempestuous and flamboyant life, which in turn fashioned the strange career of her son, the painter Maurice Utrillo. But Valadon's fame did not depend on him. Her own artistic contribution was considerable.

She was illegitimate, born in the village of Bessines-sur-Gartempe near Limoges on September 3, 1865, to a widowed seamstress, Madeleine Valadon, whose husband, one Courlaud, had died years before in the Limoges jail. In old age, Madeleine attributed paternity sometimes to a miller, subsequently crushed to death, sometimes to a construction engineer who drowned. She had had at least two children from her unhappy marriage, but they were reared by her family. Madeleine named her last baby Marie Clémentine. Accounts vary as to when, 1866 or 1869, she took her child to Paris, never to return to Bessines.

She settled in the heart of the Montmartre Butte working class district and artists' bohemia, still dotted with ruins of old windmills, a few cottages, and gardens, but fast becoming a quarter noted for wild nocturnal gaiety. Eventually Madeleine placed the little girl as a day pupil at the Convent of St. Vincent de Paul. But during the battle between Communards and the Army of Versailles, following the Franco-Prussian War of 1871, the sisters were too frightened to open their doors to day pupils. Hence Marie Clémentine, an elfin gamin (often barefoot), roamed the streets while her mother scrubbed floors. Unable to find employment as a seamstress, Madeleine had become a charwoman, frequently fortifying herself with brandy and cheap wine. She may also have worked as a laundress.

Longing for a hero-father, the perky Marie Clémentine became obsessed with the medieval renegade poet François Villon. She even

called herself Mlle. Villon, practicing a walk that she thought made her resemble him.

Once the terror of the Commune was over, the sisters reopened their doors. But Marie Clémentine, now deeply in love with the steep, curved streets, became the most prodigious truant in the school's history and was dismissed. Possessing few toys, she found other amusements. When not outdoors drawing on walls and pavements with chalk or coal, she drew with pencil stubs and charcoal on wallpaper and scraps of paper she found in the Valadons' tiny tenement room.

Soon Madeleine apprenticed her to a seamstress, who actually ran a sweatshop, which Marie Clémentine endured for three years. There are no well-established facts about much of her adolescence because the artist, later to be known as Suzanne Valadon, had a lively imagination when recalling her early life. There are stories that she took jobs as waitress, pushcart vendor at the marketplace Les Halles, groom in a livery stable, and nervy equestrienne in a carnival, where supposedly one day she substituted for an ailing trapeze performer and fell during one of her turns, thus cutting short her performing days. Whatever her experiences, she acquired a remarkable resilience and toughness of character.

In her teens she began modeling in artists' studios and became fascinated by painting: "I remember saying to myself over and over again, 'This is it! this is it'.... I did not know why. But I knew that I was somewhere at last and that I would never leave." She wanted "to work like mad" to produce "good drawings which capture a moment of life in movement—all intensely." She also turned to pastels.

A vivacious, lovely brunette with a well-rounded figure, she presided as the queen of the lighthearted balls and bawdy night life in Montmartre and Montparnasse. She had had several affairs by the time she was 16. According to her later claim, for a short spell she was the mistress of 57-year-old Pierre Puvis de Chavannes, the celebrated allegorical muralist, who posed her for both the male and female figures in *The Woods Sacred to the Arts and to Music.* Eventually he engaged her as a model for his *St. Genevéve-de-Paris.*

At one of the Montmartre cafés early in 1883, Marie Clémentine met Miguel Utrillo y Molins, a young Spanish engineering student and amateur artist from Barcelona. They were often seen together, and rumor made them out to be lovers. But she was also involved with Adrian Boissy, an alcoholic, would-be painter. When her son Maurice was born in December 1883, she refused to name the father, but suddenly her circumstances bettered. She moved herself, Madeleine, and the baby into a three-room flat and even hired a nurse. The next summer Miguel Utrillo went abroad.

One of her early brief affairs had been with Pierre Auguste Renoir.

In 1882 she had posed for his *Country Dance* and *Dance at Bougival*. In 1885 he again used her as a model for his *Girl Braiding Her Hair, Bather Arranging Her Hair,* and *La Toilette*. When she showed him some of her drawings, he told her to build on her talent though he gave no helping hand.

The real boost came from Henri Toulouse-Lautrec, who in 1887 occupied a studio on the floor above her. He became her first customer, her tutor in social ways, and an occasional lover, despite his stubby appearance. He had painted two portraits of her in 1885 and 1886. In 1889 he posed her for *The Drinker*. It was he who persuaded her to change her name to the more elegant Suzanne Valadon. In his studio she met Vincent van Gogh and later described the intense Dutchman's visits:

> He arrived, carrying a heavy canvas, which he stood in a corner where it got a good light and then waited for some attention to be shown. But no one bothered. He sat opposite his picture, scrutinizing the others' glances, taking little part in the conversation, and finally he left, wearied, taking his last work with him. But the next week he came back and began the same pantomime all over again.

Toulouse-Lautrec also introduced her to the cool and worldly Edgar Degas; impressed by the drawings in her portfolio, he described them as "bold and supple." Since the lively girl had an acid tongue and an easily aroused temper, he jokingly called her his "terrible Maria." But he was not jesting when he said she was "one of us." Still another famous artist inspired Suzanne Valadon; at the Exposition Universelle in 1889, accompanied by Degas, she marveled at Paul Gauguin's decorative paintings with their arabesques of sinuous black lines. The focal point of the Exposition, the Eiffel Tower, must have excited her too.

Her romantic relationships had never lasted long until around 1890, when she began one with Paul Mousis, a wealthy young lawyer and banker. She had always suffered from the stigma of illegitimacy and did not want her frail son Maurice to do so. In Mousis she thought she had found a father for him, but her lover appeared reluctant to adopt the boy. Then Miguel Utrillo, who had returned to Paris as an art critic, learned of her desire and offered to sign an act of recognition of paternity and to adopt Maurice officially. The proposal was accepted, but the child remained under the care and supervision of his mother and grandmother. Suzanne herself did not acknowledge Miguel Utrillo as the father, but in Maurice's manhood, friends saw a strong physical resemblance between him and the Spaniard. At least they thought he looked like an impoverished grandee with the thin, delicate hands of an El Greco figure.

Henri Toulouse-Lautrec, *Portrait of Suzanne Valadon* (1885), oil on canvas, 21¾ × 18 in., Ny Carlsberg Glyptothek, Copenhagen.

For a time Mousis had enjoyed the frowsy atmosphere of Montmartre, but in 1892, wanting some relief, he rented a house in the village of Pierrefitte, about 25 kilometers north of Paris. There he established Madeleine and Maurice on a year-round basis, while he and Suzanne came on holidays and weekends.

During this period Suzanne carried on an affair with a sardonic young cabaret pianist and budding composer, Erik Satie, who thought an appro-

priate gift for her was a necklace of sausages, and who wrote Madeleine love letters, he said, because he knew she could not read them. At first Mousis accepted Suzanne's involvement with Satie, declaring she had passion enough for two men, and she insisted she loved them both. Later, though, he wanted her to give up Satie; when she refused, he left in a huff, only to return in six months. The portrait she painted of Satie (1892-93) was her first in oils. Soon Satie grew restless, and the affair dissolved.

Undeterred, Suzanne flaunted her prosperity by driving smartly about in a trap drawn by a belled and beribboned mule, with a pair of wolfhounds at her feet and a caged parrot on the seat beside her. In 1896 Mousis built a large, year-round house, the Château of the Four Winds, on the butte which divides Pierrefitte and Montmagny, and for a time within its fussy, ornate interior Suzanne settled down to domesticity. She became known as a gracious hostess, and Mousis often introduced her as his wife, though they never went through any wedding ceremony.

His generosity enabled her to keep her Paris studio. Typical of her output, her drawing A Seated Nude (1893) shows a small, earthy woman totally preoccupied with her body. But Valadon also sketched and painted in the village of Montmagny and in her garden, where she developed a passion for flowers, a passion that lasted a lifetime. Mostly she concentrated on soft ground etchings after she learned the technique in Degas' studio. Nudes or deminudes, never seductive, became her principal theme. As models she preferred short, plump working women or servants, caught in the act of bathing or dressing. She once said, "I paint people so as to get to know them. Never bring me a woman to paint who is in search of the polite or the pretty. I shall most certainly disappoint them." In 1895 Degas asked Ambroise Vollard to exhibit a set of Valadon's etchings, and the art dealer was so impressed he ordered 100 prints of Two Girls Drying Themselves.

Until Maurice was 14, Suzanne had shown few maternal feelings. The spindly boy often fell into fits of anger or grief, and to calm him Madeleine gave him wine, watered down in peasant tradition. But in 1897, when the teenager started drinking heavily and moved in and out of school, Mousis convinced Suzanne that Maurice needed to go to work. For a few years the boy took and quickly left jobs Mousis got for him. At this point Suzanne excused Maurice by declaring that he had inherited his unfortunate tendencies from Boissy, who she said had raped her at the steamy Le Lapin Agile café in 1883.

In desperation over Maurice, she consulted a series of doctors and psychologists, and finally in 1901 he was treated for alcoholism at the sanatorium of St. Anne. While waiting for his release, Valadon closeted herself in her studio, turning out hundreds of drawings of nudes, but destroying most of them. Usually she was her own model.

After one doctor suggested some kind of manual therapy, particularly painting, Suzanne in 1902 began to teach Maurice as much as her work schedule and social life permitted and took pleasure in introducing him to her own distinctive palette of chrome yellow, turkey red, vermilion, and white zinc. Maurice, who showed amazing talent, seemed most fascinated by walls and did not want to paint people. He had never been pleased with his name change and for some time stubbornly signed his paintings Maurice Valadon, eventually compromising on Maurice Utrillo V. He always kept the V. as part of his signature. By 1906 he settled in his mother's studio in Montmartre, where he passed his days with painting the tumbledown white houses and shop fronts, his nights with heavy drinking.

One of Maurice's closest friends was André Utter, a painter three years his junior. André had been expected to take over his father's plumbing business, but had instead chosen carefree days in Montmartre. When his health broke down after too much hashish and alcohol, his parents sent him to a convalescent home at Pierrefitte-Montmagny. After he and Maurice ran into each other, Maurice brought him to the Château of the Four Winds to introduce him to Suzanne. The mutual attraction was instantaneous, but Valadon did not act immediately.

For a long time she had felt cramped by her life at Montmagny. Mousis saw the danger signals and rented an apartment and studio on the rue Cortot in Paris, and the Château of the Four Winds became only a weekend retreat. One day, after moving to the new quarters, Suzanne saw Utter in the street and called to him from her apartment window. The upshot of her invitation to step inside was that the handsome young man with ruddy cheeks, wavy blond hair, and slight beard became the Adam of her witty painting *Adam and Eve* (1909). Soon Valadon and Utter were lovers, keeping rendezvous in the studio he had come to share with Maurice. Finally in 1909 she left Mousis and moved with Madeleine into the Utrillo-Utter studio. Soon all four were ensconced in the rue Cortot apartment with two tomcats and a German shepherd.

Disregarding Valadon's deftly drawn and explicitly titled *Seated Nude with Standing Woman Seen from Back in the Background* (1908), Utter encouraged her to work hard with oils and forget graphics. Before doing so, she finished *Bathing the Children in the Garden*, a drypoint (1910). In the "Valadon Drama," as Utter called it, he saw "a kind of true magic which moves of itself." As the affair grew in passion, Maurice went off to find a place to sleep, but he daily visited the rue Cortot apartment. He had begun the "White Period" of his best painting (1902–1914), contrasting white walls with blocks of blue and brown in cityscapes laced with poetry, serenity, and melancholy. During this time Suzanne painted a memorable double portrait of her brooding, mustachioed son and his wizened grandmother with a dog (1910).

The age gap between Valadon and Utter did not matter because she still looked beautiful and sensual. Having now given up etching completely, she turned out vividly colored landscapes, still lifes, and forthright nudes and half-nudes. Her style was always distinctive, boldly colored, vigorous, even tough, in line. Utter was her main subject. In *Adam and Eve* she had made his lithe figure, with foliage over his groin, less sexually assertive than that of the woman.

Even as she found great happiness with her boyish lover, Maurice, in the midst of his luminous "White Period," continued to distress her. He could not handle wine, but he could not keep away from it. He also experimented with other substances. When roaring drunk on wine, rum, benzene, or denatured alcohol he often grew violent at home or in cafés. In the spring of 1912 he was picked up in a bout of delirium tremens, and his mother confined him to a private sanatorium at Sannois for a few months.

On Maurice's release he took a holiday with Valadon and Utter at Ouessant, a Brittany village. The purpose, she said, was "to do homage to Gauguin." The following summer they went to Corsica, where they painted together. Here Valadon made sketches for *The Nets*, with Utter posing for all three intertwined nudes. In the finished version of 1914 his masculinity would come to the fore under her joyous and sensuous brush. It was a pioneering effort, a woman painting a male nude.

After their return to Paris, Maurice became violent again and this time was placed in an insane asylum at Villejuif. Shortly after his release in 1914, four of his paintings of Montmartre were put up for auction along with those of Pablo Picasso, Henri Matisse, and Henri Rousseau, and sold for almost 1000 francs.

When World War I broke out, André Utter was among the first to enlist. Before leaving for the front, he insisted on marrying Suzanne. As soon as Utter was gone, Maurice, flatly rejected by the army, resumed his wild behavior, screaming maniacally, hallucinating, and lurking after pregnant women, whom he especially hated. Once again he was confined for a time in an insane asylum at Villejuif. Valadon's *Self-Portrait* from this period is understandably somber in the extreme.

Her spirits lifted the next year after her successful one-woman show at Berthe Weill's gallery. One critic exclaimed, "At the point of her brush everything comes to life, lives and breathes."

But there were new griefs. Her mother died in the summer, and Maurice was briefly confined in another hospital at Villejuif, then released. Finally Suzanne put him in the hands of a Dr. Vicq, who suspected that the young man's alcoholism was rooted in sexual disturbances. But Maurice grew impatient with his therapy and bolted.

Suzanne found relief at her easel; from it came *Nude Doing Her Hair*

(1916), which outlines a robust body in generous curves, and *Study of the Cat Raminou* (1917), a loving portrait. In 1917 the Bernheim-Jeune Gallery put on a joint exhibit of Valadon, Utrillo, and Utter. Unfortunately, an air of scandal hovered about "the wicked trinity," and few works were sold.

While Utter was convalescing from a wound in the first three months of 1918, Valadon joined him at Bellevue-sur-Saône for an ecstatic reunion. Back in Paris, she painted her exotic *Black Venus*, filled with arabesques, and her trenchant *Maurice Utrillo Painting*. But as she worked in her studio, where Maurice came daily, she noted with dismay that his powers as a painter seemed to have failed after his return from Dr. Vicq. The poetry had disappeared. On wild binges with his longtime friend, the gifted Italian painter Amadeo Modigliani, who called Valadon his "adopted mother," he was incorrigible. "Modi" died of meningitis and tuberculosis in 1920, but Maurice did not sober up.

Valadon herself felt terrified by the thought of growing old and began exhibiting extravagant behavior. Often she appeared on the Montmartre Butte with a goat at her heels. One evening she stood before a café milking a mare into a wine glass and drinking the libation.

Shortly after the war ended, Berthe Weill held a Valadon-Utter exhibit. A catalogue commentary noted of Valadon: "There is in the painting a faith and certainty which can be acquired only by those who have learned to use their fists." Then the writer prophesied that one day she would be "among the glories of feminist French painting." Utter, a sensitive artist, went unrecognized. Another dealer staged a show for Maurice.

Once again, in the spring of 1920, Maurice was confined in the asylum at Picpus, from which he twice escaped. The first time he was easily discovered, but on the second occasion Suzanne spent five frantic nights searching for him. Finally she found him in fine spirits in Montmartre, where a friend had taken him in.

Frustrated at the coolness of critics, Utter turned businessman and negotiated a lucrative deal with the Bernheim-Jeune gallery for a Valadon-Utrillo show. Later came a contract for a guarantee of a yearly sum for all the future works of mother and son. The couturier Paul Poiret bought several of Valadon's pictures, and suddenly it became chic to own her work. Three notable paintings from this period were the elegant *Bouquet of Flowers in an Empire Vase* (1920), *The Family of André Utter* (1921), and *The Abandoned Doll* (1921), which treats of a mother explaining puberty changes to her adolescent daughter, who looks away from her doll to examine her own body. Valadon's portrait of Mme. Levy (1922), whose gaze is intense, is deliberately crude.

The Utters celebrated the success of the Bernheim-Jeune exhibit by

buying the rundown Château St. Bernard near Lyons. In its tower Valadon made her studio. Also in the flush of triumph she painted one of her best-known pictures, *The Blue Room* (1923) in which a chunky woman, with aggressive gaze, dangles a cigarette from her lips as she languorously reclines amid a welter of floral patterns. The theme was lifted from the less successful *The Future Unveiled*, which Valadon had painted in 1912. The same year Valadon created a *Self-Portrait* showing the deterioration of her once remarkable beauty.

Even though privately he demeaned his stepson's paintings, Utter arranged for mother and son to participate in many exhibits and realized large sums, particularly from selling Maurice's work, which included churches and the French countryside. Objecting to the way Maurice monopolized his mother's attention, Utter began drinking heavily again and seeing other women, who made extravagant demands on him. Nonetheless he and Valadon gave the appearance of remaining together, she hiding his disillusionment under a bright smile.

Successful and popular as well for her originality and pungent speech, Valadon now lived in even greater style, feeding her beloved cats Beluga caviar on Fridays, employing a chauffeur, and often hiring taxis to drive hundreds of miles on one of her whims. Her entertainments were splendid. Escoffier prepared her buffets; her guests, besides painters, included Premier Édouard Herriot, the dancer Mistinguette, and the ballet impresario Sergei Diaghilev. Still she never forgot her impoverished childhood. At bistro tables she left thousand-franc notes under her plate, and she lavished gifts on her postman and laundress.

Now she painted fewer nudes and focused on still lifes, especially flowers. And again she felt called on to defend her son. As far back as 1909, Maurice had often used postcards as aids for his paintings. To his detractors, who cried out that therefore he was not a professional, Valadon made sharp retorts. Noting the liberties he took with the printed views, she insisted vehemently: "From picture postcards my son has made masterpieces; others fancy that they are creating masterpieces when they are turning out picture postcards."

All the lavish lifestyle, however, continued to play against an ever sadder background. By 1924 Maurice, disturbed by his growing fame, had grown wilder and more alcoholic. One day in a police station he smashed his head against the wall in a suicide attempt. Valadon feared that the lunacy which had dogged him all his life had struck him down permanently. But once again he recovered, watched over by his mother at the Château St. Bernard. By now, Valadon and Utter, who had argued incessantly over Maurice, lived apart, though they saw each other frequently. When Bernheim-Jeune bought a house on the avenue Junot in Maurice's name in 1925, Utter did not move into it.

Suzanne Valadon, *The Abandoned Doll* (1921), oil on canvas, 51×32 in., National Museum of Women in the Arts, Washington, D.C., gift of Wallace and Wilhelmina Holladay.

An official delegation visited Maurice Utrillo at the Château St. Bernard in 1927 and awarded him the ribbon of the Legion of Honor, but he gave little indication that he understood what all the fuss was about. Friends called the short ceremony Valadon's bitter victory. She herself stayed productive. *Nude on Sofa* (1928) showed again her strong linear movement and bold colors. The next year she did *Lilacs and Peonies,* an exceptionally handsome still life. Now came a period of critical success when major retrospectives were held and several group shows included new work such as *Bouquet of Flowers* (1930). In *Girl on a Small Wall* (1930) she returned to the expressive flat figure. Typically, the model is not handsome.

For her seventieth birthday party in 1935, Valadon offered the toast, "Vive l'Amour!" Soon after, she was rushed to the American Hospital at Neuilly with uremic poisoning. Later she claimed that while she lay there, an old friend, Lucie Pauwels, the stout, somewhat theatrical widow of a Belgian banker, told her, "I have decided to take care of your son since you cannot." But Mme. Pauwels always asserted that Valadon had asked what would happen to Maurice if she died. Whoever made the first move, Lucie Pauwels acted quickly.

After seeing that Maurice was baptized and confirmed in the Catholic church, she married him in civil and religious ceremonies. Watering down his wine, she kept him constantly at work. She dismissed Utter as Maurice's business manager, stopped all sales of his pictures for a while, and then began to release them at high prices. The Utrillos lived in a fashionable villa, La bonne Lucie, where Maurice seemed pitifully dependent on his wife. But when she was out of sight, he flung barbs in her direction.

Believing that for greed Lucie pushed Maurice into turning out bad pictures, Suzanne grew furious. She would not admit that with his marriage, her son enjoyed better health than at any time in his life.

By now she was no longer wealthy. Toward the last she met a young painter who called himself Gazi-I.G. To him she was "Mémère." Because of his blazing eyes and swarthy skin, people referred to him as Gazi the Tartar, but he hailed from Provence. He came to live with her and tried to convert her to his kind of mystical Catholicism, centered on the Virgin Mary. Not only to him but to everybody she saw in Montmartre, Valadon talked incessantly about her past, always changing stories.

Her pride had stayed intact. When the tiny old woman in worn tweeds and oversize moccasins went to the Exhibition of European Women Painters at the Jeu de Paume in 1937, she peered through big horn-rimmed spectacles at the canvases of Elizabeth Vigée–Le Brun, Berthe Morisot, Eva Gonzalès, Marie Laurencin, Seraphine Louis, Marie Blanchard, and Sonia Delaunay and said to a friend, "Do you know,

chérie? I think God maybe made me France's greatest woman painter." She spoke no longer of Maurice's steadily declining creativity. She did not live to see his pathetic last pictures.

She was at work on a floral still life when she suffered a stroke on April 6 that same year. She died the next day. As the body of the onetime street urchin lay before the altar of the parish church of St. Pierre, Picasso, Georges Braque, and André Derain paid homage. Her old friend Herriot delivered the eulogy, which failed to match the eloquence of a tribute he had written in 1932 for her one-woman show at the Galerie Georges Petite:

> To us who admire and love her art, Suzanne Valadon is springtime — a creature in whose sharp, incisive forms we find the fountains of life, the spontaneity of renewed day-to-day living. Before this very great and dedicated artist, the heir of those masters of the nineteenth century, whose names we now revere, I marvel that so singular a respect for the truth of form is able to achieve such a fete of color and movement.

Academically untrained, she had been her own best teacher. And at a most formative stage, as she herself often stated, she had truly lived among giants.

Suzanne Valadon : Works Mentioned

Erik Satie (1892–93), Musée National d'Art Moderne, Paris
A Seated Nude, drawing (1893), Metropolitan Museum of Art, New York
Seated Nude Woman with Standing Woman Seen from Back in the Background, drawing (c. 1908), Art Institute of Chicago
Adam and Eve (1909), Musée National d'Art Moderne, Paris
Bathing the Children in the Garden, drypoint (1910), National Museum of Women in the Arts, Washington, D.C.
Utrillo, His Grandmother, and a Dog (1910), Musée National d'Art Moderne, Paris
The Future Unveiled (1912), Private Collection
The Nets (1914), Musée National d'Art Moderne, Paris
Self-Portrait (1915), Collection of Paul Pétrides
Nude Doing Her Hair (1916), Museum of Women in the Arts, Washington, D.C.
Study of the Cat Raminou (1917), Musée National d'Art Moderne, Paris
Black Venus (1919), Musée Municipal de Menton, France
Bouquet of Flowers in an Empire Vase (1920), National Museum of Women in the Arts, Washington, D.C.
The Family of André Utter (1921), Musée National d'Art Moderne, Paris
The Abandoned Doll (1921), National Museum of Women in the Arts, Washington, D.C.
Mme. Levy (1922), Musée National d'Art Moderne, Paris
The Blue Room (1923), Musée National d'Art Moderne, Paris

Nude on Sofa (1928), Metropolitan Museum of Art, New York
Lilacs and Peonies (1929), Metropolitan Museum of Art, New York
Girl on a Small Wall (1930), National Museum of Women in the Arts, Washington,
 D.C.
Bouquet of Flowers (1930), Musée National d'Art Moderne, Paris

IX

Käthe Kollwitz

(1867–1945)

At the beginning of her career, Käthe Kollwitz staked out a social purpose, describing her goal in the simplest terms: "to express the suffering of man, which never ends." Most often her inspiration came from the plight of the poor and oppressed.

She was born Käthe Ida Schmidt in the Baltic port of Königsberg, East Prussia (now Kaliningrad, USSR) on July 8, 1867, the fifth child of Carl and Katharina Schmidt. Three of their seven children died in infancy. Käthe (called Katuschen) grew up with two sisters, Julia and Lise, and a brother, Konrad. She alone suffered from childhood tantrums and nightmares.

In 1871, Otto von Bismarck, minister president of Prussia, who had won the Seven Weeks War against Austria in 1866, successfully concluded the Franco-Prussian War, established the German Reich, and immediately began pushing his country toward swift advances in commerce and industry. His "age of progress" would have deep repercussions for the future artist.

After rejecting a law career, which he feared his socialist allegiance would hamper, Carl Schmidt had become a master stone mason and building contractor. Käthe greatly admired her cultured father, who brought his politics into their big house by the Pregel River. Judging Prussian schools as too rigid, he and his wife arranged to have their children educated in small private groups. Later Käthe attended an academy.

Both parents were talented amateur artists. From her well-educated mother she learned to read widely. She was also influenced by her maternal grandfather, Julius Rupp, an ordained Lutheran minister, orator, teacher, legislator, and founder — after two years of imprisonment for his religious views — of the Free Congregation (Friends of Light), which rejected the state church and practiced early Christian tenets and rites.

"Gabe ist eine Aufgabe" (talent is a responsibility) was one of Rupp's favorite axioms. Käthe echoed him years later when she wrote in her journal: "Everyone who is vouchsafed life has the obligation of carrying out to the last item the plan laid down in him."

Once she noted: "I felt both Grandfather and Father within myself as my origins. Father was nearest to me because he had been the guide toward Socialism, in the sense of the longed-for brotherhood of mankind. But behind him stood Rupp, whose traffic was not with humanity, but with God." In 1884 Carl Schmidt succeeded his late father-in-law as spiritual leader of the Free Congregation.

Another strong intellectual presence in Käthe's life was her brother Konrad, who urged her during her adolescence to read Johann Wolfgang von Goethe, Leo Tolstoy, and Heinrich Heine. In time Goethe became her favorite writer.

With pride the Schmidts had watched Käthe make her first drawings on scraps of her father's blueprint paper, and eventually they sent her for art lessons with G. Naujok, a painter, and with an engraver, Rudolph Mauer, who set her to drawing plaster casts. She found it far more pleasant to roam the streets of Königsberg with her sister Lise. The two girls were permitted to stroll unescorted, and they usually found their way to the waterfront, where the honesty, dignity, and broad free movements of the Lithuanian and Polish *jimkes* (dockhands) impressed them greatly. Long afterwards, Käthe would trace much of her work back to these "casual expeditions" through the world of the workers. She later remembered: "The first drawing of mine that clearly had real working people in it was a drawing based on Ferdinand Freilgrath's poem 'The Emigrants.'"

About this time she often held animated discussions with Konrad's friends Karl Kollwitz and his sister Elizabeth. A favorite pastime was to argue over August Bebel's *Woman and Socialism,* published in 1879. Bebel, cofounder of the first socialist party, the Social Democratic Workers' Party (SPD), championed feminist views and argued that under socialism women could abandon their second class status.

Meanwhile, Karl Kollwitz, a medical student, had fallen in love with Käthe. It was hard for her to understand his romantic interest because she thought herself extremely plain-looking, handicapped as well by a slight lisp. Her feelings toward him were less ardent, but in 1884 they became secretly engaged. Karl proposed just after Käthe returned from a trip with her mother and sister Lise to Berlin, Munich, and a spa in Switzerland. The Pinakothek in Munich had filled her with enthusiasm for Peter Paul Rubens' sweeping technique.

A year later she left for Berlin, where Konrad was studying philosophy and political economy at the university. He met her at the railroad

station, and, in a gesture characteristic of both, the first place they visited was the cemetery with the graves of the worker martyrs of the March Revolution of 1848.

According to plan, Käthe enrolled at the Art School for Women sponsored by the Berlin Academy of Art. There she studied with a multi-talented young Swiss artist, Karl Stauffer-Bern, who strongly urged her to concentrate on drawing and encouraged her to attend the graphics exhibit of the naturalist engraver and sculptor Max Klinger; it made a lasting impact on her. At the school she found a lifelong friend in another young student, Emma Jeep. In keeping with their feminist views, they decided to call each other Schmidt and Jeep, a practice they continued after each married. Practicing further independence, the two young women took time off from their studies for a brief, inexpensive vacation in Venice.

When Käthe arrived home in Königsberg, after two semesters, she hoped that within a year or so she could return for further study with Stauffer-Bern. But the next year she heard that he had died, suddenly insane, in Italy. In the meantime, she studied with Emil Neide, a well-respected genre painter.

Munich tempted many art students, and encouraged by her father, Käthe arrived there in 1888 for classes at the School of the Women Artists Association, which had been founded in 1882 just as German women's groups were clamoring for emancipatory social action. Before she left Königsberg, Karl gave her an engagement ring, which she wore, against rules, at the school, where she studied painting under Ludwig Herterich. There, to her delight, she found her friend Jeep. Student life brought carefree hours along with serious application, and Käthe Schmidt enthusiastically enjoyed the dances and outings. More seriously, she joined the informal Composition Club and accepted the Etching Club's invitation to attend its afternoon workshops.

Back in Königsberg in 1890, Käthe persuaded her teacher Mauer to show her the basics of etching. That winter, working by herself, she made a great many studies. Her gifted sister Lise, of whose talents Käthe had been secretly jealous, had given up art after her marriage, and when Käthe announced in 1891 that she was finally ready to marry Karl Kollwitz, her father warned her that it would be difficult to combine family and artistic demands. She was sure, however, that she could be a loving wife and mother and a fine artist at the same time. Just before her wedding, her father told her, "Be whatever you have to be with all your heart."

After graduating from medical school, Karl Kollwitz had become a health insurance doctor for a clothing workers' factory. He brought his bride to a flat located in the same building as his office, at 25 Weissenburger Strasse (now Käthe Kollwitz Strasse) in a working class district of northeast Berlin.

Käthe's studio adjoined Karl's rooms downstairs. At first she used a rolling pin to make proofs from her etched plates. Later she bought a small press, but ultimately turned to a professional printer. Long after, she wrote of a tinge of masculinity within herself that helped her in her work even then and of her own belief that "bisexuality is almost a necessary factor in artistic production." Meanwhile, she had read Klinger's book *Malerei und Zeichnung* (Painting and Drawing), which declared that drawing and graphics were more suitable than painting for certain themes, particularly somber ones. Käthe knew she would be emphasizing a dark side, the social problems with which she was so deeply concerned.

Eleven months after the Kollwitz wedding, Käthe gave birth to a son, Hans, who as he grew became the model for several drawings and etchings. Soon Lina Makler, a young woman about Käthe's age, became a live-in housekeeper and nanny, so satisfactorily that she remained permanently in the household.

Much of Kollwitz's subject matter stood right at her threshold. With mounting compassion she drew the laborers and their families who thronged the medical waiting room. In spite of Bismarck's social insurance reforms, the urban workers suffered from long hours, low pay, poor food, frequent exhaustion, and squalor. In 1893, two of her paintings and some graphics were hung at the Free Berlin Art Exposition and caught the eye of the critic Julius Elias.

During the first years of her marriage, Kollwitz reacted strongly to Émile Zola's novels of the oppressed and their exploiters. "Middle class people," she once wrote, "held no appeal for me at all. Bourgeois life as a whole seemed to me pedantic. The proletariat, on the other hand, had a grandness of manner, a breadth to their lives." Konrad, working for the SDP's newspaper, *Vorwärts*, continued to influence her political beliefs.

But her most overwhelming impression had come early in 1893 from Gerhart Hauptmann's play *Die Weber*, portraying the 1844 revolt of indigent Silesian weavers against painful working conditions. She attended its premiere given by the Freie Bühne company and felt overwhelmed, declaring later: "The performance was a milestone in my world."

Almost at once she decided to use Hauptmann's theme in a series symbolic of current ills, particularly a wave of strikes. Feeling a bit uncertain about her technique, she produced *A Weavers' Rebellion*, an unusual combination of three lithographs and three etchings. The stark titles— *Poverty, Death, Conspiracy, Weavers on the March, Attack*, and *The End*— fitted her realistic, grave, intensely moving imagery. In 1898, when the series was shown at the Greater Berlin Art Exposition, Kaiser Wilhelm II objected to its political overtones and ordered the jury's intended Little Gold Medal withdrawn. A year later, however, Kollwitz received the Little Gold Medal at the German Art Exposition in Dresden.

Her second son, Peter, had been born in 1896, and motherhood now became a central theme in her prints, often connected with the appalling sickness and early death she saw about her. "All my life," she reflected in old age, "I carried on a conversation with death." Often she felt consumed with fears for her own sons' survival.

After her first confrontation with autocratic art policy, Kollwitz formally joined the Berlin Secession, for "free artists," and for years she contributed works to its shows. At this point, she drew new inspiration from Edvard Munch's expressionistic pictures of human suffering, from William Hogarth, and from Honoré Daumier. As a result of the success of the *Weavers* series, she was asked to teach drawing and etching at the Art School for Women in Berlin, where she stayed five years.

From 1900 to 1903 Kollwitz used pastels, colored chalk, and colored prints for many single prints and portraits of women, often nude. A dramatic etching, *Downtrodden* (1900), shows the misery of a proletarian family. Inspired by Charles Dickens' *Tale of Two Cities*, another etching, *The Carmagnole* from the next year, has French women dancing around the guillotine. But from her studio there also came tender images of the mother-child relationship.

Then, reading a book about the German Peasants' War, 1524-25, Kollwitz became haunted by the account of a peasant woman, known as Black Anna, who helped incite the rebellion. With raised arms leading a mob into action, the woman dominated a new etching called *Outbreak*. Kollwitz had made many changes as she went along, pulling variations called "states." When, after many states, she presented it to the Association for Historical Art, she received a commission to complete a series on the uprising. So in 1902 she began her second graphics cycle, *The Peasants' War*, again on the theme of revolt among the oppressed. It would take her five years to complete the cycle. She did not aim for authenticity in dress or setting. Rather, she wanted to bring the past into the present. Again she offered both lithographs and etchings, the etching process combined with aquatint and soft grounds. Again she used straightforward titles: *Plowers, Raped, Whetting the Scythe, Disturbing Weapons in a Vault, After the Battle.*

Kollwitz had long been interested in sculpture, and for several weeks in 1904 she attended classes at the Académie Julian in Paris; twice she met Auguste Rodin. But she postponed working much with clay. While in the French capital, she came upon an indigent boy, Georg Gretor, whose mother had been one of her classmates in Munich. She brought him home with her, and he remained in the household for years.

While still working on *The Peasants' War* in 1907, Kollwitz was awarded the Villa Romana Prize for study in Florence. The prize had been founded by Klinger, one of the artists she most admired. But she

seldom used the handsome studio provided for her in the Klinger villa, preferring to be outdoors as much as possible and to visit the museums. At first her son Peter, recovering from a bout with tuberculosis, stayed with her. And once more she had the companionship of Jeep, who had married a religious writer and lived near Florence. After the fresh air helped make Peter well, he returned to Berlin.

Another friend was an independent young English writer, Constanza (Stan) Harding, married to a German physician named Kroyl. With Stan, Käthe took a walking tour along the coast to Rome. Stan had armed herself with her father's revolver, her usual weapon for long hikes, but the two women did not have to use it. In Rome, they found Käthe's son Hans, who arrived for some sightseeing; then, for Käthe's fortieth birthday, Karl and Peter met her at a house by the Ligurian Sea. Jeep and her husband and Stan and Dr. Kroyl joined them for a happy vacation. Though she had not worked much, Kollwitz realized that the Italian sojourn had changed her style and advanced her to a larger format that gave a monumental quality to her pictures.

Before her departure she had again incurred the Kaiser's displeasure. A poster showing a careworn working woman, made for the German Home Industries Exhibition, was brought to the attention of the court, and the Kaiserin Augusta refused to attend until the offending piece had been removed.

Printed and exhibited in 1908, *The Peasants' War* met with acclaim, and at 41, Käthe Kollwitz was relatively famous. Viewers did not miss the symbolism; at the beginning of the twentieth century many German agricutural workers were still treated like slaves, even dragging the plow.

That year she began a journal, which she would keep for 34 years, expressing her inmost feelings and thoughts filled with melancholy. Her son Hans would remember that for years "she constantly swung between long periods of depression and inability to work and much shorter periods when she felt she was making progress in her art and mastering her tools."

From 1908 to 1911, she contributed a series of charcoal drawings of working class women, *Pictures in Misery* to *Simplicissimus*, a satirical weekly in Munich, where she had been hired as a free-lance illustrator. By now her draughtsmanship was so finished she did not require live models. The output from etcher's plates and lithographer's stones in Kollwitz's studio remained fairly steady, but after 1910 she seldom used color. Always the perfectionist, she made countless preliminary studies for each print. Meanwhile she worried constantly about her sons, who frequently had been ill. Showing her preoccupation with death, an especially moving etching, *Death and Woman*, dates from that year.

Also at this time she seriously took up sculpture. Over the next three years her pieces were mostly exploratory. Often, like Rodin, she created only partial figures.

Again in 1912 she fell under royal displeasure. One of her posters, *For Greater Berlin,* commissioned by a local union action group, showed a hungry girl holding a little boy's hand as they stood in front of an apartment with a sign forbidding children to play. Two years earlier, another poster, *Run Over,* had warned what could happen to children playing in the streets.

Kollwitz now had more time than ever for her work because both sons had left home. Peter, who gave promise as an artist, worked as a farmhand in Poland. Hans, deeply interested in the theater, had acceded to his father's urging to study medicine. She herself had reached a new stage. Dissatisfied with her work, she almost abandoned etching and instead chose drawing, lithography, and sculpture.

By 1913 she had become even more partial to lithography. She now used broad chalk strokes on the stone and varied her graining. That year she got "saddled" with the post of second secretary of the New Secession, formed in 1910 after conservatives had taken over the Secession. Three years later she was voted the first woman juror of the new group.

Unlike her fervently patriotic countrymen, Kollwitz first reacted to the outbreak of war in August 1914 by crying bitterly. In late October, 18-year-old Peter, a volunteer, was killed in action at Dixmuiden, Belgium. He had finally decided he wanted to be an artist. Kollwitz's grief, compounded by thoughts of what he might have become, fed her growing pacifism, which did much to inspire her work over the next two decades.

Within a year she was consumed with the idea of using Peter's image for a granite memorial to fallen volunteers. Many of her drawings and prints expressed this dream. Her first attempts, however, proved unsatisfactory. "Strength is what I need," she wrote during the mourning period. "It's the one thing which seems worthy of succeeding Peter. Strength is to take life as it is and unbroken by life — without complaining or overmuch weeping — to do one's work powerfully."

By 1917 her fame had so increased that Paul Cassirer's Gallery, known as a Secessionist stronghold and notorious for its antiwar stand, gave Kollwitz a big retrospective for her fiftieth birthday. That same year an exhibit at Cassirer's of Ernst Barlach's Gothic-influenced woodcuts excited her.

Came the Armistice, and sailors, soldiers, and workers successively rebelled. Kaiser Wilhelm had abdicated two days earlier, and Friedrich Ebert, leader of the SPD, established a provincial government. As workers' and artists' councils were set up across Germany, Kollwitz attended some

of their meetings. Because Ebert's six-man council felt intimidated by the military commander, it did not follow through on any of the revolutionary demands. Instead, it scheduled national elections for January 1919.

A few days before the polls opened, Rosa Luxemburg and Karl Liebknecht were assassinated. They were the founders of the German Communist Party, Spartacus, which had attempted an armed insurrection. The Liebknecht family asked Kollwitz to make drawings of Karl Liebknecht's body as it lay in state. Remembering the impact the Ernst Barlach exhibit had made on her, she decided that her *Memorial to Karl Liebknecht* would be her first woodcut. Like medieval artists, she included the title and dedication in the design.

After the newly elected National Assembly met at Weimar and drafted a constitution, the Weimar Republic was established with Ebert as president. Women were granted suffrage, and Kollwitz became the first woman elected to the Prussian Academy of the Arts, with the title of professor and the use of a large studio.

Hans married the artistically gifted Othilie Ehlers after the war, and by 1921 Käthe and Karl Kollwitz had their first grandchild, a boy named Peter. Subsequently twin girls, Jordi and Jutta, were born. In spite of baby Peter's arrival, it was a bleak year for Käthe. The first Peter's death and the war had led her to what she called a state of "nothingness." In her journal she wrote: "Low, low. Touching bottom."

She emerged from her depression by beginning work on a third graphic cycle, *War*, seven white-on-black woodcuts, into which she poured her vehemence. Her style had now changed from her earlier naturalism to a kind of expressionism. The series was finished in 1923. Once more she kept the titles starkly simple: *Sacrifice, The Volunteers, The Parents, The Widow I, The Widow II, The Mothers,* and *The People.* Each condemned war from the woman's viewpoint. Using monumental forms, Kollwitz achieved magnificent simplicity and emotional power. *War* was first presented at the Berlin Academy's Black and White Exhibition, and the artist noted happily: "A great response from my show."

Postwar inflation reached its peak in 1924, a year in which Kollwitz worked harder than ever. The Weimar Republic encouraged free expression, and she portrayed the general destitution in her powerful lithograph, *Bread.* Reproduced by photoelectric processes, it became one of her most widely distributed pictures. Almost as popular was another poster, *War, Never Again!* with a young man raising his arm in an oath. Other posters denounced profiteers, the law against abortion, and women's unequal rights. Meanwhile, Kollwitz was reworking prints for her fourth great cycle, *The Proletariat* (1925). Its three woodcuts she called *Unemployed, Hunger,* and *The Children Die.* For the second print she recorded 15 separate states.

Käthe Kollwitz, *Self-Portrait* (1924), lithograph, National Gallery of Art, Washington, D.C., Rosenwald Collection.

Kollwitz was by inclination not a joiner, but in 1926 she participated in founding the Society for Women Artists and Friends of Artists, a group of Austrian and German feminists committed to the sharing and sponsoring of women's art work.

For years she had worked sporadically at the memorial to Peter and his fallen comrades and had felt frustrated over her inability to produce

Käthe Kollwitz, *Hunger*, from *The Proletariat* (1925), woodcut, National Gallery of Art, Washington, D.C., Rosenwald Collection.

a satisfactory sculpture. One day news came that his body was to be removed to a soldiers' cemetery in Roggevelde, Essen, near Dixmuiden. In the spring of 1926 she and Karl went to see the new cemetery. She felt rejuvenated, and for the next five years worked on her new concept, two life-size statues of a mournful father and mother, actual likenesses of herself and Karl.

On the occasion of Kollwitz's sixtieth birthday in 1927, an essay in *The Socialist Monthly* hailed her: "The things in her work that grip us, shake and shatter us, are human destinies and human emotions. They are war and hatred, struggle and love, poverty and death." That same year she and Karl went to Moscow as official guests at the tenth anniversary celebration of the Russian Revolution. She noted: "I am not a Communist. But what has happened in Russia during the last 10 years seems to be an event which both in stature and significance is comparable only

with the French Revolution." A new honor came the next year when she was named director of the master studio for graphic art at the Berlin Academy of Arts.

In 1931 the *Memorial for the Fallen: The Parents* was finally completed and went on exhibit at the Berlin Academy of Arts, causing a sensation. Then Kollwitz worked with two stone sculptors, and the granite statues were placed at Roggevelde in 1932. Soon came a new grief, the death of her beloved brother Konrad, who had risen to be professor of political economy at the Berlin Technical Institute and director of the Freie Bühne in Berlin.

Both Kollwitzes were bitterly opposed to the rise of the Nazi Party and Adolf Hitler. As 1933 began, President Paul von Hindenburg, under pressure from German industrialists and aristocrats as well as the military, appointed Hitler chancellor. In his effort to gain supreme power, the Nazi leader promptly called for parliamentary elections. Earlier, the Kollwitzes had signed a manifesto appealing for unity among the parties on the weakening Left. With the Nazi victory, they were regarded as enemies, and Kollwitz was forced to resign her civil post at the academy. Having lost her studio there, she relocated in another, which did not have adequate room for sculpting.

After her ejection from the academy, she finished her last great cycle, *Death,* a series of eight stark lithographs entitled *Woman Entrusting Herself to Death, Girl in the Lap of Death, Death Reaches into a Group of Children, Death Seizes a Woman, Death by the Roadside, Death Recognized as a Friend, Death in the Water,* and *The Call of Death.*

Throughout her long career she had pictured herself often in deeply introspective drawings, etchings, lithographs, and sculpture. Her first self-portrait, a drawing from 1885, depicts a laughing, confident young face; the late, often androgynous likenesses reveal the taut and stricken expression of a woman who has suffered tremendously. Many critics wrote that more and more she took on the look of the workers she portrayed.

The Nazis attacked her husband as well. Because of his membership in the Social Democratic Physicians' Society they refused to let him continue as a health insurance physician, and he turned to private practice in the family living quarters, still at Number 25. Later, however, he was reinstated for a short period. Hans, who also had had his practice taken away, was likewise reinstated, but suffered the indignity of having his home searched by the Nazis, who seized much of his mother's art.

Hitler forbade Kollwitz to exhibit anywhere, but she kept working in her studio. Under the Nazi repression, she turned more and more to small bronze pieces for which she had enough working space. *Self-Portrait* (1934), *Rest in the Peace of His Hands* (1936), *Tower of Mothers* (1938), and *Pieta* (1938) were deeply emotional.

Barlach died in 1938, and Kollwitz mourned him as the artist she now most respected. To express her grief she made *The Lament,* a sculpture showing her face half covered by her hands.

A year after World War II began with Hitler's invasion of Poland, Karl, bedridden for several months, died of a heart attack. In her journal Käthe Kollwitz had often complained when she felt disharmony between them, but in the last months when she constantly watched over him, she felt closer to him than ever before. She fully appreciated his long devotion. "Karl was always at my side," she wrote. Two years later, Hans's son Peter fell at the front, and Kollwitz produced her last print, a lithograph, depicting a frantic mother clutching her children. Its title, "Seed Corn Must Not Be Ground," came from Goethe's *Wilhelm Meister.* She had used the same words in 1918 in a newspaper letter criticizing the poet Richard Dehmel's fervent appeal to young Germans to lay down their lives.

As British and American bombers zoomed over Berlin in 1943, Kollwitz left with her sister Lise and several relatives for Nordhausen, where a young sculptor, Margarete Boning, placed part of her house at their disposal. That fall an air raid destroyed Käthe's home for 52 years at Weissenburgerstrasse 25. Klara Stern, niece of Lise's late husband, was badly burned as she tried to save some of Kollwitz's work.

Though reviled by official Germany, Kollwitz agreed to answer a questionnaire sent out to several artists, who were asked to express their views on the dignity of art. The writer of the questionnaire had earlier denounced Kollwitz's work as "gutter stuff." But with great dignity Käthe Kollwitz sat down at Nordhausen to reply:

> As a rule the artist is a child of his times especially when the period of his personal development occurs during times such as the early days of socialism. My own development coincided with that period, and the idea of socialism captured my mind completely. But what had I to do with the laws of beauty, with those of the Greeks, for instance, which were not mine and with which I had no sympathy? The proletariat was my idea of beauty.

Her last self-portrait, done in charcoal, clearly indicates her belief.

The following year Prince Ernst Heinrich of Saxony, an ardent art collector, offered Kollwitz a small apartment on his estate, Rudenhof, at Moritzburg near Dresden. Her granddaughter Jutte came to stay with her.

She now called herself "the very old Käthe." To add to her melancholy, a heart condition made even walking difficult. When given a piece of charcoal and some paper, she said brusquely, "No, I shan't work again. I'll not do anything second rate." Yet she was still idealistic, telling Jutte, "One day a new ideal will arise, and there will be an end to all wars."

Käthe Kollwitz died on April 22, 1945, 16 days before the Nazis signed terms of unconditional surrender at Reims. Her last words were reported as "My greetings to all." That autumn an urn with her ashes was laid beside Karl's urn in the cemetery at Friedrichsfelde in Berlin. Her bronze relief, *Rest in the Peace of His Hands,* was placed on a slab at the family gravesite. In it her face is serene, free of worry and age. In a fervent declaration, she had once summed up her own days: "No matter whether life is long or short, the important thing is to hold our banner high and to fight in the struggle. For without struggle there is no life."

Käthe Kollwitz : Print Collections

Achenbach Foundation for Graphic Arts, California Palace of the Legion of Honor, San Francisco
Akademie der Kunste, Kollwitz Archiv, Berlin
The Fogg Museum, Harvard University
Los Angeles County Museum of Art, Los Angeles
Minnesota Museum of Arts, St. Paul
National Gallery of Art, Washington, D.C.
Rheinisches Bildarchiv, Cologne
Staatliche Museen zu Berlin
Stanford University Art Museum, Stanford, California

X

Paula Modersohn-Becker

(1876–1907)

During her brief career, Paula Modersohn-Becker struggled to reconcile the conflicting demands of family life and the solitary existence she deemed necessary to be a dedicated artist. She died largely unrecognized; today she is considered an extraordinary precursor of German Expressionism.

No artistic antecedents lay behind either her father, Carl Woldemar Becker, a railroad administrator, or her mother, Mathilde, who came from the aristocratic von Bultzingslöwens. But the warm home atmosphere emphasized art and music appreciation. Paula, third child of seven, was born on February 8, 1876, in Dresden. Even when small, she preferred keeping to herself as much as was possible in a large family. In 1888, the Beckers moved to Bremen, and since she drew well, her parents sent her to a local painter, Bernard Wiegandt, for lessons.

At 16, Paula packed her bags for London to stay several months with her father's sister, Marie. There the budding artist talked so much about her talent and dreams of succcess that her relatives called her conceited. All the same, her aunt brought her to the St. John's Wood Art School, which prepared students for Royal Academy schools. But on her return home her parents, feeling constrained by Herr Becker's forced early retirement, urged her to get ready to support herself. With little enthusiasm she entered the local teachers' seminary, where she earned excellent grades after all.

With this success, she finally persuaded her reluctant parents, in the spring of 1896, to let her enroll in the Art School for Women in Berlin, where Käthe Kollwitz, an alumna, would soon begin teaching graphics and life drawing. Paula stayed with the family of her maternal uncle, Wulf von Bultzingslöwen, in suburban Schlactensee, and daily took the 15-kilometer train ride into Berlin. As a student she thrilled to the works

of Michelangelo, Hans Holbein the Younger, Lucas Cranach, Sandro Botticelli, and Rembrandt in local museums. After an aristocratic friend of Mathilde Becker recommended Fritz Mackensen as a teacher, Paula's parents agreed to pay for her lessons with him at Worpswede, a village and artists' colony on the flat moorland about 16 kilometers from Bremen.

The young Paula had started to keep a journal in which she took great pains to express herself romantically and poetically. Doubtless it was influenced by her reading the *Journal* of short-lived Marie Bashkirtseff, the Russian-born painter, who dwelt on her penchant for glory and her dismay at the discrimination meted out to women artists.

In her journal for the summer of 1897, Paula greeted Worpswede rhapsodically: "Birches, birches, pines, and the willows, beautiful brown moors, exquisite brown! Canals with black reflections, asphalt black. The Hamme with its dark sails. It's a wonderland, a land of the gods." The pines she labeled "mighty men," the gleaming birches her "modern young women." She studied informally with Mackensen, but was not interested in doing moor landscapes and village scenes in the nostalgic and reverential style he and his fellow painters, Otto Modersohn and Heinrich Vogeler, the *Jugendstil* illustrator, practiced. She preferred to explore the formal possibilities. Paula, petite and physically delicate, felt most attracted to the tall Modersohn, of whom she wrote in her journal: "There was something gentle and sympathetic about his eyes."

In the fall of 1897 she came back to the art school in Berlin. Then before Christmas she enriched her lessons with a trip to Vienna to see its great art treasures and to explore the city's historic past. But her mood sobered when her father kept pressing her to earn a living. Gracefully she refused in long, loving letters to him and her mother, whom she addressed as "Dear, Darling People."

That summer of 1898 she accompanied her Uncle Wulf on a fishing trip to Norway though, as she wrote, she disliked the idea of spending four hours waiting and then ten minutes tormenting the fish that had been caught. Paula was a passionate reader, and at this point the melancholy Danish novel *Niels Lyhne* captivated her; of its author, J. P. Jacobsen, she noted: "Never has anyone captured so well for me that mood of a room in the soul."

Financial help from relatives now made it possible for her to study art for three more years, and Herr Becker did not object when she made up her mind to settle in Worpswede. She arrived there with her mother and sisters, Milly and Herma, in September. Immediately Frau Becker rented a farmhouse studio, Brunjeshof, for her daughter. After her family left, Paula found a good friend in dark-haired Clara Westhoff, a young sculptor whom she described as "big and splendid, both as a person and as an artist."

She resumed lessons with Mackensen and used the dark colors he favored. But she disliked his condescending manner toward academic training and thought him too emotionally distant from the figures in his landscapes. She herself felt deeply involved with the subjects of her charcoal, chalk, and pencil drawings: peasants; peat cutters; shabby, wistful children with whom she played; and inmates of the poorhouse. One favorite was Old Drebeen, or Mother Schröder, a dwarfish woman who hobbled on a cane and told mysterious stories. (Drebeen was the local pronunciation for *dreibeinig* or three-legged.) She would figure in many of Paula's oils. Another favorite was Old Bredow, a well-educated nobleman's son, who had formed a deep attachment to his cow. In 1899 Paula started to make a penetrating charcoal study of his aristocratic face with its air of vulnerability. Always showing deep compassion for her models, she chose to stress physical peculiarities, however grotesque, that to her expressed personality. *Seated Girl,* for example, emphasizes in black and red chalk a chinless profile and a too-high forehead. Some of the village's young women and adolescent girls, willing to model for pennies, posed nude for her sketches.

Paula also tried her hand at etching, grateful for use of the printing press Vogeler, Mackensen, Fritz Overbeck, and Hans am Ende had bought and installed at the Barkenhoff, Vogeler's white-gabled house. *The Goosegirl* (1899–1900), an etching with aquatint, ranks among her best graphics.

More and more she sought the company of Modersohn, whom she characterized as a "fine dreamer," and his wife, Helène. He too had favorable impressions of Paula, noting in his diary: "Cheerful, lively, fresh temperament. Compensates for mine.... Outwardly charming, sweet, strong, healthy, energetic."

Modersohn may have overstated her good health and strength, but not her energy. One late evening Paula and Clara Westhoff, while on a walk, impulsively climbed the church tower, pulled the ropes of the big and little bells, and swung themselves up in the air. Suddenly the churchyard swarmed with excited villagers — the young women had rung the fire bells! For days Worpswede talked of nothing else. A penitent Clara subsequently gave the church eight copies of an angel's head she had been working on.

In late summer, 1899, Paula accompanied her Tante Marie on a journey through Switzerland. That December with Clara Westhoff and Maria Beck, another member of the Worpswede art colony, she participated in a group show in Bremen, sending some self-portraits and studies of peasant types "in runic script," as she described them. A conservative critic gave all three women unfavorable notices.

But Paula shrugged off the criticism. She had fixed her mind on Paris,

the mecca for art students. On New Year's Day she arrived there to find Clara preparing to study anatomy at the Académie Julian and armed with an introduction to Auguste Rodin, whose school she would join for a short time. Paula stayed in Paris for six months, renting a small room that also served as her studio and taking drawing and painting lessons at the Académie Cola Rossi. She also went to *croquis* (rapid sketching) classes, for which she paid a small fee to use a studio and model, and took anatomy lessons at the École des Beaux-Arts. More important were the collections at the Louvre ("my alpha and omega") and the Luxembourg Palace and the art exhibits at the Exposition Universelle. At Ambroise Vollard's cluttered gallery she discovered Paul Cézanne; seven years later she wrote to Clara that seeing his pictures had been like a thunderstorm, a great event that completely changed her mind. Soon the air would turn electric with a proliferation of art styles unmatched in any period in history.

Well outside the *la belle époque* circles, Becker had made friends with other German art students in Paris and joined enthusiastically in their dancing and boating parties. There was only a brief encounter with the painter Emil Nolde, who later wrote in his autobiography: "During a noon hour, I met two strange German girls. The one, Paula Becker, was small, questioning, vivid; the other, Clara Westhoff, sculptress, was tall and restrained. I never saw either of them again."

Doubt and gloom still beset Paula, and therefore she looked forward to the arrival of Otto Modersohn and the Fritz Overbecks. Paula intended to travel home with them. But plans for a delightul visit were shattered only a few days after the guests appeared when Otto received word of his wife's sudden death. He rushed back to Worpswede and their two-year-old daughter, Elsbeth.

Becker kept to her plan of returning because she needed to recuperate from overwork and strained nerves. Of all her friends, Otto Modersohn came most frequently to sit at her bedside. By the time she was up again, deeper feelings had surfaced on both sides, but because Otto was a recent widower, the courtship remained secret — so secret that letters were left under a certain stone in the silent moorland.

Woldemar Becker meanwhile kept pressuring his daughter to apply for a governess job. Paula, however, would not give up her easel. In her journal she wrote: "I know I will not live very long. . . . My life is a celebration, a short, intense celebration."

Her passion for art also made her agonize over Otto's quiet wooing. Though she craved independence and solitude, she realized marriage could release her from financial dependency on her parents. Besides, her early admiration for Otto had developed into love.

In the meantime, Worpswede stimulated her literary and musical tastes as well. The colony drew such guests as the playwright Gerhart

Hauptmann and the poet Rainer Maria Rilke, just back from a journey to Russia and wearing his shirt outside his trousers, to village consternation. With Rilke, who called her "the blonde painter" despite her brown hair, Paula held deep conversations and found in him a sensitivity matching hers. He likened her voice to "folds of silk." Rilke seemed equally fascinated by the pert Becker and the more reserved Clara Westhoff and referred to both "girls," as he described them, in his poems. Especially he saw Paula as a symbol of girlhood.

Musical pleasures came from the well-to-do Vogeler, a capable violinist, who invited other musicians in small groups to play Handel, Beethoven, and Richard Strauss at the Barkenhoff; the entire art colony, which now included another woman, Ottilie Reylander, attended. Sometimes Paula's sister Milly sang in the candlelit white music room, where the slender young women in their white party frocks harmonized well with the Empire furniture. These Sunday gatherings, also devoted to long conversations about art and literature, lasted till dawn and were the great event of the week. On a less elevated level, Paula flung herself lightheartedly into dancing at the village festivals.

That year of 1900, she continued with landscapes: *Glade, Barn against An Evening Sky,* and *Worpswede Landscape* did not satisfy the Worpswede aim of achieving a pleasing composition, but they did fulfill her wish to simplify and to express her feeling. Later that year she produced a striking *Still Life with Blue and White Porcelain,* her view focused on a single corner of the table. She also drew nudes, harsh and heavily shadowed, to show ugliness and awkwardness.

Paula and Otto became engaged in October. To her Tante Marie she wrote: "His whole person really consists of feeling. . . . We understand each other very well in art." They often painted the same subjects, for Otto as well felt attracted to the poorhouse characters.

Paula's parents opposed her marriage, convinced that with 11 years seniority Otto was too old for her; besides, he brought the encumbrance of a small daughter. With the new year they softened but insisted that Paula must spend two months in Berlin at a cooking school.

Romance now filled the art colony. Clara Westhoff and Rilke became engaged, and Vogeler prepared to wed his sweetheart. With his fiancée absent in Berlin, Otto jotted down what to him seemed her most attractive qualities: heavy chestnut brown hair (which she caught up in a fat bun at the nape of her neck), merry laugh, freshness, vivacity, and cleverness.

His brother performed the wedding ceremony in May 1901 at her parents' home, while Woldemar Becker, terminally ill, watched from an adjoining room. The Modersohns spent their honeymoon in Schreiberhau at the home of Dr. Carl Hauptmann, the playwright's brother, and came

home by way of Prague and Munich. Rilke and Westhoff had married in April.

That summer Otto painted his bride at her easel in their garden. She preferred, however, to work unobserved in her studio. While still fascinated by physical peculiarities, she now was drawn toward disability or illness. That year she created her haunting *Portrait of a Sick Girl.*

Some of the glow Paula had felt before her marriage rather quickly dissipated during the next year and a half. In her journal she noted a "great lonely truth," that her art was a separate world. On Easter Monday, 1902, sitting in her kitchen watching a roasting veal, she wrote in her housebook: "It is my experience that marriage doesn't make one happier. It takes away the illusion that previously sustained one's whole reality, that there is a companion for one's soul." Her unhappiness was compounded by her father's death and a rift in her friendship with Clara Westhoff and Rilke, partly caused by the Rilkes' precarious financial situation and partly by Clara's total immersion in her marriage. The new Vogeler marriage, Paula sadly noted, showed strains.

In spite of her black moods she went on painting. Her still dark landscapes showed the continuing influence of her husband and Overbeck, but bypassed the sentimentality of the usual Worpswede style. In her diary she wrote, "One should not think so much about Nature in relation to painting. The color sketches should be made just as one perceives them in Nature. But one principal thing is my personal feeling." Her portrait of little Elsbeth in the apple orchard brought her the first genuine satisfaction she had realized with her work.

She wrote her mother: "My creative ability and my expressive powers are growing. I definitely feel that still more good will come out of this work." On the other hand, she painted *Girl in Front of a Window* in one of her periods of depression.

By February 1903, Worpswede began to pall, and she felt that only from the distance of stimulating Paris could she examine the art colony with a critical eye. Arriving in the French capital, she located Westhoff and Rilke, and in stages the three reconciled.

The new freedom, however, brought loneliness. Suddenly she wanted King Red Beard, as she called her husband, to join her, but Rilke wrote to Otto advising him to stick to his own country. During the six weeks Paula remained in Paris, she again took drawing classes and *croquis* sessions at the Académie Cola Rossi and at the Louvre sketched Greek, Roman, Egyptian, and Gothic works, which she had come to value for their great simplicity of form.

Rilke, increasingly friendly with Auguste Rodin and soon to become his secretary, obtained for her a ticket to an afternoon reception in the sculptor's atelier. He gained Paula's admittance with a note introducing

her as "the wife of a very distinguished painter." Rodin did not notice her then or later when she went out to his pavilion at Meudon.

The works of Rodin, like the Rembrandts in the museums, proved particularly inspirational. Both artists emphasized the character of the surface, an emphasis she called "Krause" (curl). She also found it in Vincent van Gogh's vibrating lines. Later, to achieve this surface quality herself, she painted on various materials, experimenting with paper, cardboard, slate, wood, masonite, and pasteboard. Sometimes, according to her husband, she worked on the surface of her paintings with brush handles or roughened up the coat of paint that had dried and painted over it.

Still other art made its impact. With the Rilkes she attended an exhibition of Japanese scroll paintings and sculptures that were to be auctioned off, and in them she saw "a more pointed way," a stress on what was important. Also during that fertile and meaningful half-year in Paris, she came across the work of the Nabis, young symbolist artists, whose name means the Prophets in Hebrew—Pierre Bonnard, Édouard Vuillard, and Maurice Denis. She audaciously planned to visit their studios unescorted.

The next two years in Worpswede, Modersohn-Becker threw herself into painting and sketching. She finished *Girl with Flowers,* begun in 1902; in stark contrast to its delicacy were the lumpish peasant faces of *Girl and Boy. Infant with Mother's Hand* (1903) revealed her ongoing fascination with ugliness even in a young baby face. *Still Life with Jug* incorporated Cézanne's tilted perspective and monumental forms but retained Becker's original style. For six years she had been picturing herself introspectively. The *Self-Portrait* of 1903 bears the composed expression of a settled young *hausfrau,* yet contains a tinge of melancholy. Sadness also lurks in the dark and sketchy *Evening Festival in Worpswede,* lacking any celebratory mood.

Otto worked hard too, and she wrote a sister praising his "really beautiful pictures." He did not fail to return the compliment: "She is a genuine artist of whom there are few in the world; she has something quite rare." Lamenting that she was unknown and unrecognized, he said, "Someday all this will change."

Again she grew restless. By 1905, feeling that life in the Worpswede art colony revolved too much around inner experiences, she craved the old excitement of Paris. Just after her twenty-ninth birthday she left to enroll in the Académie Julian. This time she did not ask her husband to join her. He came nonetheless for ten days, accompanied by her sister Milly and the Vogelers. Modersohn-Becker was receptive to a Van Gogh retrospective and to all the new art on view, but Otto did not care for such expressive emotion. Together they saw several Paul Gauguin retrospectives, Otto as unmoved by the primitivism as she was excited.

Paula Modersohn-Becker, *The Old Peasant Woman Praying* (c. 1905), oil on canvas, 29¾ × 22¾ in., ©The Detroit Institute of Arts (58.385), gift of Robert H. Tannahill.

She came home in April. In June she wrote her Tante Marie that she was painting, sleeping, eating, and "stuffing the gullets of two magpies." Old Drebeen had served as model for *Poorhouse Woman by the Duckpond.* Paula worked now on her remarkable *Still Life with Pumpkin, Still Life with Fruit, Still Life with Chestnuts,* and *Still Life: The Breakfast Table.* Simplifying the composition, she wanted to get through to the inner

quality of each object by using strong colors, large forms, and compact groupings. She produced more studies of the poor, like *Old Peasant Woman Praying*, marked by an air of quiet dignity. The ocher, blue, and green tones grew lighter in the stylized foliage behind the rugged head. She also painted a highly sensuous *Reclining Nude* and a portrait of Clara, striking in a white dress.

Rilke, by now Rodin's secretary, came at Christmas to Worpswede, where his wife was living with their small daughter. After seeing Modersohn-Becker's work, he wrote that she was "in a completely original style of her painting, painting recklessly and boldly things which are very Worpswede-like and yet which were never seen or painted before." He saw them "in their completely original way strangely in affinity with Van Gogh."

Only a few weeks later Modersohn-Becker's journal held ominous words: "I couldn't stand it any longer, and I'll probably never be able to stand it again either." By the beginning of 1906 she had found marriage and Worpswede too confining. Desperately she set out for Paris. Her journal for February 24 read: "I have left Otto Modersohn, and I am standing between my old and my new life."

The new life meant classes in anatomy and art history at the École des Beaux-Arts. She also drew plaster casts there, enrolled in an atelier for an evening drawing course, and painted almost furiously in her little studio. She told her Bremen family that she was living the most intensely happy period of her life, but in the same letter asked them to send her sixty francs for models' fees. Her sister Herma had been in Paris since 1905, studying French. Though each was too busy to seek much companionship, in the spring they managed to travel together to Brittany.

Modersohn-Becker made important new friends, the German sculptor Bernard Hoetger and his wife, Lee. Meanwhile she saw the Rilkes often and admired their decision to give each other the freedom to lead separate lives.

Otto wrote constantly, pleading with her to come home, and he encouraged family and friends in Bremen and Worpswede to do the same. In June he arrived for a week and begged her permission to return in the fall. Only after Hoetger "preached" to her did she relent, insisting, however, that she and her husband keep separate living quarters. He came to Paris in November, along with the Vogelers.

While the Modersohns were in Paris, they sent works to another exhibit at the Kunsthalle in Bremen. One critic, museum director Gustav Pauli, wrote about Paula:

> Unfortunately I fear that her serious talent will not find many friends among the public at large. She lacks nearly everything to win

Paula Modersohn-Becker, *Self-Portrait, Half Nude, with Amber Necklace* (1906), oil on canvas, 24³⁄₈ × 20 in., Öffentliche Kunstsammlung Basel, Kunstmuseum.

hearts.... Whoever says that this young artist has exceptional power, a highly developed color sense, and a strong feeling for the descriptive in painting will have to be prepared for the opposition.

Post-impressionism had left its mark on her. She was the first German artist to benefit from it. But though she had assimilated varied painting techniques from Cézanne, Van Gogh, and Gauguin, her work always had an original stamp.

More than any other year, 1906 was prodigious. *Still Life with Apples and Green Glass* (one of the few pictures she ever sold) and *Still Life with Pottery Jug* again reflected the Cézanne influence. Her portraits of Herma, Lee Hoetger, the well-known sociologist Werner Sombart, and Rilke (severe, with black, wide, staring eyes and left unfinished) showed the simplicity she had observed in antique heads, yet caught the essence of each personality. Again she pictured stolid Old Drebeen with her air of mystery—even foreboding—in *Poorhouse Woman with a Glass Bowl*. In *Girl with Stork* and *Child with Goldfish Bowl*, derived from Gauguin's primitive Polynesian style, she painted statue-like nude children, decorated like their backgrounds with crowns, beads, bracelets, and flowers. That year too, unmindful that she would be pregnant by Christmas, Modersohn-Becker did a sensuous nude *Mother and Child*.

Best of all were the splendid explorations of herself, showing a confident yet still searching look—*Self-Portrait with Hand on Chin*, *Self-Portrait with White Necklace*, *Self-Portrait with Amber Necklace*, and *Self-Portrait, Half Nude with Amber Necklace*. In *Self-Portrait on Her Sixth Wedding Day*, one hand rests on her protruding belly though she was not yet pregnant. In his *Requiem for a Woman Friend* (1908) Rilke would write: "...and much like fruit you saw the woman."

The Modersohns returned to Worpswede in April 1907. By then she was carrying Otto's child. Though suffering from upsets and fatigue she worked constantly, producing *Still Life with Tomatoes*, *Seated Nude Girl with Flowers* (another Polynesian type), *Mother and Child* (with a monumental mother), *Kneeling Mother and Child* (with a symbolic circle of oranges), and perhaps her most famous painting, *Self-Portrait with Camellia Branch*, in which her face resembles that of a Coptic mummy.

She gave birth to a daughter, Mathilde, named for her maternal grandmother, on November 2. Otto decorated her room so festively she felt Christmas had arrived. Nineteen days later, as Paula rose from childbed, she died of an embolism and heart attack, only 31 years old. "What a pity!" she said at the last.

Soon after her death Otto and Overbeck went into her studio, where the widower was amazed to find how much of her production she had kept to herself. The trove included 400 paintings and over 1000 drawings and graphics.

Paula Modersohn-Becker died unrecognized, but within twenty years her work began to be noticed. During the Hitler era her reputation suffered, only to increase steadily thereafter. Her fierce determination to be somebody has now resulted in fame perhaps greater than she ever dreamed.

Paula Modersohn-Becker : Works Mentioned

Old Bredow (1899), Ludwig-Roselius Sammlung, Böttcherstrasse, Bremen
Seated Girl (1899), Ludwig-Roselius Sammlung, Böttcherstrasse, Bremen
The Goosegirl (1899–1900), etching with aquatint, Private Collection
Glade (1900), Ludwig-Roselius Sammlung, Böttcherstrasse, Bremen
Barn Against an Evening Sky (1900), Kunsthalle Bremen
Worpswede Landscape (1900), Wallraf-Richartz Museum, Cologne
Still Life with Blue and White Porcelain (1900), Landesgalerie, Hannover
Portrait of a Sick Girl (1901), Westfälisches Landsmuseum für Kunst and
 Kulturgeschichte, Munich
Elsbeth (1902), Ludwig-Roselius Sammlung, Böttcherstrasse, Bremen
Girl in Front of a Window (1902), Private Collection
Girl with Flowers (1902–03), Staatliche Museum Preussicher Kulturbesitz, Na-
 tionalgalerie Berlin
Girl and Boy (1903), Ludwig-Roselius Sammlung, Böttcherstrasse, Bremen
Infant with Mother's Hand (1903), Kunsthalle Bremen
Still Life with Jug (1903), Kunsthalle Bremen
Self-Portrait (1903), Kunsthalle Bremen
Evening Festival in Worpswede (1903), Graphisches Kabinett Wolfgang Werner
 KG, Bremen
Poorhouse Woman by the Duckpond (1904–05), Ludwig-Roselius Sammlung, Bött-
 cherstrasse, Bremen
Still Life with Pumpkin (1905), Von der Heydt-Museum, Wuppertal, Germany
Still Life with Fruit (1905), Kunsthalle Bremen
Still Life with Chestnuts (1905), Von der Heydt-Museum, Wuppertal, Germany
Still Life: The Breakfast Table (1905) Ludwig-Roselius Sammlung, Böttcherstrasse,
 Bremen
Old Peasant Woman Praying (1905), Detroit Institute of the Arts
Clara Rilke-Westhoff (1905), Kunsthalle Bremen
Reclining Nude (1905), Private Collection
Still Life with Apples and Green Glass (1906), Ludwig-Roselius Sammlung, Bött-
 cherstrasse, Bremen
Still Life with Pottery Jug (1906), Private Collection
Rainer Maria Rilke (1906), Ludwig-Roselius Sammlung, Böttcherstrasse, Bremen
Lee Hoetger (1906), Ludwig-Roselius Sammlung, Böttcherstrasse, Bremen
Herma (1906), Worpsweder Archiv, Worpswede, Germany
Werner Sombart (1906), Kunsthalle Bremen
Poorhouse Woman with a Glass Bowl (1906), Ludwig-Roselius Sammlung, Bött-
 cherstrasse, Bremen
Girl with Stork (1906), Private Collection
Child with Goldfish Bowl (1906), Haus der Kunst, Munich
Self-Portrait with Hand on Chin (1906), Ludwig-Roselius Sammlung, Bött-
 cherstrasse, Bremen
Self-Portrait with White Necklace (1906), Westfälisches Landesmuseum für Kunst
 und Kulturgeschichte, Münster
Self-Portrait with Amber Necklace (1906), Ludwig-Roselius Sammlung, Bött-
 cherstrasse, Bremen
Self-Portrait, Half-Nude, with Amber Necklace (1906), Ludwig-Roselius Sammlung,
 Böttcherstrasse, Bremen

Self-Portrait on Her Sixth Wedding Day (1906), Ludwig-Roselius Sammlung, Böttcherstrasse, Bremen

Still Life with Tomatoes (1907), Graphisches Kabinett, Wolfgang Werner KG, Bremen

Seated Nude Girl with Flowers (1907), Von der Heydt-Museum, Wuppertal, Germany

Mother and Child (1907), Museum an Ostwall, Dortmund, Germany

Kneeling Mother and Child (1907), Ludwig-Roselius Sammlung, Böttcherstrasse, Bremen

Self-Portrait with Camellia Branch (1907), Museum Folkwang, Essen, Germany

XI

Gabriele Münter

(1877–1962)

Often during the years she spent as Vassily Kandinsky's mistress and fiancée, Gabriele Münter felt overshadowed by his powerful personality and art. Yet, as he acknowledged, she "remained herself" and made her work "quite unmistakable." After the heartbreak of their final separation, without marriage, she suffered a long barren period, but in middle age she renewed her creativity when she found a new love. Over the next 25 years her distinctive style never faltered.

An 1882 photograph of the Münter family shows a small, solemn girl clutching the hands of her seated parents, a white-haired, white-bearded father and a stout, serious mother, who is well into middle age. Two youths and a teenage girl, the older children, stand behind them. The "nachkömmling" (late arrival) is Gabriele, born on February 19, 1877, in Berlin.

Thirty-one years earlier, Carl Friedrich Münter, a fiery young German idealist, had been sent by his parents to the United States to avoid scandal and imprisonment for his liberal political views. In the South he met and married a German girl, Wilhelmina Sheuber, and speculated in industrial obligations. In 1864, his business disrupted by the Civil War, Carl and Minna returned to Germany, and he set up a dental practice in Berlin. He continued to prosper.

After Gabriele's birth, the family lived for a time in Herford; when she was 7, they moved to Koblenz. This trade center at the confluence of the Rhine and Moselle rivers was best known for its sparkling Moselle wine and fine pianos. Altogether it was a stimulating place for Carl and Minna Münter, who were drawn to music, literature, and philosophy. Though they showed scant interest in the visual arts, they applauded Gabriele's early sketching attempts.

When Gabriele was 10, Carl died, leaving his wife and family in

comfortable circumstances. Growing up, Gabriele had easy access to the opera house and concert hall. She played the piano well, and after school days at a girls' lyceum were over, she composed and sang *lieder.* In 1897, observing her growing passion for drawing, her brothers Karl and August encouraged her to begin formal training in the atelier of an elderly painter in nearby Düsseldorf. Bored after two months, she moved on to the Art School for Women in Berlin, which Käthe Kollwitz and Paula Modersohn-Becker had attended. But unlike them she soon grew restless and depressed. She hated the drudgery of drawing plaster ornaments and copying in pastels her teachers' oil paintings; it contradicted her own special talent for rapid, spontaneous sketching.

After Frau Münter died in 1898, Gabriele left the school and with her sister Emmy traveled to the United States to spend two years visiting their mother's relatives in Moorefield, Arkansas; Plainview, Texas; and St. Louis. Exuberantly she drew adults, children with toys, farmhouses, pets, plants, and an occasional stretch of countryside. She also bought a Kodak, sometimes used by her relatives to photograph their diminutive, vivacious visitor with brown hair wound up in a decorous topknot.

Following this sojourn, Emmy married a professor in Bonn, and Gabriele stayed in the city until the spring of 1901, when she determined to continue art training in Munich. She enrolled at the School of the Women's Art Association, which Kollwitz had also attended. Unlike Käthe, Gabriele reacted unenthusiastically to the jolly camaraderie of student life. Even more disappointed by the academic atmosphere, she soon dropped out and started working on woodcuts in a printmaking shop.

She would soon have a fateful encounter. A tall, bearded painter, Vassily Kandinsky, had given up a legal career in Russia and come to Germany in 1896 to devote himself to art. By 1900 he had founded an artists' club, Phalanx, "to overcome the difficulties which young artists encounter in getting their work exhibited." The next year he opened his avant-garde school of painting and drawing, the Phalanxschule. Gabriele Münter admired the work of one of its instructors, the young sculptor Wilhelm Hüsgen, and as one of the school's first students expectantly entered his class. Again she was disillusioned and moved on to an evening modeling class, then for a few months to a painting class taught by the brilliant Kandinsky, who remained the school's director. At 36, he was involved in literary and musical circles and happily called Munich "the intellectual island that stimulates the world."

Gabriele took her first lessons with him in still life. Hitherto she had met with little encouragement from her teachers, and to her astonishment he praised her. "He looked at me," she later wrote, "as if I were a human being, consciously striving, a being capable of setting tasks and goals." Nonetheless, Kandinsky decided he could not teach her anything,

only guide her and make sure that "no falsity touched her innate talent." He told her, "You can only do what was grown from within." But he did show her how to paint landscapes with a palette knife.

Expectantly Gabriele enrolled in his summer course in the mountains. Since they were the only ones in the group who could ride bicycles, they started to make excursions together as he oversaw the progress of his scattered students. With autumn, at his insistence, she did not return to the Phalanxschule. He had left behind in Russia a wife, who was also his cousin, and he felt nervous about his growing interest in his young student. Still he invited her to join his classes for the summer of 1903 in Kallmunz near Regensburg. There she evolved her own speedy approach to landscape study, noting the areas in contour lines drawn in her sketchbook, then setting down numbers for specific color tones.

By this time she and Kandinsky were deeply in love, and before the summer ended they exchanged engagement rings. But marriage was far off. Though Kandinsky wanted a divorce, the process, involving the approval of the Russian Orthodox Church, was tedious and difficult. Meanwhile the lovers felt relieved that both the Münter and Kandinsky families approved of the liaison; Kandinsky often introduced Gabriele as his wife.

The closing of the Phalanxschule in 1904 ushered in a period of travel and living abroad. Like Gabriele, who relied on a family trust, Kandinsky never was bothered by lack of funds since his father, the well-to-do manager of a tea firm in Odessa, generously provided for him. On completing visits to various members of the Münter family, the couple stayed briefly in Holland. Next Gabriele waited in Bonn while Kandinsky closed out his Munich apartment. Toward the end of the year they left for the blazing sunlight of Tunis, a welcome antidote to gloomy German weather. In Kairouan, an ancient desert city filled with mosques and round towers, the Muslim interdiction against representational painting and the wholly abstract patterns of tiles and textiles impressed them, and Kandinsky said to his young mistress that actual objects in a picture really disturbed him. They stayed until April 1905.

Munich again kept them only a short while. A bicycle trip through Saxony ended with a two-month stay in Dresden. Before Christmas they boarded a train for Rapallo on the Italian Riviera, but after four months Paris beckoned. Since Kandinsky did not want a social life, they settled in the suburb of Sèvres. Even there he adopted a proprietary attitude toward Gabriele, decreeing that she dress only in black and never go dancing. Aside from these restrictions, which she resented, it was a happy period as they sketched, painted, and visited galleries and museums in the city. In 1907 they saw Pablo Picasso's *Mademoiselles d'Avignon*, which introduced the Cubist revolution. Kandinsky and Münter were also

impressed by Paul Cézanne and Paul Gauguin retrospectives and by the work of Henri Matisse, Georges Rouault, and Henri Rousseau. But Münter would later indicate that they did not allow themselves to be too much influenced by any art movement. Still, Kandinsky wrote of Matisse's colors and Picasso's forms: "Two great signposts pointing toward a great art."

Meticulousness was part of his temperament. As he worked on landscapes based on icons and on romantic and radiantly colored Russian folk themes, he kept his studio as neat as an operating room.

In 1907 and 1908 both Münter and Kandinsky exhibited at the Salon des Indépendants and the Salon d'Automne. To the first show Münter brought landscape sketches, entitled *Études*, of sites in Sèvres, St. Cloud, and Bellevue; to the second, graphics portraits. She had made great progress at the Atelier de la Grand Chaumiére, under Théophile-Alexandre Steinlen, considered the most brilliant graphics artist in Paris. "With your drawing," he complimented her, "you will do great things." On his own Kandinsky was making woodcuts too.

At this stage Gabriele began learning the more flexible technique of cutting linoleum color blocks. She drew faces in strong contour lines, and like Félix Valloton, she used decorative backgrounds, which referred to her sitter's special interest. Her output included portraits of M. and Mme. Vernet, whom she knew in Sèvres; sketches worked from those she had made in Tunis and Rapallo; and the only formal portrait she ever did of Vassily Kandinsky.

Following more travel in Switzerland and Germany, the pair returned to Munich in 1908 and set up housekeeping at Ainmiller Strasse 36 in the residential district of Schwabing, its streets thronged by artists. There, late one afternoon, Kandinsky walked into his studio and came face to face with one of his recently completed paintings. In the twilight only the colors seemed important; the subject matter did not count. So for him began a laborious process of learning to dispense with figurative material. Münter meanwhile made six linoleum blocks, titled *Playthings*, which revealed a talent for caricature and expressed her fascination with miniature objects.

That August they spent a holiday in Murnau, a small village in the foothills of the Bavarian Alps. The landscape perspectives offered by two lowland lakes (Straffelsee and Riegsee), surrounding moors, mountains, and farms, so delighted them that in the fall they returned with two Russian friends, Alexei Jawlensky and Marianne von Werefkin, both painters. Together they put up at the Griesbrau Inn, where they placed their easels at the windows of their rooms and painted enthusiastically.

Murnau had an especially electrifying effect on Münter. The broad, simple mountain ranges (one triangular "blue mountain" would become

Gabriele Münter, Dresden (1905), photograph by Vassily Kandinsky, Gabriele Münter- und Johannes Eichner–Stiftung, Munich.

a recurring feature of her pictures) were set off by varying colors and shapes. Meadows were lusciously green; rolling clouds filled a brilliant blue sky. Everything led her to seek form reduction and even greater clarity. In her words, "After a short period of anguish I made a leap

forward—from painting nature more or less impressionistically—to find-
ing content, toward abstracting." At last she knew she could express her
feelings for landscape in directly personal terms. Her experience par-
alleled that of Vincent van Gogh, who had written: "Working directly on
the spot, all the time, I try to grasp what is essential in the drawing—later
I fill in the spaces which are bounded by contours either expressed or not,
but in any case felt—with tones which are also simplified."

Back in Munich for the winter, Kandinsky and Münter thought long-
ingly of Murnau only 50 miles away. So in 1909 she bought there a two-
story house at Kortmuller Allee 33. Kandinsky had fallen in love with it
though it had no running water, no electric lights, and only one stove.
"You must buy it for our old age," he had urged her. Once they had moved
in, he exuberantly painted the stairways and furniture with folk designs.
Hitherto his landscapes had not been too different from Münter's; now,
seeking his "inner reality," he began moving toward complete abstrac-
tion.

When Jawlensky and Werefkin were not abroad, they lived in Mur-
nau in an apartment on Giselastrasse, but spent so much time in the
Münter-Kandinsky house that locally it became known as Russenhaus
(House of the Russians). Gabriele, who said, "In a portrait humor often
helps," painted Marianne in a huge, flower-laden hat and a trailing purple
scarf, expertly catching her haughty self-containment. Despite her avowal
of now being influenced by any movement, friends saw Matisse's in-
fluence in the portrait, for like him she had no qualms about using ar-
bitrary colors, free from any representational function. The vivid blues,
oranges, and ochres of Marianne's spectacular headgear are repeated in
her face; each shape is heavily outlined in black. Münter's *Portrait of a
Young Woman* that same year celebrated a forthright, determined
independence.

In Paris, Jawlensky had been introduced to the Symbolist concept of
Synthesis, the reduction and abstraction of color and form; Kandinsky,
ever inclined toward mysticism, was grappling with this very idea. Jawlen-
sky also directed Münter to a more simplified painting style, using pig-
ment directly on unprimed canvas and strong, dark outlines to emphasize
her geometric shapes.

Those artists who clustered around Münter and Kandinsky had not
yet considered themselves a group and showed no inclination to associate
with other movements. Long after, Münter commented, "We were
only...friends who shared a common passion for painting as a form of
self-expression." Then suddenly, after the idea was first broached at the
Giselastrasse apartment, Kandinsky began talking with Jawlensky, Weref-
kin, and other painters in Munich and Murnau about organizing a New
Artists Association with Synthesis as its guiding principle. Münter did not

actively participate in the debates, preferring to remain an observer. Yet she willingly joined the group once it was formed and felt pleased to see how it affected Munich's cultural life. In Dresden, meanwhile, another group, the avowedly Expressionist *Die Brücke* (The Bridge), had been formed under Ernst Ludwig Kirchner and Erich Heckel, but it had no women members.

Münter contributed to the first New Artists Association exhibit in 1909 at the Galerie Thannhäuser; it traveled on from Munich to other cities. For the second exhibit, also at the Galerie Thannhäuser the next year, Kandinsky wrote a preface which affirmed: "To speak of mystery in terms of mystery. Is not this content?...Man speaks to man of the superhuman—the language of art."

Murnau in 1910 inspired several Münter landscapes in bright flat tones: *Straight Road with White House, Yellow House with Apple Tree,* and *Village Street—Blue,* begun in 1909. One of her finest paintings, *Boating,* shows Kandinsky standing in the stern of a little boat on the Staffelsee, Münter rowing, Marianne von Werefkin and Jawlensky's young son facing her. Water, mountains, meadowland, the women's broad-brimmed hats are all strongly colored. Another portrait catches Kandinsky and the painter Erma Bosse sitting in the "tischecke" (table corner) of the Murnau house. Still more, Münter and Kandinsky painted contrasting interpretations of the village church with its onion steeple. In *Sunflowers and the Church,* she used a primitive approach; in *Church in Murnau,* he took a lyrical. About the same time he painted a completely nonobjective watercolor, to which he gave no title.

That same amazingly productive year of 1910, Münter finished many still lifes. Two years earlier she had begun to put into her paintings tiny wooden and ceramic figures she had collected from auctions and church fairs, knowing their importance in household worship of the region. The inspiration to use them had coincided with her experiments in behind-the-glass painting (*Hinterglasmalerei*), begun after Jawlensky introduced her to the Rambold family, who followed the Bavarian tradition of drawing dark outlines of religious images on the back sides of glass and then filling them in with bright color.

Still Life with Russian Tablecloth and *Still Life with Sunflowers* showed her increasing interest in her miniature figures; *Madonna and Child* was a fine behind-the-glass painting. Despite the lack of heat in "Russenhaus," Münter and Kandinsky spent part of the winter in Murnau, their visits reflected in her *House on a Wintry Road* and *Village Street in Winter.* A charming *Still Life with St. George* (1911) is again filled with small folk art figures.

By this time Vassily Kandinsky had no use for figures in his paintings. He had completely abandoned objectivity for a type of abstract painting

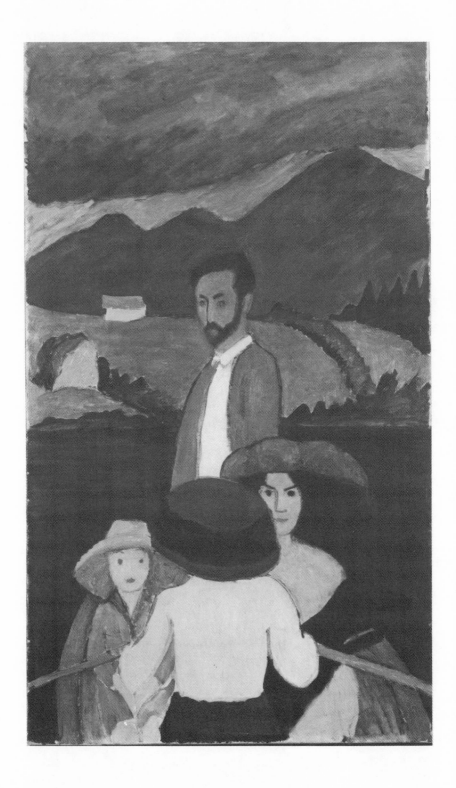

analogous to music. When the jury of the New Artists Association re-
jected his *Composition V*, he, with Münter, Franz Marc, and Alfred
Kubin, left the group. With Marc, a young artist who wanted to convey
through his painting a pantheistic empathy with animals and nature, Kan-
dinsky founded *Der Blaue Reiter* (The Blue Rider) in 1911. Its first
members included Münter, Elizabeth Eppstein, and August Macke, a
young painter who wrote a friend that he was in love with Gabriele, but
dared make no moves because Kandinsky, Jawlensky, and Werefkin con-
stantly hovered over her. (He made a humorous little sketch of himself
watering a plant whose flower was Münter's head.)

Discussions had taken place around the tea table presided over by
Marc's wife, Maria. The group chose its name from a blue rider on
horseback in a 1903 painting by Kandinsky, whose favorite color was blue.
For him and Marc it signified a spiritual quality. At Murnau, on a drawer
of Gabriele's little wooden dresser, Kandinsky had painted in jest two blue
riders, a man beckoning to a woman as she surges forward. Münter had
declared that a polite "Come along" should have been lettered above
them.

She contributed six paintings to the first exhibit at the Galerie
Thannhäuser in December 1911; it included pictures by two French art-
ists, Robert Delaunay and Henri Rousseau. The second exhibit, only two
months later in February 1912, concentrated on prints, drawings, and
watercolors, bringing together such artists as Picasso, Heckel, Kirchner,
Jean Arp, André Derain, Paul Klee, Maria Marc, Natalia Goncharova, and
Maurice Vlaminck. This second exhibit produced a passionate statement
of belief: "Today we are searching behind the veil of superficial external
appearance for the hidden things that to us seem to matter more than the
discoveries of the Impressionists." One outcome of the 1912 *Blaue Reiter*
exhibit was that an American collector bought Münter's *Still Life with
Queen*, which shows a pastel-colored doll floating in a bouquet of
flowers.

That year Marc, Macke, and Kandinsky also published the *Blue Rider
Almanac*, which carried articles on art, theater, and music. Most notable
was Kandinsky's essay, "On the Problem of Form." Münter's disinterest in
theory kept her from contributing. As things turned out, there were no
subsequent issues.

At this stage Kandinsky became attached to Madame Blavatsky's
theosophical dream of spiritual contemplation and universal enlighten-
ment, but the practical-minded Münter distanced herself from it. In the
meantime Kandinsky had published *Concerning the Spiritual in Art*,

Opposite: Gabriele Münter, *Boating* (1910), oil on canvas, 49¼ × 28⅞ in.,
Milwaukee Art Museum, gift of Mrs. Harry Lynde Bradley.

suggesting that abstract painting should be a kind of visual music, with special laws of harmony and counterpoint that aroused an emotional response.

Though Gabriele was beyond his romantic reach, Macke — ten years her junior — found her a stimulating friend:

> I have the feeling that she is strongly drawn to the mysterious in life, saints, lilies in a corner of a garden, sharply lit storm clouds, lamps, and old-fashioned chairs. There is something "German" in this, touched with romanticism of church and family. I like her very much.

That same year Michael Sadler, who would become Kandinsky's first collector in England, came to Murnau and in a letter to his wife described his hosts:

> Murnau is a clean little town — white and red in very green fields — looking down on a very large lake.... To the south is the great wall of the Bavarian Alps — an hour away — deep blue against grey sky.... The Kandinskys live in a cottage among fields — with a German-American cook, wire blinds against the mosquitoes, and a quiet view across a little valley to the white church and Schloss of Murnau.

Sadler characterized Münter as "a clever woman, very simple, friendly, a painter too, and a Prussian. Kandinsky pulls her leg about this, and she defends herself as best she may." Kandinsky himself, "dark, olive skin, a thin black beard...sweet smile and a Mongolian look," had the "gentle, rather dreamy Russian way."

Gabriele Münter finished what was to be her best-known portrait in 1913 after observing a conversation between Kandinsky and Klee in Munich, where they were neighbors; later she declared that the visual impact of Klee's summer outfit had given rise to *Man in an Armchair*. "The white trousers," she wrote, "stood in the center of the painting, and the man was in clearly defined rectangles merged with the chair and the pictures on the wall." She portrayed him as very tense.

The year brought a major exhibit of Münter's works at the Neue Kunstsalon Dietzel; it went on tour from Munich to Dresden, Stuttgart, and Frankfurt. Kandinsky had been represented in the famous Armory Show in New York that opened in February 1913, and his *Improvisation No. 27* had proved that he was one of the most revolutionary artists represented there. Every other painting was based on some kind of model; his picture derived from images originating in his mind.

That summer Kandinsky visited Russia for the first time since his departure, and Münter traveled around to relatives in Herford, Bonn, and Berlin. The long Kandinsky-Münter liaison had not always been happy

because from its beginning he had often brooded over its immorality. Though finally divorced, he was not ready to marry Gabriele.

World War I, erupting soon after Kandinsky's return, provided him with a reason for separation. (*Lake at Evening*, which Münter painted in 1914, may have indicated the fading relationship.) As an enemy alien Kandinsky was forced to leave Germany. Münter accompanied him to neutral Switzerland, to Mariahalde near Goldach at Lake Constance. There he coolly asked her to close their Munich apartment, then informed her that he could not continue to live with her, but would visit her now and then. He packed his bags once more and as leader of a group of refugees set out for Russia by way of the Balkans.

In January 1915, Münter returned to Munich to arrange their affairs. Kandinsky had taken a few large-format paintings with him, but in her safekeeping was an extensive collection of medium size and small paintings, together with sketches, books, and furniture. Soon she received news that Macke had been killed at the age of 27 in the very first month of the war. Marc was to suffer a similar death two years later.

From Odessa in the spring of 1915 Kandinsky wrote: "Dear, good, sweet Ella, You must never forget and you must constantly feel that I, who have spoiled your life, am really ready to shed my blood for you." After storing his paintings, Münter began living in Stockholm, hoping it would be easy for him to come to neutral Sweden.

Kandinsky arrived in Stockholm for a Christmas reunion. He stayed in the city for three months because Gummeson's Kunsthandel had organized an exhibit for each artist, Kandinsky first. Carefully he prepared catalogues for both exhibits. In Münter's case, after distinguishing between virtuoso and creative art, which he identified with the expression of inner meaning, he called her a creative artist. When he left Stockholm, she sensed that their separation was final, but she did not wholly give up her dream of living with him again.

Münter now created a group of works with a specific theme: women in interiors. Two of her finest pictures, *Reflecting* and *Woman in Stockholm*, were completed within a week of each other. The same woman is seen in different moods, first meditative and then radiating alertness and focus.

The intervals between Kandinsky's letters became longer and longer. In June 1917, he abruptly sent her a note from Moscow; he had married Nina Andreevskaya, the teenage daughter of a general. A despairing Münter went on to Copenhagen where, in spite of her grief and humiliation, she helped organize her first complete retrospective. For the next ten years she would almost abandon painting.

She returned to Germany in 1920, moving restlessly about to Berlin, Munich, and Murnau, sometimes staying in pensions, sometimes with

friends and relatives. She kept no studio and made no attempt to renew contacts with the art world. But she did fill her sketchbooks. Now there were money worries, for the family trust, on which she had long relied, dwindled in the disastrous inflation of the postwar years.

Kandinsky had returned to Germany, taking up a post in the Bauhaus in Weimar in 1922. As soon as he was back in the country, Münter filed for an entitlement of maintenance. Matters dragged on for four years until the two former lovers signed a legal agreement to divide their property. Kandinsky received his books and furniture and some important oil paintings and drawings and watercolors. Münter kept the rest of his work.

The barren years, made more bitter by her declining patrimony in the postwar inflation, ended in 1927 when she met the German art historian Johannes Eichner, who encouraged her to resume her painting. *Table in a Garden Café* resulted from an eight-month sojourn in Paris during 1929–30. *Winter Landscape* followed quickly. In 1931 Eichner moved into Russenhaus, inspiring and encouraging her. The next decade produced *Still Life with Small Figure and Flowers, Titmice on Snow Covered Branches, Breakfast of the Birds, House on the Outskirts of Murnau, View of the Mountains* and *Wetterstein from Guglhör with Farmhouses.* For income she relied on painting portraits.

The contented life with Eichner, however, was darkened by the Nazi takeover of Germany. The Nazis considered Münter's work "degenerate" like that of many other artists, and in 1937 the district leader of the Nazi Party closed Münter's exhibit at the Munich Art Association.

After World War II, she went back to her studio and produced such memorable canvases as *Flowers on a Blue Ground* (1950) and *Abstract Composition* (1952). Recognition returned; indeed many now considered her Germany's most important living woman artist.

When Eichner published his book *Kandinsky und Gabriele Münter: Von Ursprüngen moderner Kunst* in 1957, the art world learned for the first time of the Kandinsky treasures in Münter's keeping—120 of his early paintings that she had protected through two world wars and the Nazi period. On her eightieth birthday in the same year, she donated them to the Städtische Galerie im Lenbachhaus in Munich along with about 30 of her pre-1914 paintings. But she refused to attend the resultant exhibit.

Eichner died in 1958 at the age of 72, and the 81-year-old Münter was alone again, except for a housekeeper. Her health deteriorated; she lost her sense of balance and found walking difficult. But her mind remained sharp, her eyesight keen, and she still drew and painted.

She died in Murnau on May 19, 1962, having requested burial beside the church which had appeared so often in her paintings. Unlike Kandinsky, she had remained touchingly loyal to the town where they had passed the most formative and romantic period of their lives.

Gabriele Münter : Works Mentioned

M. Vernet, linoleum block (1906), Gabriele Münter- und Johannes Eichner-Stiftung, Munich

Mme. Vernet, linoleum block (1906), Gabriele Münter- und Johannes Eichner-Stiftung, Munich

Playthings, linoleum blocks (1908), Gabriele Münter- und Johannes Eichner-Stiftung, Munich

Marianne von Werefkin (1909), Städtische Galerie im Lenbachhaus, Munich

Portrait of a Young Woman (1909), Milwaukee Art Museum

Village Street-Blue (1909–10), Private Collection

Madonna and Child (1909–10), Städtische Galerie im Lenbachhaus, Munich

Straight Road with White House (1910), Private Collection

Yellow House with Apple Tree (1910), Private Collection

Boating (1910), Milwaukee Art Museum

Kandinsky and Erma Bosse (1910), Private Collection

Sunflowers and the Church (1910), Private Collection

Still Life with Russian Tablecloth (1910), Gabriele Münter- und Johannes Eichner-Stiftung, Munich

Still Life with Sunflowers (1910), Private Collection

House on a Wintry Road (1910), Milwaukee Art Museum

Village Street in Winter (1911), Städtische Galerie im Lenbachhaus, Munich

Still Life with St. George (1911), Städtische Galerie im Lenbachhaus, Munich

Still Life with Queen (1912), Art Institute of Chicago

Man in an Armchair (1913), Städtische Galerie im Lenbachhaus, Munich

Lake at Evening (1914), Städtische Galerie im Lenbachhaus, Munich

Reflecting (1917), Städtische Galerie im Lenbachhaus, Munich

Woman in Stockholm (1917), Private Collection

Table in a Garden Café (c. 1930), Private Collection

Still Life with Small Figures and Flowers (1933), Private Collection

Titmice on Snow-covered Branches (Cc. 1934), Private Collection

Breakfast of the Birds (1934), National Museum of Women in the Arts, Washington, D.C.

House on the Outskirts of Murnau (1934), Private Collection

View of the Mountains (1934), Städtische Galerie im Lenbachhaus, Munich

Wetterstein from Guglhör with Farmhouses (1935), Gabriele Münter und Johannes Eichner-Stiftung, Munich

Flowers on a Blue Ground (1950), Städtische Galerie im Lenbachhaus, Munich

Abstract Composition (1952), Städtische Galerie im Lenbachhaus, Munich

XII

Vanessa Bell

(1879-1961)

Vanessa Bell, one of England's most innovative women artists, and her sister, the famous novelist Virginia Woolf, were aware of their separate talents even in childhood, and they agreed that Vanessa would become a painter and Virginia a writer. In their family the literary precedent seemed more dominant, for their father, Leslie Stephen, was a noted Victorian man of letters. Art talent came less directly; their mother's aunt, Julia Margaret Cameron, was the most renowned woman photographer of the nineteenth century.

In 1878 Leslie Stephen, a middle-aged widower, had married a young widow, Julia Duckworth, who brought with her three children, George, Gerald, and Stella. Laura Stephen, Leslie's daughter by his first marriage to William Makepeace Thackeray's daughter Minny, lived with the family intermittently. She was retarded and given to fits of wild anger and at 17 would be placed permanently in a special home.

On Stella Duckworth's tenth birthday, May 30, 1879, Leslie and Julia Stephen's first child, a daughter, was born at 22 Hyde Park Gate, London. Leslie was then working on a biography of Jonathan Swift, who had immortalized his two loves as Stella and Vanessa; Leslie named the new baby Vanessa.

In the next four years three more children were born: Julian Thoby in 1880, Adeline Virginia in 1882, and Adrian in 1883. At the time of Virginia's birth, Leslie Stephen became editor of the mammoth *Dictionary of National Biography*, a position he would relinquish in 1891, after showing alarming signs of overwork.

The children were educated at home, with outside lessons for the girls in piano, voice, and dancing. For 12 summers from 1882 to 1894, the Stephens vacationed at Talland House, St. Ives, a painters' haven in Cornwall. Vanessa always remembered the sound of the sea in every

room. After she became really keen on drawing, her father hired Ebenezer Cooke, a leading reformer in art education, to give her lessons. Vanessa's pictures looked so promising that Cooke showed them to Arthur Cope, who ran a popular art school in Kensington.

In 1895, Julia Stephen died, leaving her husband distraught, and George Duckworth felt obliged to take over as head of the family. His unwelcome displays of affection toward Virginia began after she suffered a breakdown, in grief over her mother. By the next summer Vanessa started drawing classes at Cope's School, a refuge from the emotion-charged atmosphere at home. Cope emphasized draughtsmanship.

Beautiful Stella died in the summer of 1897, three months after her wedding to Jack Hills. Vanessa now took her place as hostess for Leslie Stephen's "at homes" (frequented by literary luminaries such as Henry James, George Meredith, and Thomas Hardy). George, eager to enhance his own social prestige, found the statuesque, lovely Vanessa an ideal companion for his rounds. To tempt her to go about with him, he gave her jewelry as well as an Arab mare which she rode down Lady's Mile near Hyde Park nearly every morning.

Within two years Vanessa fell in love with Jack Hills and he with her. But there was no hope of marriage because under an English law, which stayed in effect until 1909, it was illegal to wed the sister or brother of a deceased spouse. Her disappointment left Vanessa permanently dissatisfied with society and its legal system.

Thoby entered Trinity College, Cambridge, in 1899 and made special friends in Leonard Woolf and Clive Bell. Together they adopted the teachings of the philosopher G. B. Moore, who stressed devotion to human relationships and the idea of the good, and they became the vanguard of the Bloomsbury Group.

In 1901 Vanessa was one of 20 accepted by the Painting School of the Royal Academy for classes in anatomy, perspective, portraiture, composition, and drawing from statuary and life. Though her attempts to paint in the old masters style won praise, she garnered no prizes. There she did feel fortunate in taking instruction from the American society painter John Singer Sargent, who told her to concentrate on tone and a well-loaded brush. But she never lingered in the classroom. Every afternoon at 4:30 she had to put away her smock and bicycle home to act as her demanding father's teatime hostess. Outside his circle she had her own friends, among them Charles Furse, who changed her taste in interior decoration; ever afterward she wanted light, airy, uncluttered rooms.

Vanessa's and George Duckworth's visit to Rome and Florence in 1902 was cut short by her father's illness. Just as the doctors informed the family that he was dying of abdominal cancer, he was created knight commander of the Order of the Bath (KCB).

The next two years brought new restrictions for his daughters. Though Vanessa had to curtail her attendance at the Painting School of the Royal Academy, she demonstrated her ability to deal with unpalatable situations by turning the old day nursery at home into a studio and arranging to paint there from a model. When she read an English translation of Camille Mauclair's book about the French Impressionists, she realized, "There was something, beside the lovely quality of old paint, we aimed at." Despite her dislike of public lectures, she did attend a series on the Impressionists.

After Sir Leslie Stephen died in 1904, a family friend, Henry James, thinking also of Julia and Stella, spoke of the "House of the Dead." To get away from that gloomy atmosphere, the four Stephens traveled within a couple of months to Venice and Florence with their half-brother Gerald and were later joined by Virginia's friend Violet Dickinson. As the three women dropped their male companions and moved on to Genoa and Siena, Vanessa studied all the paintings she could possibly see. When the two sisters rejoined Thoby in Paris a month later, his Cambridge friend, Clive Bell, showed them around the city. Thoby described Clive as "a cross between Percy Bysshe Shelley and a country squire." By now an eye for painting had created a bond between him and Vanessa. Two years her junior, he came from a wealthy family. Some of her friends thought him a "pompous ass," too much given to gossip, but Vanessa found him kind and clever.

Only days after the Stephens returned to London, Virginia suffered a second nervous breakdown. Following her recovery, Vanessa thought about classes again, but the Royal Academy Schools refused to readmit her. That fall when she briefly attended the Slade School, the family moved from Hyde Park Gate to 46 Gordon Square, Bloomsbury. There, the next year, Clive proposed marriage, but Vanessa refused.

The two brothers and sisters lived amicably enough at Gordon Square, Thoby and Adrian studying law, Virginia writing and Vanessa painting. The Misses Stephen also acted as shy hostesses for the "Thursday Evenings" attended by the developing Bloomsbury Group. At the same time Vanessa busied herself organizing a Friday Club for exhibits, discussions, and lectures. At one of its gatherings she met 20-year-old Duncan Grant, a Scottish-born painter and cousin of the writer Lytton Strachey. Meanwhile Vanessa had received her first commission from Lord Robert Cecil, who asked her to paint a portrait of his wife at Chelwood Gate, Sussex. It was shown at the Summer Exhibition, 1905, of the new Gallery.

She painted a portrait of Lord Cecil the next spring. That summer she refused Clive's second proposal, but gave some hope she might change her mind. Inveterate travelers, the Stephens, together with Violet

Dickinson, left for Olympia, Greece by autumn. Vanessa, however, fell ill in Constantinople, probably because of nervous strain. Thoby, also unwell, went back to London. He had not improved when his sisters arrived at Gordon Square; Vanessa also required nursing. Two days after the brilliant, handsome Thoby died of typhoid fever at the age of 26, Vanessa agreed to become Clive Bell's wife.

The couple was married at St. Pancras Registry, London, in February 1907, and honeymooned at Manorbier on the Pembroke coast. Clive, who supported himself as an art historian and writer, often found it convenient to fall back on family resources. In April they met Virginia and Adrian in Paris, where they dined with Duncan Grant, who exclaimed, "What a quartet!" The Bells were equally charmed and back in London invited Duncan to dinner. "He is clever and very nice," Vanessa wrote later.

Julian Howard Bell was born three days before the first wedding anniversary. Vanessa, though she rejoiced in motherhood, sensed that Clive was bothered by a young baby, who had the potential of driving a wedge between his parents.

As the Bells had taken over the house at 46 Gordon Square, Adrian and Virginia had sought alternative accommodations in Fitzroy Square. Thus for the Bloomsbury Group, with its sometimes self-important posturing, there were two centers. In Frances Partridge's words, its members already were "left-wing, atheistic pacifists, lovers of the arts and travel, and readers, francophiles. . . . And since they believed marriage to be a convention and convenience and never celebrated it in church, love, whether heterosexual or homosexual, took precedence over it." Vanessa was comfortable in this atmosphere as her marriage had made her feel suddenly liberated; she began to use bawdy words and strive to match all-male chatter.

The year of Julian's birth, 1908, Virginia and Clive began an extended flirtation. Vanessa felt jealous, but made no trouble, simply withdrawing and suffering silently. Before his marriage Clive had had a long affair with a Mrs. Ravens-Hill, and in spite of his interest in Virginia he easily returned to his old relationship. Leaving Julian in a nurse's care, the Bells took off in September with Virginia for Siena, Perugia, Pavia, and Assisi, with Vanessa remaining stoically silent about Clive and Virginia's obvious attraction to each other.

In 1909 she sent several paintings to the New English Art Club, an alternative to the Royal Academy. Her silvery still life *Iceland Poppies* (1908), which spelled out her bittersweet mood, was accepted. She and Clive had visited Florence together in the spring, and that fall they vacationed at Studland Bay, Dorset, to which they returned for the next few years.

Toward the end of 1909, however, they felt so directionless they

considered moving to a more exciting artistic life in Paris. Nothing happened; they remained in Bloomsbury after all, perhaps because Vanessa now seemed the central figure in the group gathering there — Strachey, Woolf, Grant, John Maynard Keynes, and other highly articulate young intellectuals — offering repose, mellow understanding, and tolerance of the homosexual explorations many of them made.

As 1910 began, an arresting figure entered Vanessa's life. While waiting at the Cambridge station one January day, the Bells ran into Roger Fry. Shyly Vanessa reminded him of two previous meetings. At a dinner party five years before, she had sat next to him and hotly defended Sargent. Fry, scholar of Italian art and former art curator of the Athenaeum, thereupon had invited her to visit him in Hampstead, where he lived with a wife who suffered from recurring mental illness. But after that visit Vanessa had not seen Roger Fry again because he had moved to New York as European adviser for the Metropolitan Museum of Art, a responsibility which involved much travel. The position had also led to a dispute with J. P. Morgan, president of the Metropolitan board, and Fry had been dismissed.

As Fry and the Bells boarded the Cambridge train for London, the two men held a lively conversation about modern French art. But Vanessa discerned that depression hid behind Fry's gaiety. His wife was now confined to an asylum; her illness had interfered with his career, and at 44 he did not know where he was heading.

Meanwhile Vanessa exhibited a nude study at the New English Art Club and two still lifes at the Friday Club. That summer the Bells' second son, Claudian (later renamed Quentin), was born. But in the midst of her happiness Vanessa harbored new worries about Virginia, again ill with nervous tension.

By fall Roger Fry decided to recoup his fortunes with a major exhibit, "Manet and the Post-Impressionists," to open in December at the Grafton Gallery. Vanessa had seen a few paintings by Paul Cézanne, Vincent van Gogh, and Edgar Degas before; now experiencing them in large numbers, she wrote of a "sizzle of excitement." Later she said, "It is impossible that any other exhibition can have had so much effect as did that on the rising generation." Especially influenced by Paul Gauguin and the Nabis (Prophets), Pierre Bonnard and Édouard Vuillard, Vanessa now began to outline her forms in black, but sometimes broke them off spontaneously. She felt increasingly warm toward Fry, who had opened new worlds of painting to her. At the same time he became a close friend, who expressed deep sympathy for her sometimes ailing new baby.

Despite the maternal role she so greatly enjoyed, Vanessa had no qualms about leaving her sons in the care of nurses while she traveled. In the spring of 1911 she and Clive went with Fry and Harry Norton, a

mathematician, to Constantinople, a trip of which Roger took complete charge. He and Vanessa sketched and drew endlessly. When she suffered a miscarriage, it was Roger who nursed her until Virginia came out to Bursa to bring her sister home.

As Vanessa recovered her health in a cottage near Roger's home, Durbins, Guildford, she discovered that she was in love with him. But she did not want to cast off Clive, who had never failed her as a friend. As an adult Quentin would write that between 1911 and 1914 the Bell marriage turned into "a union of friendship." Vanessa was not physically estranged from Clive, but could not love him fully.

That summer of 1911 she began her large, busy *Bathers* with an emphasis on silhouettes. Gratefully she accepted Roger's advice whenever he came calling at Gordon Square, where his attentions watered down some of Clive's feelings for Virginia. Vanessa had been deeply hurt by that flirtation, but the sisters were too strongly bonded to allow any estrangement. In the fall they jointly rented Asheham House, in the Sussex downs, for their vacations.

Always restless, the Bells eagerly accepted Roger's invitation to travel with him to Italy in the spring of 1912. Clive resented Roger's hovering over Vanessa ("so intense, so concentrated, and in a way so narrow in her vision") but greatly admired his expertise in judging art. When Vanessa caught the measles and was convalescing in Bologna, Roger brought her colored paper, which she cut into small squares. Delighted by their brilliant hues, she declared her intention to develop the medium of mosaics.

Even as her love for Roger increased after their return to London, 33-year-old Vanessa deepened her friendship with Duncan Grant. Lively, charming, enormously attractive, Duncan, after affairs with Strachey, the mountaineer George Leigh Mallory, and the future economist Keynes, was then in love with Adrian Stephen. Vanessa often painted in his studio and toyed with his semipointillist manner. Finally, however, she decided to work with larger patches. Duncan hired a Spanish-looking model to pose for both of them. Vanessa's *Spanish Dancer* sold for five guineas. Other times, too, they used the same subject, he exuberant and restless in his handling, she grave and restrained. For *Studland Beach* (1912), begun in Dorset, she pared down her vocabulary still more and flattened and reduced shapes.

After Virginia married Leonard Woolf, Vanessa went with her children to Asheham to stay till winter, enjoying carefree days with her little sons running naked in the garden. She herself looked picturesque in loose skirts and the bright scarves she wore over her straight brown hair that knotted on her neck. A rather architectonic *Landscape with Haystack, Asheham*, ushered in a period of painting *en plein-air* until the weather

became too cold. There at Asheham in 1912 she made a sensitive likeness of Virginia, a reluctant model, who disliked being stared at for long periods. Duncan also objected to sitting as a model, and Vanessa almost always painted him at work.

Among visitors that fall, Frederick Echtells, a painter, and his sister, Jessie, brought some upset, particularly because their dog fought with Vanessa's sheepdog, Gurth. But the couple managed to pose for a double portrait, *In the Studio*. Their heads were featureless, but friends claimed they found the two instantly recognizable. More clearly limned was Henri Doucet, Fry's French painter friend. Vanessa also caught him and Duncan working together in *The Studio: Duncan Grant and Henri Doucet Painting at Asheham*, their faces more or less blanked out.

That November Roger Fry held a second Post-Impressionist exhibit, this time dominated by the work of Henri Matisse. Vanessa had four paintings in the English section. She had felt strongly influenced by Matisse's bold colors and reduction of form. Paintings such as *The Bedroom, Gordon Square* and *Street Corner Conversation* (both 1912) reflected her admiration. After the success of his exhibit, Fry was asked to write a book on Post-Impressionism, but he was too busy with a new workshop project and asked Clive Bell to do the job. Clive was most pleased to undertake the assignment.

An odd quartet set out for Italy in the spring of 1913 to visit Rome, Viterbo, Ravenna, and Venice: Vanessa, Clive, Roger, and Duncan. Already she was falling out of love with Roger and falling in love with Duncan. The shift had been gradual. Often Roger seemed too demanding, his energy and intellect challenging her independence. On realizing he had lost her, he was deeply wounded, but settled for friendship with his goddess.

When Vanessa compared her paintings with Duncan's, she thought that his looked more animated and exuberant. She was sure that he was also more gifted. Increasingly aware of his sensuous good looks, she well knew that he ran from man to man.

Nursery Tea (1913) became her largest painting so far. "I paint as if I were mosaicking," she said. Daringly she let abstract considerations play down the human situation. Next, in a Fauve-like style with exaggerated color and loose outline, she painted Strachey. He had first sat for her at Studland two years earlier.

That summer Virginia Woolf was depressed and unwell, and Vanessa suffered from neurasthenia. But she read Clive's emerging manuscript, gave him advice, and promised to check the galley proofs. In *Art* (published in 1914), Clive declared his basic tenet: Significant form is the distinguishing quality of art. Vanessa, too, adopted this credo.

She also occupied herself with the opening of the Omega Workshops

of which Roger, she, and Duncan were codirectors. Fry had founded them to help young artists earn money and to encourage the pure color and free-expression ideas of Post-Impressionism in the decorative arts. The Russian Ballet that Sergei Diaghilev brought to London also influenced the project. Headquarters were at 433 Fitzroy Square, with a showroom, demonstration studio, and shop to paint furniture. All craftwork, except pottery, was done off the premises. Anything with surface decoration—mosaics, stained glass windows, pottery, fabrics, painted furniture—could be commissioned. Vanessa herself designed textiles, screens, a mosaic floor, carpets, and embroideries.

In spite of a busy schedule with the workshops, Vanessa still kept to her easel, for it came before all else. From 1913 to 1915, using oils, gouache, and collage, she painted abstractions marked by simplicity of design and grave tonal poetry. It was a radical step for an English female painter. Her pieces bore simply the titles *Abstract* or *Abstract Composition.* But abstract art never wholly appealed to her; a sensitive relationship with the everyday world suited her better.

Vanessa did not react emotionally to the outbreak of war. The Bloomsbury Group, still artists and intellectuals, came often to Asheham House and took more of her attention. By now Adrian Stephen gave every indication of falling in love with a young woman, Karin Costelloe, and Duncan Grant, half in love with Vanessa, interested himself in the young writer David (Bunny) Garnett. Bunny Garnett saw a grave beauty in Vanessa's face, a deceptive innocence in her blue-gray eyes under heavily hooded lids, but humor and impudence in her lovely mouth. Duncan's portrait of her in 1918 confirms those observations. Bunny also noted her swaying walk—with good reason Virginia had nicknamed her sister "the Dolphin." Much more flatteringly, Fry once wrote her, "You have this miracle of rhythm in you." Often she lapsed into reverie or fell into long silences.

She felt proud when Virginia's first novel, *The Voyage Out*, was published in the spring of 1915, but complained in sisterly fashion that the author had not distanced herself adequately from her subject matter, which required, she thought, more detachment. The character of Helen Ambrose probably was based on Vanessa Bell.

Again the need to paint dominated her. She left Julian and Quentin with their nurse in London and packed for Eleanor House, rented by Clive's friend, Mary Hutchinson, and her husband, St. John Hutchinson, in West Wittering on the Sussex coast. The Hutchinsons were not yet ready to come, and Vanessa invited Bunny and Duncan to join her. Clive approved of her blossoming affair with Duncan; she in turn encouraged Clive's liaison with Mary Hutchinson, who was Duncan's cousin. Fascinated that a woman of her age, class, and beauty talked so freely about

licentious subjects, Bunny wanted to have an affair with Vanessa too. Refusing him, she still managed to plait herself and her two boarders into a binding chord of affection even as Bunny slept with Duncan.

Vanessa may have been stretching her tolerance of Duncan's behavior, but now her paintings, which were frequently exhibited, blazed with assurance. In her voluminous portrait of the young Iris Tree, artist and poet, she used eye-catching colors.

Virginia's mental breakdown that same spring was not wholly unexpected because she had showed some ominous signs months before. The worst period of her madness occurred in April and May, but Vanessa with her single-mindedness was able to keep on painting. By summer she had Duncan to herself because Bunny Garnett had joined the Friends' War Victims' Relief in France.

When the Hutchinsons moved into Eleanor House, the Bells, reunited with their sons, rented The Grange at Boham, not too far from Mary, whose portrait Vanessa painted, pouty and brimming with color. After Duncan left to visit his parents, Roger Fry appeared, still unhappy over his lost love.

By 1916 Vanessa Bell wanted to do something for conscientious objectors like Duncan and Bunny, who had returned from France, and she began working for the National Council for Civil Liberties. Since it was necessary to find noncombatant service for her two friends, Vanessa saw an opportunity in Wissett Lodge, a small Victorian farmhouse in Halesworth, Sussex, left by a relative of Duncan's mother. With children, cook, and nursemaid in tow, Vanessa joined Duncan and Bunny there, quickly putting the old house in order. Now she first began to paint what would be a recurrent motif for her, the view from a window. At Wissett Lodge she completed A *Conversation*, a vivid group portrait of three women she had begun in 1913. Then, though Bunny and Duncan had duly received their exemption from military service in order to do farm work, authorities decided they could not be their own employers. Vanessa, always the organizer and solver of problems, found work for them at New House Farm near Asheham House, where the Woolfs had established their residence.

To be close, Vanessa rented an eighteenth century brick house, Charleston, at Firle, near Lewes, Sussex; it would be her home for the next three years. Its size fitted family life. Since its interior cried for decoration, she and Duncan painted everywhere.

Clive seldom was there, but gave his wife an allowance. On Keynes's advice she made some investments, as Clive had done, and was well enough off to hire three servants. Keynes had taken a lease on 46 Gordon Square for the duration of the war with the proviso that it could be used as a townhouse for Clive and the Charlestonians when necessary.

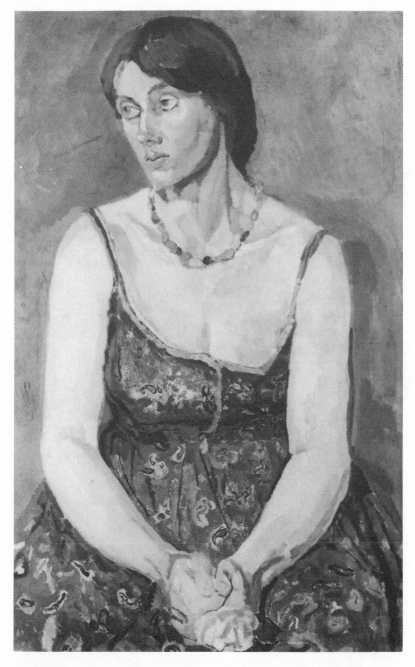

Duncan Grant, *Vanessa Bell* (c. 1918), oil on canvas, 37 × 23⅞ in., National Portrait Gallery, London.

Vanessa Bell, *A Conversation* (1913–1916), oil on canvas, 35 × 31⅜ in., Court-auld Institute of Art, London.

As a preliminary experiment, Vanessa began a small school for Julian and Quentin and a few friends. While she taught them French and elementary mathematics, a maid acted as governess. Vanessa was not, however, always on duty. She soon took off to visit Roger Fry, and both painted a Madonna lily. Vanessa's version showed that she had abandoned abstraction.

Roger, philosophical about their broken liaison, felt that she balanced her responsibilities well in spite of an unusual lifestyle. After her return to Charleston he wrote her:

> I think you go straight for the things that are worthwhile. You have done such an extraordinarily difficult thing: cut through convention. You kept friends with a persnickety creature like Clive, got quit of me

and yet kept me your devoted friend, got all the things you need for your development, and yet managed to be a splendid mother. . . . You give one a sense of security, of something solid and real in a shifting world.

Virginia had recovered from her breakdown, and when in the summer of 1917 the Woolfs founded Hogarth Press, Vanessa enthusiastically designed illustrations and dust jackets in the form of elegant woodcuts. Nonetheless Virginia gave an unflattering picture that perhaps was meant to be affectionate: "Nessa. . .living like an old hen wife among ducks, chickens, and children." The first school had been abandoned; now she revived her idea of having a school at Charleston and advertised for pupils. Only three turned up, and the school ran for only one term.

Again in her broad-minded way, Vanessa painted *The Tub*, using Mary Hutchinson as her naked model. There were nervous strains, however, in one relationship at Charleston. Duncan showed jealousy of Bunny's affairs with both men and women. After three months he became indifferent.

Living conditions seemed comfortable enough until the last year of the war when coal was hard to buy and food rations were meager. To Vanessa's profound relief, Keynes, Clive, and Mary Hutchinson brought food from London.

To her the things that mattered most were painting and family, and she continued to form her life around them. At 39, she found herself pregnant with Duncan's child.

After Angelica was born on Christmas Day, 1918, Clive gave the sickly baby his name. In *Woman in Furs* Vanessa portrayed Dr. Marie Moralt, who brought the tiny girl back to health.

At Charleston, Vanessa kept avoiding confrontations and mitigating disturbances. Keynes, however, called her Mrs. Ludendorf-Bell, alluding to the German quartermaster general who stayed in power by threatening to resign.

After the Armistice, Vanessa took a flat in Regent Square for a year. Sadly she saw that the war had prevented the Omega Workshops from achieving the success Roger Fry had envisioned. Still, they did influence English decorative art for several years. Profits were so slim that in February 1920, Omega went into voluntary liquidation. Duncan and Vanessa, however, kept busy at Charleston applying their inventive calligraphy and designs to the walls, ceilings, fireplaces, tabletops, chairbacks, even the bathtub, an enthusiasm that would last for years.

After the Bells had taken one more spring holiday in Italy with Keynes and Duncan, they moved to 50 Gordon Square, but continued to summer in Sussex. Strachey described the Charleston atmosphere:

"Duncan and Vanessa painting in each other's arms. Pozo [Keynes] writing on Probability. . . . Clive reading Stendhal. . . . The children screaming and falling into the pond." The garden had become a compelling interest. "Pinks, irises, and anything you have to spare," Vanessa pleaded, and Roger Fry brought pots, plants, and seeds from London. She refurbished an old army hut as her studio and fondly painted the flowers.

Bunny married Ray Marshall the next year; Vanessa swallowed her pride enough to accept Duncan's newest boyfriend. Grant accompanied her, the children, and servants to St. Tropez, where Roger Fry was staying for the fall and winter months. Roger wrote a friend: "I am very glad you have met Mrs. Bell. She is a most outstanding person with a quite true passion for art and I think great talent." Fearing that her and Duncan's styles were growing too similar, Vanessa thought they should paint in separate rooms.

With the boys in boarding school and Angelica under a nurse's care, Vanessa, back at Gordon Square, was able to concentrate on her first one-woman show in 1922 at the Independent Gallery. Her 27 paintings included French scenes, still lifes, and portraits and sold well though she got no reviews. But the next year her reputation suddenly began to grow. After she showed at the London Group Exhibition, one enthusiastic critic hailed her as "the best of our women painters."

Invited to give a talk at Leighton Park School a few months later, she emphasized that the artist's principal preoccupation must lie with color and form. An artist, she told her audience, made available to others his peculiar sensitivity. Vanessa herself was fascinated with the stroking, sensuous quality of light. Color determined her subject matter.

The Omega Workshops had awakened new possibilities of total decoration, murals, fabrics, and furnishings. As painters transforming interiors, Vanessa and Duncan carried out several commissions for family and friends. A trip to Spain with Fry in 1923 imbued them with Mediterranean culture, and their decorative work looked more baroque and Italianate than ever.

As always, Vanessa gave Duncan free rein and diffused the pain of his often brief affairs by absorbing his boyfriends into her social life. Tongue in cheek, Roger Fry marveled, "It really is an almost ideal family based on adultery and mutual tolerance with Clive as the deceived husband." Clive himself was never without a mistress. When Duncan and Vanessa took off for Italy the following summer, she generously agreed to take along Duncan's newest lover.

Vanessa moved to 37 Gordon Square in 1925; Clive kept rooms at No. 50, which she and Duncan later decorated. But the *The Open Door, Charleston* (1926) showed her preference for country living. Interior decoration and trips to France and Italy occupied the next few years.

Duncan left Charleston in 1927 to visit his mother at Cassis, France, on the Mediterranean coast. When he became ill there, Vanessa dashed to his bedside and, staying at the Villa Corsica, watched him recover. Meanwhile the setting had so enchanted her that within a year she took a 10-year lease on a villa, La Bergére, for vacations whenever the fancy suited her.

In the late 1920s and early 1930s she and Duncan stood at the height of their reputations. They were considered leading interior decorators and admirable painters. Grant had a bravura style; Vanessa Bell, critics said, showed more feeling and commitment, and her work gave the impression of solid personality. More than anything the London Artists Group Association, now directed by Keynes, steered them into the limelight. Its 1930 show was devoted to her. But Virginia Woolf commented, "Vanessa refuses to be a celebrated painter, buys no clothes, sees whom she likes as she likes."

Work was a panacea, for she was hurt by Duncan's continuing affairs. In London she had a studio next door to his and swallowed hard whenever he invited characters from the criminal fringe around Tottenham Court Road to sit as models or merely to watch him work. *The Nursery,* painted by Vanessa in 1932, impressed Roger Fry, who saw that it harked back to her *Nursery Tea* from 1913. The later picture, however, was more naturalistic and more detailed.

"Everything is as bright as possible with every sort of color," she wrote about her décor for the ballet *High Yellow,* given by the Carmargo Society at the Savoy Theater in 1932. "The music is jazz and there are negro dances and it's supposed to be on an island, all very hot and tropical—so I simply did sea with boats and huge tropical flowers and a striped awning and a cocktail bar."

Also in 1932 the most complete Bell-Grant interior, a "Music Room" installed at the Lefevre Galleries, was celebrated with a party at which Mayfair rubbed elbows with Bloomsbury, now welcoming younger members. Vanessa's output was enormous. She and Duncan revived their interest in pottery decoration, and she designed sets for ballets by Sir Frederick Ashton and other choreographers. After a spell of decorative work she always returned refreshed to her painting. With Duncan she also took time to encourage younger artists.

During the 1930s her favorite subject was close at hand: *Late Afternoon, Charleston* (1933), *The Garden at Charleston* (c. 1936), *The Apple Tree, Charleston* (c. 1936), *Tilton from the Pond, Charleston* (1937), and *The Studio Door* (c. 1938). An empty chair before a window figured as a recurrent motif.

Only a year after her successful exhibit with the London Artists Group Association, Vanessa and Duncan resigned their membership.

Their departure marked the beginning of an estrangement with their old friend Keynes.

But those years also brought shattering changes. Roger Fry died in 1934. And then Vanessa lost her elder son. Julian, a brilliant Cambridge graduate, took a post as English professor in Hankow, China, in 1935. But after he had an affair with a colleague's wife he resigned and came home only long enough to tell his mother that he was going to war-torn Spain as an ambulance driver for Spanish medical aid. In July 1937 an airplane strafed him with shrapnel as he took cover under a lorry, having thrown himself protectively over one of his friends. Within six hours he was dead. Vanessa completely collapsed for a couple of months, but not before she unburdened herself of an old secret: She told Angelica the name of her real father. But Duncan was unprepared for any paternal role. He remained the irreverent, irresponsible charmer at Charleston.

From 1939 on, Vanessa, Duncan, Quentin, and Angelica stayed all year round at Charleston. Bunny Garnett's wife, Ray, had cancer and was not expected to live. For solace he came frequently to Charleston, where, to Vanessa's and Duncan's shock, he and Angelica fell in love. The next year Ray Garnett died, and Angelica began living with the widower.

E. M. Forster, Vanessa's "favorite novelist," stayed at Charleston in the summer of 1940 so that he could attend a meeting of the Memoir Club. It had been founded in 1920 by "Old Bloomsbury" and dedicated to the presentation of autobiographical papers. Later, younger members like Quentin Bell were admitted. Vanessa produced an excellent portrait of Forster and about 1942 painted a group portrait, *The Memoir Club*.

While the Battle of Britain raged, Vanessa and Duncan, with Quentin, became involved in decorations for Berwick Church in Sussex, though they professed no religion. Since they had agreed to paint on plaster board panels, they were able to work at Charleston, which was, Vanessa wrote, "all adither with Christianity." Her two decorative panels, *Nativity* and *Annunciation*, were for either side of the aisle. Soon in London an incendiary bomb set Duncan's studio on fire and spread to Vanessa's; both lost many paintings.

Julian's death had been accidental; another family death was intentional. Virginia Woolf drowned herself in the Ouse River in 1941. Because there had been previous fits of madness, Vanessa could accept this tragedy better than Julian's death.

She remained bitterly opposed to the marriage of Angelica and Bunny Garnett, but did not stop their wedding. A year later they presented her with her first grandchild.

During the war years, Vanessa painted still lifes, landscapes, portraits—one even of Leonard Woolf, with whom she had often disagreed. Two of her Charleston neighbors, Mrs. Frances Byng Stamper and Miss

Caroline Byng Lucas, elderly sisters who lived at Miller's House, encouraged her by giving her commissions and arranging exhibits in their home.

During the 1950s she reestablished an old routine. She painted, traveled abroad, and made occasional visits, but now she pointedly ignored Duncan's newest conquest. He and Vanessa had rejoined the London Artists Group Association after the war. But more often she sent her paintings to the Royal West of England Academy at Bristol.

At Charleston she was still the earliest riser. After toast and coffee and the first of three daily cigarettes, she gave orders to her housekeeper, then retired to her studio upstairs. By 4 o'clock she emerged for tea, and if guests were present, she insisted on making scones. Aside from that delicious smell, Charleston usually gave off odors, her biographer writes, of turpentine, toast, apples, and cut flowers.

Vanessa Bell's pictures at the Adams Gallery in London in early 1956 sold well, but she was not concerned with their commercial value and insisted that she painted primarily for herself. Her inspiration derived from what she saw about her: a garden path, reflections in a glass, color chords of objects at Charleston. Her small still lifes—*Apples and Michaelmas Daisies, Flowers on the Studio Mantelpiece, Still Life with White Roses, Still Life with Quill Pens,* and *Hydrangeas and Apples*—often arranged against patterned cloths, looked serene. But when Duncan painted her in 1959, she appeared brooding and withdrawn. She had painted self-portraits since 1915.

In 1961, hearing that Clive had broken his leg, she hoped he would recuperate at Charleston. But before he could arrive, she developed bronchitis. On April 21 her heart gave out. She was buried without any religious ceremony near Charleston, the house that represented the most significant experiences of her life. Duncan, with whom she had formed such a strange but productive union, lived on for 17 more years.

Vanessa Bell : Works Mentioned

Lady Robert Cecil (1905), Private Collection
Lord Robert Cecil (1906), Private Collection
Iceland Poppies (1908), Private Collection
Lytton Strachey (1911), Private Collection
The Bathers (1911), Private Collection
Studland Beach (1912), Tate Gallery, London
Landscape with Haystack, Asheham (1912), Estate of the Artist
Virginia Woolf (1912), Private Collection
In the Studio (1912), Tate Gallery, London
Henri Doucet (1912), Estate of the Artist

The Studio: Duncan Grant and Henri Doucet Painting at Asheham (1912), Estate of the Artist
The Bedroom, Gordon Square (1912), Estate of the Artist
Street Corner Conversation (1912), Estate of the Artist
Nursery Tea (1913), Private Collection
Lytton Strachey (1913), Private Collection
A Conversation (1913–16), Courtauld Institute of Art, London
Iris Tree (1915), Private Collection
Mary Hutchinson (1915), Tate Gallery, London
Self-Portrait (1915), Private Collection
The Tub (1918), Tate Gallery, London
Woman in Furs (1919), Private Collection
The Open Door, Charleston (1926), Private Collection
The Nursery (1930–32), present whereabouts unknown
Late Afternoon, Charleston (1933), Estate of the Artist
The Garden at Charleston (c. 1936), Estate of the Artist
The Apple Tree, Charleston (c. 1936), Estate of the Artist
Tilton from the Pond, Charleston (1937), Estate of the Artist
The Studio Door, Charleston (c. 1938), Estate of the Artist
E.M. Forster (1940), Estate of the Artist
The Memoir Club (c. 1942), Private Collection
Apples and Michaelmas Daisies (c. 1945–50), Estate of the Artist
Flowers on the Studio Mantelpiece (c. 1948), Estate of the Artist
Still Life with White Roses (1949), Private Collection
Still Life with Quill Pens (c. 1950), Private Collection
Hydrangeas and Apples (c. 1955), Estate of the Artist
Self-Portrait (1958), Private Collection

XIII

Sonia Delaunay

(1885–1979)

"One day you make paintings, and one day you make clothing," observed Sonia Delaunay, who brought the abstraction of her pioneering canvases to the decorative arts. In both fields she had a major impact on the twentieth century.

Though her roots were Russian Jewish, she was never a practicing Jew. A second child, after a brother, she was born Sarah Stern on November 15, 1885, in the Ukrainian village of Gradizhsk. At the time her father, Elie, was serving in the army. Returning to civilian life, he found work in a nail factory, where eventually he became foreman. He always acted cheerful about his lot, but her mother, Hanne, felt discontented and dreamed of St. Petersburg's high society, in which her brother Henri (Gherman) Terk and his wife Anna moved effortlessly. In Gradizhsk, three more children came after Sarah, each increasing Hanne's unhappiness.

The Terks were childless, and Hanne Stern arranged for them to adopt Sarah, who was always told that her mother's purpose had been to give her a better life and provide for her education. (As an adult she refused to talk about her early years.) At five she was taken to the Russian capital and never saw her mother again. Long after she was grown, her father visited her once in Paris.

Henri Terk was a specialist in international law and a familiar figure on the French-Russian Bourse. In the grand salon of their well-staffed town house, he and his highly cultivated wife staged musical soirées for Jewish and gentile friends; in their 100-foot-long formal dining room they gave banquets that lasted for hours. The good life included trips abroad and a summer residence in Novaya Kirka on the Gulf of Finland.

Sarah Stern's name was changed to Sonia Terk, but she continued to call her adoptive parents uncle and aunt. Henri was warm and

165

outgoing, Anna, reserved and cool; in that sense they resembled Elie and Hanne Stern. Under German, French, and English governesses, Sonia became multilingual. Once or twice a brother arrived on vacation from Gradizhsk, but essentially she grew up as an only child, without girl friends until she was 12. At 13 she entered a lycée, where one of the teachers recognized her talent for drawing.

At home she had ample exposure to art. Henri Terk hung on his walls works of the Russian artists Isak Levitan and Ilya Rapin, and for his study he chose a reproduction of that *fin de siècle* favorite *The Isle of the Dead*, by the melancholy Swiss painter Arnold Böcklin. Sonia had permission to pore over Henri's treasured albums of copper plate engravings of famous paintings, and frequently he accompanied her to the Hermitage galleries.

In 1900 the Terks took her to Munich and its Pinakothek and to Zurich. At Lake Maggiore Henri rented a yacht, which sailed past the Borromean Island, and Sonia recognized the setting for *The Isle of the Dead*. Böcklin lived in Fiesole outside Florence, and Sonia hoped to meet him, only to be told that he was too famous to receive any strangers. Though disappointed, she delighted in Florence, most of all in the Uffizi Gallery, where Paolo Veronese's light, clear colors captivated her. On the way back to Russia, they stopped in Berlin to see Henri's friend, the painter Max Liebermann, who gave Sonia her first box of paints.

For the next couple of years Miss Bernstein, the teacher who had first discerned Sonia's talent, kept suggesting that the girl study abroad. For the Terks it was a difficult decision. They felt that she was too young for worldly Paris or Munich or Berlin. Since she did not speak Italian, Florence was not a good choice either. Finally in 1903 Henri Terk settled on the fine arts academy in Karlsruhe, Germany, and Sonia set out on her own for the first time in her life.

At the academy she entered the class of Ludwig Schmid-Reutte, who emphasized careful drawing. Karlsruhe also boasted a musical college, where Arnold Schönberg, one of the graduate students, was already displaying revolutionary tendencies in his compositions. Sonia became good friends with him and his wife, Mathilde.

She spent the summer of 1904 in Novaya Kirka and then returned for a second year at the Karlsruhe school. An attractive young woman with beautiful dark eyes, heavy brows, and distinctive profile, she had enjoyed several flirtations, but she had not yet fallen in love. A German art critic's book about Édouard Manet suddenly filled her with longing to go to Paris. The Terks were not enthusiastic, yet told her that her income was assured. After she married, it would increase. In her name they had bought some apartment houses in St. Petersburg, and each month she would receive the rent monies. For her Paris residence in 1905 they chose

Sonia Delaunay, gouache rendering by John A. Houston

a pension, where she boarded with three other Russian girls, two of whom joined her in enrolling at the Académie de la Palette.

That October the Salon d'Automne became the talk of the city because of two rooms of paintings that featured vivid faces, cream skies, green shadows, and red tree trunks, a riot of spontaneous colors intended to convey the artists' emotions. To the exhibitors—Henri Matisse, Georges Rouault, Albert Marquet, André Derain, Maurice Vlaminck, and Kees

van Dongen—critics gave the name Fauves (wild beasts). In the same Salon, paintings by the late Vincent van Gogh provided another bomb-shell.

The exhibit gave Sonia a sense of urgency. Anxious to learn new techniques as quickly as possible, she took lessons from Rudolf Gross-mann in etching, halftone work, and drypoint. One day in 1906, on her way to his studio, she met his neighbor on the floor below. Wilhelm Uhde was a tall, well-born German art dealer, who immediately invited her to his Galerie Notre Dame-en-Champs. Soon they were on a first-name basis.

That summer when Sonia returned to St. Petersburg for her vaca-tion, Henri and Anna Terk told her it was high time for her to think of getting married and settling down. They were somewhat mollified when she told them about her friendship with Willy Uhde and finally allowed her to spend another year in Paris.

Since her experience at the Académie de la Palette had been neither enjoyable nor inspiring, she did not want to study there any longer and felt quite ready to work on her own. The Paul Gauguin retrospective in 1906, three years after his death, pushed her toward a highly expressive style. When she had first seen Gauguins in Ambroise Vollard's gallery the year before, she had learned what the eccentric painter meant when he called for a "breaking of all the old windows, even if we cut our fingers on the glass."

For several months, beginning in the fall of 1907, she created some powerful paintings that showed indebtedness to Gauguin, Van Gogh, and the Fauves: a portrait of the Russian poet Chuiko, *Young Finnish Girl*, *Yellow Nude*, and *Young Girl Asleep*. All blazed with color; all showed a primitive style. Summering at home once more in 1908, she picked as her model Philomène, one of the Terks' maids. These sketches, later turned into oils, were made in the midst of new squabbles with Henri and Anna Terk over Sonia's future.

Back in Paris, she noticed in Willy's gallery a new painting, a portrait of him that unerringly caught his receding hairline, dreamy blue eyes, and blond mustache. The artist was Robert Delaunay, whom she had met in Willy's apartment. Robert, who had begun as a theatrical designer, was the son of the wealthy and eccentric Countess Berthe de la Rose, one of Uhde's friends. She traveled incessantly, and when she told Uhde she wanted to commission a painting celebrating at least one of her adven-tures, he had brought her to Henri Rousseau, who painted *The Snake Charmer*, based on one of her stories about India.

In the fall of 1908 Willy hung three of Sonia's paintings in his gallery alongside three pictures by Pablo Picasso, three by Derain, three by Raoul Dufy, and five by Georges Braque. Not long after this exhibit, talk of

marriage arose between Willy and Sonia. As an old woman, Sonia would tell a television audience that it was she who had sprung the idea. Marriage would free her from her adoptive parents' domination, ensure her a greater income as Uncle Henri had promised, and it would enable her to stay in Paris and continue with her art. In his memoirs Uhde would write: "Sonia wished to have a harmonious and orderly existence and a serious relationship of the mind. We therefore agreed to give our camaraderie the exterior appearance of marriage." He failed to reveal that a wedding ceremony was a convenient cover for his homosexuality. The marriage of convenience took place in London at the Holborn registry office on December 5, 1908, with the Terks in attendance. Willy was 34, Sonia 23.

Established in a Paris apartment, the newlyweds gave sparkling dinner parties, at various times seating Derain, Braque, Picasso, Vlaminck, Van Dongen, Marie Laurencin, Gertrude Stein, and Alice B. Toklas at their table. Sonia found that their most stimulating guest was the tall, red-haired, and endlessly talkative Robert Delaunay. She later remarked that she had been carried away "by the poet in him, the visionary, the fighter." Sometimes he appeared with his mother; mostly he came alone.

Fired by Paul Cézanne's late work, Delaunay was experimenting with the fragmentation of form. Also influenced by Cézanne, Picasso and Braque had originated the Cubist style to reconcile the volumes and shapes of persons or things seen with the flat rectangular surfaces on which they were painted. Natural forms were transposed into arrangements of overlapping or transparent planes. But Robert Delaunay was dissatisfied with the subdued early-Cubist palette of ochres, tans, and greens. He wanted to drench it with color.

For the summer of 1909, Willy and Sonia rented a villa in Chaville on the western outskirts of Paris. Robert Delaunay, who had been partially raised by an uncle and aunt in Chaville, visited the Uhdes in the evenings, eager to talk about the Cubist-like variations he was painting on the Saint-Severin church. Soon he began appearing in the daytime too, often inviting Sonia for long hikes in the Meudon forest.

In Paris that autumn they saw even more of each other. Constantly they visited the Louvre, passing up the painting galleries in favor of the rooms devoted to Egyptian jewelry, Assyrian sculpture, and Mesopotamian religious arts. On their walks through the city they always felt drawn to the Eiffel Tower, which to Robert symbolized the city and modernity. In the next three years he would capture it in over 30 paintings, customarily described as vertiginous. One critic wrote: "The Eiffel Tower toppled over, presumably with an eye to destroying the nearby houses, which, dancing a cancan, are rudely sticking their chimney pots into each other's windows." Sonia received one of his first versions in 1909.

Sonia also came to visit Robert in his cluttered garret apartment.

There he showed her a copy of an 1839 book, *Of the Laws of Simultaneous Contrast,* by the French chemist Michel-Eugène Chevreul, which had influenced Georges Seurat and other Pointillists. Chevreul had postulated: "When two objects of different colors are set side by side, neither keeps its own color and each acquires a new tint owing to the influence of the colors of the other objects." Color perception was intensified. But instead of following the pointillist technique of applying dots of color to be blended in the viewer's eye, Robert was interested in using large areas of juxtaposed, contrasting color.

In his garret studio Sonia and Robert became lovers. By June 1910, she realized she was pregnant and asked Willy for a divorce. Gallantly he told a friend, "It did not occur to me to stand in the way of a beautiful future for her." To speed the process, he feigned a liaison for himself, documented with false letters. Sonia's lawyer even asked her to write a dramatic note: "You have a mistress. Don't deny it. I have proof."

While Willy sat for his portrait by Picasso, who emphasized his high forehead, pursed lips, and general air of fastidiousness, Sonia accompanied an aunt on a brief visit to the Genoa region in Italy. By August she and Robert were reunited in Chaville and from there went to his uncle and aunt's new house at Chevreuse. The divorce was speedily granted, and a civil ceremony united Robert and Sonia on November 10.

Their son Charles was born in January 1911. Not long after, word arrived of Anna Terk's death in St. Petersburg, but Sonia did not attend the funeral. In his first months the baby took much of her time. For his crib she stitched a blanket from pieces of fabric and fur, much like the ones Russian peasants made. "When it was finished," she later wrote, "the arrangements of the pieces of material seemed to me to evoke Cubist conceptions and we tried then to apply the same process to other objects and painting."

Before long, Sonia hired a young woman to look after Charles. Every night the Delaunays went out or entertained at home; each Sunday they held open house. Daytimes they worked in the studio, where Sonia transmitted to Robert some of her passion for vivid hues. With great pride she watched him create in three weeks a large prismatic composition, *City of Paris,* for the Salon des Indépendants. Dominated by three geometric nudes, it seemed to the poet Guillaume Apollinaire to be the most important picture in the Salon. After his "destructive" period of torn, jagged, dramatic forms, Robert had now entered his "constructive" period. The edges of Picasso's arcs and planes were softened into cores of light of graduated intensities. Invoking the name of the poet and musician Orpheus of Greek myth, Apollinaire began to use the word Orphism (Orphic Cubism) for the color dynamism also practiced by the Czech painter Frantisek Kupka.

About his next work, a series of *Windows*—the sky seen through a casement with glimpses of the Eiffel Tower—Robert wrote: "I got the idea of doing a painting that technically was held up by color, contrasts of color, developed in a time lapse but seen simultaneously in one flash." The concept of *Simultanisme* now permeated the Delaunays' lifestyle and theory. Based on the use of light to unify contrasting colors, it came to mean the creation of unity out of a number of elements customarily regarded as inharmonious. After *Windows,* Robert decided to abolish objects "that come to break and corrupt the colored work." In *Disks and Cosmic Circular Forms* he showed his new resolve. Though Cubism was left behind, Apollinaire still applied his term Orphism to Robert's championship of pure color in pictorial composition.

Many rainy nights Sonia and Robert strolled the boulevards, where electric lights had replaced the old gas lights, and were fascinated to see how those lights on the wet pavement separated into a spectrum. Sonia expressed her pleasure in *Study of Light, Boulevard Saint Michel.* That same year of 1912 she followed Robert into abstraction and painted her first completely nonrepresentational picture, *Simultaneous Contrasts.* "The pure colors becoming planes and opposing each other by simultaneous contrasts," she would write, "create for the first time new constructed forms through the depth of color itself."

Apollinaire was a special friend, and when his apartment was being renovated during the late autumn, they gave him house room and sympathy. He had been accused of acting as an accomplice in the sensational theft of the *Mona Lisa* from the Louvre. Loyally the Delaunays stood by him until his name was cleared.

A new friend entered their circle at the beginning of 1913. Blaise Cendrars, an eccentric poet, impressed them so much at their first meeting that he soon came to lunch at their studio-apartment every day. Sonia made a collage binding for his poem *Pâques à New York,* which Paul Klee claimed pushed him toward abstraction. Then Cendrars asked Sonia to collaborate with him on a poem-painting, *La Prose du Transsibérien et de la Petite Jehanne de France,* which was based on a trip (from Moscow to Nikolskoye on the Sea of Japan) Cendrars had made as a homesick youth.

But before Sonia could study the poem, Cendrars accompanied Robert and Apollinaire to Berlin, where Robert was feted by Herwarth Walden, the founder-publisher of an influential art magazine, *Der Sturm,* and his wife, Else Lasker-Schueler.

On the trio's return, Cendrars and Sonia went to work. At her bidding the *Prose Transsiberién* was printed on a single sheet of paper folded accordion style and unfolded to a length of 6½ feet. Alongside the 23 panels of symbolist prose-poetry, she placed colored arcs, interlacing triangles

and rectangles and, close to the bottom, a red Eiffel Tower. Typography was varied, stencils decorated the cover. Apollinaire praised the project as "a unique experiment in simultaneity, written in contrasting colors in order to train the eye to read with a single glance the whole poem." Cendrars' Polish mistress contributed 3,000 francs for the printing. Only 62 copies were made, and few sold.

It was a busy year with Sonia doing many bookbindings. And there was new excitement in the Delaunays' social life. The Bullier, a dance hall in Montparnasse, had become immensely popular with young Parisians caught up in the tango craze. Unlike Robert, Sonia did not like to dance, preferring to sit quietly at a table watching the ever moving color geometry on the floor. Still, she and Robert were conspicuous for their clothes. In a single outfit he combined a half dozen bright colors. Apollinaire described one of Sonia's "Simultaneous" dresses as purple, "with wide, purple and green sash, and, under the jacket, a corsage divided with brightly colored zones... where there is mixed an old rose, yellow-orange color, Nattier blue, scarlet... appearing in different materials." He added, "So much color cannot escape notice; it transforms fantasy into elegance."

Sonia's hours of watching resulted in the semiabstract *Tango Magic-City* and *The Bullier Ball* (almost 13 feet wide) and several studies on the same theme. Faceless couples melt into a multitude of color forms. Meanwhile Robert's color symphony *City of Paris*, which had created a sensation at the Salon des Indépendants, was sent to New York for the famous Armory show; there it was eclipsed by Marcel Duchamps' *Nude Descending a Staircase*.

That same year the Waldens came to Paris and were so attracted to Sonia that they arranged for 20 of her paintings to be exhibited with Robert's 21 at the gallery associated with *Der Sturm*. In the fall the three Delaunays traveled to Berlin for the Herbstsalon.

For Robert, circles became assimilated to aircraft imagery in *Homage to Blériot*, his ambitious tribute to the pioneer who had flown across the English Channel. Following Robert's lead, Sonia used disks in her *Electric Prisms* at the 1914 Salon des Indépendants. Regarding disks as cosmic and mystical, Robert had hailed them as "the form that least restricts color and at the same time constitutes a feeling of dynamism, of movement." As Arthur Cohen notes, by this time Sonia Delaunay had established her basic vocabulary—"the play of color and light through flat surfaces and geometric shapes, blending, abutting, whether softly delineated or severely edged."

With their son Charles (Charlot), the Delaunays were vacationing in Fuenterrabia, a little Basque town just over the Spanish border, in August 1914, when Europe went to war. Many of their friends had volunteered or

Sonia Delaunay, *Electric Prisms* (1914), oil on canvas, 98½ × 98½ in., Musée National d'Art Moderne, Paris.

been conscripted on both sides, but for several reasons they decided against returning to Paris. Charles and their Spanish maid Beatris Moreas were both recovering from typhoid fever. Robert had completed his military service several years before and besides was overage for the first conscription. Spain had declared its neutrality, and within a month the Delaunays moved to Madrid.

Before long, friends drew them to Portugal. With two painters, the American Sam Halpert and the Portuguese Eduardo Vianna, they rented a fisherman's house at Vila do Conde near Porto and immediately named it La Simultanée.

Both Delaunays were fascinated by the music, the dances, and the brightness of the country and painted enthusiastically. From 1915 to 1917, Sonia partially returned to figuration in two versions of *Flamenco Singers*, in *Portuguese Still Lifes*, *Portuguese Toys*, and the poetic *Market in Minho* (encaustic on canvas) in which market women, an ox, and the colored arches of the town aqueduct dissolve into each other.

When Portugal seized German ships in its harbors, Germany declared war in the spring of 1916. At the same time Robert was ordered to present himself to the French consulate in Vigo, just across the border in Spain, for a check on his conscription status. After a medical examination, he had no idea how long he would have to wait for the army board's decision. Sonia and Charlot, who had accompanied him to Vigo, therefore started for Vila do Conde, but on the Portuguese side of the border, she was accused of espionage and detained. Taken to Porto, she was confronted with charges that the colorful, large *Disks and Circles* pictures she had painted while standing on the beach had been used to signal German U-boats! Halpert had left for the United States, but at La Simultanée, Vianna and the maid Beatris were also detained.

Within a couple of weeks a friend from Lisbon cleared up the matter. Robert was granted a permanent medical discharge because of an abnormally large heart and collapsed right lung, and Sonia was permitted to return with Charlot to Spain for a happy reunion. Soon the Delaunays went back to Portugal to spend the winter in Valença do Minho. There Sonia was asked to design tiles for the facade of the chapel of a Jesuit monastery, but *Homage to the Donor* proved to be an unfinished project.

All these years the Delaunays had lived well because Henri Terk had faithfully sent a large monthly check from St. Petersburg. Robert's mother, Countess Berthe, had also given them money, but her income had steadily dwindled. Two blows struck in 1917. Henri Terk died, and the Russian Revolution completely destroyed Sonia's income from the St. Petersburg apartments. Always more practical than her visionary husband, she understood that their paintings could not assure enough income. Costume design and interior decoration offered better opportunities. Why not use art expertise and theories in a new way?

Such a career dictated settling in a big city, in Madrid. There in 1918 Sonia ran into Sergei Diaghilev, the flamboyant ballet impresario, whom she had first met in 1905. Impressed by her sharp intelligence, he commissioned her to design costumes for his revival of the ballet *Cléopâtre* in London and picked Robert to do the sets. To watch rehearsals, the couple traveled with the ballet to Barcelona, where Sonia also received a commission to create several costumes for a production of the opera *Aïda*.

Diaghilev and other friends introduced her to Madrilene high society, and many rich women rushed to her new atelier, the Casa Sonia, where she designed and sold dresses, hats, coats, handbags, and interior decoration items. At a popular actress's request, Sonia also planned the interior of a redecorated Petit Casino.

After an absence of six years, the Delaunays resettled in Paris in 1920. Once more in their apartment, decorated in "Simultaneous" colors, they

held open house on Sundays. But they greatly missed Apollinaire, who after recovering from a war wound had died of the Spanish flu. New friends were the poets André Breton, Louis Aragon, and Tristan Tzara, who shortly would style themselves Surrealists. Tzara was also founder and chief spokesman for the Dadaist movement, which stressed the absurdity of life. The enthusiastic hosts invited all guests to paint their signatures or poems on the apartment walls. Robert's round pink face wore a perpetual smile; Sonia's appearance was more dramatic. Her sleek, burnished hair, drawn into a chignon, her high heels, and her simple wraps for her own plumpish figure gave her a sophisticated look. She had opened a fashion and interior design boutique, the Maison de Sonia. From it issued geometric "poem fashions" for the jazz age, "Simultaneous" scarves, and avant-garde book covers.

As always, dance fascinated her. With Lidica Codrano she created *Dancer with Disks,* an experiment, she explained, with "the theater of color." Another theatrical event that same year proved less successful. For Tzara's *Coeur à Gaz* (The Gas Operated Heart), a burlesque, Sonia made cardboard costumes. But what had been billed as a great surrealist evening turned into disaster when police intervened after the author had been struck to the floor by irate members of the audience.

On a happier note, enthusiastic patronage came from the Lyons silk manufacturers, who ordered Sonia's designs, a pure geometry of squares, triangles, stripes, zigzags, and diamonds, all most appropriate for the 1920s styles of short skirts and dropped waistlines and expressive, in Robert's phrase, of the rhythm of the modern city. Nancy Cunard, the English socialite, and Gloria Swanson, the reigning American film star, wore Sonia's designs with special flair.

During the 1925 Exposition Internationale des Arts Decoratifs et Industriels Modernes, which gave its name to the Art Deco movement, Sonia presided over a stand on the Alexander III bridge, briskly selling dresses and coats made from her designs by the couturier Jacques Heim. Robert had painted a panel for the official pavilion, but grew upset when told that his semiabstract nude in a Seine perspective was too provocative. Though he painted a veil over the offending parts, the panel was removed. Exploding with anger, he boycotted the entire exposition, and Sonia had to ask friends to accompany her to the various pavilions.

Soon she took Heim as a partner in a new enterprise, the Ateliers Simultanés, which produced dresses, fur coats, fashion accessories, fabrics, and upholstery. Eventually she opened a wholesale office in London and a boutique in Rio de Janeiro. Enthusiastically she applauded Robert's idea of printing patterns and sewing instructions on the reverse side of fabrics, and he took out a patent. Somehow he never got around to promoting his scheme.

During this period the Delaunays were asked to design costumes and sets for several films. They accepted the offers, but felt they were doing routine craftwork. Their son Charles often complained that the intellectuals who surrounded his parents spent too much time "on the run, partying, going to shows, sitting in cafés." He showed artistic talent, but aside from his art classes, was bored in school. At 18 he plunged into jazz and the advertising milieu.

Sonia's fashion triumphs were not always easy for Robert, proud though he was of her. She provided most of the family income. He painted a notable *Helix* in 1923, some more Eiffel Tower variations, a dazzling series of *Runners* and conventional portraits, but had few buyers.

Then in 1931 the Great Depression hit Europe hard. Sonia's wealthy clientele disappeared, and she was forced to dissolve her corporation. Still she continued to accept some private orders. But now she felt she could return to painting, reinterpreting her vividly colored squares and circles in rhythmic designs. She was conscious that her concentration on the decorative arts had resulted in a somewhat narrow interpretation of her skills as a painter. So she welcomed the challenge. Still, she was always careful to give Robert his due. He was returning to abstract painting, but critics thought his power had declined. Sonia always bristled when Vassily Kandinsky was hailed as the originator of modern abstract art. Robert's theories, she staunchly believed, stamped him as founder. She did not mention the fact that before him Kupka had painted the first purely abstract picture.

During 1936 and 1937 the Delaunays undertook the design of some giant murals for the Air and Railroad pavilions of the Exposition Internationale des Arts et Techniques in Paris. Robert was project director, in charge of a floor crew of 50 painters. Sonia's pictures at the railway pavilion, *Portugal* and *Distant Voyages* (with disks, squares, and spokes), won acclaim, and she received a gold medal for *Portugal*. Robert's enormous compositions featured fantasy machines.

At the beginning of 1939 the Delaunays helped organize the first ever all-abstract show. After a successful opening, sales went well. But a shadow hung over them. Robert had begun consulting doctors because of lassitude and fatigue. That autumn on medical advice they motored to the farm they had bought in Gambais in the south of France. But Robert craved more than rest. He wanted to oversee rehabilitation work on the farm.

Before they left, France and England declared war on Germany, following Adolf Hitler's blitzkrieg on Poland. Charles was called up for military service, but Robert, like most Frenchmen, believed in the security of the Maginot Line. After a refreshing sojourn at Gambais, they came back to a Paris that shrugged at the "phony war."

But by April 1940 the lull ended. German troops were streaming toward Paris, and its citizens fled south. Ill though he was, Robert drove their enormous automobile, loaded down with canvases, to a friend's house in Mougins near Cannes. Rapidly he lost strength, and a local doctor determined that he had colon cancer, his tumor the size of a tangerine. Surgery in July brought little improvement. Finally he was referred to a clinic in Montpellier, where he died in October.

The French army had been disbanded. To comfort his overwrought mother, Charles, who in the midst of war had written a successful book on jazz, came on an arduous journey from occupied Paris, sneaking across the demarcation line. Nervously an exhausted Sonia made him promise that none of Robert Delaunay's art would be sold except to museums. He had not been accorded proper recognition in his lifetime, she told her son, and from now on she would dedicate herself to assuring her husband a place in history.

Longtime friends, the Swiss sculptor Jean Arp and his wife, Sophie Tauber-Arp, invited her to their home in Grasse, where Mary Cassatt had once wintered. But Sonia preferred to rent two rooms nearby. Three other artists, Alberto Magnelli, Ferdinand Springer, and François Stahly, also had found Grasse a wartime haven. Lacking any means of marketing their paintings and sculpture, the friends simply exchanged them as gifts. Sometimes they made collective pictures. Because oils were scarce, Sonia used gouache.

She needed money badly, and when she heard that a museum in Basel wanted to buy one of Robert's paintings, she determined to make the journey. The Kunstmuseum finally decided to buy two paintings and gave her a generous advance until they could be delivered. Without incident she returned to Grasse. Sonia was unaware that Charles had joined the resistance movement, had been arrested, then released rather suddenly. She did not even know that he had reached Gambais, where he lived with his sweetheart, Denise.

First Italian, then German occupation troops rolled into Grasse in the autumn of 1944. Sophie was ill with cancer, and the Arps left for Switzerland. Quickly the rest of the little colony scattered, and Sonia decided to stay near the Spanish border. She left by train from Cannes. During a surprise check, Nazi officers ordered her and five other passengers to leave their seats. As she waited in a Toulouse cafe, she suddenly saw Wilhelm Uhde. He saw her too, but for safety's sake they did not acknowledge each other. Outwardly composed, inwardly she quaked with fear that close Nazi scrutiny of her *carte d'identité* would reveal the Jewish name, "née Sarah Stern," amid the lines. But after a few perfunctory questions the inspector did not even unfold her identification card.

She had last seen Willy at his gallery in 1938. Now he invited her to

stay with him, Tzara, and some friends at a château near Grisolles. Sonia gratefully accepted and remained there for several months, then returned to Paris on New Year's Day, 1945. Peace was only a few months away.

For the next decade, in solemn dedication to Robert's memory, she made inventories of his works and arranged exhibits. But she and Charles quarreled bitterly whenever he tried to renege on his promise that his father's paintings would go only to museums. He wanted to sell to whomever would buy. Now well-known as a jazz critic and concert promoter, he had made his first trip to the United States and brought Dizzy Gillespie and bebop to France. He was also president of the Hot Club of France and publisher of a jazz magazine and had aspirations to buy a second. After her divorce, he had married Denise; two sons were born, Jean-Louis and Eric. Sonia had not gotten on well with Robert's mother; now she could not adjust to Denise. As her grandsons grew, she decided they should spend every August with her, away from their mother. Such vacations included trips to Italy and Switzerland.

For Sonia Delaunay the next decades spelled great personal triumph. She felt that she had gained for Robert the recognition that had eluded him in his lifetime. She expressed this happiness through great productivity—gouaches, tapestries, lithographs, mosaics, stained glass windows, fabric design, book illustrations. She also returned to oils. *Triptych* and a series of *Colored Rhythms* showed new variations of bright disks, sometimes interlocking, sometimes broken.

Galleries clamored for her pictures. But she refused to participate in exhibits for women only. Asked about women painters, she said, "I don't see any difference. There are good and bad painters, like the men." Finally she and Charles agreed to give the bulk of the Delaunays' oeuvre, 117 pieces, to the Musée National d'Art Moderne. They were first exhibited at the Louvre; thus Sonia Delaunay became the first living woman painter to be shown there.

At 80 she gained a special friend, Jacques Damase, a journalist in his 30s. After he interviewed her about her years as a fashion leader, she agreed to collaborate with him on a book, *Rythmes-Couleurs*, contributing stencil prints for his poems. Four years after the Delaunays' magnificent contribution, the Musée National d'Art Moderne staged a large Sonia Delaunay retrospective, placing her paintings in chronological order. Damase actively promoted her work in other places as well. On her ninetieth birthday she received the cross of the Legion of Honor. Then she designed the UNESCO poster for the Women's International Year.

In January 1977, she fractured her femur. Because of her age, doctors decided not to operate, and she resigned herself to live with a wheelchair and a day nurse. She painted gouaches, designed costumes for a Comédie Française production, and began preparing for a joint Robert-Sonia

Delaunay show in Tokyo. Damase published a book of her drawings over 70 years, and the originals were placed on exhibit.

Sonia had recently sold Robert's *Helix* to the Tokyo Museum of Modern Art. The day after a big check arrived, on December 5, 1979, she suffered a massive stroke and died instantly. It was the seventy-first anniversary of her marriage to Wilhelm Uhde.

She was buried beside Robert in Gambais. Damase declared that historians would be wrong to place her in her husband's shadow. Her artistic life, with a versatility second to none, had represented "an extraordinary crossing of the 20th century."

Sonia Delaunay : Works Mentioned

The Poet Chuiko (1906), Musée National d'Art Moderne, Paris
Young Finnish Girl (1907), Musée National d'Art Moderne, Paris
Yellow Nude (1907), Private Collection
Young Girl Asleep (19007), Musée National d'Art Moderne, Paris
Philomène (1907), Musée National d'Art Moderne, Paris
Study of Light, Boulevard Saint Michel (1912), Musée National d'Art Moderne, Paris
Simultaneous Contrasts (1912), Musée National d'Art Moderne, Paris
La Prose du Transsiberién et de la Petite Jehanne de France, Musée National d'Art Moderne, Paris
Tango-Magic City (1913), Kunsthalle, Bielefeld, Germany
The Bullier Ball (1913), Musée National d'Art Moderne, Paris
The Bullier Ball (1913), Kunsthalle, Bielefeld, Germany
Electric Prisms (1914), Musée National d'Art Moderne, Paris
Flamenco Singers (1915), Musée National d'Art Moderne, Paris
Portuguese Still Lifes (1916), Musée National d'Art Moderne, Paris
Portuguese Toys (1916), Musée National d'Art Moderne, Paris
Market in Minho (1916), Musée National d'Art Moderne, Paris
Homage to the Donor, preliminary design (1916), Musée National d'Art Moderne, Paris
Distant Voyages, gouache (1937), Musée National d'Art Moderne, Paris
Colored Rhythm (1958), Musée National d'Art Moderne, Paris
Colored Rhythm (1958), Kunsthalle, Bielefeld, Germany
Colored Rhythm (1958), Albright-Knox Gallery, Buffalo, New York
Colored Rhythm (1959–60), Musée National d'Art Moderne, Paris
Colored Rhythm (1961), Musée National d'Art Moderne
Triptych (1963), Tate Gallery, London

XIV

Georgia O'Keeffe

(1887–1986)

The first woman in American art to gain recognition as a modernist, Georgia O'Keeffe disliked having her work labeled feminist. It was, she insisted, simply art. More forthrightly she declared, "I am not a woman painter." But she did believe that her Midwestern roots strongly marked her pictures and her independent character.

On a prosperous dairy farm near Sun Prairie, Wisconsin, on November 15, 1887, Francis and Ida O'Keeffe welcomed their second child, Georgia Totto. She was named in honor of the maternal grandfather, George Totto, a Hungarian aristocrat, who had emigrated to the United States. The new baby also had strains of Dutch blood, and on her father's side, Irish. A brother, Francis Jr., had preceded her; four sisters, Ida, Anita, Catherine, and Claudia, and a brother, Alexis, were to follow during the next twelve years. To help with the large family, Ida O'Keeffe's widowed aunt, Jane Wyckoff Varney ("Auntie" to the children), lived with them.

The young O'Keeffes enjoyed a country childhood and attended the Number V District schoolhouse (known as the Town Hall School) on Totto property. Their mother, serious, cultivated, and educationally superior to their jolly, fiddle-playing father, encouraged wide reading, but Georgia preferred stories of the Wild West. Mrs. O'Keeffe also arranged for the three oldest girls to take drawing lessons from the Town Hall School teacher, who boarded with the family. A year later she sent them to painting lessons in Sun Prairie. By the age of 12, Georgia, a curious, solitary child, full of "crazy notions," as she later admitted, had decided to be an artist. Though she had seen few paintings and knew nothing about women artists, a small illustration of a Grecian girl in one of her mother's books inspired her "to make something lovely."

In 1901 Ida O'Keeffe enrolled Georgia at Sacred Heart Academy, a Dominican convent boarding school in Madison, where the girl won a

medal for drawing. Having objected to her mother's framing her efforts "pretentiously," she began a lifelong habit of insisting on the simplest frames. The following year she was taken out of the convent so that Ida and Anita could enter. Georgia remained in Madison, however, living with two aunts while she attended Madison High School. There one day as she walked past an art classroom, she saw a teacher encouraging the students to carefully inspect a jack-in-the-pulpit. Suddenly she realized it was more important to paint growing things than plaster casts.

Tuberculosis had killed three of Frank O'Keeffe's brothers, and he worried that he would come down with the disease in the severe Wisconsin winters. Therefore he and his wife decided to move their family to Williamsburg, Virginia, leaving the four oldest children in Madison to finish school. As soon as the Sun Prairie farm was sold in the spring of 1903, Frank O'Keeffe bought Wheatlands, a homestead near Williamsburg.

Georgia, Frank Jr., Ida, and Anita came to Virginia that summer. In the fall Georgia was enrolled at Chatham Episcopal Institute, 200 miles from Williamsburg. Though at first she startled everybody with her simple black dresses, she quickly became a popular student. She played the piano and the violin and was chosen editor of the yearbook. She was also a favorite of the headmistress, Elizabeth May Willis, who doubled as the art teacher.

Both Mrs. O'Keeffe and Mrs. Willis wanted Georgia, considered the best art student at Chatham, to continue with her training. So after graduation she was sent off to the School of the Art Institute of Chicago in September 1905, to stay for almost two years. Here John Vanderpoel's meticulous drawing techniques left a lasting impression on her.

Summering in Williamsburg in 1907, she came down with typhoid fever, which caused her to lose all her hair temporarily. Since Georgia did not want to return to Chicago, Mrs. Willis recommended she attend the Art Students League of New York, and she enrolled there in the fall. The puckish, boyishly graceful young woman was well liked by her fellow students and had several beaux. She took most interest in portrait and still life classes with William Merritt Chase, a well-known realist painter, who taught European methods, particularly the use of a loaded brush. He required a daily painting. With her *Rabbits and Copper Pots* Georgia won first prize that year.

That winter she first saw Alfred Stieglitz, the widely known photographer and advocate of modern art, who had opened the 291 Gallery, named for its street number on Fifth Avenue. His exhibit of controversial drawings by the French sculptor Auguste Rodin marked the start of his showing avant-garde drawings and paintings. Georgia attended the Rodin exhibit, but was more intrigued by the peppery Stieglitz.

Summer in Williamsburg seemed bleak, for after several unsuccess-
ful business ventures Frank O'Keeffe's problems had worsened, and in
November 1908, Georgia decided to look for a job. She found one in
Chicago, where she lived with her mother's sisters, Ollie and Lola. For two
years she drew advertisements for lace and embroidery until an attack of
measles temporarily left her with weakened eyes and consequent eye
strain when she worked. So she went home from Chicago.

Meanwhile in 1909 her mother, though often ill and like her husband
threatened with tuberculosis, moved to Charlottesville and opened a
boarding house. Frank O'Keeffe would not arrive there until 1912, when
he started a creamery. Wintering in Charlottesville, Georgia became
discouraged about her prospects and announced she was giving up art.
But then in the spring of 1911 she filled in at Chatham for Mrs. Willis, who
had taken a six-weeks leave of absence, and she swiftly regained her
enthusiasm.

Young Ida and Anita O'Keeffe enrolled at the University of Virginia
summer school the next year, and Anita excitedly informed Georgia
about a class for elementary school teachers taught by Alon Bement, an
associate of Arthur Wesley Dow, head of fine arts at Columbia Teachers
College in New York. In accordance with Dow's methods, Bement de-
rived exercises to encourage his students to make their own designs in-
stead of copying others. After observing just one class, Georgia signed up
for it. At long last she felt free of derivative styles and compositions.

That fall a boarding school friend from Texas told her about an open-
ing for a school drawing supervisor in Amarillo, then a frontier town and
center of cattle drives in the heart of the Panhandle. Georgia applied, was
accepted, and went West, later describing the area as "my country—
terrible winds and a wonderful emptiness."

Back in Virginia for the summer of 1913, she agreed to be one of Be-
ment's teaching assistants at the summer school. As the term progressed,
she was influenced by his total concern with expressing beauty and by
Vassily Kandinsky's recent book, *Concerning the Spiritual in Art,* which at
one point declared that abstract art could evoke music. Her watercolors
now reflected the Kandinsky dictum.

When she returned to Amarillo for the fall of 1913, she headed into
a controversy. A new Texas law required the use of textbooks chosen by
a special commission, but stubbornly Georgia refused to comply. The
next summer, 1914, possibly to the school's relief, she resigned and,
enriched by a money gift from her Aunt Ollie, enrolled for the fall at Co-
lumbia Teachers College to study directly under Dow and Bement. She
was now known as Pat because of her Irish surname. From Dow, Georgia
picked up an interest in Japanese art, a tolerance for all kinds of ex-
perimentation, and a conviction about "filling a space in a beautiful way."

While at school, which she could afford for only a year, she went again to 291, becoming more and more impressed with Stieglitz's critical acumen and judgment. In spite of his broken nose and lined face (he was 49), Georgia found him physically attractive with his thatch of graying hair, thick mustache, and piercing eyes. Besides, he had begun to create a dramatic appearance for himself, wearing a flat hat, black cape, and sometimes a red vest.

In the summer of 1915 she again taught at the University of Virginia with Bement and enjoyed an increasingly warm relationship with Arthur MacMahon, a young political science professor. That fall she accepted a position with a teachers' college for women in Columbia, South Carolina, feeling relieved to be the entire art department. Through correspondence she felt closer than ever to Arthur, and at Thanksgiving he came to Columbia to spend the weekend with her.

There in South Carolina, deciding to please herself rather than just her former instructors, she made several totally abstract charcoal drawings that she sent to Anita Pollitzer, a friend from Dow's class, asking her not to show them around. They arrived in New York in January 1916, and without getting Georgia's permission Anita took them to Stieglitz because she knew Georgia valued his judgment so highly. The usual story is that an overwhelmed Stieglitz exclaimed, "At last a woman on paper." His remark, however, may have come later.

Hardly was Georgia settled at Columbia College than she began considering a job as head of the art department at a college in Texas, which wanted her to prepare for the post by taking Dow's teaching methods course. Abruptly, just as the second semester began in early 1916, she resigned and began Dow's classes a few weeks later.

For a long time the news from home had been grim. Her mother's tuberculosis had advanced, and her father, having failed with his creamery, roamed about, working wherever possible. That spring Ida O'Keeffe died. On top of this sorrow came an unexpected exasperation. Without obtaining Georgia's consent because he had been unable to get in touch with her, Stieglitz hung her pioneering charcoal drawings at 291 along with the abstractions of two young male friends. At first she reacted angrily and demanded he take down her pictures, now titled *Lonesome Spaces in Charcoal*; then she realized he had acted in her best interests and agreed to let them stay.

West Texas State Normal College, where she arrived in September 1916, was located in Canyon, twenty miles south of Amarillo. So it was familiar territory. Now as she took long walks across the prairie, night and morning, Georgia found new, wonderful subjects, which she captured in more than fifty abstract watercolors over the next fifteen months. In one, *Canyon with Crows*, she used both transparent wash and opaque color.

Claudia, her youngest sister, came to stay with her and attend the college. Georgia had several male friends, but continued to think herself in love with Arthur MacMahon. In their correspondence, however, it was she who penned the more ardent letters. Stieglitz wrote with increasing frequency.

The next year he gave her a first solo show consisting of her Palo Duro Canyon landscapes and her watercolors, many of them all blue. *Blue No. 1, Blue No. 2, Blue No. 3,* and *Blue No. 4,* generally interpreted as showing a male-female dichotomy, attracted the most attention. Three days after the opening, however, the United States entered World War I, and attendance plummeted at 291. Stieglitz, already depressed over the war, and unhappily married (to Emmy Obermayer), sank into further gloom on learning he was about to lose his gallery, for the building was to be torn down. Reading his moody letters, O'Keeffe decided to leave immediately after her last class to be with him for a few days.

Stieglitz received Georgia warmly and asked her to pose for his camera. After a few sessions she returned to teach summer school at Canyon. She was corresponding with Paul Strand, Stieglitz's young protégé, whom she had met in New York, immediately announcing to friends, "I fell for him!" Before the autumn semester began, she and Claudia traveled to Colorado. On the return trip, because they had to make a detour, she saw New Mexico for the first time and declared that she "loved the sky."

The following February, after a bad attack of the flu, she took a leave of absence for health reasons, but gossip had it that the college had expressed dissatisfaction with her antiwar sentiments. After a letter from Georgia indicated that a man apparently had attempted to break into the house where she was staying with a friend, Stieglitz sent Strand to escort her to New York. He had always been fascinated by women who dressed in black, and Georgia, who never wore anything except black with a touch of white at the throat, had attracted him from the beginning. The black may have been inspired by her days in the convent school. It never became a mourning costume for her father, who died in November after falling off a roof. She had grown distant from him and did not attend his funeral.

In New York she stayed in the two-room studio of Stieglitz's niece, Elizabeth Stieglitz. Soon Alfred Stieglitz and Georgia became lovers, and she distanced herself from MacMahon and Strand, who remained friends. After discovering her husband photographing his grave-eyed model in the Stieglitz bedroom, Emmy ordered him out of the house. Later she apologized, but Stieglitz reveled in his new freedom. Their high-strung daughter, Kitty, about to enter Smith College, turned on her father in fury.

That summer Stieglitz took Georgia up to his family's summer estate, Oaklawn, at Lake George, New York, often called the most beautiful lake in the Adirondacks. She recorded her impressions of the place in the strongly stylized *Lake George Coat and Red*. During many summers in the 1920s she would paint the lake in different kinds of weather. The results were increasingly abstract compositions.

After Stieglitz asked her what she wanted to do, she answered, "To paint full time." So on his advice she resigned her position in Canyon and remained in New York. To make things easier for her, he persuaded a patron to lend her one thousand dollars. By autumn Elizabeth Stieglitz married Donald Davidson and offered her studio to Alfred and Georgia. Alfred's brother, Dr. Leopold (Lee) Stieglitz, paid the rent, for Alfred had lost his financial support from the Obermayers after his and Emmy's separation. Georgia arranged for her clothing and artwork to be sent from Texas in a huge barrel, but when it arrived, she threw away most of her pictures.

Now Stieglitz began to photograph her intensively, nude and semi-nude, with a close scrutiny of each part of her body. In less than two years he made more than 200 prints, erotic and sexually playful, contrasting her soft body and strong, almost masculine face. But even he knew he could not entirely penetrate her haunting mystery. The photographs were shown at a 1921 exhibit to critical acclaim. When not posing, Georgia painted flowers, particularly red cannas, and abstractions of light and space such as *Music—Pink and Blue* (1919), interpreted by later critics as depicting a vaginal void.

The building where Alfred and Georgia lived was torn down in 1920; needing new quarters, they moved into Dr. Lee Stieglitz's house. Since his mother-in-law lived there too, he gave Georgia and Alfred rooms on different floors with an upstairs living room and darkroom.

By this time Oaklawn was proving too expensive to maintain, and the Stieglitz family prepared to sell the estate, moving up the hill to The Farmhouse, purchased 30 years before and in need of extensive renovations. Georgia, who showed impressive domestic skills at Lake George, frequently quarreled with Alfred's relatives, but never with his gentle mother, Hedwig, who died in 1922.

In January 1923, Stieglitz gave her another solo show at the Anderson Galleries: 100 oils, watercolors, pastels, and drawings. For the catalogue essay she wrote: ". . . one day seven years ago. . . I decided I was a very stupid fool not to at least paint as I wanted to and say what I wanted to when I painted as that seemed to be the only thing I could do that didn't concern anybody but myself—that was nobody's business but my own. So these paintings and drawings happened. . . . I found I could say things with color and shape that I couldn't say any other way—things I had no

words for." Her flower paintings, which caused most comment, were small, usually not more than a foot wide.

After the exhibit, critics began to consider her an artist in her own right, not just a photographer's model. The public also responded, and she realized $3000 from eager collectors. Stieglitz now wanted her to be known simply as O'Keeffe.

Emmy Stieglitz had finally begun divorce proceedings, and Stieglitz talked marriage. Georgia was not enthusiastic, but finally capitulated; the two were wed by a justice of the peace in the painter John Marin's house at Cliffside Park, New Jersey, on December 11, 1924, with Marin as witness.

At once they disagreed about having children. O'Keeffe wanted them, but Stieglitz did not because he thought motherhood would interfere with her career and because his daughter Kitty, who had married in 1922 after concluding an uneasy peace with him, had suffered a severe postpartum depression in 1923, leading to a permanent loss of her sanity. Besides, his favorite sister, Flora, had died in childbirth in 1890.

That year of 1924 O'Keeffe had completed some mammoth flower paintings, many three and four feet across, declaring, "I'll paint what I see — what the flower is to me, but I'll paint it big and they will be surprised into taking time to see it." At first her husband was suspicious, then turned enthusiastic. One of the first such canvases was *Flower Abstraction*. Until 1932, either working representationally or distilling abstract shapes from them, she would paint all kinds of flowers: more cannas, petunias, poppies, peonies, jack-in-the-pulpits, calla lilies, tulips, pansies, irises, roses, often in series as though she were disclosing one fact about the flower in each canvas. Sometimes she carried out these bee- or butterfly-eye views, beautifully detailed, in brilliant, startling, intense colors that nonetheless expressed subtle variations. But O'Keeffe actually preferred dark blossoms as in *Corn, Dark I* (1924). Scrutinizing her studies, particularly *Black Iris III* (1926), critics saw in the decoratively arranged flower parts overt allusions to male and female sexual organs. O'Keeffe vehemently denied any such symbolism, faulting those critics for writing what they thought they saw, not what she did. Some years later she explained that with her flower abstractions she was trying to convey her experience of the flower or the experience that made the flower significant to her at a particular time.

In 1925 Dr. Lee Stieglitz sold his house, and Alfred and Georgia moved to the Hotel Shelton in Manhattan. O'Keeffe, who wanted "to live

Georgia O'Keeffe, *Black Iris III* (1926), oil on canvas, 36 × 29⅞ in., The Metropolitan Museum of Art, New York, The Alfred Stieglitz Collection, 1949.

up high," chose a two-room apartment on the hotel's twenty-eighth floor. In accordance with both their wishes the interior stayed uncluttered, even bare. That same year Stieglitz had opened his Intimate Gallery, an inner room rented from the Anderson Galleries.

Georgia soon became friends with gallery intimates, the Precisionist painters, Charles Demuth, Arthur Dove, and Charles Sheeler. Like them she used clean color and hard edges, always insisting, however, that she was never a joiner of any movement. Still, barns were a favorite Precisionist

subject, and O'Keeffe painted barns until 1933, some at Lake George, others in central Wisconsin and in Canada.

The view from her high perch at Hotel Shelton inspired O'Keeffe to tackle cityscapes and the new skyscrapers. *The Shelton with Sunspots* (1926), in pastels; *The American Radiator Building* (1927); and *East River from the Shelton* (1928) expressed an urban intensity hitherto foreign to her.

But even as she painted Manhattan, she continued to put flowers on her canvases, big and small.

Two of her most famous, *Oriental Poppies* (30 × 40 inches) and *Red Poppies* (7⅛ × 9 inches), date from 1927. A vacation at York Beach in Maine also resulted in a beautiful shell series. *Closed Clam Shell* and *Open Clam Shell* expressed her fascination with the theme of accessibility and seclusion.

In 1928 a French millionaire bought a painting of six small calla lilies for $15,000, and Stieglitz lost no time in unleashing a barrage of publicity. It so disgusted O'Keeffe that for a time their relations were strained. But shortly after she returned from a vacation in Wisconsin, he suffered a heart attack, and they were reconciled. In Portage, Wisconsin, Georgia had visited her sister Catherine, who like their sister Ida, in New York, had started painting. Georgia praised them both but would offer no advice.

In the winter of 1928–29, a new complication arose in her marriage. Stieglitz began showing intense interest in lovely young Dorothy Norman, a writer, editor, and art collector, whom he had met in his gallery in 1926. O'Keeffe became further depressed by the lukewarm critical approval given her 1929 exhibit. For years Stieglitz's record of exhibiting her paintings and selling them had been remarkably successful. Now reviews complained that she had succumbed to formula.

In her disillusionment she heeded the advice of Mabel Dodge Luhan, the flamboyant, much-married heiress, and Dorothy Brett, the painter daughter of an English lord, to experience Taos, New Mexico. Her traveling companion that summer of 1929 was Paul Strand's wife, Beck (Rebecca). They stayed for a time with Mrs. Luhan at her home, Los Gallos, gathering place of artists and intellectuals, but were soon assigned to a guest house, Casa Rosita, where the writer D. H. Lawrence had once resided. Getting along better with the Pueblo Indian Tony Lujan (he did not anglicize his name) than with his temperamental wife, O'Keeffe took many camping trips and horseback rides with him. She also learned to drive and bought a Model A Ford to roam the desert.

After the Taos sojourn, O'Keeffe and Stieglitz had a joyous reunion, he finding her "radiant." Together they went to Lake George. But soon he felt depressed because his Intimate Gallery had to shut its doors after

the Anderson Galleries closed. By December, however, he opened a new gallery, An American Place.

Another summer at Los Gallos in 1930 was marred by frequent quarrels and feuds among Mabel Luhan and her intimates, and O'Keeffe decided she had had enough of "Mabeltown." But before leaving she painted a series based on the mission church at Rancho de Taos.

Home with Stieglitz, she became bitter again over his growing involvement with Dorothy Norman, now studying photography with him. After the birth of her second child late that year, Dorothy believed she was in love with Alfred. Naively he thought that the affair with her was enriching his marriage.

In spite of his objections, O'Keeffe rented a cottage at the H and M Ranch in Alcalde, New Mexico, for a part of the summer of 1931. She constantly explored the landscape in her car and said she had never had a better time. She felt especially attracted toward "a place called Abiquiu." Since 1929 she had been picking up bleached bones in the desert and sending them east. Back at Lake George that autumn she felt so inspired by New Mexico and her pile of bones that she started a new series, steely and austere. *Cow's Skull with Calico Roses* provided a surprising twist, but *Cow's Skull—Red, White, and Blue* would win the greatest popularity.

The following spring she enraged Stieglitz by independently contracting with the designer of the Music Hall interiors at Rockefeller Center in New York to paint a large mural for the ladies' powder room. Stieglitz tried to interfere, threatening that as her agent he would revoke the contract. But O'Keeffe, still bitter over his involvement with Dorothy Norman, remained committed to the project. That February he had exhibited his photographs of Dorothy. He thought she very much resembled the young Georgia, and he enjoyed her obvious hero worship.

The attraction to New Mexico temporarily dispelled, O'Keeffe stayed at Lake George for part of the summer of 1932. In August she traveled to the Gaspé Peninsula in Canada with Georgia Engelhard, Alfred's niece. The artist thrilled to the northern sea, but later complained that the climate was too cold.

That autumn she worked on her designs for the powder room, where she planned to paint several large flowers on canvas laid down in plaster. But in November when she arrived at the Music Hall, the plaster was still wet. Under constant pressure from Stieglitz, she lost heart and declared she would not continue. As never before, she felt humiliated, and within days of her withdrawal she suffered its psychological effects. Rest at Lake George and a brief stay with her sister Anita in New York did not improve her condition, and by the first of February 1933, she had entered a hospital for treatment of psychoneurosis. Stieglitz, fearing that Georgia would lapse into madness as had his daughter Kitty, lost part of his interest in

Dorothy Norman, who remained nonetheless a supportive assistant at his gallery.

During O'Keeffe's hospital stay, her self-taught sister Catherine held a one-woman show in New York. Angry and jealous, and convinced that Catherine was attempting to cash in on her sister's fame, O'Keeffe wrote her a thoroughly nasty letter. As a consequence, the sisters did not communicate for four years, and Catherine set aside her paints for good.

To recuperate after her hospitalization, O'Keeffe left in March with a friend, Marjorie Content, for a couple of months in Bermuda. She spent the rest of the year at Lake George. There in December she welcomed the black poet Jean Toomer, whom she and Alfred had known since the 1920s. His warm companionship strengthened her and helped her regain her emotional balance. Stieglitz arrived for four days just before Christmas, and after his departure O'Keeffe and Toomer seemed to be heading toward a more intimate relationship. But suddenly he left.

Having been away from her palette for a whole year, she began to paint again. She went to Bermuda for the spring of 1934 and came back with an even greater sense of well-being. While she was away, Toomer met Marjorie Content, and the attraction was immediate. When Marjorie cautiously informed her, Georgia told her, "For both of us it is very good as it is." O'Keeffe accepted her disappointment gracefully; dedicated to friendship, she headed west with Marjorie, now engaged to Toomer, who soon followed them. Again she chose the H and M Ranch. Driving about one day, Georgia discovered the monumental setting of another dude ranch, Ghost Ranch, with huge cliffs and low hills. "Half your work is done," she said. Quickly she moved over there.

She had firmly set her seasonal pattern: summers in New Mexico, winters in New York. Ghost Ranch attracted her for the summers of 1935 and 1936. In 1937, however, no room was available. Then Arthur Pack, the Ghost Ranch owner, offered to rent his house, which he was vacating. Meanwhile in 1936 Georgia and Alfred had left Hotel Shelton and moved into a penthouse studio, which she chose on her own.

Sue Loeb has vividly pictured Georgia O'Keeffe, no longer committed to black, as she appeared in the late 1930s at Lake George:

> . . . I see her in cool mornings or evenings hugging her slenderness in a near-blanket size shawl or a too-large rough cardigan. Even with the strap of an undershirt invading the wide neckline, she brings an unaffected elegance to everything she wears. . . . Her predominant white is often enlivened with a bright sash; her homespun skirt, after her first trips to the Southwest, is sometimes a throbbing Navajo red. . . . Her carriage. . . lends the austerity of her profile the proud look of a ship's figurehead. . . sometimes she is arm-in-arm with Alfred, her sleek head inclined toward his unruly thatch of gray.

With the outbreak of World War II, O'Keeffe was little concerned. Proud of his German ancestry, Stieglitz, on the other hand, grieved that for the second time in his life the United States and Germany were bitter enemies.

In 1940 Georgia bought Rancho de los Burros, where she had lived in 1937, from Arthur Pack. Ghost Ranch lay about 12 miles north of Abiquiu. The single-story adobe house, within its boundaries, was extremely isolated, without telephone or radio. She did some remodeling, adding a studio and more windows so that she could see the mountain Pedernal, the wrinkled, red hills, and the sandstone cliffs, which she painted several times. *Grey Hills* (1942) was one of her favorite works. Many nights she slept on the rooftop. Her New York setting changed too. In 1942 she and Stieglitz left their penthouse for a smaller apartment closer to An American Place.

As 1943 began, the Art Institute of Chicago displayed 61 of her pictures — early charcoal drawings, flowers, fruit, landscapes, bones — in a special exhibit, a deep satisfaction for the institute's former student.

Her discovery of pelvic bones in the desert provided O'Keeffe with inspiration for a new series that same year. Sometimes their contours framed her pictures. "The bone," she wrote, "seems to cut sharply to the center of something that is keenly alone in the desert even though it is vast, empty, and untouchable." In Stieglitz's 1944 exhibit she commented on her *Pelvis with Blue (Pelvis I)*: "I was most interested in the holes in the bones — what I saw through them. . . . They were most wonderful against the Blue — the Blue that will always be here as it is now after all man's devastation is finished."

Pelvic Series-Red with Yellow (1945), however, was entirely abstract. When critics accused her of having a "bone formula," she complained that they had not noticed her new subject, red hills, as in *Red Hills with Bones* and many other canvases combining the bones with the desert landscape. "A red hill doesn't touch everyone's heart," she wrote, "as it touches mine."

Nobody could label her vision of the West. Though it fell within the representational tradition, it remained Modernist. Still, it was not Cubist, Expressionist, or Surrealist. It was uniquely her way of expressing the timelessness, the agelessness of the terrain.

Within a few years of buying Rancho de los Burros, O'Keeffe wanted more property for water rights and garden. This time her choice fell on an old abandoned hacienda on a mesa above the village of Abiquiu. After she bought it and remodeled it, visitors insisted it looked like a huge fortress. Frequently she painted the white flowers in the garden; but the patio and its door also fascinated her and inspired a whole series, which would later culminate in the purified *Patio with Clouds* (1956).

Now she had two houses in New Mexico. Until 1946 she followed a pattern each summer of setting out for Taos in her car with tubes of paint and rolls of canvas, and then returning in the autumn with the back seat removed to make room for a batch of paintings for a new Stieglitz show.

This seasonal pattern shattered when Alfred Stieglitz died of a brain hemorrhage in July 1946. It was the year she was given a major retrospective at the Museum of Modern Art in New York. As executor of Stieglitz's estate, O'Keeffe faced the task of giving away 850 modern works of art, hundreds of photographs, and 50,000 letters. The bulk went to the Metropolitan Museum of Art.

O'Keeffe was elected to the National Institute of Arts and Letters in 1949, but felt that the Manhattan art world was too absorbed with abstract expressionism to remember her. Nonetheless she showed 31 paintings at An American Place's last show in 1950. In 1949 she had given up New York for good and moved permanently to New Mexico.

In the following years O'Keeffe discovered the delights of international travel. She joined friends on a trip to Mexico in 1950, and in Mexico City met Diego Rivera, the famous muralist, and his wife, Frida Kahlo, also a painter. Of the two, O'Keeffe preferred Kahlo. A trip to Europe highlighted the year of 1953. Madrid became her favorite European city, and she returned there the next year. With Betty Pilkington, a young Abiquiu woman who served as secretary and companion for some years, she flew to Peru in 1956 and called it the most beautiful country she had ever seen. Then at 72 the indomitable O'Keeffe made a trip around the world, stopping for seven weeks in India. Another long trip in 1963 would acquaint her with Japan, Formosa, Hong Kong, Saigon, Bangkok, and several South Pacific islands.

Flying in airplanes focused her attention on rivers, and in 1961 she took a raft trip on a stretch with a minimum of white water; over the next few years she repeated the adventure. Air travel also inspired her largest canvas, a 24 × 8 *Sky Above Clouds, IV* (1963). Over a period of months the septuagenarian artist stood in her garage and, with an assistant, painted from morning till night. The next four years she concentrated on similar, not so large canvases of clouds diminishing in size as they near the horizon.

Just as her Abiquiu home, guarded by Chow dogs, looked remote, so O'Keeffe, ramrod straight and prickly, remained aloof from the town, even more after 1971 when her eyesight began to deteriorate. Long before then she had admitted, "I don't get acquainted easily."

Fiercely she guarded her privacy and solitude until one morning in 1973 when Juan Hamilton, a good-looking potter in his late twenties, knocked at her door, asking for work. O'Keeffe told him to teach her how

to make hand-rolled pottery. As her interest grew, she had a kiln built. Too soon, however, she became frustrated and returned to painting. But the friendship with Juan mellowed the old woman. He moved into her house and assumed more and more responsibility. Rumor even had the couple married, but their denials were firm. Hamilton put things in perspective when he declared that he really wanted a 23-year-old Georgia.

Within a year he bought a house, presumably with a loan from O'Keeffe, who later forgave all his debts. After becoming her secretary, business manager, and assistant, he helped her prepare her huge book, *Georgia O'Keeffe*, revealing how her paintings had happened. But he also fell back on the friendship to gain gallery space for his pots. Doris Bry, O'Keeffe's agent, became infuriated when Hamilton and O'Keeffe sold two paintings without any notification to her. Responding to Bry's complaint, O'Keeffe demanded the return of all her works, then sued Bry in federal court. Bry in turn filed a counterclaim for breach of contract and sued Hamilton in the New York State Supreme Court for "malicious interference" and for influencing O'Keeffe to turn away from her agent. The judge dismissed most of Bry's claims, and she bitterly settled both lawsuits.

O'Keeffe chose photographs of herself for a Stieglitz retrospective in 1979. Without nostalgia, the 92-year-old woman coolly viewed the 31-year-old model.

Juan Hamilton married a young woman in 1980, but he remained constantly at O'Keeffe's side. After she suffered a coronary attack in 1984, he ordered a move to Santa Fe so that she could be closer to a large hospital. He, his wife, Anne Marie, and their two young sons, Brandon and Albert, settled in a large house, giving O'Keeffe a downstairs room with separate entrance.

On March 6, 1986, one year short of her one hundredth birthday, Georgia O'Keeffe died in a Santa Fe hospital. Typically, she had requested no memorial service, asking only that her ashes be scattered over Ghost Ranch.

A bitter aftermath ensued. Juan Hamilton had encouraged her to sign a codicil that changed the terms of all her previous wills and an earlier codicil. In this second codicil she had left almost everything to him. O'Keeffe's sister Catherine Klenert, her daughter and grandson, and Alexis O'Keeffe's daughter June O'Keeffe Sebring all challenged this codicil and the earlier one, saying they wanted to see most of the paintings sent to museums. As their lawyers tried to prove that Hamilton had intimidated the old woman, he and his lawyers announced an out-of-court settlement. He gained Rancho de los Burros, 24 paintings, and certain copyrights. The claims of the Klenert family and of June Sebring resulted in a million dollars in cash and paintings for each of the two parties. Forty-two

paintings were allotted to museums. Distribution was put in the hands of a board run by June Sebring, Catherine Klenert, and Juan Hamilton. The enemies had reconciled to "perpetuate the legacy of Georgia O'Keeffe for the public benefit."

Georgia O'Keeffe : Works Mentioned

Canyon with Crows (1916), Estate of the artist
Blue No. 1, Blue No. 2, Blue No. 3, Blue No. 4 (1916), Brooklyn Museum
Lake George Coat and Red (1918), Private Collection
Music, Pink and Blue (1919), Private Collection
Flower Abstraction (1924), Whitney Museum of American Art, New York
Corn, Dark I (1924), Metropolitan Museum of Art, New York
Black Iris III (1926), Metropolitan Museum of Art, New York
Lake George Barns (1926), Walker Art Center, Minneapolis
The Shelton with Sunspots (1926), Art Institute of Chicago (reported lost in 1990)
The American Radiator Building (1927), Alfred Stieglitz Collection, Fiske University, Nashville, Tennessee
Oriental Poppies (1927), University Art Museum, University of Minnesota, Minneapolis
Red Poppy (1927), Private Collection
Closed Clam Shell (1927), Private Collection
Open Clam Shell (1927), Private Collection
East River from the Shelton, New York (1928), Estate of the artist
Ranchos Church, Taos, New Mexico (1930), Amon Carter Museum of Western Art, Ft. Worth, Texas
Cow's Skull with Calico Roses (1931), Art Institute of Chicago
Cow's Skull—Red, White, and Blue (1931), Metropolitan Museum of Art, New York
Red Hill and Bones (1941), Philadelphia Museum of Art
Grey Hills (1942), Indianapolis Museum of Art
Pelvis with Blue (Pelvis I) (1944), Milwaukee Art Museum
Pelvis Series—Red with Yellow (1945), Private Collection
Patio with Clouds (1956), Walker Art Center, Minneapolis
Sky Above Clouds IV (1963), Private Collection

XV

Frida Kahlo

(1907–1954)

"A ribbon wrapped about a bomb" was the apt description the French surrealist poet André Breton gave to Frida Kahlo's art. For it and her turbulent life, physical and psychological pain provided the wellsprings.

She was born Magdalena Carmen Frieda Kahlo y Calderón on July 6, 1907, in a blue stucco house in Coyoacán on the southwestern periphery of Mexico City. She would die in the same house, which is now a museum. As she later changed the spelling of her name to Frida, so she changed the date of her birth to 1910 to coincide with the outbreak of the bloody Mexican Revolution, which lasted until 1920. Mexico City was a frequent battleground.

Guillermo (Wilhelm) Kahlo, hailed as "official photographer of the cultural patrimony" for his outstanding pictures of the nation's architectural heritage, was a German immigrant, of Hungarian-Jewish ancestry, who had arrived in Mexico at the age of 19. His second wife, Matilde Calderón y Gonzalès, self-effacing and religious, gave him four daughters. Frida was the third, following Matilde and Adriana and followed by Cristina. Guillermo's two daughters by his first marriage had been placed in a convent school.

Of his six daughters, Guillermo was most attached to Frida. He taught her to use a camera and as an amateur painter shared with her his enthusiasm for art and architecture. Often, however, he was subject to epileptic seizures, the chronic result of an accident in his youth.

When Frida painted *My Grandparents, My Parents, and I (Family Group)* in 1936, she used her grandparents' and parents' wedding pictures. She said that her Indian grandfather and his wife, who was of Spanish extraction, were symbolized by the earth, the European grandparents by the sea. Both couples are enveloped in clouds. A pink fetus is on Matilde Kahlo's skirt. The paternal grandmother has the heavy joined eyebrows

Frida Kahlo, *My Grandparents, My Parents, and I (Family Tree)* (1936), oil and tempera on metal panel, 12⅛ × 13⅝ in., Collection, The Museum of Modern Art, New York, gift of Allan Roos, M.D., and B. Mathieu Roos.

which Frida inherited and made into a distinguishing feature of her many self-portraits.

At six Frida contracted polio and was confined for nine months in her room, finally emerging with a slightly withered right leg. She overcompensated for the isolation she had felt by becoming a tomboy and prankster.

In 1922 she entered the Preparatoria, the National Preparatory School in Mexico City, with many classes at college level. Effervescent and flashy, with thick black hair, almond-shaped eyes, full lips, and dimpled chin, she was the most stunning member of the Cachuchas, a student group named for their caps and locally famous for their brains and penchant for mischief as well as their romantic socialism. With a fellow member, Alejandro Gómez Arias, Frida fell deeply in love.

José Vasconcelos, the minister of education, had commissioned several artists to paint murals in the Preparatoria. Among them Diego

Rivera, newly returned from several years of living in Europe, worked in the school auditorium. With fascination Frida watched the ugly, fat, sloppily dressed artist paint his favorite subjects—peasants, laborers, and Indians—while he continuously talked to his onlookers. He had recently joined the Communist Party.

During vacations and after school she held various jobs and studied shorthand and typing. When she applied for work at the Ministry of Education, a young woman employee seduced her. But Frida did not dwell on the incident, turning her attention instead to a paid apprenticeship with Fernando Fernández, one of her father's friends, at his engraving studio. He taught her to draw by asking her to copy prints by the Swedish artist Anders Zorn. She also had drawing lessons and learned clay modeling at the Preparatoria. Fernández thought she had tremendous talent.

Tragedy struck in September 1925. A trolley car rammed the bus in which Frida was riding with Alejandro, and her injuries were appalling—broken collarbone, pelvis, spinal column, and several ribs; fractured right leg; and dislocated and crushed right foot. For a month she lay encased in a plaster cast, then left the hospital. Alejandro, who had suffered less serious injuries, seldom came to see her; he was jealous of Fernández. Since she had to miss the final examinations in the fall, she did not register at the Preparatoria for 1926.

After the accident she knew what she wanted to do, and using her father's oil paints she chose her friends and her sister Adriana as her first subjects. She also pored over her father's art books and became most interested in Sandro Botticelli and the Pre-Raphaelites. When she did see Alejandro, they quarreled because he accused her of being "loose." Her first self-portrait was a gift to him the next year, and soon they reconciled. But then he sailed for Europe. After his homecoming he fell in love with one of Frida's friends.

In 1928 she entered the circle surrounding Julio Antonio Mella, the exiled Cuban Communist revolutionary. His mistress, the photographer Tina Modotti, introduced Frida to Diego Rivera at a party. In the six years since she had first seen him at the Preparatoria, he had become famous for murals depicting the socialist idealism of the Mexican Revolution and proclaiming the concept of *Mexicanidad*. Frida's own version of meeting him was that she had gone to the place where he was working and called to him to step down and look at the paintings she had brought with her.

Rivera, popularly called the "Frog Prince," fascinated even the most beautiful women, who succumbed to his charm and softness if not to his baggy clothes. In Paris he had left behind a Russian common-law wife. His second wife, Lupe Marín, mother of his two daughters, put up with constant philandering.

At once he showed a deep interest in Frida's work, but did not offer to teach her, saying he did not care to spoil her innate talent. Still, her early pictures echoed his style, bright amplified areas of sparkling color. Before long their physical attraction to each other had increased to the point that Rivera sued Lupe Marín for divorce and proposed to Frida, who had joined the Communist Party. On hearing the news of the engagement, Señora Kahlo could not believe that her lovely daughter would marry an ugly atheist 20 years her senior. Initially, Guillermo Kahlo likewise showed little enthusiasm for the union, but gradually his perception that Diego Rivera was not only famous but also rich and generous changed his mind.

A civil ceremony by Coyoacán's mayor united the couple in August 1929. From her Indian maid Frida borrowed skirts, blouse, and *rebozo*. Lupe Marín attended the wedding and according to Rivera's biographer, lifted up the bride's skirts, crying out, "You see those sticks? These are the legs Diego now has instead of mine."

Frida spent her first months as a married woman living with Diego and four of his Communist friends in a large house on the elegant Paseo de la Reforma. For Diego it was a politically upsetting period. As general secretary of the Mexican Communist Party, he fell under constant attack for accepting mural commissions from a reactionary government. Besides, he had numerous disagreements with party officials. Two months after marrying Frida, he was expelled from his post and the party, but did not relinquish his allegiance to Communism.

Controversy or not, he always worked hard on his murals. After finishing those at the Ministry of Education, he painted some for the Ministry of Health and then the walls of the main staircase of the National Palace. Next, to the horror of his Communist friends, he accepted a commission from Dwight Morrow, Wall Street financier and American ambassador to Mexico, to paint murals for the Cortes Palace in Cuernavaca. Rivera, however, chose an anti-imperialist theme, contrasting the brutalities of conquest and the scenic glories of Mexico. When the Morrows went to London, they invited him and Frida to stay at their weekend house in Cuernavaca for the greater part of the year.

Frida took up domesticity with relish, even getting advice from Lupe Marín on what to cook for Diego. Of Spanish-Indian and Jewish-Portuguese ancestry, he liked to emphasize his young wife's Indian blood. She pleased him and herself by usually appearing in Tehuana costume (from the Isthmus of Tehuantepec), consisting of an embroidered blouse, a long skirt ruffled at the bottom, and golden chains and bracelets. Usually Frida wore the jewelry in excess. In addition to flattering Diego the flamboyant costume disguised her fragile physique.

By 1930 Rivera received commissions to paint some murals in the

San Francisco Stock Exchange Luncheon Club and the California School of Fine Arts. Because of his Communist background, he had some trouble getting a visa, but finally an American art patron secured the necessary permission. In San Francisco, Frida became friends with Leo Eloesser, a well-known thoracic and bone surgeon, whom she was to trust more than any other doctor. Giving the first indication of fantasy in her paintings, she portrayed the famous horticulturist Luther Burbank, depicting him as a hybrid, half man, half tree. In San Francisco, too, she created a double portrait, *Frida and Diego Rivera*, considering it a long-delayed wedding picture. He looks enormous; she seems to float delicately beside him. As she would so many times, she placed an informative inscription on a ribbon, a customary practice in Mexican colonial painting.

That summer President Ortiz Rubio called on Diego to finish the National Palace staircase murals, and the Riveras flew back to Mexico City, staying in the Kahlos' blue house in Coyoacán. With his American earnings, Diego also started to build a new home in the San Angel section, actually two houses linked by a bridge. Then, abruptly, he left his work unfinished at the National Palace and took Frida to New York for his retrospective at the new Museum of Modern Art. The show, to which Diego brought a group of just completed panels clearly displaying a Marxist view of Mexico, proved a big success. Always appearing in her Indian costume, Frida participated happily in parties and receptions and made a special friend in Lucienne Bloch, daughter of the Swiss composer Ernst Bloch.

While in San Francisco, Rivera had accepted an invitation to come to Detroit to create a large mural celebrating industry, particularly the automotive industry. After beginning with sketches for two large panels in the glass-roofed Garden Court of the Detroit Institute of Arts, he felt that two walls were not enough and asked for permission to decorate 27 panels around the whole court. While he worked, Frida suffered a miscarriage and, on recovering, painted her tiny *Henry Ford Hospital*, the first of several bloody and terrifying self-portraits which react to her unsuccessful attempts to become a mother. Here she lies hemorrhaging in bed, surrounded by a fetus and several symbols of maternal failure.

Henry Ford Hospital was also her first picture on sheet metal in the Mexican *retablo* or votive painting style, which Diego had suggested she try. A second small painting on sheet metal, *Self-Portrait on the Borderline between Mexico and the United States*, joins sun and moon and lets the American flag hover in industrial smoke while Mexico appears in an agrarian vision.

Soon after, Frida received news that her mother was dying of cancer. With Lucienne Bloch, who had come to Detroit and moved in with the Riveras, she hurried to Mexico, arriving one week before Matilde Kahlo

died. Within a few weeks Frida and her friend returned to Detroit, where in mournful mood she finished *My Birth,* a picture that also referred to the death of her child.

Diego Rivera's Detroit frescos were unveiled in March 1932, to a storm of conservative disapproval over their Communist overtones. A week later the Riveras left for New York, where young Nelson Rockefeller had signed a contract with Diego to work on a mural for the RCA building in Rockefeller Center. A newspaper headline blazoned: "Rivera Paints Scenes of Communist Activity, and John D. Jr. Foots the Bill." The fresco mixed Wall Street stockbrokers with unemployed workers and protesters killed by police; by contrast it also showed a Marxist utopia. Fanned by press criticism, the atmosphere around the RCA building grew hostile. Finally when Diego started to change the sketch of a labor leader into a portrait of Lenin, Nelson Rockefeller protested. Diego replied that he would balance Lenin's head with that of Abraham Lincoln. Immediately Rockefeller ordered him to stop working, then handed him a check and a letter of dismissal. The mural was covered with tar paper and a wooden screen, then months later was chipped off and thrown away. (Rivera had his revenge in 1934 by repainting it in the Palace of Fine Arts in Mexico City.)

So low had Rivera's reputation fallen in the United States that his commission to paint a mural at Chicago's Century of Progress (world's fair) was canceled. But work remained in Gringoland, as Frida called the United States. He went on to paint 21 panels depicting American history for the New Workers' School.

The canceled commissions and attendant attention, as well as Diego's infatuation with the young sculptress Louise Nevelson, strained the relationship between him and Frida. The more she yearned to go home, the more he wanted to stay. *My Dress Hangs There* showed the strength of her longing. Her Tehuana costume is suspended in the middle of a composite image of Manhattan, which all at the same time mocks American obsession with efficient plumbing and competitive sports, eclecticism, and human waste. Mockingly, too, she includes the Statue of Liberty and Mae West on a billboard.

Finally back in Mexico City at the end of 1935, the Riveras moved into the new home Diego had begun in 1931 in the San Angel district — two unadorned cubes, the blue for her, the pink for him. A cactus wall surrounded it.

The new year proved highly unproductive for Frida, mostly because of Diego's affair with her sister Cristina, a mother of two, whose husband had deserted her. Insensitively, Diego posed his wife, sister-in-law, and the two children in his Modern Mexico mural for the National Palace staircase. To add to Frida's despair, she entered the hospital three times in

three months for an appendectomy, an abortion on doctors' advice, and foot problems.

Her sheet metal painting *A Few Small Nips* expressed her anger over Diego's involvement with Cristina. She based it on a newspaper story of a man who had stabbed his girl friend 30 times, afterwards protesting his arrest in the words of the title, which was inscribed on a ribbon ironically bordered with doves. Though Frida moved out of the San Angel home, taking a pet monkey with her, she saw Diego constantly. His affair with Cristina did not last long, and characteristically Frida forgave them both. After she returned from a flying trip to New York, she and Diego reconciled.

Now again politics came to play a salient role in their lives. In 1936 Diego joined the Mexican section of Leon Trotsky's dissident party, the Fourth International. Trotsky, a leader of the Bolshevik Revolution and the second most important man under Lenin, had been expelled from the Soviet Union in 1927 for championing revolutionary internationalism. In exile he had founded his party. When Trotsky came from Norway to Mexico in January 1937, the Riveras invited him and his wife to stay in the Coyoacán house. At once he asked for an international commission to examine evidence used against him in his Moscow trials. One was arranged with the American philosopher and educator John Dewey in charge. Attired in her colorful Indian costumes and elaborate gold jewelry, Frida sat as close as possible to Trotsky during the week-long trial, which ended with the commission's finding him innocent.

After that resolution, the Trotskys and Riveras saw much of each other. Though the revolutionary hero was 60 and white-haired, Frida felt attracted to his intellectual brilliance and by Diego's obvious admiration of him. She began her seduction by speaking to him in English, which his wife did not understand. Still, Natalia Trotsky knew that something was going on and became jealous and depressed. Diego never became aware of the liaison, which like the Diego-Cristina affair proved to be short-lived. After it ended, Frida presented Trotsky with a sultry *Self-Portrait*, framed in pink and green velvet.

Trotsky behind her, she turned increasingly to painting, and in one year realized a remarkable output. She always considered the small *retablo*-style *My Nurse and I* one of her best paintings. She presented herself with an infant's body, a small child's head suckling a dark Indian nurse. At the same time Frida declared her pride in Mexican culture and affirmed her part-Indian heritage.

The Deceased Dimas emphasized her preoccupation with death. Her still lifes of exotic fruits and flowers further projected her fascination with death as well as fecundity. *What the Water Gave Me*, a bathtub fantasy, is filled with small images recalling Hieronymus Bosch and Pieter Brueghel,

but they are not surreal; they are based on her life. "I never painted dreams," she said, "I painted reality." Amid the images of memory, sexuality, pain, and death floating in the water, the big toe of her deformed foot is cracked open. Again blood spills; there is a parade of insects. The painting also provided proof of her lesbianism; she was now bisexual. The lesbian theme would appear again the next year in *Two Nudes in a Forest*.

Though Diego tolerated Frida's affairs with women, he would not accept her male lovers, whom she preferred, and she had to carry on in secret, sometimes at Cristina's house. The most exciting of her lovers was the handsome young sculptor Isamu Noguchi.

The summer of 1938 brought her first sale. The American film actor Edward G. Robinson visited her and chose four paintings. Another visitor was André Breton, painter as well as poet. His beautiful wife, Jacqueline, became Frida's understanding friend.

For a New York exhibit offered by the gallery owner Julian Levy the same year, she provided folkloric frames for her pictures and at the opening appeared in her extravagant Mexican costume. *Time* magazine commented: "Little Frida's pictures, mostly painted in oil on copper, had the daintiness of miniatures, the vivid reds and yellows of Mexican tradition, and the playfully bloody fancy of an unsentimental child." Half her pictures sold. Admired for her sardonic wit and swept up in a social whirl, Frida flirted with Levy, even with Edgar Kaufmann, Sr., when Levy took her to Fallingwater, the landmark home Frank Lloyd Wright had designed for Kaufmann. Frida reserved her love, however, for Nikolas Muray, a Hungarian-born portrait photographer, whom she had met in Mexico and who helped her set up the New York show. But even he could not alter her deep attachment to Diego.

After the Levy exhibit, an enthusiastic Breton promised to arrange an exhibit in Paris. But when Frida arrived at the French gallery, she discovered that he had surrounded her paintings with pre-Columbian sculptures, photographs, and all that "junk" he had found in Mexico. Consequently she had many disagreements with Breton until Marcel Duchamps stepped in. The show attracted Pablo Picasso, who presented her with a pair of earrings, and Vassily Kandinsky, who had tears in his eyes when he saw her work. "I never knew I was a surrealist," Frida wrote later, "until André Breton told me I was. The only thing I know is that I paint because I need to and I paint always what passes through my head without any consideration." She did not mention that actually she was very well informed about the art of the past and the present.

In midsummer 1939 the Riveras separated. The press reported them as saying that divorce was the only way "to preserve their friendship."

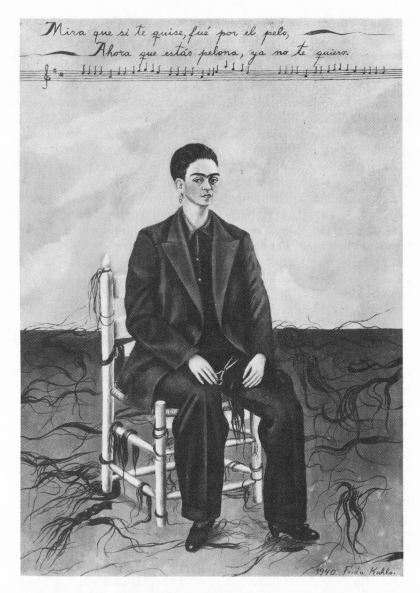

Frida Kahlo, *Self-Portrait with Cropped Hair* (1940), oil on canvas, 15¾ × 11 in., Collection, The Museum of Modern Art, New York, gift of Edgar Kaufmann, Jr.

Frida, however, remained enigmatic about the reasons. Friends knew that she had not voiced objections to her husband's infidelity. He wanted freedom to carry on with the women who attracted him. But she took as a private humiliation his habit of choosing those who were much his

inferior except in looks. To hide the pain of Diego's rejection she had embarked on sometimes wild flirtations. Believing that a diamond-studded smile increased her allure, she wore gold caps with small stones on her teeth.

When the divorce papers came through, Frida had just finished what came to be one of her best-known paintings, *The Two Fridas*. One Diego had loved, the other he no longer loved. Both have exposed hearts. The unloved Frida, who holds a picture of him as a child, also has a ruptured artery and uses a surgeon's forceps to try to stop the trickle of blood.

Self-portraits now multiplied because they best expressed her emotions. In a 1940 *Self-Portrait* with her favorite spider monkey, a black cat, and a hummingbird, she wears a necklace of thorns. The *Self-Portrait with Cropped Hair* (she had cut it during the Diego-Cristina affair), also from 1940, shows her wearing a man's suit and shoes, with earrings as the only feminine touch.

After Trotsky escaped assassination during the spring of 1940, Diego Rivera came under suspicion because of his publicized falling-out with the Russian revolutionary. Again he had difficulty obtaining a passport. Finally friends in government procured one for him so that he could paint a mural for the library of San Francisco Junior College. Working in public on Treasure Island, he chose as his theme Pan-American unity.

That summer one Ramón Mercader used an ice ax to kill Trotsky. Since Frida had met Mercader in Paris and had invited him to dinner in her Coyoacán home when he came to Mexico City, the police questioned her for 12 hours, then released her.

Again her health deteriorated, and she took off for San Francisco to see Dr. Eloesser. There Diego asked her to remarry him. After the second ceremony she lived in Coyoacán while he kept the San Angel houses as a studio, reserving a bedroom for assignations with American women tourists, especially susceptible to his Buddha-like appearance and never-diminishing charm.

More than ever, Frida became engrossed in her pets—a little parrot, an eagle, hairless Azel dogs. Together with animals and birds, she loved children and flowers, and, fated to be childless, she became a doting aunt to Cristina's children and used them as models.

Once more there were building schemes. In 1942, seeking to express their Mexican culture, she and Diego began constructing a gloomy temple-museum, Anahuacalli (now an anthropological museum), on 45 acres of parched land in the Pedregal section of Coyoacán. Meanwhile she painted steadily, but her portraits of others were not as original as her self-portraits. Still her exposure was ever widening. She always maintained she was first recognized in the United States; during the 1940s she participated in exhibitions in New York, Philadelphia, and San Francisco.

With Diego, Frida began teaching at the Ministry of Public Education's School of Painting and Sculpture (La Esmerelda) in 1943. She remained a teacher without a program, seldom interfered with her pupils, gave them the benefit of her penetrating remarks, but was never caustic. As her health began to deteriorate once again, her pupils, soon known as the Fridos, came to her house in Coyoacán. Commuting proved inconvenient for many, and their number dwindled to four. Undaunted, Frida had them painting murals of country scenes for a local *pulqueria* or bar. To celebrate the artwork's completion, a fiesta was held with dignitaries in attendance.

Beginning in 1944, Frida was put into what seemed like an endless succession of orthopedic corsets, 28 in all. In *The Broken Column*, nails in her naked body express her pain, a corset holds her split sides together, and her spinal cord becomes a classical column. That year a Mexican doctor also diagnosed syphilis and prescribed a blood transfusion, bismuth, and sunbaths.

The self-portraits, which unduly emphasized a faint mustache and her heavy joined eyebrows, continued to be a form of silent crying. She would make a total of 22. She produced her most stoic image, *Self Portrait with Small Monkey*, in 1945. Ribbons symbolize the connection between herself, a monkey, a dog, and a pre–Columbian statue.

In all her operations, many of which Dr. Eloesser believed were unnecessary, she had refused to be anesthetized unless Cristina was holding her hand. So in 1946 she took her sister to New York, where she had a spinal fusion. This event she commemorated in *Tree of Hope*, where in Tehuana costume she sits beside her lacerated body, and in *The Little Deer*, where a wounded animal bears her face.

Frida's friends said that she often consented to unnecessary surgery in the hope of keeping Diego more or less at her side. The frequent hospital visits, however, in no way diminished his infidelity which, when she was up and about, she countered with casual and not so casual affairs of her own. Because of her frailty, she turned often to women, sometimes to those with whom Diego had already had an affair. Owing to his jealousy, however, she had to keep her heterosexual affairs private.

For all the Riveras' sexual independence, their bond remained strong. Through their quarrels and reconciliations, Diego never faltered in his admiration of her art. "We are all clods next to Frida," he said. "Frida is the best painter of her epoch."

Kahlo's most passionate affair was with a Spanish refugee painter, who has remained anonymous. It lasted until 1952. When she heard of Diego's affair with the beautiful film star Maria Félix, Frida succeeded in making her an intimate. "Why do I call him my Diego?" she mourned. "He never was nor ever will be mine. He belongs to himself."

She was welcomed back into the official Communist fold in 1948, but Diego had to wait six years for his reinstatement in the party. Tremendously interested in the careers of her old pupils, the Fridos, she encouraged them to read Marxist literature and to follow Diego's socially conscious realism.

Ultimately the spinal fusion proved disastrous. In 1950 she was hospitalized for a year. Her room, however, always had a kind of party atmosphere. She included her attending physician Farill in a self-portrait, where she is seen painting him on a kind of *retablo*. Home from the hospital, she propelled herself about in a wheelchair, walked short distances with cane or crutches, and even went on some outings. As she grew physically worse, however, her art changed. The colors became grating, her precise brushwork grew loose, even messy. With friends around her, Frida sought relief in drugs and drink.

As she lay wasting away, the Galería Arte Contemporáneo in Mexico City gave Frida Kahlo her first one-woman show in Mexico. So ill at the time that she could not stand, she had her bed moved to the gallery so that she could attend the opening. In Tehuana costume, loaded wtih jewelry, she arrived by stretcher and then was placed in her bed, which had a mirror canopy and was festooned with pictures and dolls.

That August, doctors diagnosed gangrene and told her they would have to amputate her right leg. After the surgery, she was fitted with an artificial leg and learned to walk with it. Nonetheless, the deterioration relentlessly continued. She drank more than ever, took more drugs, sometimes became hysterical over Diego and her pain. She had painted almost nothing for a whole year when in the spring of 1954 she forced herself out of bed and was wheeled into her studio. In those last months she painted many still life *retablos* to show her political faith, even one titled *Frida and Stalin*.

On July 2, 1954, Frida, who was convalescing from pneumonia, disobeyed her doctor's orders and participated in a Communist demonstration as Diego pushed her wheelchair through the streets. She suffered a relapse after she got out of bed one night to take a bath. In spite of her condition, on July 5, she painted her last picture, a still life with watermelon slices, bearing the red-lettered inscription *Viva la Vida*. She made her birthday, July 6, the usual festive celebration. Seven days later she died, of a pulmonary embolism according to the official account. Some of her friends believed she had taken a drug overdose.

Diego had sat at her bedside the night before she died, but he was at his San Angel studio when her heart stopped in the early morning hours. He arranged a funeral that extolled her as a Communist heroine; then she was cremated.

For the praise heaped on Communism during the ceremony, Rivera

was readmitted to the party. In 1955 the widower, who had only two more years to live, took his agent, Emma Hurtado, as his fourth wife. He also gave the Coyoacán house to the Mexican people as a memorial museum and tomb for Frida. Her ashes rest in a pre-Columbian urn in her bedroom.

Frida Kahlo : Works Mentioned

Luther Burbank (1931), La Noria Museum, Mexico City
Frida and Diego Rivera (1931), San Francisco Museum of Modern Art
Henry Ford Hospital (1932), La Noria Museum, Mexico City
Self-Portrait on the Borderline between Mexico and the United States (1932), Private Collection
My Birth (1932), Private Collection
My Dress Hangs There (1933), Private Collection
A Few Small Nips (1935), La Noria Museum, Mexico City
My Grandparents, My Parents, and I (Family Group) (1936), Museum of Modern Art, New York
Self-Portrait (gift to Trotsky) (1937), Private Collection
My Nurse and I (1937), La Noria Museum, Mexico City
The Deceased Dimas (1937), La Noria Museum, Mexico City
What the Water Gave Me (1938), Private Collection
Two Nudes in a Forest (1939), Private Collection
The Two Fridas (1939), Museo de Arte Moderne, Mexico City
Self-Portrait (1940), Harry Ransome Humanities Research Center, University of Texas, Austin
Self-Portrait with Cropped Hair (1940), Museum of Modern Art, New York
The Broken Column (1944), La Noria Museum, Mexico City
Self-Portrait with Small Monkey (1945), La Noria Museum, Mexico City
Tree of Hope (1946), Private Collection
The Little Deer (1946), Private Collection
Self-Portrait with the Portrait of Dr. Farill (1951), Private Collection
Viva la Vida (1954), Frida Kahlo Museum, Coyoacán, Mexico City

Select Bibliography

Note: Variations occur in the spelling of Angelica Kauffmann (she signed most of her paintings Kauffman), Elizabeth Vigée-Le Brun, Vassily Kandinsky, and Käthe Kollwitz.

General

Bachmann, Donna G., and Sherry Piland. *Women Artists: An Historical, Contemporary and Feminist Bibliography.* Metuchen, N.J., and London: Scarecrow, 1978.

Broude, Norma, and Mary D. Garrard. *Feminism and Art History: Questioning the Litany.* New York: Harper & Row, 1982.

Bryan, Michael. *Dictionary of Painters and Engravers.* 5 vols., George Williams, ed. New York: Macmillan, 1903.

Chadwick, Whitney. *Women, Art, and Society.* New York: Thames and Hudson, 1990.

Clement, Clara Erskine. *Women in the Fine Arts: From the Seventh Century B.C. to the Twentieth Century A.D.* Boston: Houghton Mifflin, 1904; reissued New York: Hacker Art Books, 1974.

Fine, Elsa Honig. *Women and Art: A History of Women Painters and Sculptors from the Renaissance to the 20th Century.* Montclair, N.J.: Allanheld and Schram, 1978.

Greer, Germaine. *The Obstacle Race: The Fortunes of Women Painters and Their Work.* London: Secker & Warburg, 1979; New York: Farrar, Straus and Giroux, 1979.

Harris, Ann Sutherland, and Linda Nochlin. *Women Artists, 1550–1950.* New York: Knopf, 1976.

Hill, Vicki Lynn, ed. *Female Artists Past and Present.* Rev. ed. Berkeley, Cal.: Women's History Research Center, 1974.

Hiller, Nancy G. *Women Artists: An Illustrated History.* New York: Abbeville, 1987.

Lyle, Cindy, et al. *Women Artists of the World.* New York: Midmarch Associates, 1984.

Munsterberg, Hugo. *A History of Women Artists.* New York: Potter, 1975.

The National Museum of Women in the Arts. New York: Abrams, 1987.

Nochlin, Linda. *Women, Art, and Power and Other Essays.* New York: Harper & Row, 1988.

Parker, Rozsika, and Griselda Pollock. *Old Mistresses: Women, Art, and Ideology.* New York: Pantheon, 1981.

Peterson, Karen, and J. J. Wilson. *Women Artists: Recognition and Reappraisal from the Early Middle Ages to the Twentieth Century.* New York: New York University Press, 1976.

Slatkin, Wendy. *Women Artists in History: From Antiquity to the Twentieth Century.* Englewood Cliffs, N.J.: Prentice Hall, 1985.

Tufts, Eleanor. *Our Hidden Heritage: Five Centuries of Women Artists.* New York: Paddington, 1974.

Artemisia Gentileschi

Bissell, R. Ward. *Orazio Gentileschi and the Poetic Tradition in Caravaggesque Painting.* University Park and London: Pennsylvania State University Press, 1981.

Garrard, Mary D. *Artemisia Gentileschi: The Image of the Female Hero in Italian Baroque Art.* Princeton, N.J.: Princeton University Press, 1989.

Masterpieces of Painting and Sculpture from the Detroit Institute of Arts. Detroit: Institute of Arts, 1949.

Moir, Alfred. *The Italian Followers of Caravaggio.* 2 vols. Cambridge, Mass.: Harvard University Press, 1967.

Wittkower, Rudolf, and Margot Wittkower. *Born under Saturn, The Character and Conduct of Artists: A Documented History from Antiquity to the French Revolution.* New York and London: Norton, 1963.

Judith Leyster

Bernt, Walter. *The Netherlandish Painters of the Seventeenth Century.* Tr. by P.S. Falla. New York: Phaidon, 1970.

Descargues, Pierre. *Hals. Biographical and Critical Study.* Tr. by Jane Emmonds. Geneva: Skira, 1968.

Harms, Juliette. "Judith Leyster: Ihr Leben und ihr Werk." *Oud-Holland,* vol. 44, 1927, pp. 88–96, 112–126, 145–154, 221–242, 275–279.

Hofrichter, Frima Fox. *Judith Leyster.* Doornspijk, The Netherlands: Davaco, 1989.

Hofstede de Groot, Cornelis. "Judith Leyster." *Jahrbuch der Königlich Preussischen Kunstsammlungen,* vol. 14, 1893, pp. 190–198, 232.

————. "Schilderijen door Judith Leyster." *Oud-Holland,* vol. 46, 1929, pp. 25–26.

Neurdenburg, Elizabeth. "Judith Leyster." *Oud-Holland,* vol. 46, 1929, pp. 27–30.

Schneider, Arthur von. "Gerard Honthurst und Judith Leyster." *Oud-Holland,* vol. 40, 1922, pp. 269–273.

Wijnman, H. F. "Het Geboortejaar van Judith Leyster." *Oud-Holland,* vol. 49, 1932, pp. 62–65.

Angelica Kauffmann

Angelica Kauffmann und ihre Zeitgenossen. Bregenz: Vorarlberger Landesmuseum, 1968.

Angelika Kauffmann und ihre Zeitgenossen. Vienna: Österreich Museum für Angewandte Kunst, 1969.

Gerard, Frances A. *Angelica Kauffman: A Biography.* London: Ward and Downey, 1893.

Goethe, Johann Wolfgang von. *Italian Journey.* Tr. by W.H. Auden and Elizabeth Mayer. New York: Shocken, 1968.

Hartcup, Adeline. *Angelica, the Portrait of an Eighteenth Century Artist.* London: Heinemann, 1954.

Manners, Lady Victoria, and G. G. Williamson. *Angelica Kauffmann, R.A.: Her Life and Works.* London: The Bodley Head, 1924; reprint ed., New York: Hacker Art Books, 1976.

Mayer, Dorothy Moulton. *Angelica Kauffmann, R.A. 1741-1807.* Gerards Cross, England: Colin Smythe, 1972.

Rossi, Giovanni Gherado de. *Vita de Angelica Kauffman, Pittore.* Florence: 1810.

Walch, Peter S. *Angelica Kauffmann.* Doctoral thesis, Princeton University, 1969.

Elizabeth Vigée-Le Brun

Baillio, Joseph. *Elizabeth Vigée Le Brun.* Doctoral dissertation, University of Rochester, New York, 1983.

_____. *Elizabeth Vigée Le Brun.* Ft. Worth, Texas: Kimbell Art Museum, 1982.

Helm, William H. *Vigée-Lebrun, Her Life, Works, and Friendships.* London: Hutchinson, 1916.

Levey, Michael. *From Rococo to Revolution: High Trends in Eighteenth Century Painting.* New York: Oxford University Press, 1977.

Nolhac, Pierre de. *Mme. Vigée Le Brun, Peintre de la Reine Marie Antoinette, 1755-1842.* Paris: Goupil, 1912.

Vigée-Le Brun, Elizabeth. *Souvenirs de Mme. Vigée-Le Brun.* 2 vols. Paris: 1835-37. Tr. as *Memoirs of Vigée-LeBrun* by Gerard Sheeley, New York: Doran, 1927; and by Lionel Strachey, New York: Doubleday, Page, 1903.

Rosa Bonheur

Ashton, Dore, and Denise Brown Hare. *Rosa Bonheur: A Life and a Legend.* New York: Viking, 1981.

Boime, Albert. *The Academy and French Painting in the Nineteenth Century.* Reprint ed., New Haven, Conn.: Yale University Press, 1986.

Klumpke, Anna Elizabeth. *Memoirs of an Artist.* Lilian Whiting, ed. Boston: Wright and Potter, 1940.

_____. *Rosa Bonheur, Sa Vie, Son Oeuvre.* Paris: Flammarion, 1908.

Letters of Rosa Bonheur. Collection, Jake and Nancy Hamon Arts Library, Southern Methodist University, Dallas.

Mainrode, Patricia. *Art and Politics of the Second Empire.* New Haven, Conn.: Yale University Press, 1987.

Maas, Jeremy. *Gambart—Prince of the Victorian Art World.* London: Barrie and Jenkins, 1975.

Shriver, Rosalia. *Rosa Bonheur, with a Checklist of Works in American Museums.* Cranbury, N.J.: Art Alliance, 1982.

Stanton, Theodore, ed. *Reminiscences of Rosa Bonheur*. New York: Appleton, 1910; reprint ed., Hatcher Art Books, 1976.
Weisberg, Gabriel. *The Realist Tradition: French Painting and Drawing, 1830–1900*. Cleveland Museum of Art, Ohio, 1980.
Yieldham, Charlotte. *Women Artists in Nineteenth Century France and England*. New York: Garland, 1984.

Berthe Morisot

Adler, Kathleen, and Tamara Garb. *Berthe Morisot*. Ithaca, N.Y.: Cornell University Press, 1987.
Angoulvent, Monique. *Berthe Morisot*. Paris: Morrance, 1933.
Bataille, M. L., and Georges Wildenstein. *Berthe Morisot — Catalogue des Peintures, Pastels, et Aquarelles*. Paris: Les Beaux Arts, 1964.
Herbert, Robert L. *Impressionism: Art, Leisure, and Parisian Society*. New Haven, Conn.: Yale University Press, 1988.
Higgonnet, Anne. *Berthe Morisot*. New York: Harper & Row, 1990.
Huisman, Philippe. *Enchantment*. Tr. by Diana Imber. New York: International Art Books, 1963.
Manet, Julie. *Journal (1893–1899)*. Paris: Klincksieck, 1979.
Morgan, Elizabeth. *Berthe Morisot — Drawings, Pastels, Watercolors*. New York: Shorewood, 1960.
Rey, Jean-Dominique. *Berthe Morisot*. Tr. by Shirley Jennings. Bergamo, Italy: Bonfini, 1982.
Rouart, Denis, ed. *The Correspondence of Berthe Morisot*. Tr. by Betty Hubbard. London: Lund Humphries, 1957.
Stuckey, Charles, William Scott, and Suzanne Lindsay. *Berthe Morisot*. New York: Hudson Hills, 1987.
Valéry, Paul. *Degas, Manet, Morisot*. Tr. by David Paul. New York: Pantheon, 1960.

Mary Cassatt

Biddle, George. *An American Artist's Story*. Boston: Little, Brown, 1939.
Breeskin, Adelyn Dohme. *The Graphic Work of Mary Cassatt: A Catalogue Raisonné*. New York: H. Bittner, 1948; Washington, D.C.: Smithsonian Institution Press, 1979.
————. *Mary Cassatt: A Catalogue Raisonné of the Oils, Pastels, Watercolors and Drawings*. Washington, D.C.: Smithsonian Institution Press, 1970.
Breuning, Margaret. *Mary Cassatt*. New York: Hyperion, 1944.
Bullard, E. John. *Mary Cassatt: Oils and Pastels*. New York: Watson-Guptill, 1972.
Carson, Julia M. H. *Mary Cassatt: Oils and Pastels*. New York: McKay, 1966.
Hale, Nancy. *Mary Cassatt*. Garden City, N.Y.: Doubleday, 1975.
Havemeyer, Louisine W. *Sixteen to Sixty: Memoirs of a Collector*. New York: Privately printed for the family of Mrs. H.O. Havemeyer and the Metropolitan Museum of Art, 1961.
Mathews, Nancy Mowll, ed. *Cassatt and Her Circle: Selected Letters*. New York: Abbeville, 1984.

_____. *Mary Cassatt.* New York: Abrams, in association with the National Museum of American Art, Smithsonian Institution, 1987.

_____, and Barbara Stein Shapiro. *Mary Cassatt: The Color Prints.* New York: Abrams, in association with Williams College of Art (Massachusetts), 1989.

Segard, Achille. *Mary Cassatt: Une Peintre des Infants et des Mères.* Paris: Libraire Paul Ollendorf, 1913.

Sweet, Frederick A. *Miss Mary Cassatt, Impressionist from Philadelphia.* Norman: University of Oklahoma Press, 1966.

Suzanne Valadon

Basler, Adolphe. *Suzanne Valadon.* Paris: Cres, 1929.

Beachboard, Robert. *La Trinité Maudite.* Paris: Amiot-Dumont, 1952.

Coughlan, Robert. *The Wine of Genius: A Life of Maurice Utrillo.* New York: Harper, 1951.

Jacometti, Nesto. *Suzanne Valadon.* Geneva: Cailler, 1947.

Polnay, Peter de. *Enfant Terrible: The Life and Works of Maurice Utrillo V.* New York: Morrow, 1969.

Storm, John. *The Valadon Drama: The Life of Suzanne Valadon.* New York: Dutton, 1959.

Käthe Kollwitz

Bittner, Herbert. *Käthe Kollwitz Drawings.* New York: Yoseloff, 1959.

Bonus-Jeep, Beate. *Sechzig Jahre Freundschaft mit Käthe Kollwitz.* Rev. ed. Bremen: Karl Rauch, 1963.

Fanning, Robert Joseph. *Käthe Kollwitz.* New York: Wittenborn, 1956.

Fecht, Tom, ed. *Käthe Kollwitz: Works in Color.* Tr. by A.S. Wensinger and R.H. Woods. New York: Shocken, 1988.

Kearns, Martha Mary. *Käthe Kollwitz.* Old Westbury, N.Y.: Feminist, 1976.

Klein, Mina C., and H. Arthur Klein. *Käthe Kollwitz: Life in Art.* New York: Holt, Rinehart, and Winston, 1972.

Klipstein, August. *The Graphic Work of Käthe Kollwitz.* New York: Galerie St. Etienne, 1953.

Kollwitz, Käthe. *Aus meinem Leben.* Hans Kollwitz, ed. Munich: List, 1957

_____. *The Diary and Letters of Kaethe Kollwitz.* Hans Kollwitz, ed. Tr. by Richard and Clara Winston. Chicago: Regnery, 1955.

Nagel, Otto. *Käthe Kollwitz.* Tr. by Stella Humphries. Greenwich, Conn.: New York Graphic Society, 1971.

Zigrosser, Carl, ed. *Kaethe Kollwitz.* Rev. ed. New York: Braziller, 1951.

_____, ed. *The Prints and Drawings of Käthe Kollwitz.* New York: Dover, 1969.

Paula Modersohn-Becker

Busch, Günter. *Paula Modersohn-Becker: Malerin-Zeichnerin.* Frankfurt: S. Fischer, 1981.

Hetsch, Rolf, ed. *Paula Modersohn-Becker: Ein Buch der Freundschaft.* Berlin: Rembrandt, 1932.

Modersohn-Becker, Paula. *The Letters and Journals of Paula Modersohn-Becker.* Tr. by J. Diane Rydacki. Metuchen, N. J.: Scarecrow, 1980.

Murken-Altrogge, Christa. *Paula Modersohn-Becker: Leben und Welt.* Cologne: DuMont, 1980.

Paula Modersohn-Becker: Zum Hundertsten Geburtstag. Essays by Gunter Rolf and Museum Staff. Bremen: Kunsthalle, 1976.

Pauli, Gustav. *Paula Modersohn-Becker.* 3rd ed. Berlin: Kurt Wolff, 1934.

Perry, Gillian. *Paula Modersohn-Becker: Her Life and Work.* New York: Harper & Row, 1979.

Steltzer, Otto. *Paula Modersohn-Becker.* Berlin: Rembrandt, 1958.

Werner, Wolfgang. *Paula Modersohn-Becker: Oeuvre Verzeichnis der Graphik.* Bremen: Graphische Kabinett Wolfgang Werner, 1972.

Gabriele Münter

Eichner, Johannes. *Kandinsky und Gabriele Münter: Von Ursprüngen moderner Kunst.* Munich: F. Bruchmann [1957].

Grohmann, Will. *Wassily Kandinsky: Life and Work.* New York: Abrams, 1958.

Kandinsky, Wassily. *Concerning the Spiritual in Art.* Tr. by Michael Sadler. New York: Wittenborn, 1947.

Kleine, Gisela. *Gabriele Münter–Wassily Kandinsky. Biografi eines Paares.* Frankfurt am Main: Insel, 1990.

Mochon, Anne. *Gabriele Münter Between Munich and Murnau.* Cambridge, Mass.: Fogg Art Museum, 1980.

Roethel, Hans K., and Jean K. Benjamin. *Kandinsky.* New York: Hudson Hills, 1981.

Weiss, Peg. *Kandinsky in Munich: The Formative Jugendstil Years.* Princeton, N.J.: Princeton University Press, 1979.

Zweite, Armin. *The Blue Rider in the Lenbachhaus Munich.* Munich: Prestel, 1989.

Vanessa Bell

Bell, Clive. *Art.* London: Chatto & Windus, 1914.

_____. *Old Friends: Personal Recollections.* London: Chatto & Windus, 1956.

Bell, Quentin. *Virginia Woolf: A Biography.* 2 vols. London: Hogarth, 1972.

Charleston Papers, Letters of Vanessa Stephen Bell. To Roger Fry, 454 letters, 1911–1934; to Clive Bell, over 300 letters, 1902–1960; to John Maynard Keynes, 92 letters, 1900–1935; to Thoby Stephen, 24 letters, 1897–1901. Library of King's College, Cambridge.

Collins, Judith. *The Omega Workshops.* Chicago: University of Chicago Press, 1984.

Fry, Roger. *Vision and Design.* London: Chatto & Windus, 1920.

_____. *Duncan Grant.* London: Hogarth, 1923.

Garnett, Angelica. *Deceived with Kindness: A Bloomsbury Childhood.* San Diego: Harcourt Brace Jovanovich, 1984.

Johnstone, J. K. *The Bloomsbury Group.* London: Secher & Warburg, 1954.

Rosenbaum, S. P., ed. *The Bloomsbury Group. A Collection of Memories: Commentary and Criticism.* London: Croom Helm, 1975.

Shone, Richard. *Bloomsbury Portraits: Vanessa Bell, Duncan Grant, and Their Circle*. Oxford: Phaidon; New York: Dutton, 1976.

Spalding, Frances. *Roger Fry: Art and Life*. London: Eilek/Granada, 1980.

_____. *Vanessa Bell*. San Diego: Harcourt Brace Jovanovich, 1985.

Stansky, Peter, and William Abrahams. *Journey to the Frontier: Julian Bell and John Cornford, Their Lives and the 1930s*. London: Constable, 1966.

Zink, David. *Leslie Stephen*. New York: Twayne, 1972.

Sonia Delaunay

A.B.C. Alphabet de Sonia Delaunay. Text by Jacques Damase. New York: Crowell, 1972.

Anscombe, Isabelle. *A Woman's Touch: Women in Design from 1960 to the Present Day*. New York: Viking-Penguin, 1985.

Buckberrough, Sherry A. *Sonia Delaunay: A Retrospective*. Buffalo, N.Y.: Albright Knox Art Gallery, 1980.

Cohen, Arthur. *Sonia Delaunay*. New York: Abrams, 1978, 1988.

Contensie, Bernadette, and Danielle Molinari. *Robert et Sonia Delaunay*. Paris: Musée d'art Moderne, 1987.

Damase, Jacques. *Rythmes et Couleurs de Sonia Delaunay*. London: Thames and Hudson, 1972.

_____. *Sonia Delaunay: Dessins Noirs et Blancs*. Paris: Artcurial, 1978.

Delaunay, Sonia. *Nous Irons Jusqu'au Soleil*. With Jacques Damase and Patrick Raynaud. Paris: Laffont, 1978.

Desanti, Dominique. *Sonia Delaunay: Magique Magicienne*. Paris: Éditions Ramsay, 1988.

Dorival, Bernard. *Sonia Delaunay*. Paris: Éditions Jacques Damase, 1980.

Hoog, Michel. *R. Delaunay*. New York: Crown, 1976.

Lhote, Andre, ed. *Sonia Delaunay: Ses Objets, Ses Tissus Simultanés, Ses Modes*. Paris: Editions Chuetieu, 1925.

Madsen, Axel. *Sonia Delaunay: Artist of the Lost Generation*. New York: McGraw-Hill, 1989.

Robes-Poèmes de Sonia Delaunay. With extracts of texts by Guillaume Apollinaire and Blaise Cendrars and introduction by Jacques Damase. Milan: Edizione del Naviglio, 1969.

Sonia Delaunay: Art into Fashion. Introduction by Elizabeth Morano, foreword by Diana Vreeland. New York: Braziller, 1986.

Vriesen, Gustav, and Max Imdahl. *Robert Delaunay: Light and Color*. New York: Abrams, 1967.

Georgia O'Keeffe

Bry, Doris, and Nicholas Callaway, eds. *Georgia O'Keeffe in the West*. New York: Knopf, in association with Callaway Editions, 1989.

Castro, Jan Garden. *The Art and Life of Georgia O'Keeffe*. New York: Crown, 1985.

Cowart, Jack, and Juan Hamilton. *Georgia O'Keeffe: Art and Letters*. Boston: Little, Brown, 1987.

Georgia O'Keeffe: A Portrait by Alfred Stieglitz. Introduction by Georgia O'Keeffe. New York: Metropolitan Museum of Art/Viking, 1978.

Georgia O'Keeffe: One Hundred Flowers. New York: Knopf, 1989.

Gherman, Beverly. *Georgia O'Keeffe: The Wideness and Wonder of Her World.* New York: Athenaeum, 1986.

Goodrich, Lloyd, and Doris Bry. *Georgia O'Keeffe Retrospective, Whitney Museum of American Art.* New York: Praeger, 1970.

Haskell, Barbara. *Georgia O'Keeffe: Works on Paper.* Santa Fe: Museum of New Mexico Press, 1985.

Kuh, Katherine. *The Artist's Voice: Talks with Seventeen Artists.* New York: Harper & Row, 1962.

Lisle, Laurie. *Portrait of an Artist: A Biography of Georgia O'Keeffe.* New York: Seaview, 1986.

Lowe, Sue Davidson. *Stieglitiz: A Memorial Biography.* New York: Farrar, Straus and Giroux, 1983.

Norman, Dorothy. *Alfred Stieglitz: An American Seer.* New York: Random House, 1960.

O'Keeffe, Georgia. *Georgia O'Keeffe.* New York: Viking, 1976.

Pollitzer, Anita. *A Woman on Paper: Georgia O'Keeffe.* New York: Simon & Schuster, 1985.

Rich, Daniel Catton. *Georgia O'Keeffe.* Chicago: Art Institute of Chicago, 1943.

Robinson, Roxana. *Georgia O'Keeffe: A Life.* New York: Harper & Row, 1985.

Frida Kahlo

Brenner, Anita. *Idols Behind Altars.* New York: Payson and Clarke, 1929.

del Conde, Teresa. *Vida de Frida Kahlo.* Mexico City: Secretaria de la Presidencia, Departamento Editorial, 1976.

Herrera, Hayden. *Frida: A Biography of Frida Kahlo.* New York: Harper & Row, 1983.

Rivera, Diego, with Gladys March. *My Art, My Life: An Autobiography.* New York: Citadel, 1960.

Rodriguez Prampoline, Ida. *El Surrealismo y Arte Fantástico de Mexico.* Mexico City: Instituto de Investigaciones Estéticas, Universidad Nacional Autónoma de México, 1969.

Tibol, Raquel. *Frida Kahlo: Crónica, Testimonios y Aproximaciones.* Mexico City: Ediciones de Cultura Popular, S.A., 1977.

_____. *Frida Kahlo.* Tr. into German by Helga Prignitz. Frankfurt: Verlag Neue Kritik, 1980.

Wolfe, Bertram D. *The Fabulous Life of Diego Rivera.* New York: Stein & Day, 1963.

Index

Adam, Robert 27, 31
Adams, Abigail 42
Anne Amalia, grand duchess of
 Saxe-Weimar 35
Apollinaire, Guillaume 170, 171, 175
Aragon, Louis 175
Arbuckle, John 62
Arias, Alejandro Gómez 197, 198
Arp, Jean 143, 177
Augusta, empress of Germany 114

Baburen, Dirck van 15
Barberini, Cardinal Antonio 8
Barberini, Cardinal Francesco 8
Barlach, Ernst 115, 116, 120
Bashkirtseff, Marie 123
Baudelaire, Charles 73
Bazille, Fréderic 69, 73
Bebel, August 110
Beck, Maria 124
Becker, Carl Woldemar 122, 123, 125,
 126
Becker, Herma 123, 130
Becker, Mathilde 122, 123, 126, 127,
 132
Becker, Milly 123,126, 128
Bell, Angelica see Garnett, Angelica
 Bell
Bell, Clive 149, 150, 151, 152, 153, 154,
 155, 156, 158, 159, 160, 163
Bell, Julian 151, 152, 155, 156, 158, 160,
 162
Bell, Quentin 152, 153, 155, 156, 158,
 160, 162
Bell, Vanessa 148-164
Bernheim-Jeune 103, 104
Bernini, Gianlorenzo 6
Bernsdorff, Count 29
Bertin, Rose 42
Bismarck, Prince Otto von 70, 109, 112
Blanchard, Mari 106

Blavatsky, Madam 143
Bloch, Lucienne 200
Blue Rider Almanac 143
Böcklin, Arnold 166
Boissy, Adrian 97, 100
Bonheur, Auguste 53, 54, 55-56, 57,
 60
Bonheur, Germain 57
Bonheur, Isidor 53, 54, 55-56, 63
Bonheur, Juliette 52, 55, 57, 62
Bonheur, Marguerite Pecord
 Peyrol 55, 57
Bonheur, Raymond (Raimond) 53, 54,
 55, 57, 59
Bonheur, Rosa 53-65
Bonheur, Sophia Marquis 53, 54, 62,
 64
Boning, Margarete 120
Bonnard, Pierre 128, 152
Bosch, Hieronymus 202
Botticelli, Sandro 123, 198
Bowles, George 33
Braque, Georges 107, 168, 169
Braquemond, Felix 67
Breton, André 175, 196, 203
Breton, Jacqueline 203
Brett, Dorothy 189
Brueghel, Pieter 202
Bry, Doris 194
Bultzingslöwen, Wulf von 122, 123
Buonarotti, Michelangelo, the
 Younger 5

Caetoni, Prince Orano 32
Callot, Jacques 5
Calonne, Charles Alexandre de 42
Cameron, Julia Margaret 148
Canova, Antonio 33, 36
Caracci, Annibale and Agostino 2
Caravaggio, Michelangelo Merisi
 da 1-2, 6, 15

Cassatt, Alexander 83, 87, 88, 91, 92
Cassatt, Gardner 83, 87, 91, 92
Cassatt, Katherine Kelso Johnson 83, 84, 85, 86, 87, 88, 91
Cassatt, Lydia 83, 84, 86, 87
Cassatt, Mary 76, 77, 78, 79, 83–95, 177
Cassatt, Robert (Robbie) 83
Cassirer, Paul 113
Catherine II, empress of Russia 49
Cecil, Lord Robert 150
Cendrars, Blaise 171, 172
Cérèse, Comtesse de 43
Cézanne, Paul 125, 128, 131, 132, 138, 152, 169
Chabrier, Emmanuel 78
Chaplin, Charles Jordan 84
Chardin, Paul 61
Charles I, king of England 10
Chase, William Merritt 181
Chevreul, Michel-Eugene 170
Chocarne, Geoffrey Alphonse 66
Civil War 84
Claes, Fanny 69
Clemenceau, Georges 94
Codrano, Lidica 173
Cody, William S. (Buffalo Bill) 62
Cohen, Arthur 172
Cooke, Ebenezer 149
Cope, Arthur 149
Corot, Camille 67, 68
Correggio 26, 85, 87
Cosway, Maria 31–32
Courbet, Gustave 84, 92
Couture, Thomas 84
Cranach, Lucas 123
Cunard, Nancy 175

Dalrymple, Capt. Robert 36
Damase, Jacques 178, 179
Dance, Nathaniel 27, 28
Daubigny, Charles 67
Daumier, Honoré 67, 113
Descartes, Rene 20
Degas, Edgar 69, 70, 72, 73, 74, 76, 77, 78, 81, 85, 86, 87, 88, 89, 91, 94, 95, 98, 152
Dehmel, Richard 120
Delacroix, Eugène 61
Delaunay, Charles 170, 172, 173, 174, 176, 177, 178
Delaunay, Denise 177, 178

Delaunay, Robert 143, 168, 169, 170, 171, 172, 173, 174, 175, 176, 177, 178–179
Delaunay, Sonia 106, 165–179
Demuth, Charles 188
Denis, Maurice 128
Der Blaue Reiter 143
Derain, Andre 107, 143, 167, 168, 169
Diaghilev, Sergei 104, 155, 174
Dickens, Charles 113
Dickinson, Violet 150–151
Dove, Arthur 188
Dow, Arthur Wesley 182, 183
Dreyfus, Capt. Alfred 91
Dubufe, Édouard Louis 57
Duchamps, Marcel 172, 203
Duckworth, George 148, 149
Duckworth, Gerald 148, 150
Duckworth, Stella 148, 149, 150
Dufy, Raoul 168
Durand-Ruel, Paul 73, 80, 88, 91, 92

Ebert, Friedrich 115, 116
Eichner, Johannes 146
El Greco 92, 98
Elias, Julius 112
Eloesser, Dr. Leo 200, 205, 206
Ende, Hans am 124
Enfantin, Barthelmy Prosper 54
Engelhard, Georgia 190
Eppstein, Elizabeth 143
Ernst Heinrich, Prince 180
Escoffier 104
Este, Francesco I d', duke of Modena 10
Este, Rinaldo d', duke of Modena 25
Eugénie, empress of France 60, 64

Fantin-Latour, Félix 67, 68
Félix, Maria 206
Ferdinand IV, king of the Two Sicilies 32
Fernández, Fernando 198
Flaxman, John 33, 37
Forster, E.M. 162
Franco-Prussian War 61, 70–71, 84, 96, 109
Freilgrath, Ferdinand 110
French Revolution 19, 46, 47
Frére, Édouard 84

Fry, Roger 152, 153, 154, 155, 156, 158, 159, 160, 161, 162
Furse, Charles 149
Fuseli, Johan Heinrich 28

Gainsborough, Thomas 29, 31
Galerie Georges Petit 107
Galileo Galilei 5
Gambart, Ernst 58–59, 60, 62
Gambetta, Leon 70
Garnett, Angelica Bell 159, 160, 162
Garnett, David 155, 156, 159, 162
Garnett, Ray 160, 162
Garrard, Mary D. 11
Gauguin, Paul 87, 98, 102, 128, 131, 132, 138, 152, 168
Gazi-I.G. 106
Gentileschi, Artemisia 1–12
Gentileschi, Aurelio 5
Gentileschi, Francesco 2, 10
Gentileschi, Orazio 1, 2, 3, 4, 5, 6, 8, 10
Gentileschi, Prudentia Ottaviano Montone 1
George III, king of Great Britain 27, 28, 29
Géricault, Theodore 58
Gérôme, Jean Leon 84
Gobillard, Paule 73, 80
Gobillard, Théodore 68
Gobillard, Yves Morisot 66, 73
Goethe, Johann Wolfgang von 34–35, 110, 120
Goncharova, Natalia 143
Gonzalès, Eva 70, 77, 106
Goodall, Frederick 59
Goya, Francesco 73, 85
Grant, Duncan 150, 151, 152, 153, 154, 155, 156, 159, 160–161, 162, 163
Grebber, Frans Pietersz. de 15
Gretor, Georg 11fl
Greuze, Jean Baptiste 40
Grossmann, Rudolf 168
Guiard-Labille, Adélaïde 41
Guichard, Joseph 66, 67, 74
Guillaumin, Armand 69
Guillemet, Antoine 69

Halpert, Sam 173, 174
Hals, Frans 13, 15, 16, 17, 18, 20, 21, 23, 85

Hamilton, Anne Marie 194
Hamilton, Lady Emma 35, 36, 47
Hamilton, Juan 193, 194, 195
Hamilton, Sir William 32, 35, 36, 47–48
Harding, Constanza 114
Hardy, Thomas 149
Harms, Juliette 13
Hart, Emma *see* Hamilton, Lady Emma
Hauptmann, Carl 126
Hauptmann, Gerhart 112, 125–126
Havemeyer, Henry O. 92
Havemeyer, Louisine Elder 85, 92, 94
Heckel, Erich 141, 143
Heda, William Claes 21
Heim, Jacques 175
Heine, Heinrich 110
Henrietta Maria, queen of England 10
Herder, Gottfried von 35
Herriot, Édouard 104
Herterich, Ludwig 111
Hervey, Frederick, earl of Bristol 36
Hills, Jack 149
Hindenburg, Paul von 119
Hitler, Adolf 119, 120, 132
Hoetger, Lee 130
Hofrichter, Frima Fox 13, 23
Hofstede de Groot, Cornelis 13, 23
Hogarth, William 113
Holbein, Hans, the Younger 123
Honthurst, Gerard van 15, 16
"Horn, Count de" (Brandt) 28, 29, 32
Hurtado, Emma 208
Husgen, Wilhelm 136
Hutchinson, Mary 155, 156, 159
Huysmans, J. K. 87

Jacobsen, J. P. 123
James, Henry 149, 150
Jawlensky, Alexei 138, 140, 141, 143
Jeep, Emma 111, 114
Jones, Inigo 10
Joseph II, Holy Roman emperor 33, 41, 42
July Revolution 53

Kahlo, Adriana 196, 198
Kahlo, Cristina 196, 201, 202, 203, 205, 206

Kahlo, Frida 193, 196–208
Kahlo, Guillermo 196, 198, 199
Kahlo, Matilde 196, 198, 199
Kahlo, Matilde Calderón y Gon-
 zalès 196, 199–200
Kandinsky, Nina Andreevskaya 145
Kandinsky, Vassily 135, 136, 137, 138,
 140, 141, 143, 144, 145, 146, 176, 182,
 203
Kauffmann, Angelica 25–38, 47, 48
Kauffmann, Cleofe 25, 26
Kauffmann, Johann Anton 36
Kauffmann, Johann Joseph 25, 26, 27,
 28, 31, 32
Kaufmann, Edgar, Sr. 203
Keynes, John Maynard 152, 153, 156,
 159–160, 161, 162
Kirchner, Ernst Ludwig 141, 143
Klee, Paul 143, 144, 171
Klenert, Catherine O'Keeffe 180, 189,
 191, 194, 195
Klinger, Max 111, 112, 113
Klumpke, Anna 62, 63
Kollwitz, Elizabeth 110
Kollwitz, Hans 112, 113, 114, 115, 116,
 119
Kollwitz, Jutte 116, 120
Kollwitz, Karl 110, 111, 112, 114, 115,
 118, 119, 120, 121
Kollwitz, Käthe 109–121, 122, 136
Kollwitz, Othilie Ehlers 116
Kollwitz, Peter (first son) 113, 114, 115,
 116, 117–118
Kollwitz, Peter (second son) 116, 120
Kubin, Alfred 143
Kupka, Frantisek 170, 176

Lammenais, Abbé 54
Landseer, Sir Edwin 59
Landseer, Thomas 59
Laurencin, Marie 106, 169
Lawrence, D. H. 189
Le Brun, Jean Baptiste Pierre 40–41,
 42, 43, 47, 48, 49
Le Franc, Eugénie Le Brun 51
Leroy, Louis 74, 75
Le Sèvre, Jacques François 40
Levitan, Isak 166
Levy, Julian 205
Leyster, Jan 13, 14, 15, 20
Leyster, Judith 13–24

Leyster, Trijn Jaspers 14, 15, 20
Liebknecht, Karl 116
Lievens, Jan 21, 22
Loeb, Sue 109
Louis, Seraphine 106
Louis XVI, king of France 41, 46, 47,
 48, 51
Louis XVIII, king of France 41, 51
Louis Philippe, king of France 53,
 57
Louise, queen of Prussia 49
Lucas, Caroline Byng 163
Luhan, Mabel Dodge 189, 190
Lujan, Tony 189
Luxemburg, Rosa 116

Macke, August 143, 144, 145
Mackensen, Fritz 123, 124
MacMahon, Arthur 183
MacMonnies, Mary Fairchild 89
Magnelli, Alberto 177
Makler, Lina 112
Mallarmé, Stéphane 74, 78, 79, 80,
 81
Mallory, George Leigh 153
Manet, Édouard 67, 68, 69, 70, 72, 73,
 74, 75, 76, 77, 79, 86, 92, 152, 166
Manet, Eugène 72, 74, 75, 76, 77, 78,
 79, 80
Manet, Gustave 77
Manet, Julie 76, 77, 79, 80
Manet, Suzanne 73
Marat, Jean Paul 32
Marc, Franz 143, 145
Marc, Maria 143
Marcello 68
March Revolution 111
Maria Carolina, queen of the Two
 Sicilies 32, 33, 47
Marie Antoinette, queen of France 40,
 41, 42, 43, 45–46, 47, 48
Marin, John, 187
Marín, Lupe 198, 199
Marquet, Albert 167
Matisse, Henri 102, 107, 138, 140, 154,
 167
Mauclair, Camille 150
Mauer, Rudolph 110, 111
Maximilian, emperor of Mexico 60
Medaglia, Donna Tuzia 3
Medici, Cosimo de, II, grand duke of
 Tuscany 5

Mella, Julio Antonio 198
Mengs, Raphael 26, 27
Mercador, Ramón 205
Meredith, George 149
Mexican Revolution 196
Micas, Nathalie 55, 57, 58, 59, 60, 61, 62, 64
Michelangelo Buonarotti 2, 123
Millet, Aimé 67
Mistinguette 104
Modersohn, Elsbeth 125, 126, 127
Modersohn, Helène 124, 125
Modersohn, Mathilde 132
Modersohn, Otto 123, 124, 125, 126, 127, 128, 130, 132
Modersohn-Becker, Paul 122–134, 136
Modotti, Tina 198
Modigliani, Amadeo 103
Molenaer, Jan Miense 17, 20, 21, 22, 23
Molenaer children, 21, 22
Monet, Claude 69, 73, 74, 75, 76, 78, 80, 89, 92
Moore, G. B. 149
Moreas, Beatris 173, 174
Morisot, Berthe 66–82, 86, 87, 88, 106
Morisot, Edma see Pontillon, Edma Morisot
Morisot, Edme Tiburce 66, 67, 68, 69, 70, 72, 74
Morisot, Marie Cornelie Thomas 66, 67, 68, 69, 70, 71, 72, 74, 75
Morisot, Tiburce 66, 60
Morisot, Yves see Gobillard, Yves Morisot
Morrow, Dwight 199
Moser, Mary 29, 31
Mousis, Paul 98, 99, 100, 101
Munch, Edvard 111
Münter, August 135, 136
Münter, Carl Friedrich 135–136
Münter, Emmy 135, 136
Münter, Gabriele 135–136
Münter, Karl 135, 136
Murat, Caroline 50
Muray, Nikolas 203

Napoleon III, emperor of France 57, 60, 61, 63, 66, 67, 70, 79
Napoleon Bonaparte, emperor of France 49, 50–51, 57
Naujok, G. 110

Neide, Emil 111
Nevelson, Louise 201
Nigris, Gaétan Bernard 49, 50
Noguchi, Isamu 203
Nolde, Emil 125
Norman, Dorothy 189, 190, 191
Norton, Harry 152, 153

O'Keeffe, Alexis 180, 194
O'Keeffe, Anita 180, 181, 182, 190
O'Keeffe, Catherine see Klenert, Catherine O'Keeffe
O'Keeffe, Claudia 180, 184
O'Keeffe, Francis 180, 181, 182, 183, 184
O'Keeffe, Francis, Jr. 180, 181
O'Keeffe, Georgia 180–195
O'Keeffe, Ida 180, 181, 183, 189
O'Keeffe, Ida Totto 180, 181, 182, 183
Omega Workshops 154–155, 159, 160
Orphism 170
Oudinot, Achille Francois 67
Overbeck, Fritz 124, 125, 127, 132

Pack, Arthur 191, 192
Palmer, Mrs. Potter 89
Paris Commune 61, 72, 96, 97
Parmagianino 85
Partridge, Frances 151
Paul I, emperor of Russia 32, 49
Pauli, Gustave 130
Pauwels, Lucie see Utrillo, Lucie Pauwels
Peasants' War 113
Picasso, Pablo 102, 107, 137, 138, 143, 168, 169, 170, 203
Pilkington, Betty 193
Piranesi, Giovanni 27
Pissarro, Camille 69, 73, 86, 88–89
Poiret, Paul 103
Pollitzer, Anita 183
Pontillon, Adolphe 69
Pontillon, Edma Morisot 66, 67, 68, 69–70, 71, 72, 73, 75, 77, 79, 80
Pontillon, Jeanne 79, 80
Porter, Paulus 55
Pozzo, Cassiano dal 8, 10
Pre-Raphaelites 198
Provence, Comte de see Louis XVIII

Puvis de Chavannes, Pierre 69, 72, 97

Quorli, Cosimo 3

Raimondi, Carlo 85
Raphael 39, 50
Rapin, Ilya 166
Reiffenstein, Johann Friedrich 26, 35
Rembrandt van Rijn 10, 21, 39, 123, 128
Renoir, Auguste 69, 73, 74, 75, 76, 78, 79, 80, 97, 98
Reylander, Ottilie 126
Reynolds, Sir Joshua 27, 29, 31
Riddle, Mrs. Robert Moore 87
Riesener, Léon 68
Rilke, Rainer Maria 126, 127, 128, 130, 132
Ripa, Cesare 8
Rivera, Diego 193, 197–198, 199, 200, 201, 202, 203, 204, 205, 206, 207, 208
Rivière, Auguste 48
Rivière, Caroline Vigée 51
Robert, Hubert 47
Robinson, Edward G. 205
Rockefeller, Nelson 201
Rodin, Auguste 113, 115, 125, 127, 128, 130, 181
Romney, George 35
Rosa, Salvator 55
Rose, Countess Bertha de la 168, 169, 174, 178
Rossetti, Dante Gabriel 89
Rouart, Denis 78
Rouault, Georges 138, 167
Rousseau, Henri 102, 138, 143, 168
Rousseau, Jean Jacques 40
Rubens, Peter Paul 39, 41, 69, 77, 85, 110
Rubio, Ortiz 200
Ruffo, Don Antonio 10, 11
Rupp, Julius 109, 110
Ruskin, John 59
Russian Revolution 118, 174
Ryland, William 29–30

Sadler, Michael 144
Saint-Simon, Comte Raymond de 53–54

Sand, George 58
Sargent, John Singer 149
Sartrain, Emily 85
Satie, Erik 100
Schmid-Reutte, Ludwig 166
Schmidt, Carl 109, 111
Schmidt, Julia 109
Schmidt, Katharina Rupp 109, 110
Schmidt, Konrad 109, 110–111, 112, 119
Schmidt, Lisa 109, 110, 111, 120
Schönberg, Arnold 166
Schrevel, T. 22
Schutz, J. G. 35
Scott, Sir Walter 55, 60
Sebring, June O'Keeffe 194, 195
Segard, Achille 84, 86
Seurat, Georges 77, 170
Shakespeare Gallery 35
Sheeler, Charles 188
Shuvalov, Count Ivan 40, 49
Sisley, Alfred 69, 73, 75, 76, 80
Soyer, Paul 84
Springer, Ferdinand 177
Staël, Mme. de 51
Stahly, Francois 177
Stamper, Frances Byng 162
Stanzione, Massimo 8
Stauffer-Bern, Karl 111
Stein, Gertrude 169
Steinlen, Théophile-Alexandre 138
Stephen, Adrian 148, 150, 151, 153, 155
Stephen, Julia Duckworth 148, 149, 150
Stephen, Laura 148
Stephen, Sir Leslie 148, 149, 150
Stephen, Thoby 148, 149, 150, 151
Stern, Elie 165, 166
Stern, Hanne 165
Stern, Klara 120
Stiattesi, Giovanni Battista 3
Stiattesi, Pietro Antonio di Vincenzo 3, 4, 5, 7, 10
Stiattesi, Prudentia (Palmira) 6–7, 8; second daughter (unnamed) 7, 8, 10
Stieglitz, Alfred 181, 183, 184, 185, 187, 188, 189, 190, 192, 193
Stieglitz, Elizabeth 184, 185
Stieglitz, Emmy Obermayer 184, 187
Stieglitz, Hedwig 185
Stieglitz, Kitty 184, 187, 190
Stieglitz, Dr. Leopold (Lee) 184, 185
Stillman, James 92

Strachey, Lytton 150, 152, 153, 154, 159
Strand, Beck 189
Strand, Paul 184, 189
Stuckey, Charles 72
Swanson, Gloria 175
Swift, Jonathan 148

Tassi, Agostino 2, 3, 4
Tauber-Arp, Sophia 177
Tedesco brothers 57
Terbrugghen, Hendrick 15
Terk, Anna 165, 168, 169, 170
Terk, Henri 165, 166, 168, 169, 174
Tintoretto 27
Titian 27
Toklas, Alice B. 169
Tolstoy, Leo 110
Toomer, Jean 191
Toomer, Marjorie Content 191
Totto, George 180
Toulouse-Lautrec, Henri 98
Tourny, Joseph 85
Trotsky, Leon 202, 205
Trotsky, Natalia 202
Trumbull, John 46
Tzara, Tristan 175, 178

Uhde, Wilhelm 168, 169, 170, 177–178, 179
Urban VIII, pope 6, 8
Utrillo, Lucie Pauwels 106
Utrillo, Maurice 96, 97, 98, 99, 100, 101, 102, 103, 104, 106, 107
Utrillo y Molins, Miguel 97, 98
Utter, Andre 101, 102, 103, 104

Valadon, Madeleine 96, 97, 98, 99, 100, 101, 102
Valadon, Suzanne 96–108
Valéry, Paul 81
Vallet, Mathilde 94
Vanderpoel, John 181
Van Dongen, Kees 167–168, 169
Van Dyck, Anthony 10, 39
Van Gogh, Vincent 98, 128, 131, 140, 152, 168
Varney, Jane Wyckoff 180
Vasconcelos, José 197

Vaudreuil, Comte de 42
Velásquez, Diego 14, 73, 85
Vernet, Claude Joseph 40, 41
Veronese, Paolo 67, 166
Vianna, Edouardo 173, 174
Victoria, queen of Great Britain 59
Vigée, Etienne 39, 40, 42, 48, 49, 51
Vigée, Jeanne Maissin 39, 40, 41
Vigée, Louis 39, 40
Vigée–Le Brun, Elizabeth 35, 39–52, 54, 106
Vigée–Le Brun, Julie 41, 46, 47, 48, 51
Villon, François 96
Vlaminck, Maurice 143, 147, 167, 169
Vogeler, Heinrich 123, 124, 126, 127, 128
Vollard, Ambroise 100, 125, 168
Vuillard, Édouard 128, 152

Walden, Herwarth 171, 172
Weill, Berthe 102, 103
Wentworth, Lady 27, 28
Werefkin, Marianne von 138, 140, 141, 143
West, Benjamin 26, 29, 31
Westhoff, Clara 123, 124, 1255, 126, 127, 128, 130
Winckelmann, Johann Joseph 26, 27, 33, 40
Whistler, James 78
Wiegandt, Milly 122
Wilhelm II, emperor of Germany 112, 114, 115
Willemzoon, Jan see Leyster, Jan
Willemzoon, Trijn Jaspers see Leyster, Trijn Jaspers
Willis, Elizabeth May 181, 182
Wolff, Albert 75
Woolf, Leonard 149, 152, 153, 156, 159, 162
Woolf, Virginia 148, 150, 151, 152, 153, 154, 155, 156, 159, 161, 162
World War I 94, 102, 103, 115, 145, 155, 156, 159, 173, 174, 184
World War II 120, 145, 162, 176, 177, 178, 192

Zoffany, Johann 30–31
Zola, Émile 69, 91, 112
Zorn, Anders 198
Zucchi, Antonio 31, 32, 33, 35